AIR / LUFT

OLIVER HERWIG / AXEL THALLEMER

AIR / LUFT

Unity of Art and Science
// Einheit von Kunst und Wissenschaft

ARNOLDSCHE

> CONTENTS / INHALT

Axel Thallemer One Doesn't Usually Think about Air, Doesn't Perceive It Consciously except when It Is in a State Different to the Accustomed One
// Meistens denkt man gar nicht an Luft, nimmt sie nicht bewusst wahr, außer sie ist gegenüber dem gewohnten Zustand anders

Oliver Herwig Bubbles and Other Consciousness Enlargements in 20th-Century Architecture, Design and Art
// Blasen und andere Bewusstseinserweiterungen in Architektur, Design und Kunst des 20. Jahrhunderts

WHAT IS AIR? This book is an approach to answering that question by looking at various entirely different aspects of it. They range from mythological, religious and philosophical aspects to scientific explanatory models that show the chemical, physical, atomic or energy-related qualities of air and their interrelationship with, as well as influence on, our living space.

Fragmentation of heuristic knowledge into such categories as biology, chemistry and physics, archaeology, astronomy and geology has brought with it a deepening of knowledge in each of these disciplines but has, at the same time, reduced overall knowledge of them in breadth. Consequently the present book represents an attempt at seeing things from the broader perspective. It is structured according to temporal context and energy state, technological development and paradigm shift, informed by culture, art and artefacts in space.

Humanity has always been preoccupied with air as a medium, also in the artistic sense. During the 20th century the approach to this theme was deepened in so far as air was not merely represented in visual terms, but was deliberately used as a material. Following the use of stone, wood, metal, ceramics, later glass and membranes (animal hides, leather, fabric, synthetic textiles) as historical developments, air, as the seventh building material in the applied and decorative arts as well as the visual, or fine, arts, is at once theme and medium of expression. Designers and architects use air as a building material and so do sculptors and painters. During the 1960s, student protest coincided with the worldwide »pneumatic movement«, an attempt to counteract traditional societal conventions in both architecture and interior design, which also extended to furniture design and industrial design, by using air. By comparison, subsequent generations of artists have dealt with air as a theme in a manner that is both more professional and more intellectual. Even fine art is now formulating ironical quotations from a »classical« Modernism that has outlived its time.

WAS IST LUFT? Dieses Buch nähert sich einer Beantwortung dieser Frage durch die Betrachtung ganz verschiedener Aspekte. Dies reicht von mythologischen, über religiöse und philosophische Aspekte bis hin zu wissenschaftlichen Erklärungsmodellen, so zum Beispiel der Darlegung von chemischen, physikalischen, atomaren oder energetischen Eigenschaften von Luft und deren Wechselwirkung sowie Einfluss auf unseren Lebensraum.

Die Fragmentierung der heuristischen Erkenntnis in Kategorien wie Biologie, Chemie und Physik, Archäologie, Astronomie und Geologie hat für diese jeweiligen Disziplinen zwar eine Wissensvertiefung gebracht, gleichzeitig jedoch den Gesamtblick gemindert. So ist dieses Buch ein Versuch der umfassenderen Sichtweise, es ist gegliedert in Zeitkontexte und Energiezustände, Technologie-Entwicklungen und Paradigmenwechsel, durchdrungen von Kultur, Kunst und Artefakten im Raum.

Die Menschheit hat sich mit dem Medium Luft immer schon auch künstlerisch auseinander gesetzt. Im 20. Jahrhundert erfährt dieses Thema jedoch eine Vertiefung dahin gehend, dass Luft nicht nur abgebildet, sondern bewusst als Material eingesetzt wird. Nach der entwicklungsgeschichtlichen Verwendung von Stein, Holz, Metall, Keramik, später Glas und Membranen (Fell, Leder, Gewebe, technische Textilien) wird Luft als siebtes Baumaterial in den Angewandten, Bildenden, aber auch Darstellenden Künsten Thema und Ausdrucksmedium zugleich. Designer und Architekten nutzen es als Baumaterial ebenso wie Bildhauer und Maler. Während der 1960er Jahre koinzidiert der Studentenprotest mit dem weltweiten »pneumatic movement«, der Bestrebung traditionelle gesellschaftliche Konventionen in der Architektur sowie der Raumgestaltung, bis hin zu Entwürfen für Möbel und Geräte, durch den Einsatz von Luft zu konterkarieren. Im Vergleich dazu sind die nachfolgenden Künstlergenerationen mit dem Thema Luft professioneller und intellektueller verfahren. Selbst die reine Kunst formuliert nun ironische Zitate einer sich selbst überlebt habenden »Klassischen« Moderne.

All aspects covered here are diachronically related to the observation of air as an element. The blurring of both the terminology and the boundaries of the separate disciplines is intentional. Air is not just a subject for technology or physics in the superficial sense. Viewed from the anthropocentric standpoint, it is a representation of the structure of thought as projected, which can be associated with the term »air«. Of course the structure of thought will continue to change and adjust to the current state of knowledge as it has done even in the past. Consequently, what has been printed here represents only what has hitherto been confirmed as probable rather than fallacies or even opposing conjecture. Since only what is known can be perceived, although the physiological faculty of seeing has remained as it was, future developments will, as a matter of course, result in changes here, which will affect aspects of human life.

Might it be possible to view »air« in future not just as a discrete entity, through observation of its interaction with »water«, for instance, to arrive at a holistic way of thinking, which would then be based solely on matter in the spatial and temporal context in different energy stages? The blurring of such standard terms such »air – water – earth – fire« as well as »gaseous – liquid – solid – elemental« could lead to a convergence of the specialist disciplines to which each has hitherto been assigned by the sciences. In fact we haven't really advanced all that much as far as the state of our knowledge is concerned in the past 2500 years – except for the deductive application of given natural problem-solving strategies to purely technical issues. Things would most likely become more exciting, however, if inductive, non-material aspects were to be tried out as new models.

Axel Thallemer, Munich, June 26, 2005

Alle hier dargelegten Aspekte nehmen diachronisch Bezug auf die Betrachtung des Elements Luft, wobei eine Auflösung der Begrifflichkeit wie auch der Bereichsgrenzen intendiert ist. Luft ist nicht nur vordergründig ein Thema der Technik oder der Physik, sondern in anthropozentrischer Sichtweise ein Abbild des projizierten Gedankengebäudes, welches mit der Bezeichnung »Luft« assoziiert werden kann. Natürlich wird sich jenes, wie auch in der Vergangenheit schon, stetig weiter ändern und den Erkenntnissen anpassen. So ist hier bei Drucklegung nur als bisher wahrscheinlich Konstatiertes, nicht jedoch irrtümliche Einschätzungen oder gegensätzliche Spekulationen aufgenommen worden. Da bloß wahrgenommen werden kann, was gewusst wird, obwohl das physiologische Sehbild gleich geblieben ist, ergeben selbstverständlich zukünftige Entwicklungen hier Änderungen, die sich auf menschliche Lebensaspekte auswirken werden.

Vielleicht gelingt es in der Zukunft »Luft« nicht nur als etwas eigenes, abgetrenntes zu sehen, sondern zum Beispiel durch die Betrachtung der Wechselwirkungen mit »Wasser« zu einer vereinheitlichten Anschauung zu gelangen, welche dann nur noch auf Materie im Raum-Zeit-Kontext in verschiedenen Energiestufen basierte? Die Auflösung tradierter Begrifflichkeiten wie »Luft – Wasser – Erde – Feuer«, aber auch »gasförmig – flüssig – fest – elementar«, könnte zu einer Zusammenführung der bisher jeweilig attribuierten Spezialdisziplinen in den Wissenschaften führen. Denn eigentlich sind wir in den letzten 2500 Jahren erkenntnistheoretisch gar nicht so weit vorangekommen; – lediglich im deduktiven Anwenden vorgefundener natürlicher Problemlösungsstrategien bei rein technischen Fragestellungen. Spannender verspräche es jedoch zu werden, wenn induktiv nicht-materielle Aspekte als Modellneubildungen versucht würden.

Axel Thallemer, München, 26. Juni 2005

One Doesn't Usually Think about Air, Doesn't Perceive It Consciously
except when It Is in a State Different to the Accustomed One.

Meistens denkt man gar nicht an Luft, nimmt sie nicht bewusst wahr,
außer sie ist gegenüber dem gewohnten Zustand anders.

Axel Thallemer

> CULTURAL HISTORY / KULTURGESCHICHTE

Water, fire, wood, metal and earth are defined as complementary
transformation phases in nature and global events.
Chinese philosophy differentiated five elements from 1600 BC

Wasser, Feuer, Holz, Metall und Erde sind als sich ergänzende
Wandlungsphasen in Natur und Weltgeschehen definiert.
Die Chinesische Philosophie unterschied seit 1600 v.Chr. fünf Elemente

◁ 1 The five Chinese elements (water, fire, wood, metal, earth) / Die fünf Chinesischen Elemente (Wasser, Feuer, Holz, Metall, Erde)

 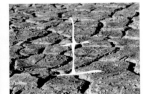

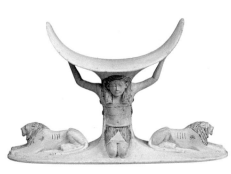

The God Shu embodies the air separating sky
(Goddess Nut) and earth (God Geb).
Egyptian mythology

Gott Schu verkörpert die Luftschicht, die den Himmel
(Göttin Nut) und die Erde (Gott Geb) trennt.
Ägyptische Mythologie

▷▷ 2 Shu, God of the air. Headrest, 18th dynasty / Luft-Gott Schu. Kopfstütze, 18. Dynastie

Bubbles and Other Consciousness Enlargements in 20th-Century Architecture, Design and Art

Blasen und andere Bewusstseinserweiterungen in Architektur, Design und Kunst des 20. Jahrhunderts

Oliver Herwig

The Creation as Afflatus, World and Wind (the World as Myth)

In the beginning was not just the Word but also the Creator's breath. Zarathustra taught that the sky was created by Ahura Mazda's breath, ovoid so that light could grow out of it after water and earth were formed. Cherokee legends report that this tribe came from the sky and did not settle the Appalachian region until the great vulture dispatched in advance to reconnoitre had formed the mountains and valleys by moving his wings. And the ancient Greeks, too, told of Nyx, primeval night, a bird with black wings, which – impregnated by the wind – laid a silver egg in the lap of darkness. Thus was Eros brought forth into the world, the gold with golden wings, the god of love, the first born. And with him the whole world.

The ancient Greeks imagined their gods in airy spheres, on Mount Olympus. And, as remote as the immortals may seem at first glance, they were directly linked with the fate of humankind. Zeus, the weather god, moved across the sky with thunder and lightning. His eagle abducted the youth Ganymede as cup-bearer to the gods and the Thunderer himself occasionally mingled with mortals. Celestial phenomena were of divine origin in pantheistic ancient Greece. Even the wind had a face, a mythological personificaton. Boreas, the cold north wind, lived in Thrace, an old man with tangled hair and beard, wo sometimes sported serpents' tails instead of feet. More popular with seafarers was Zephyr, the west wind. Zephyr was married to Iris, the rainbow. Naturally that did not prevent him from making other women and wild animals pregnant. >>>

 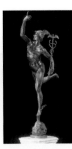

Die Schöpfung als Hauch, Welt und Wind (mythische Welt)

Am Anfang steht nicht nur das Wort, sondern auch der Hauch des Schöpfers. Zarathustra lehrte, dass der Himmel durch Ahura Masdas Atemzug entstand, eiförmig, damit aus ihm Leben wachsen konnte, nachdem Wasser und Erde gebildet waren. Legenden der Cherokee berichten, dass sie selbst vom Himmel stammten und die Appalachen erst besiedelten, nachdem der große Geier, der als Kundschafter vorausgeschickt worden war, Berge und Täler durch die Bewegung seiner Schwingen geformt hatte. Und auch die Griechen erzählten von der Urnacht Nyx, einem Vogel mit schwarzen Flügeln, der – schwanger vom Wind – ein silbernes Ei in den Schoß der Dunkelheit legte. So kam Eros zur Welt, der Gott mit den goldenen Flügeln, der Liebesgott, der Erstgeborene. Und mit ihm die ganze Welt. Ihre Götter imaginierten die Griechen in luftigen Sphären, auf dem Berg Olymp. Und so entrückt die Unsterblichen auf den ersten Blick erschienen, waren sie doch direkt mit dem Schicksal der Menschen verbunden. Zeus, der Wettergott, zog mit Blitz und Donner über den Himmel, sein Adler entführte den Jüngling Ganymed als göttlichen Mundschenk, und dann und wann mischte sich der Donnerer selbst unter die Menschen. Himmelsphänomene waren im pantheistischen Griechenland göttlichen Ursprungs. Selbst der Wind besaß ein Gesicht, eine mythologische Entsprechung. Boreas, der kalte Nordwind, hauste in Thrakien, ein alter Mann mit wildem Haar- und Bartwuchs, der manchmal Schlangenschwänze an Stelle der Füße trug. Beliebter war der Westwind Zephyr unter den Seefahrern. Zephyr war verheiratet mit Iris, dem Regenbogen. Dies hält ihn freilich nicht davon ab, fremde Frauen zu schwängern und wilde Tiere. >>>

Kopf eines Windgottes. Römisches Mosaik, 2. Jahrhundert n.Chr

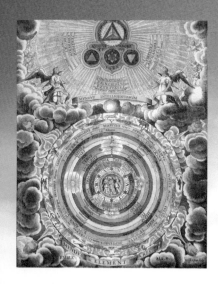

Air moved by wind or storm is venerated as the dwelling
of souls and demons.
History of religions

Die durch Wind oder Sturm bewegte Luft wird als Aufenthalts-
ort der Seelen oder Dämonen verehrt.
Geschichte der Religionen

Thales explained, according to Aristotle, the origin of all things
from water, because all life emerges from what is wet.
Thales »of Miletus«, ca. 600 BC – Empedocles viewed the 4 elements as invariable

Thales erklärte, Aristoteles zufolge, die Herkunft aller Dinge
aus dem Wasser, da aus dem Feuchten das Leben entstehe.
Thales »von Milet«, um 600 v.Chr. – Empedokles betrachtete die 4 Elemente
als unveränderlich

▷ 8 Matthäus Merian the Elder, The Fifth Day of Creation. 1630 / Matthäus Merian d.Ä., Der fünfte Schöpfungstag. 1630

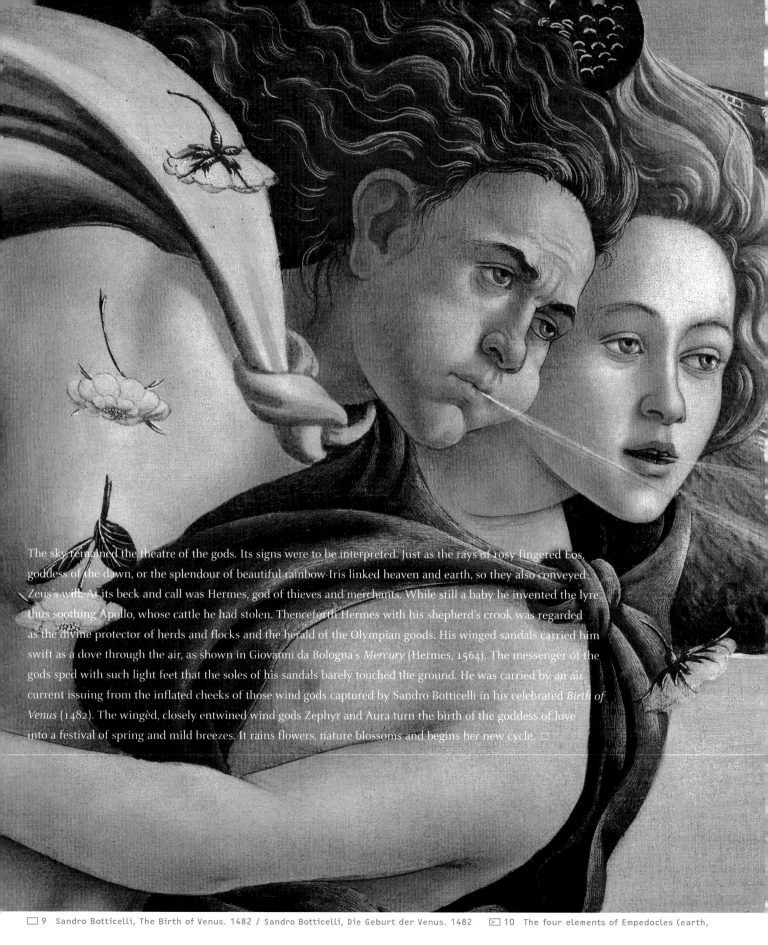

The sky remained the theatre of the gods. Its signs were to be interpreted. Just as the rays of rosy fingered Eos, goddess of the dawn, or the splendour of beautiful rainbow-Iris linked heaven and earth, so they also conveyed Zeus's will. At its beck and call was Hermes, god of thieves and merchants. While still a baby he invented the lyre, thus soothing Apollo, whose cattle he had stolen. Thenceforth Hermes with his shepherd's crook was regarded as the divine protector of herds and flocks and the herald of the Olympian goods. His winged sandals carried him swift as a dove through the air, as shown in Giovanni da Bologna's *Mercury* (Hermes, 1564). The messenger of the gods sped with such light feet that the soles of his sandals barely touched the ground. He was carried by an air current issuing from the inflated cheeks of those wind gods captured by Sandro Botticelli in his celebrated *Birth of Venus* (1482). The wingèd, closely entwined wind gods Zephyr and Aura turn the birth of the goddess of love into a festival of spring and mild breezes. It rains flowers, nature blossoms and begins her new cycle. □

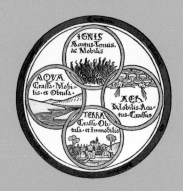

Air is one of the four elements which, in combination with earth and water, are opposed to fire.
Empedocles »of Acragas (Agrigento)«, ca. 483–420 BC; in ca. 450 BC Leucippus and Democrites: »elements consist of atoms of various sizes«

Luft ist eines der vier Elemente, welches zusammen mit Erde und Wasser, dem Feuer entgegengesetzt wird.
Empedokles »von Akragas (Agrigent)«, um 483–420 v.Chr.; um 450 v.Chr. Leukipp und Demokrit: »Elemente bestehen aus verschieden großen Atomen«

Der Himmel blieb das Theater der Götter, seine Zeichen waren zu deuten. Wie die Strahlen der rosenfingrigen Eos, Göttin der Morgenröte, oder die Pracht der schönen Regenbogen-Iris, die Himmel und Erde verband und so zugleich Zeus' Willen vermittelte. Ihr zur Seite stand Hermes, Gott der Diebe und Kaufleute. Schon als Baby erfand er die Leier und besänftigte so Apoll, dessen Rinder er entwendet hatte. Fortan galt Hermes mit seinem Hirtenstab als göttlicher Bewahrer der Herden und Herold der olympischen Götter, dessen Flügelsandalen ihn schnell wie eine Taube durch die Lüfte trugen, wie es Giovanni da Bolognas *Merkur* (Hermes) von 1564 zeigt. Der Götterbote gleitet so leichtfüßig dahin, dass seine Sohlen den Boden kaum berühren, er wird getragen von einem Luftstrom, der den geblähten Backen jener Windgötter entstammt, die Sandro Botticelli in seiner berühmten *Geburt der Venus* (1482) einfing. Die geflügelten, eng umschlungenen Windgötter Zephyr und Aura lassen die Geburt der Liebesgöttin zu einem Fest des Frühlings und lauer Winde werden. Es regnet Blumen, die Natur blüht auf und beginnt ihren neuen Zyklus. □

air, fire and water). 1472 / Die vier Elemente des Empedokles (Erde, Luft, Feuer and Wasser). 1472

Elements are explained by geometrical shapes and
numerical proportion with religion and myth.
Plato, »Timaios«, his last dialogue, is influenced by Pythagorean
thinking and dedicated to natural philosophy

Elemente werden durch geometrische Körper und
Zahlenproportionen mit Religion und Mystik erklärt.
Platon, »Timaios«, sein letzter Dialog, ist pythagoräisch beeinflusst
der Naturphilosophie gewidmet

Platonic solids symbolize the four elements and states:
fire, air, water, solids.
In »Timaios« (ca. 400 BC) Plato propounds an atomistic theory with
regular geometric solids for the elements' different atoms'

Platonische Körper symbolisieren die vier Elemente
und Zustände: Feuer, Luft, Wasser, Erde.
Platon entwickelt in »Timaios« (um 400 v.Chr.) eine atomistische
Theorie mit regelmäßigen geometrischen Körpern für die Atome
der verschiedenen Elemente

Fire warm and dry. Air warm and humid. Water cold and wet. Earth cold and dry.

Plato saw interchangeable states, Aristotle attributed those elements two qualities

Feuer warm und trocken. Luft warm und feucht. Wasser kalt und feucht. Erde kalt und trocken.

Platon sah ineinander umwandelbare Zustände, Aristoteles ordnete jenen Elementen zwei Qualitäten zu

Regular polyhedrons formed by regular polygons are assigned to the entities.

»The Academy«, founded at Athens/Greece by Plato ca. 387 BC

Regelmäßige Polyeder, gebildet aus regelmäßigen Polygonen, werden den Einheiten zugewiesen.

»Akademie«, ca. 387 v.Chr. von Platon in Athen/Griechenland gegründet

Fire as a tetrahedron, air as a octahedron, water as a icosahedron and the earth as a dodecahedron.

Plato: »Differences in shape cause the elements to have different properties.«

Das Feuer als Tetraeder, die Luft als Oktaeder, das Wasser als Ikosaeder und die Erde als Dodekaeder.

Platon: »Unterschiedliche Gestalt ist die Ursache für die verschiedenen Eigenschaften der Elemente.«

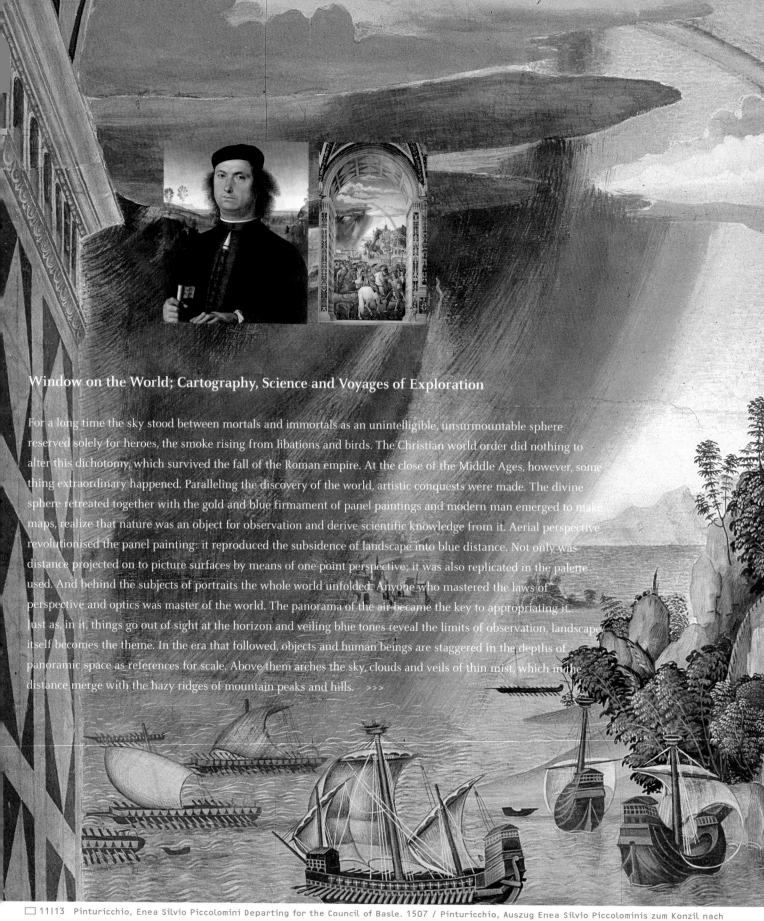

Window on the World; Cartography, Science and Voyages of Exploration

For a long time the sky stood between mortals and immortals as an unintelligible, unsurmountable sphere reserved solely for heroes, the smoke rising from libations and birds. The Christian world order did nothing to alter this dichotomy, which survived the fall of the Roman empire. At the close of the Middle Ages, however, something extraordinary happened. Paralleling the discovery of the world, artistic conquests were made. The divine sphere retreated together with the gold and blue firmament of panel paintings and modern man emerged to make maps, realize that nature was an object for observation and derive scientific knowledge from it. Aerial perspective revolutionised the panel painting: it reproduced the subsidence of landscape into blue distance. Not only was distance projected on to picture surfaces by means of one-point perspective; it was also replicated in the palette used. And behind the subjects of portraits the whole world unfolded. Anyone who mastered the laws of perspective and optics was master of the world. The panorama of the air became the key to appropriating it. Just as, in it, things go out of sight at the horizon and veiling blue tones reveal the limits of observation, landscape itself becomes the theme. In the era that followed, objects and human beings are staggered in the depths of panoramic space as references for scale. Above them arches the sky, clouds and veils of thin mist, which in the distance merge with the hazy ridges of mountain peaks and hills. >>>

11|13 Pinturicchio, Enea Silvio Piccolomini Departing for the Council of Basle. 1507 / Pinturicchio, Auszug Enea Silvio Piccolominis zum Konzil nach

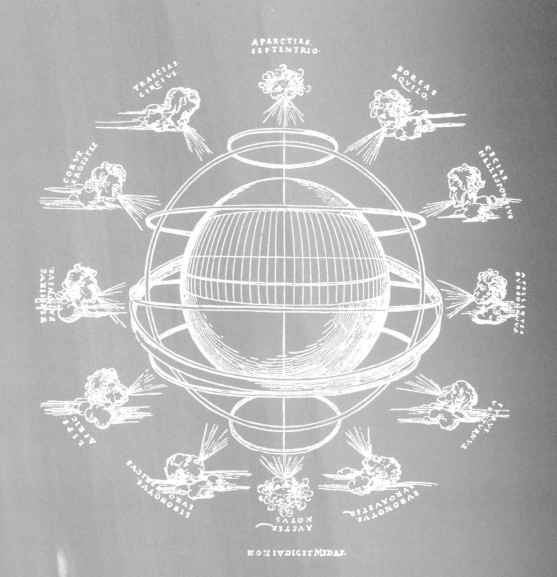

□ 14 The Moon and the Earth's atmosphere / Der Mond und die Erdatmosphäre ◁ 15 Albrecht Dürer, Armillary sphere. 1525 / Albrecht Dürer,

Die Armillarsphäre. 1525

The processes in the atmosphere are very complex and
some have remained unexplained to the present day.

Die Vorgänge in der Atmosphäre sind sehr verwickelt
und manche bis heute noch ungeklärt.

The panel painting was what opened the window on the world. The field of vision widened following the voyages
of discovery undertaken by Columbus and Magellan. Topographical accounts of travels became fashionable.
Cartographers and artists schooled in the natural sciences joined forces in the cause of progress. The skies mutated
into airspace, the field for experimenting with the most advanced devices for representation. It was knowledge
of optics, of cloud formations and aerial perspective that would first create the illusionary space in which viewers
are so eager to lose their way. Nature, on the other hand, also means human nature, portrait. The individual
stood out self-confidently against the world, which had by then become part of his will to form. ›Who wanted to
see how far it was possible for art to imitate nature,‹ wrote Vasari on Leonardo's *Mona Lisa* (1503–1506) in his
celebrated *Lives*, ›could know it from this fine head for here the most minute details have been meticulously repro-
duced.‹ Leonardo has been regarded as the universal genius down to the present day, uniting as he did science,
art and emotion and, far ahead of his time, imagining air as a medium for transportation. Vasari recognised the
duality of the artistic personality: ›In reality, one can probably assume that this outstanding intellect was hindered
in executing his ideas by their very greatness since he strove for ever more perfection and excellence.‹ Leonardo's
legacy includes drawings and sketches of flying machines, which reveal a new view of the world and man, who
moved about in with increasing poise and self-assurance: the eye of the artist as investigator. □

Fenster zur Welt; Kartographie, Naturwissenschaft und Entdeckungsreisen

Lange Zeit stand der Himmel zwischen Menschen und Göttern, als ungreifbare, unüberwindbare Sphäre, die allein Heroen, Opferrauch und Vögeln vorbehalten war. An dieser Trennung änderte auch die christliche Weltordnung nichts, die das zusammenbrechende römische Weltreich überdauerte. Am Ausgang des Mittelalters aber geschieht etwas Außerordentliches. Parallel zur Entdeckung der Erde finden künstlerische Eroberungen statt. Die göttliche Sphäre zieht sich mitsamt dem goldblauen Firmament der Tafelbilder zurück, und hervor tritt der moderne Mensch, der Karten fertigt, Natur als Gegenstand von Beobachtung begreift und daraus wissenschaftliche Erkenntnisse ableitet. Die Luftperspektive revolutioniert das Tafelbild: Sie bildet das Verrauschen und Verblauen der Landschaft in der Ferne in tief gestaffelten Bildräumen ab. Die Weite wird nicht nur durch die Zentralperspektive auf die Fläche des Bildes projiziert, sie bildet sich direkt in der Palette ab. Und hinter den Portraitierten faltet sich die gesamte Welt auf. Wer die Perspektive beherrscht und die Gesetze der Optik, beherrscht die Welt. Das luftige Panorama wird zum Schlüssel dieser Aneignung. So wie sich in ihm der Blick am Horizont verliert, Blautöne und Schleier die Grenzen der Beobachtung aufzeigen, wird die Landschaft selbst zum Thema. Gegenstände und Menschen sind in der Folgezeit als maßstabgebende Referenzen tief in den panoramatischen Raum gestaffelt. Über ihnen spannt sich der Himmel, Wolken und Schleier, die in der Ferne mit den dunstigen Kammlagen der Gebirgsspitzen und Hügel verschmelzen.

Das Tafelbild stößt das Fenster zur Welt auf. Der Blick weitet sich mit den Entdeckungsfahrten Columbus' und Magellans. Topographische Reiseschilderungen kommen in Mode, Kartographen und naturwissenschaftlich geschulte Künstler schreiten in Personalunion voran. Der Himmel mutiert zum Luftraum, zum Experimentierfeld avanciertester Darstellungsmittel. Erst die Kenntnis der Optik, von Wolkenformationen und Luftperspektive erschafft jenen Illusionsraum, in dem sich Betrachter begierig verlieren. Natur heißt andererseits auch Menschen-Natur, Portrait. Selbstbewusst hebt sich das Individuum von der Welt ab, die nun Teil seines Gestaltungswillens geworden ist. »Wer sehen wollte, wie weit die Kunst überhaupt imstande ist, die Natur nachzuahmen«, schreibt Vasari über Leonardos *Mona Lisa* (1503–1506) in seinen berühmten *Lebensläufen*, »konnte es an diesem schönen Kopf erkennen, denn hier fanden sich die winzigsten Einzelheiten aufs sorgsamste nachgebildet.« Leonardo gilt noch heute als das Universalgenie, das Wissenschaft, Kunst und Pathos vereint und seiner Zeit weit voraus die Luft als Transportmedium imaginiert. Vasari erkennt den Zwiespalt der Künstlerpersönlichkeit: »In Wirklichkeit darf man wohl annehmen, dass dieser überragende Geist gerade durch die Großartigkeit seiner Ideen an ihrer Ausführung verhindert wurde, da er nach immer höherer Vollkommenheit und Vortrefflichkeit strebte.« Leonardo hinterließ Zeichnungen und Skizzen von Fluggeräten und Tauchapparaturen, die einen neuen Blick auf die Welt und den Menschen zeigten, der sich in ihr zunehmend souverän bewegte: den Blick des forschenden Künstlers. □

Air is the mixture of gases composing
the earth's atmosphere.
DEFINITION _ Air is in itself odorless, apart
from being served with a »scent of carrots«
as it is in a gourmet restaurant at Rosas
(Girona)/Spain

Luft ist das Gasgemisch aus dem die
Atmosphäre der Erde besteht.
DEFINITION _ Luft ist an sich geruchslos,
es sei denn es wird »Karottenduft«, wie
in einem Spitzenrestaurant in Rosas (Girona)/
Spanien, serviert

78.09% nitrogen (N_2)
20.95% oxygen (O_2)
0.93% argon (Ar)
0.03% carbon dioxide (CO_2)
CONSTITUENTS _ Volume percentage
of the elements at sea level and in dry air

78,09% Stickstoff (N_2)
20,95% Sauerstoff (O_2)
0,93% Argon (Ar)
0,03% Kohlendioxyd (CO_2)
BESTANDTEILE _ Volumenprozent der Elemente
in Meereshöhe und trockener Luft

75.53% nitrogen (N_2)
23.15% oxygen (O_2)
1.28% argon (Ar)
0.04% carbon dioxide (CO_2)
CONSTITUENTS _ Weight percentage
of the elements at sea level and in dry air

75,53% Stickstoff (N_2)
23,15% Sauerstoff (O_2)
1,28% Argon (Ar)
0,04% Kohlendioxyd (CO_2)
BESTANDTEILE _ Gewichtsanteil der Elemente
in Meereshöhe und trockener Luft

☐ 17 Earth from space, with Challenger astronaut McCandless. 1984 / Erde vom All aus, mit Challenger-Astronaut McCandless. 1984

Neon (Ne), methane (CH$_4$), helium (He),
krypton (Kr), hydrogen (H$_2$),
dinitrogen monoxide (N$_2$O), xenon (Xe)
less than 0.001 %
CONSTITUENTS __ Volume percentage
of the elements at sea level and in dry air

Neon (Ne), Methan (CH$_4$), Helium (He),
Krypton (Kr), Wasserstoff (H$_2$),
Distickstoffmonoxid (N$_2$O), Xenon (Xe)
weniger als 0,001 %
BESTANDTEILE __ Volumenprozent der Elemente
in Meereshöhe und trockener Luft

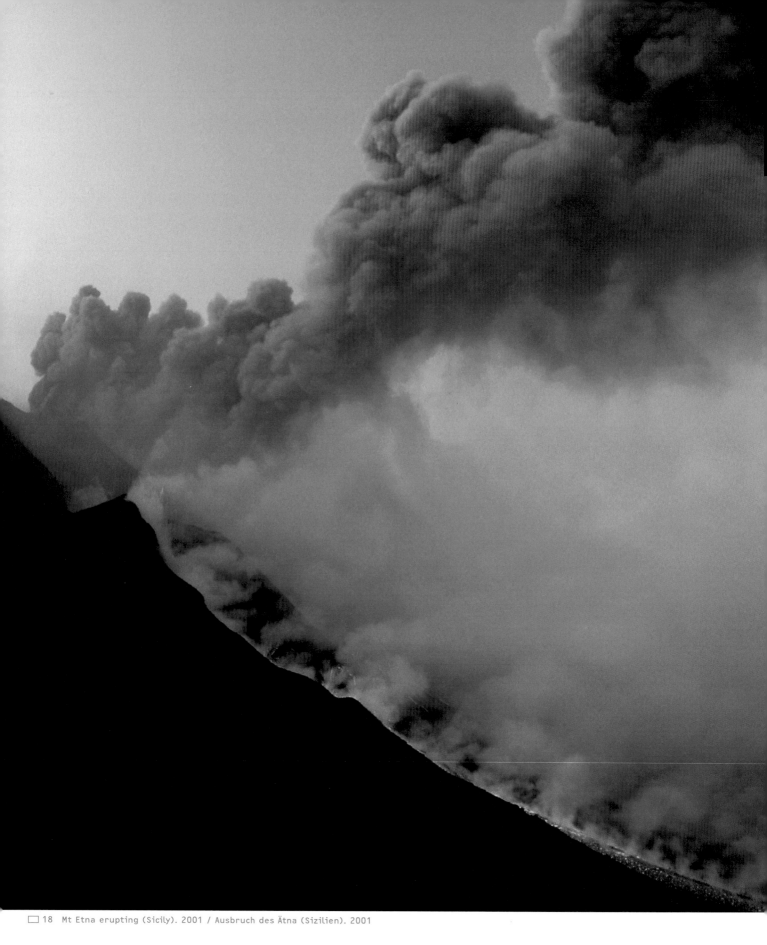

18 Mt Etna erupting (Sicily). 2001 / Ausbruch des Ätna (Sizilien). 2001

Ozone, nitrogen oxide, sulphur dioxide, ammonia, carbon monoxide, exhaust fumes, dust, particles, micro-organisms.
CONSTITUENT __ Traces present in varying quantities. Apart from those and vapour, the composition of air is constant near earth

Ozon, Stickstoffoxide, Schwefeldioxid, Ammoniak, Kohlenmonoxid, Abgase, Staub, Schwebstoffe, Mikroorganismen.
BESTANDTEILE __ Spuren davon in verschiedenen Mengen. Außer jenen und Wasserdampf ist die Zusammensetzung der Luft in Erdnähe konstant

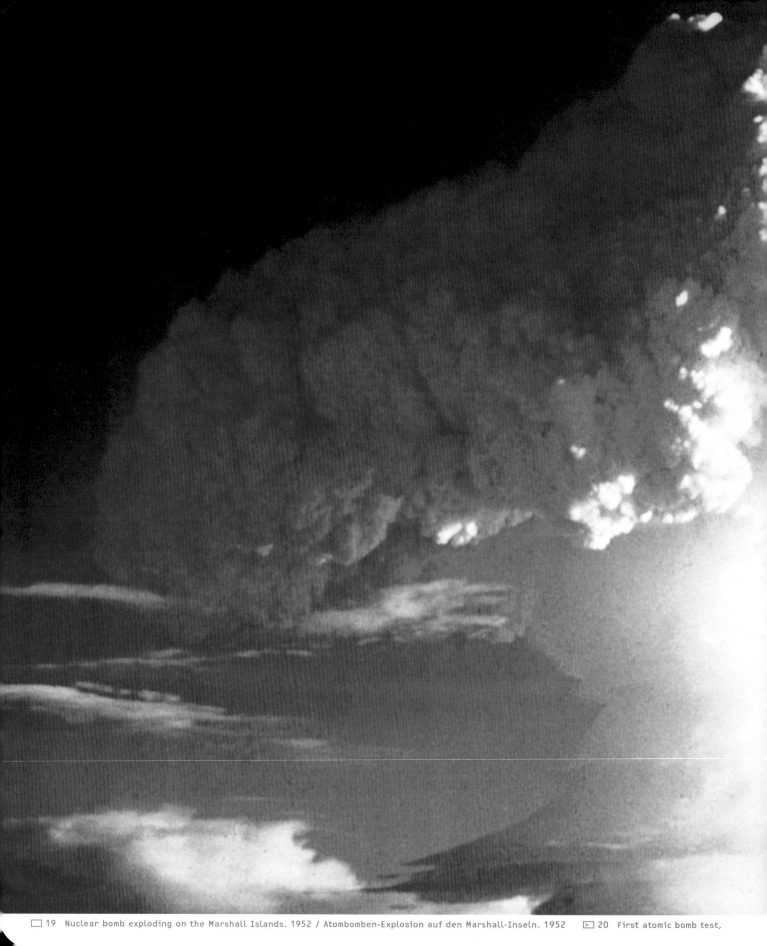

☐ 19 Nuclear bomb exploding on the Marshall Islands. 1952 / Atombomben-Explosion auf den Marshall-Inseln. 1952 ▷ 20 First atomic bomb test,

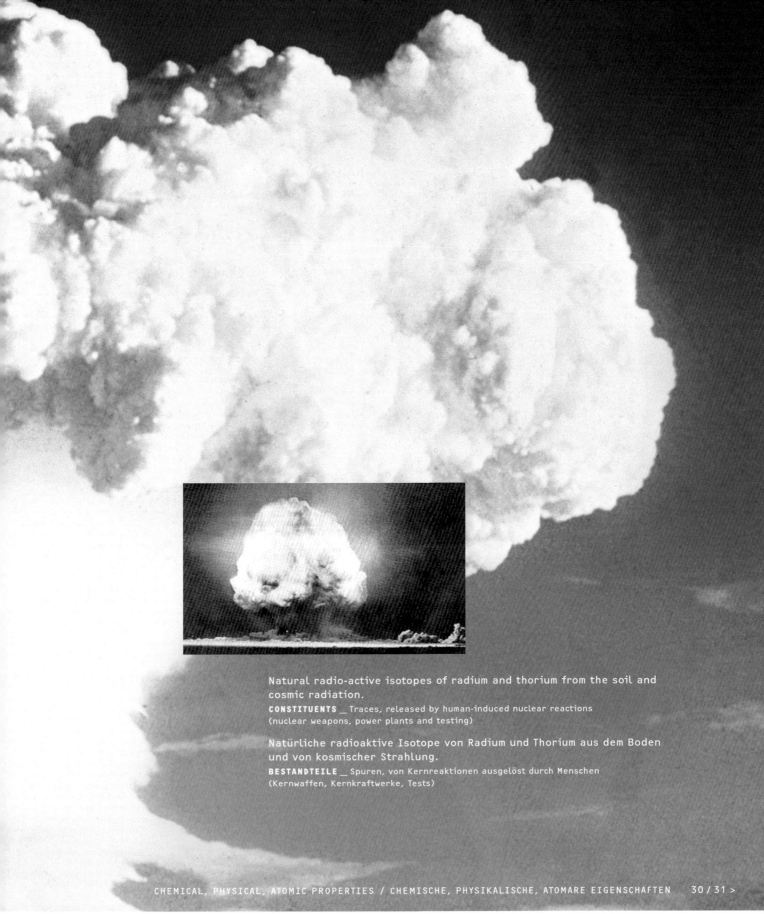

Natural radio-active isotopes of radium and thorium from the soil and cosmic radiation.
CONSTITUENTS__ Traces, released by human-induced nuclear reactions (nuclear weapons, power plants and testing)

Natürliche radioaktive Isotope von Radium und Thorium aus dem Boden und von kosmischer Strahlung.
BESTANDTEILE__ Spuren, von Kernreaktionen ausgelöst durch Menschen (Kernwaffen, Kernkraftwerke, Tests)

16 July 1945, near Alamogordo, New Mexico, USA. Erster Atombombentest am 16. Juli 1945 bei Alamogordo, New Mexiko, USA

Actually existing air contains various amounts of water vapour, ca. 1–4 vol.%.
LIGHT WATER _ H_2O hydrogen oxide

Die wirklich vorhandene Luft enthält wechselnde Mengen an Wasserdampf,
ca. 1–4 Vol.%.
LEICHTES WASSER _ H_2O Wasserstoffoxid

Maximum humidity depends on temperature, the maximum amount of water vapour
the air can absorb above a level surface of water or ice is:

Die maximale Feuchte ist temperaturabhängig, der maximale Betrag an Wasserdampf,
den Luft aufnehmen kann über einer ebenen Wasser- oder Eisfläche, beträgt:

$0.9\,g/m^3$ –––	$-20\,°C$
$2.1\,g/m^3$ –––	$-10\,°C$
$4.9\,g/m^3$ –––	$0\,°C$
$9.4\,g/m^3$ –––	$10\,°C$
$17.3\,g/m^3$ –––	$20\,°C$
$30.4\,g/m^3$ –––	$30\,°C$

At oversaturation superfluous water vapour condenses to droplets or sublimes into ice crystals. In nature there is no absolutely dry (0%) air, not even over deserts or at very low temperatures.
RELATIVE HUMIDITY __ Best records the humidity felt by human beings

Bei Übersättigung kondensiert überschüssiger Wasserdampf zu Tröpfchen oder sublimiert zu Eiskristallen. Es gibt in der Natur keine absolut trockene (0%) Luft, sogar nicht über Wüsten oder bei sehr tiefen Temperaturen.
RELATIVE FEUCHTE __ Gibt am besten das Feuchte-Empfinden des Menschen wieder

Natural water is a molecular mixture of ca. 99.985 % hydrogen 1H
and oxygen ^{16}O isotopes.
LIGHT WATER _ H_2O hydrogen oxide

Natürliches Wasser ist zu ca. 99,985 % ein Molekülgemisch aus
dem Wasserstoffisotop 1H und Sauerstoffisotop ^{16}O.
LEICHTES WASSER _ H_2O Wasserstoffoxid

Hydrogen peroxide H_2O_2 contains one more oxygen atom than water,
small amounts of it are contained naturally in rain and snow. Concentrations
of up to 1 mg per kg of air can occur in the atmosphere after thunderstorms
and heavy precipitation.
HYDROGEN PEROXIDE H_2O_2

Wasserstoffperoxid H_2O_2 enthält ein Sauerstoffatom mehr als Wasser,
es ist natürlich in geringen Mengen im Regen und Schnee enthalten.
Konzentrationen von bis zu 1 mg pro kg Luft können in der Atmosphäre
nach Gewittern und starken Niederschlägen auftreten.
WASSERSTOFFPEROXID H_2O_2

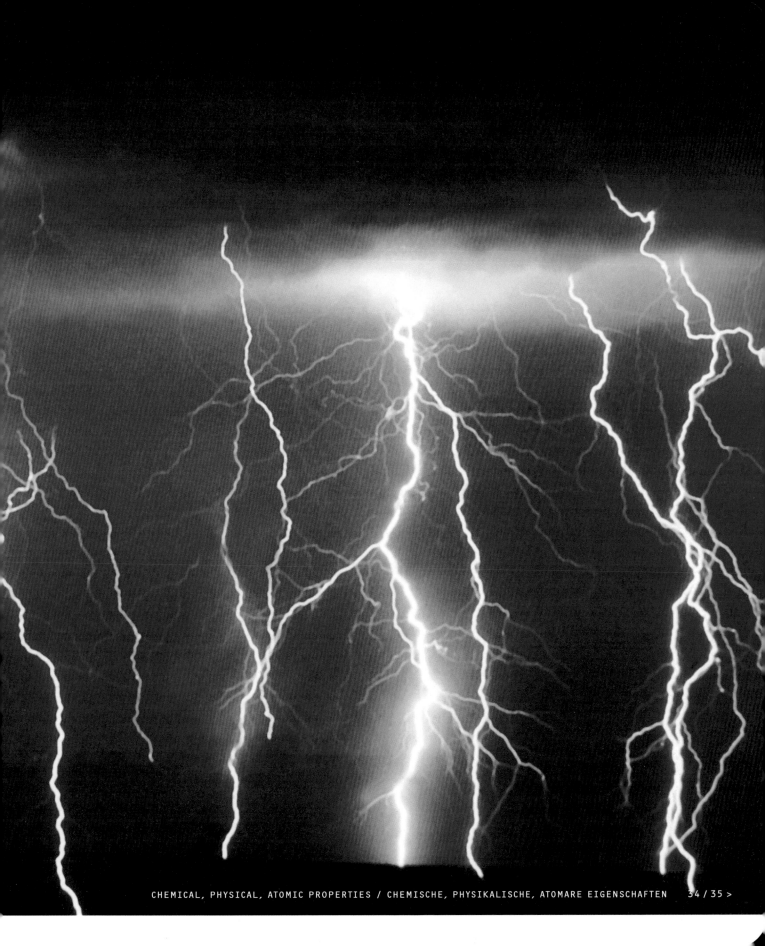

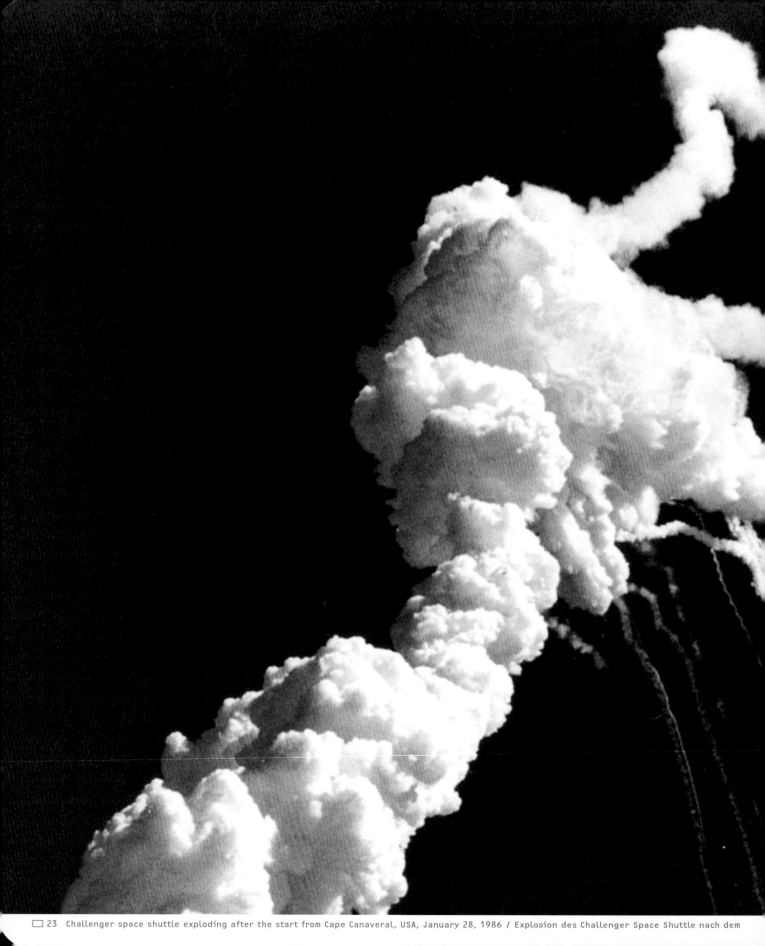

23 Challenger space shuttle exploding after the start from Cape Canaveral, USA, January 28, 1986 / Explosion des Challenger Space Shuttle nach dem

Pure hydrogen peroxide is a strong oxidant, used in rocket fuels, or for desin-
fection. It disintegrates very slowly at room temperature into water and oxygen.
HYDROGEN PEROXIDE H_2O_2

Reines Wasserstoffperoxid ist ein starkes Oxidationsmittel, das für Raketen-
treibstoffe verwendet wird, oder zur Desinfizierung. Es zerfällt sehr langsam
bei Raumtemperatur in Wasser und Sauerstoff.
WASSERSTOFFPEROXID H_2O_2

Start von Cape Canaveral, USA, 28.1.1986

Water is the third most frequently occuring molecule in the universe.
LIGHT WATER

Wasser ist das dritthäufigste Molekül im Universum.
LEICHTES WASSER

24 An unmanned Progress 14 supply vehicle leaves the International Space Station (ISS) on July 30, 2004 / Unbemanntes Versorgungsfahrzeug

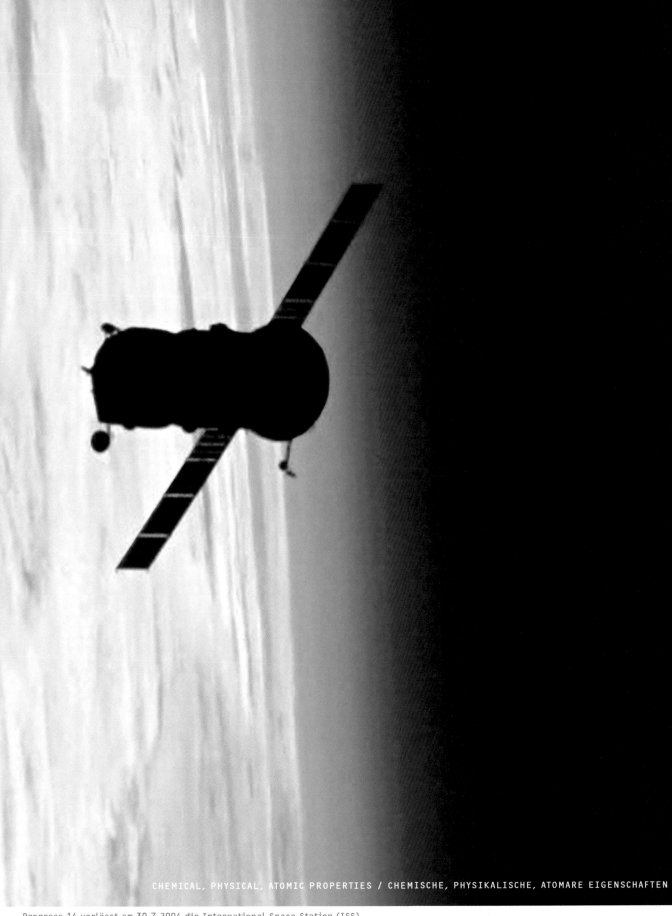

Progress 14 verlässt am 30.7.2004 die International Space Station (ISS)

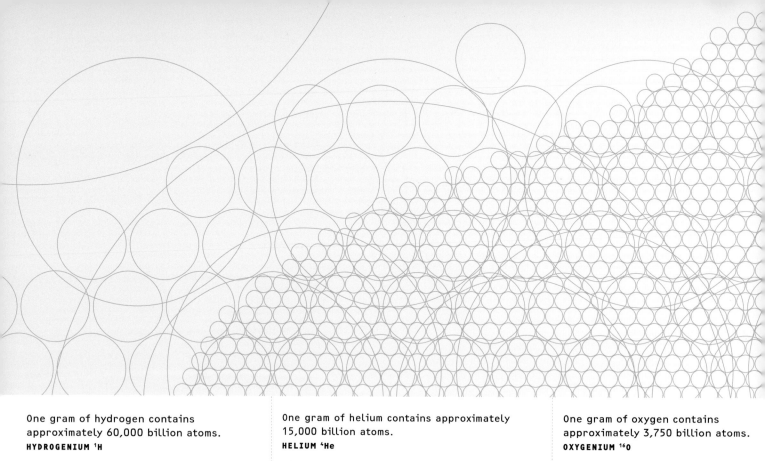

One gram of hydrogen contains approximately 60,000 billion atoms.
HYDROGENIUM ¹H

Ein Gramm Wasserstoff enthält ungefähr 60.000 Milliarden Atome.
HYDROGENIUM ¹H

One gram of helium contains approximately 15,000 billion atoms.
HELIUM ⁴He

Ein Gramm Helium enthält ungefähr 15.000 Milliarden Atome.
HELIUM ⁴He

One gram of oxygen contains approximately 3,750 billion atoms.
OXYGENIUM ¹⁶O

Ein Gramm Sauerstoff enthält ungefähr 3.750 Milliarden Atome.
OXYGENIUM ¹⁶O

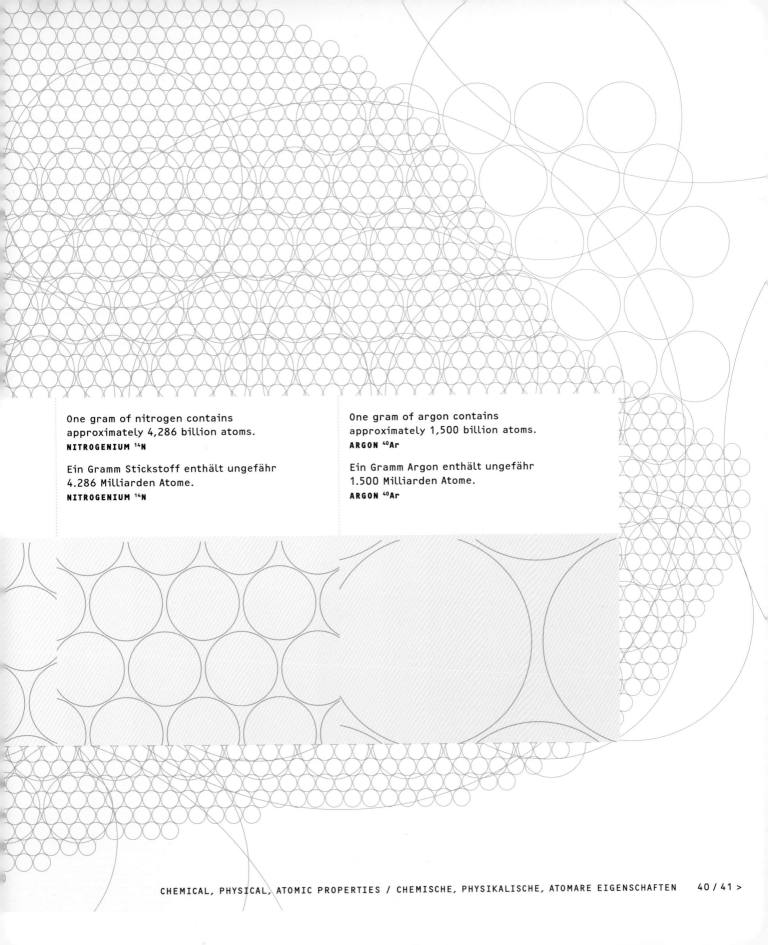

One gram of nitrogen contains
approximately 4,286 billion atoms.
NITROGENIUM ^{14}N

Ein Gramm Stickstoff enthält ungefähr
4.286 Milliarden Atome.
NITROGENIUM ^{14}N

One gram of argon contains
approximately 1,500 billion atoms.
ARGON ^{40}Ar

Ein Gramm Argon enthält ungefähr
1.500 Milliarden Atome.
ARGON ^{40}Ar

Hydrogen is the element most frequently occurring in the universe, presumably
constituting ³/₄ of the mass of the universe.
HYDROGENIUM ¹H

Wasserstoff ist das bei weitem häufigste Element im Universum. Es wird vermutet,
dass ³/₄ der gesamten Masse des Weltalls daraus besteht.
HYDROGENIUM ¹H

Helium is the second most frequently occurring element in the universe.
In the earth's crust and atmosphere, however, an exceptionally rare element.
HELIUM ³,⁴,⁶,⁸He

Helium ist das zweithäufigste Element im Universum. In der Erdkruste
und Atmosphäre jedoch ein außerordentlich seltenes Element.
HELIUM ³,⁴,⁶,⁸He

Free hydrogen occurs in higher concentrations only in some volcanic gases,
with just traces occurring in the lower atmosphere.
HYDROGENIUM [1,2,3]**H** __ Occurrence on earth 99.985 % [1]H, 0.015 % [2]H, <<10^{-15} % [3]H,
overall free H <0.00005 vol.%

Freier Wasserstoff kommt in höheren Konzentrationen nur in einigen Vulkangasen
vor, in der unteren Atmosphäre nur in Spuren.
HYDROGENIUM [1,2,3]**H** __ Vorkommen auf der Erde 99.985% [1]H, 0,015 % [2]H, <<10^{-15}% [3]H,
gesamt freier H <0,00005 Vol.%

Helium occurs in some natural gas deposits (<0.1–<9%) and uranium minerals,
emerges from radio-active decay.
HELIUM [3,4]**He** __ Occurrence on earth 99.999862 % [4]He, 0.000138 % [3]He, overall free He
in the atmosphere <0.00046 vol.% and <0.000072 weight %

Helium kommt in manchen Erdgaslagerstätten (<0,1–<9%) und Uranmineralien vor,
entsteht durch radioaktiven Zerfall.
HELIUM [3,4]**He** __ Vorkommen auf der Erde 99,999862 % [4]He, 0,000138 % [3]He, gesamt freies He
in der Atmosphäre <0,00046 Vol.% und <0,000072 Gewichts%

Hydrogenium [1]H is the lightest and simplest of all atoms. It consists
of two particles only: electron and nucleus, called a proton.
HYDROGENIUM [1]**H**

Hydrogenium [1]H ist das leichteste und am einfachsten gebaute Atom.
Es besteht nur aus zwei Teilchen: Elektron und Kern, genannt Proton.
HYDROGENIUM [1]**H**

Deuterium consists of two nuclei. Consequently, its relative atomic weight is 2.
Therefore very different physical activity while chemical activity remains
constant as [1]H.
DEUTERIUM D, [2]**H**

Deuterium besteht aus zwei Kernen. Deshalb beträgt die relative Atommasse 2.
Daher auch stark verschiedenes physikalisches bei gleichem chemischen
Verhalten wie [1]H.
DEUTERIUM D, [2]**H**

☐ 27 The eruption of Mt Etna (Sicily) on October 30, 2002 / Vulkanausbruch des Ätna (Sizilien) am 30.10.2002

The deuteron as the bonded state of two nucleons is the simplest composite atomic nucleus.
DEUTERON D

Das Deuteron als gebundener Zustand zweier Nukleonen ist der einfachste zusammengesetzte Atomkern.
DEUTERON D

The critical temperature of overly heavy hydrogen is reached at −233.2 °C. Radioactive isotope of hydrogen, half-life 12.32 years.
OVERLY HEAVY HYDROGEN _ 3H Tritium T: $^3H_2 = T_2$. Was discovered in natural rain by W.F. Libby in 1950

Kritische Temperatur überschweren Wasserstoffs bei −233,2 °C. Radioaktives Isotop von Wasserstoff, Halbwertszeit 12,32 Jahre.
ÜBERSCHWERER WASSERSTOFF _ 3H Tritium T: $^3H_2 = T_2$. Wurde 1950 von W.F. Libby im Regen entdeckt

Tritium T: 3H differs from 1H only in the nucleus. This »triton« consists of one proton and two neutrons!
TRITIUM T: 3H _ The basic material for generating thermo-nuclear energy by nuclear fusion

Tritium T: 3H unterscheidet sich von 1H nur im Kern. Dieser »Triton« besteht aus einem Proton und zwei Neutronen!
TRITIUM T: 3H _ Ausgangsstoff zur Gewinnung thermonuklearer Energie durch Kernfusion

That is why the relative atomic weight is 3. Decays to helium isotope 3He by emitting soft beta-radiation.
TRITON t

Deshalb beträgt die relative Atommasse 3. Zerfällt zu Heliumisotop 3He unter Aussendung weicher Betastrahlung.
TRITON t

Tritium T: 3H is formed naturally in the upper atmosphere by neutrons of cosmic radiation reacting with the nitrogen in the air.
TRITIUM T 3H METHOD _ Important for determining the age of water up to ca. 30 years

Tritium T: 3H wird natürlich in der oberen Atmosphäre durch Reaktion von Neutronen der Höhenstrahlung mit Stickstoff der Luft gebildet.
TRITIUM T 3H METHODE _ Wichtig zur Bestimmung des Alters von Wasser bis zu ca. 30 Jahren

Colors of oxygen: solid or fluid light blue; gaseous or in very thick strata of a bluish hue.
OXYGENIUM ^{16}O

Farben des Sauerstoffs: fest oder flüssig hellblau; gasförmig oder in sehr dicker Schicht bläulich.
OXYGENIUM ^{16}O

Oxygen, an odourless, tasteless and colorless gas, is one of the strongest electro-negative elements and chemically highly reactive.
OXYGENIUM ^{16}O __ At »normal« temperatures

Sauerstoff, ein geruch-, geschmack- sowie farbloses Gas, ist mit das stärkste elektronegative Element und chemisch sehr reaktionsfähig.
OXYGENIUM ^{16}O __ Bei »normalen« Temperaturen

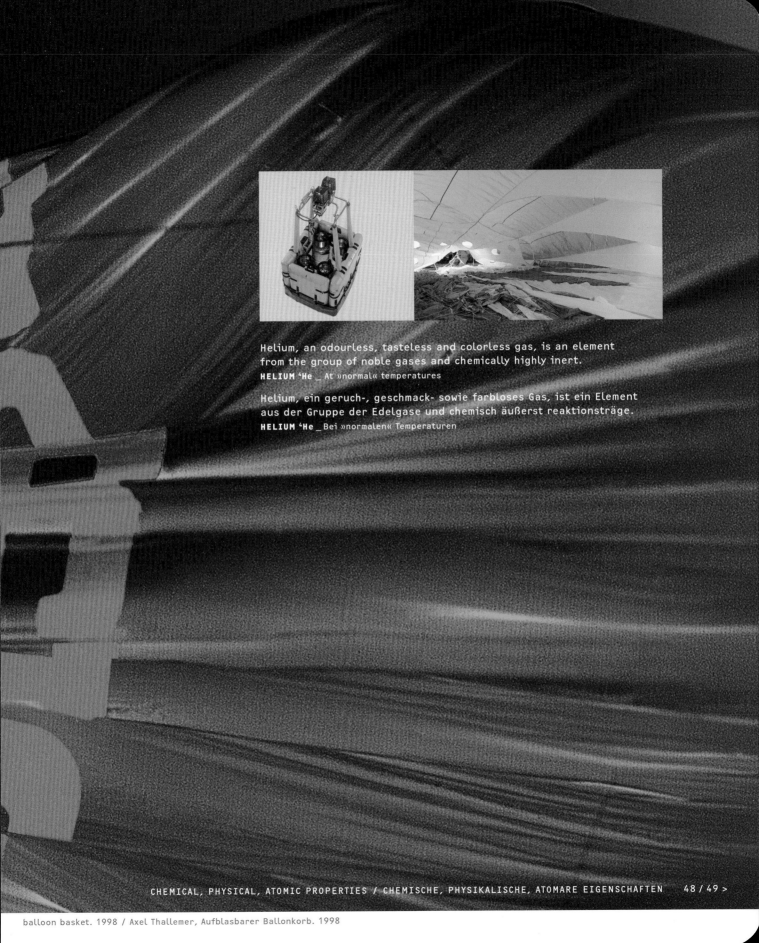

Helium, an odourless, tasteless and colorless gas, is an element from the group of noble gases and chemically highly inert.
HELIUM ⁴He _ At »normal« temperatures

Helium, ein geruch-, geschmack- sowie farbloses Gas, ist ein Element aus der Gruppe der Edelgase und chemisch äußerst reaktionsträge.
HELIUM ⁴He _ Bei »normalen« Temperaturen

balloon basket. 1998 / Axel Thallemer, Aufblasbarer Ballonkorb. 1998

Air liquifies at –194.5 °C; at 0 °C density 1.2923 kg/m³; critical temperature
at –140.7 °C, critical pressure 37.7 bar.
OXYGENIUM ¹⁶O _ Independently discovered by C.W. Scheele in 1771 and J. Priestley in 1774,
named in 1789 by A.L. de Lavoisier

Luft wird flüssig ab –194,5 °C; bei 0 °C beträgt die Dichte 1,2923 kg/m³;
kritische Temperatur bei –140,7 °C, kritischer Druck bei 37,7 bar.
OXYGENIUM ¹⁶O _ Wurde unabhängig voneinander 1771 von C.W. Scheele und 1774 von J. Priestley
entdeckt, 1789 benannt durch A.L. de Lavoisier

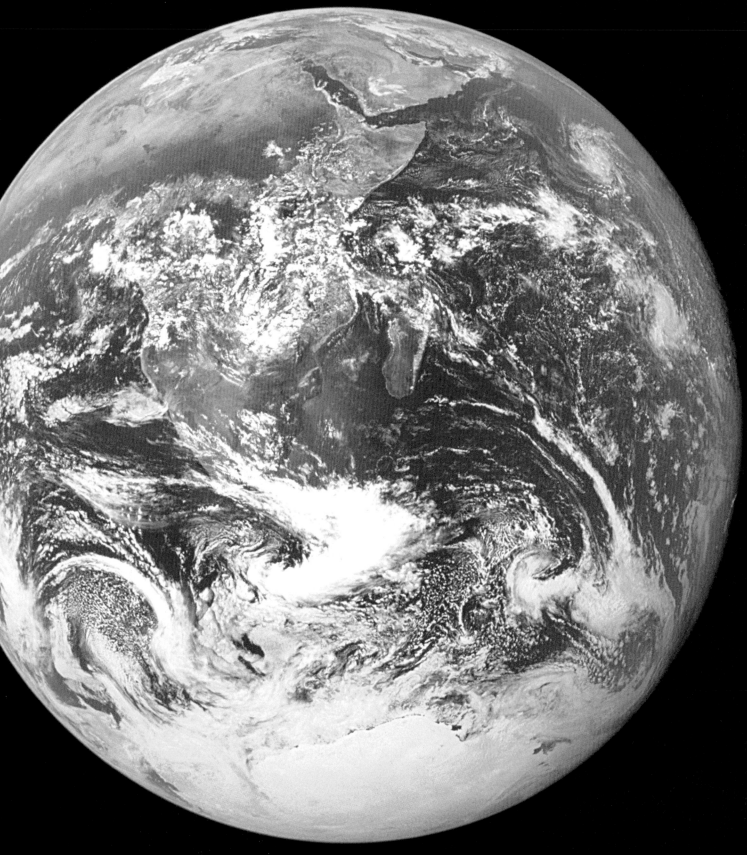

CHEMICAL, PHYSICAL, ATOMIC PROPERTIES / CHEMISCHE, PHYSIKALISCHE, ATOMARE EIGENSCHAFTEN 50/51 >

Oxygen is the most frequently occurring chemical element on earth with 49.5 %
in weight. Due to the large radius of its atom, magmatic rocks consist of
ca. 90 % in volume of oxygen. Air consists of ca. 20.95 % in volume, or ca. 23.15 %
in weight, of free oxygen.
OXYGENIUM 16,17,18O __ Occurrence on earth: 99.76 % ^{16}O; 0.04 % ^{17}O; 0.20 % ^{18}O

Sauerstoff ist mit 49,5 Gewichts% das häufigste chemische Element auf der Erde.
Wegen seines großen Atomradius bestehen magmatische Gesteine zu
ca. 90 Volumen% aus Sauerstoff. Luft besteht zu ca. 20,95 Volumen%, oder etwa
23,15 Gewichts%, aus freiem Sauerstoff.
OXYGENIUM 16,17,18O __ Vorkommen auf der Erde: 99,76 % ^{16}O; 0,04 % ^{17}O; 0,20 % ^{18}O

33 Molten lava from Mt Etna (Sicily) / Glühende Lava des Ätna (Sizilien)

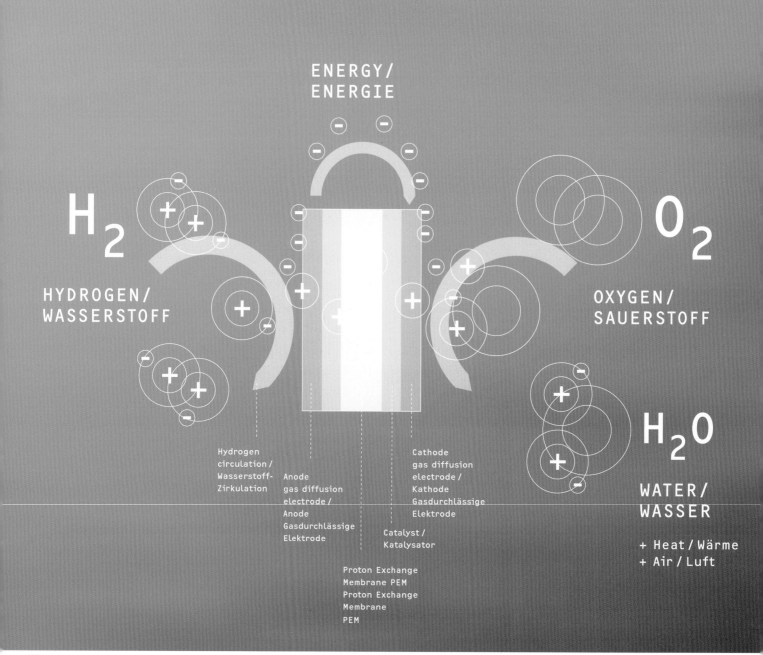

ENERGY/
ENERGIE

H2

HYDROGEN/
WASSERSTOFF

O2

OXYGEN/
SAUERSTOFF

H2O

WATER/
WASSER

+ Heat / Wärme
+ Air / Luft

Hydrogen
circulation /
Wasserstoff-
Zirkulation

Anode
gas diffusion
electrode /
Anode
Gasdurchlässige
Elektrode

Cathode
gas diffusion
electrode /
Kathode
Gasdurchlässige
Elektrode

Catalyst /
Katalysator

Proton Exchange
Membrane PEM
Proton Exchange
Membrane
PEM

34135 Fuel cell, functional diagram and use in a motor vehicle / Brennstoffzelle, Funktionsschema und Nutzung im Pkw

The combustion of hydrogen with oxygen generates water as sole residue.
Energy capacity: 141,000 kJ/kg

HYDROGENIUM H _ Energy capacities for comparison: petrol 46,000 kJ/kg;
hard coal 32,000 kJ/kg; dry wood 16,500 kJ/kg

Bei der Verbrennung von Wasserstoff mit Sauerstoff entsteht Wasser
als einziger Rückstand. Brennwert: 141.000 kJ/kg

HYDROGENIUM H _ Brennwerte zum Vergleich: Normalbenzin 46.000 kJ/kg;
Steinkohle 32.000 kJ/kg; trockenes Holz 16.500 kJ/kg

Earth's solid crust consists of 47.3 % in weight of bonded oxygen.

OXYGENIUM 16,17,18O __ Occurrence on earth: 99.76 % ^{16}O; 0.04 % ^{17}O; 0.20 % ^{18}O

Die feste Erdkruste besteht zu 47,3 Gewichts% aus gebundenem Sauerstoff.

OXYGENIUM 16,17,18O __ Vorkommen auf der Erde 99,76 % ^{16}O; 0,04 % ^{17}O; 0,20 % ^{18}O

Earth's solid crust consists of $4.2*10^{-7}$ % in weight of helium.

HELIUM 3,4He

Die feste Erdkruste besteht zu $4,2*10^{-7}$ Gewichts% aus Helium.

HELIUM 3,4He

Water consists of 88.81 % in weight of bonded oxygen.

OXYGENIUM 16,17,18O __ Occurrence on earth: 99.76 % ^{16}O; 0.04 % ^{17}O; 0.20 % ^{18}O

Wasser besteht zu 88,81 Gewichts% aus gebundenem Sauerstoff.

OXYGENIUM 16,17,18O __ Vorkommen auf der Erde 99,76 % ^{16}O; 0,04 % ^{17}O; 0,20 % ^{18}O

☐ 36 Surf breaking on the coast (magmatic rock) of La Palma (Canary Islands) / Meeresbrandung an der Küste (Lavagestein) von La Palma

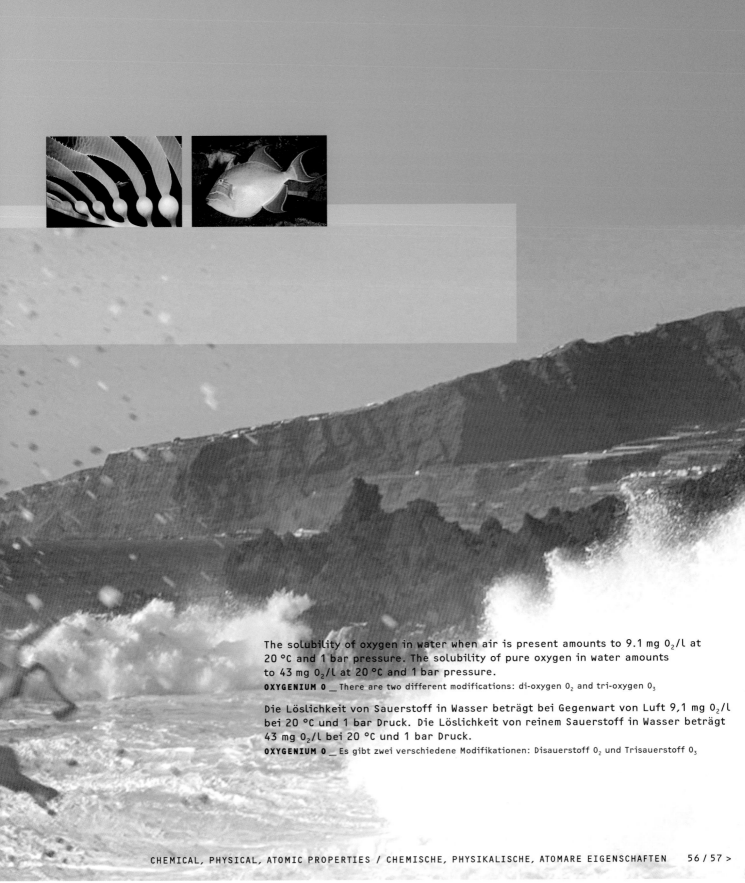

The solubility of oxygen in water when air is present amounts to 9.1 mg O_2/l at 20 °C and 1 bar pressure. The solubility of pure oxygen in water amounts to 43 mg O_2/l at 20 °C and 1 bar pressure.

OXYGENIUM O _ There are two different modifications: di-oxygen O_2 and tri-oxygen O_3

Die Löslichkeit von Sauerstoff in Wasser beträgt bei Gegenwart von Luft 9,1 mg O_2/l bei 20 °C und 1 bar Druck. Die Löslichkeit von reinem Sauerstoff in Wasser beträgt 43 mg O_2/l bei 20 °C und 1 bar Druck.

OXYGENIUM O _ Es gibt zwei verschiedene Modifikationen: Disauerstoff O_2 und Trisauerstoff O_3

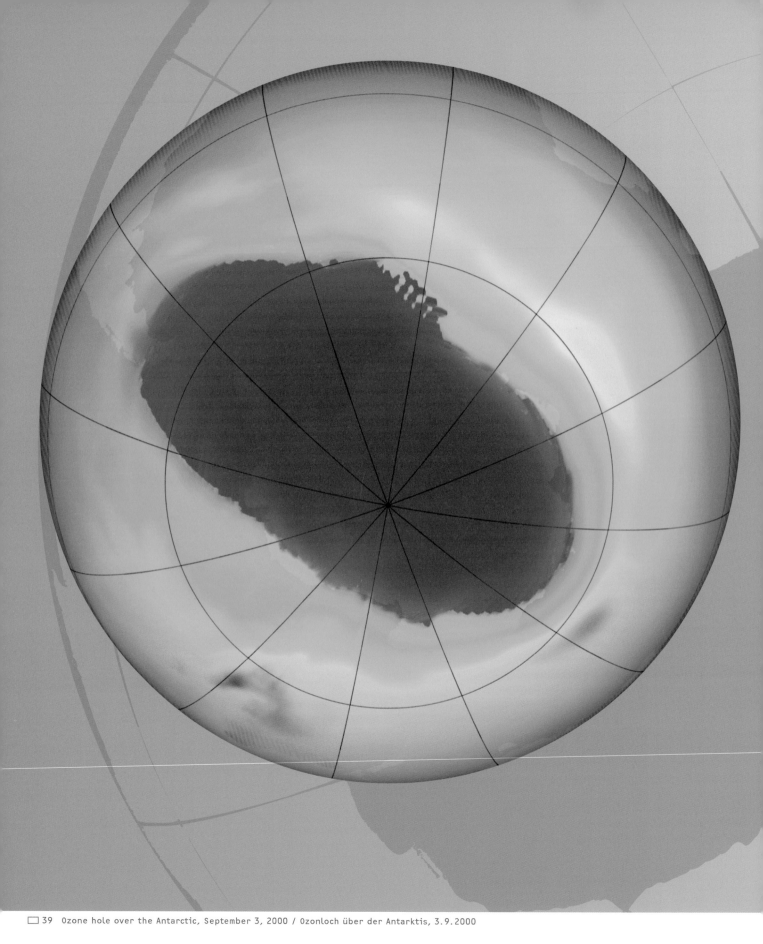

□ 39 Ozone hole over the Antarctic, September 3, 2000 / Ozonloch über der Antarktis, 3.9.2000

At altitudes of above 100 km UV light of ca. 175 nm wave length breaks down oxygen molecules into atomic oxygen O. At altitudes from 80 km UV light of 125–170 nm wave length breaks down oxygen molecules into atomic oxygen O.

OXYGENIUM O _ Above 140 km altitude only in its atomic form, apart from traces of O_2 and O_3

In Höhen über 100 km zerlegt UV-Licht von ca. 175 nm Wellenlänge Luftmoleküle in atomaren Sauerstoff O. In Höhen ab 80 km zerlegt UV-Licht von 125–170 nm Wellenlänge Luftmoleküle in atomaren Sauerstoff O.

OXYGENIUM O _ Oberhalb 140 km Höhe nur in der atomaren Form, außer in Spuren von O_2 und O_3

At altitudes from 12–35 km UV light of 200–290 nm wave length generates ozone from oxygen molecules.

OXYGENIUM O _ Ozone layer above 20 km altitude up to 35 km O_3

In Höhen ab 12–35 km bildet UV-Licht von 200–290 nm Wellenlänge Ozon aus Sauerstoffmolekülen.

OXYGENIUM O _ Ozonschicht oberhalb 20 km Höhe bis 35 km O_3

Nitrogen is the 16th most frequently occurring chemical element on earth with 0.03 % in weight of earth's solid crust.
NITROGENIUM 14,15**N** __ Occurrence on earth: 99.63 % ^{14}N; 0.37 % ^{15}N; <<10^{-15} % ^{3}H

Stickstoff ist mit 0,03 Gewichts% in der festen Erdkruste das 16.-häufigste chemische Element auf der Erde.
NITROGENIUM 14,15**N** __ Vorkommen auf der Erde: 99,63 % ^{14}N; 0,37 % ^{15}N; <<10^{-15} % ^{3}H

Nitrogen is a colorless and tasteless, non-combustible gas, even in its solid or liquid state.
NITROGENIUM 14**N** __ At »normal« temperatures

Stickstoff ist ein farb- und geruchloses, nicht brennbares Gas, auch in fester oder flüssiger Phase.
NITROGENIUM 14**N** __ Bei »normalen« Temperaturen

Nitrogen is a gaseous element which Lavoisier called <azote> because of its suffocating effect. Nitrogen is non-toxic to plants and animals but causes rapid suffocation in vertebrates because they lack oxygen for breathing.
LIGHT NITROGEN __ Discovered by Lavoisier in 1787, French »without life« from Greek <ázoos>

Stickstoff ist ein gasförmiges Element, das wegen der erstickenden Wirkung von Lavoisier <azote> genannt wurde. Stickstoff ist für Pflanzen und Tiere nicht toxisch, führt aber bei Wirbeltieren rasch zum Ersticken, da Sauerstoff für die Atmung fehlt.
LEICHTER STICKSTOFF __ Entdeckt durch Lavoisier 1787, frz. »ohne Leben« von griech. <ázoos>

In animate nature, chemically bonded nitrogen is contained in numerous important substances, especially proteins and amino acids.
LIGHT NITROGEN

In belebter Natur ist chemisch gebundener Stickstoff Bestandteil zahlreicher wichtiger Substanzen, besonders von Proteinen und Nukleinsäuren.
LEICHTER STICKSTOFF

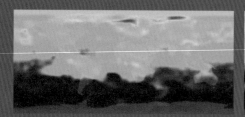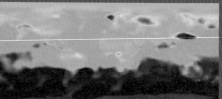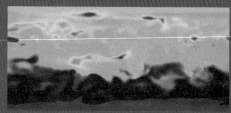

Nitrogen can be absorbed by organisms only in the form of compound.
Only some species of bacteria are capable of transforming elemental nitrogen
into compounds.
NITROGEN N

Stickstoff kann jedoch von Organismen nur in Form von Verbindungen aufgenommen
werden. Lediglich einige Bakterienarten sind in der Lage elementaren Stickstoff
in Verbindungen zu überführen.
STICKSTOFF N

Nitrogen bonding is the enzymatic reduction of atmospheric nitrogen by bacteria
living in the ground and water. Nitrogen can be bonded aerobically or anaerobically.
It is estimated that 200 million tons a year are biologically bonded.
NITROGEN N _ Assimilation, ca. 25 % of it in the oceans and ca. 50 % in farm land

Stickstoff-Fixierung ist die enzymatische Reduzierung von atmosphärischem
Stickstoff durch Bakterien im Boden und Wasser. Stickstoff-Fixierung kann aerob
oder anaerob stattfinden. Biologisch werden dadurch geschätzte 200 Mio. Tonnen
jährlich gebunden.
STICKSTOFF N _ Assimilation, davon entfallen ca. 25 % auf die Ozeane und ca. 50 % auf die Ackerböden

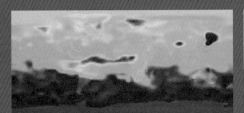

six months / Die Veränderungen der Kohlenmonoxid-Verteilung in der unteren Atmosphäre des Globus im Verlauf von sechs Monaten

Since the 1960s attempts have been made to make atmospheric nitrogen technologically useful by means of chemical reaction (but they have not yet amounted to much).
NITROGEN N

Seit den 1960er Jahren wurde versucht atmosphärischen Stickstoff technisch durch chemische Reaktion nutzbar zu machen (allerdings ohne Bedeutung bis heute).
STICKSTOFF N

Nitrogen is technically produced by air reduction and processed
by the chemical industry in considerable amounts as raw material,
especially for fertilizers.
NITROGEN N

Stickstoff wird technisch durch Luftzerlegung gewonnen und in
beträchtlichem Umfang als Rohstoff in der chemischen Industrie
verarbeitet, besonders für Düngemittel.
STICKSTOFF N

Because it is an inert gas, it is used as a protective gas and
in its fluid state as a coolant.
NITROGEN N

Wegen seiner Reaktionsträgheit als Schutzgas und flüssig
als Kühlmittel verwendet.
STICKSTOFF N

Cyclical transformation of nitrogen and its bonds in nature. The nitrogen
cycle is linked with the atmosphere, hydrosphere and lithosphere by
bacteria generating ammonia during decomposition.
NITROGEN CYCLE __ Mainly associated with organisms in the ground

Zyklische Transformation von Stickstoff und seinen Verbindungen
in der Natur. Der Stickstoffkreislauf ist über bakterielle Ammonakbildung
bei Verwesung an die Atmosphäre, Hydrosphäre und Lithosphäre ange-
schlossen.
STICKSTOFFKREISLAUF __ Der Hauptteil läuft zwischen den Bodenorganismen ab

All azides decompose when heated, a blow or thrust can detonate heavy-metal
azides, organic azides can explode violently.
NITROGEN COMPOUNDS __ With hydrogen – N_nH_{2n+2}; N_nH_{2n}; N_nH_{2n-2}

Alle Azide zersetzen sich beim Erhitzen, Schwermetallazide detonieren bei Schlag
oder Stoß, organische Azide können heftig explodieren.
STICKSTOFFVERBINDUNGEN __ Mit Wasserstoff – N_nH_{2n+2}; N_nH_{2n}; N_nH_{2n-2}

Nitrous oxide: dinitrogen monoxide or laughing-gas NH. Can be obtained
by thermal decomposition of ammonium nitrate.
NITROGEN COMPOUNDS __ With oxygen – $NH_4NO_3 –> N_2O + 2H_2O$

Stickoxide: Distickstoffmonoxyd oder Lachgas NH. Kann durch thermische
Zersetzung von Ammoniumnitrat gewonnen werden.
STICKSTOFFVERBINDUNGEN __ Mit Sauerstoff – $NH_4NO_3 –> N_2O + 2H_2O$

ich Verderben / Und was athmet – es muß sterben«. Holzschnitt, 1850

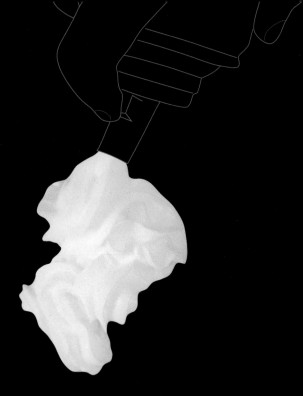

Laughing-gas is colorless, smells sweet, practically non-toxic, releases oxygen easily and sustains combustion like oxygen. It flares up as oxygen keeps wood embers glowing. Leads to narcotic states when inhaled. Is traded in liquid state. Is used in medicine and foods, e.g. as a propellant for whipping cream.

NITROGEN COMPOUNDS _ With oxygen dinitrogen(I)-oxide N_2O

Lachgas ist farblos, süßlich riechend, praktisch ungiftig, gibt leicht Sauerstoff ab und unterhält die Verbrennung wie Sauerstoff. Es entflammt ähnlich wie Sauerstoff glimmendes Holz. Führt beim Einatmen zu narkotischen Zuständen. Kommt verflüssigt in den Handel. Wird in der Medizin und im Lebensmittelsektor, z. B. als Treibgas für Schlagsahne, verwendet.

STICKSTOFFVERBINDUNGEN _ Mit Sauerstoff Distickstoff(I)-oxyd N_2O

Nitrous oxide: Nitrogen monoxide NO. Colorless, toxic gas which scarcely dissolves in water. At lower temperatures always in the form of dimere molecules. Is generated from the elements, when air is burnt by arc or spark discharge.
NITROGEN COMPOUNDS _ With oxygen nitrogen(II)-oxide NO; with oxygen dinitrogendioxidE N_2O_2

Stickoxide: Stickstoffmonoxyd NO. Farbloses, giftiges Gas, das sich nur wenig in Wasser löst. Bei tieferen Temperaturen immer in Form dimerer Moleküle. Entsteht aus den Elementen, wenn Luft durch Bogen- oder Funkenentladung verbrannt wird.
STICKSTOFFVERBINDUNGEN _ Mit Sauerstoff Stickstoff(II)-oxyd NO; mit Sauerstoff Distickstoffdioxyd N_2O_2

Lightning always converts some atmospheric nitrogen into nitrogen monoxide by the same reaction.
NITROGEN COMPOUNDS _ With oxygen (air) rapid reaction to nitrogen dioxide NO_2

Durch die gleiche Reaktion wird von Gewitterblitzen stets etwas Stickstoff der Atmosphäre in Stickstoffmonoxyd überführt.
STICKSTOFFVERBINDUNGEN _ Mit Sauerstoff (Luft) sehr rasche Reaktion zu Stickstoffdioxyd NO_2

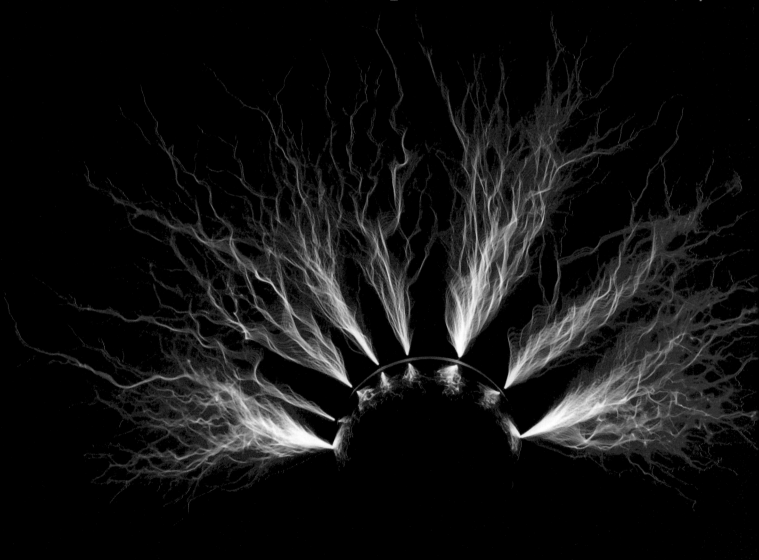

44 Sparks discharged by a tesla coil / Funken-Entladung einer Tesla-Spule

Nitrogen dioxide separates oxygen off easily, strong oxidizing effect.
In liquid state used in rocket fuels.
NITROGEN COMPOUNDS _ With oxygen nitrogen dioxide or nitrogen(IV)-oxide NO_2

Stickstoffdioxyd spaltet leicht Sauerstoff ab, wirkt stark oxidierend.
In verflüssigter Form in Raketentreibstoffen verwendet.
STICKSTOFFVERBINDUNGEN _ Mit Sauerstoff Stickstoffdioxyd oder Stickstoff(IV)-oxyd NO_2

45 Atlantis Space Shuttle starting on the STS-27 mission on December 2, 1988 / Das Atlantis Space Shuttle startet am 2.12.1988 zur STS-27 Mission.

Nitrogen oxides are always formed when combustion processes occur at high temperatures when there is a surplus of oxygen. For instance in emissions from coal-fired power stations, cars, airplanes, household heating and the chemical industry.

NITROGEN COMPOUNDS __ Mixture of nitrogen oxides – NO_x

Stickstoffoxyde entstehen überall dort, wo Verbrennungsvorgänge bei hohen Temperaturen unter Sauerstoffüberschuss ablaufen. Zum Beispiel in Abgasen konventioneller Kohlekraftwerke, von Autos, Flugzeugen, Haushaltsfeuerungen und chemischer Industrie.

STICKSTOFFVERBINDUNGEN __ Gemische der Stickstoffoxyde – NO_x

◁ 46 Household heating emissions / Emission von Haushaltsfeuerungen ▷ 47 Woman wearing a respirator / Frau mit Atemschutz

Nitrogen oxides attack the mucous membranes of the respiratory organs, making them susceptible to colds and infections.
NITROGEN COMPOUNDS _ Simplified formula because composition varies – NO_x

Stickstoffoxyde greifen die Schleimhäute der Atmungsorgane an, begünstigen Katarrhe und Infektionen.
STICKSTOFFVERBINDUNGEN _ Vereinfachte Formel wegen wechselnder Zusammensetzung – NO_x

Under the influence of sunlight in combination with organic compounds from car exhaust fumes, nitrogen oxides develop photochemical smog, which can be reduced by denitrifying gases in factory smoke and by catalytic converters in cars.
NITROGEN COMPOUNDS _ Simplified formula because composition varies – NO_x

Unter dem Einfluss von Sonnenlicht zusammen mit organischen Bestandteilen der Autoabgase entwickeln Stickstoffoxyde photochemischen Smog, der durch Rauchgasentstickung bei Feuerungsanlagen und Katalysatoren in Autos vermindert werden kann.
STICKSTOFFVERBINDUNGEN _ Vereinfachte Formel wegen wechselnder Zusammensetzung – NO_x

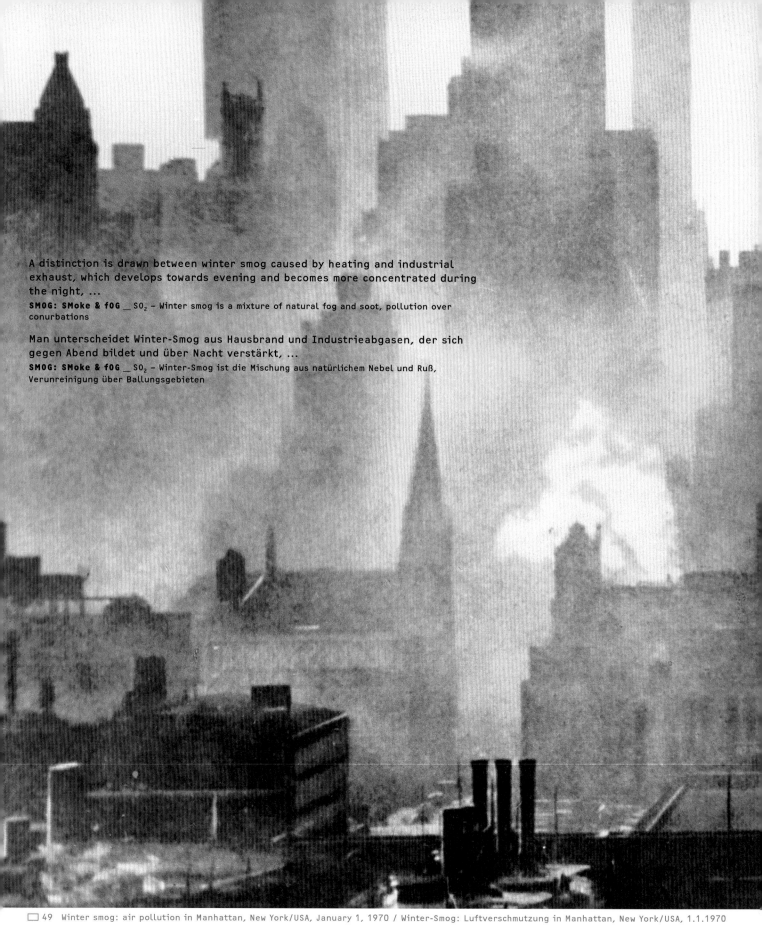

A distinction is drawn between winter smog caused by heating and industrial exhaust, which develops towards evening and becomes more concentrated during the night, ...
SMOG: SMoke & fOG __ SO_2 – Winter smog is a mixture of natural fog and soot, pollution over conurbations

Man unterscheidet Winter-Smog aus Hausbrand und Industrieabgasen, der sich gegen Abend bildet und über Nacht verstärkt, ...
SMOG: SMoke & fOG __ SO_2 – Winter-Smog ist die Mischung aus natürlichem Nebel und Ruß, Verunreinigung über Ballungsgebieten

☐ 49 Winter smog: air pollution in Manhattan, New York/USA, January 1, 1970 / Winter-Smog: Luftverschmutzung in Manhattan, New York/USA, 1.1.1970

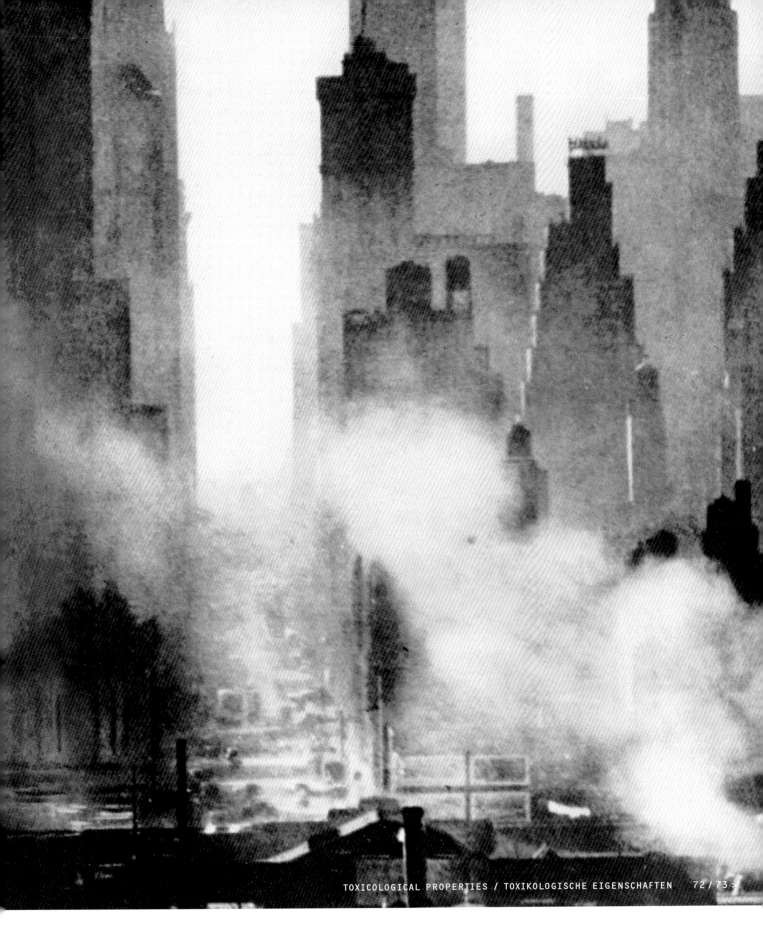

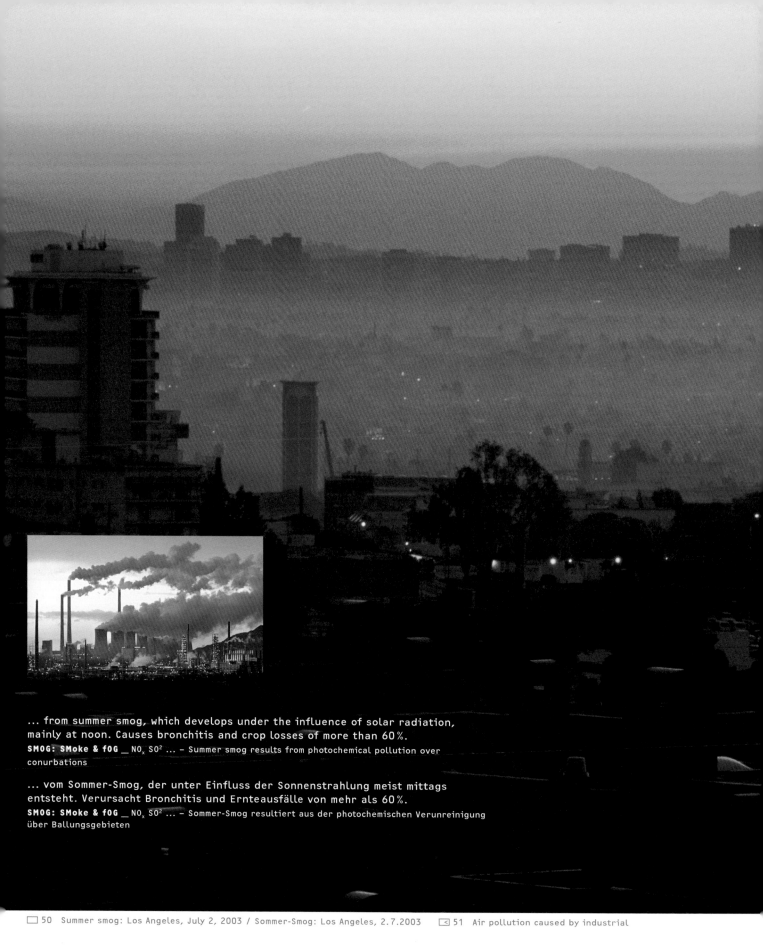

... from summer smog, which develops under the influence of solar radiation, mainly at noon. Causes bronchitis and crop losses of more than 60%.
SMOG: SMoke & fOG __ NO$_x$ SO2 ... – Summer smog results from photochemical pollution over conurbations

... vom Sommer-Smog, der unter Einfluss der Sonnenstrahlung meist mittags entsteht. Verursacht Bronchitis und Ernteausfälle von mehr als 60%.
SMOG: SMoke & fOG __ NO$_x$ SO2 ... – Sommer-Smog resultiert aus der photochemischen Verunreinigung über Ballungsgebieten

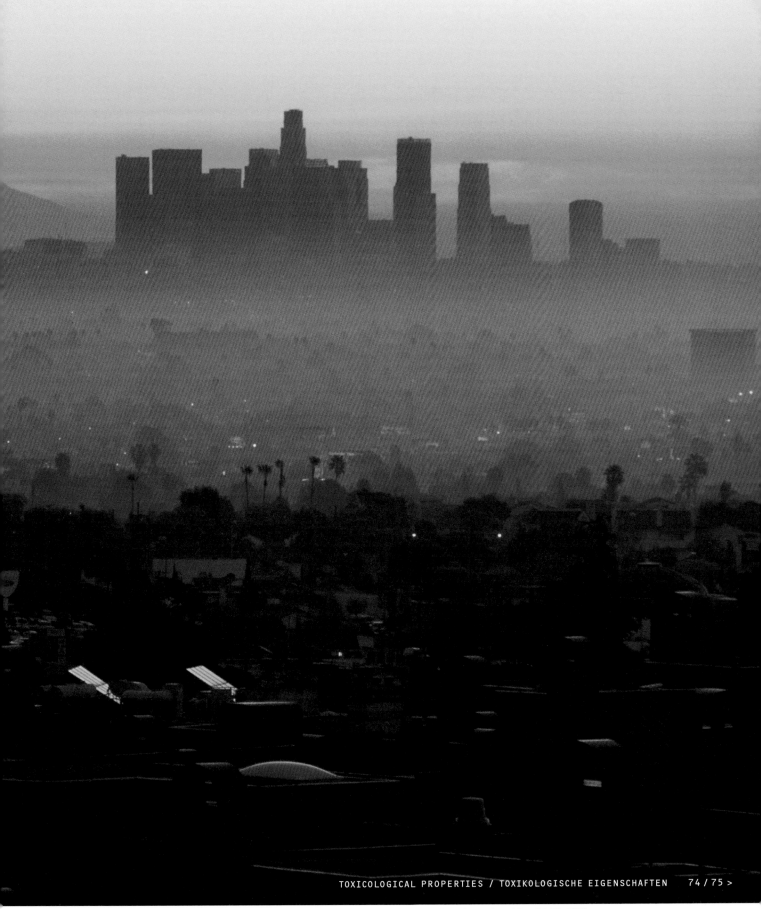

emissions over the Ruhr, November 20, 2000 / Luftverschmutzung durch Industrieabgase über dem Ruhrgebiet, 20.11.2000

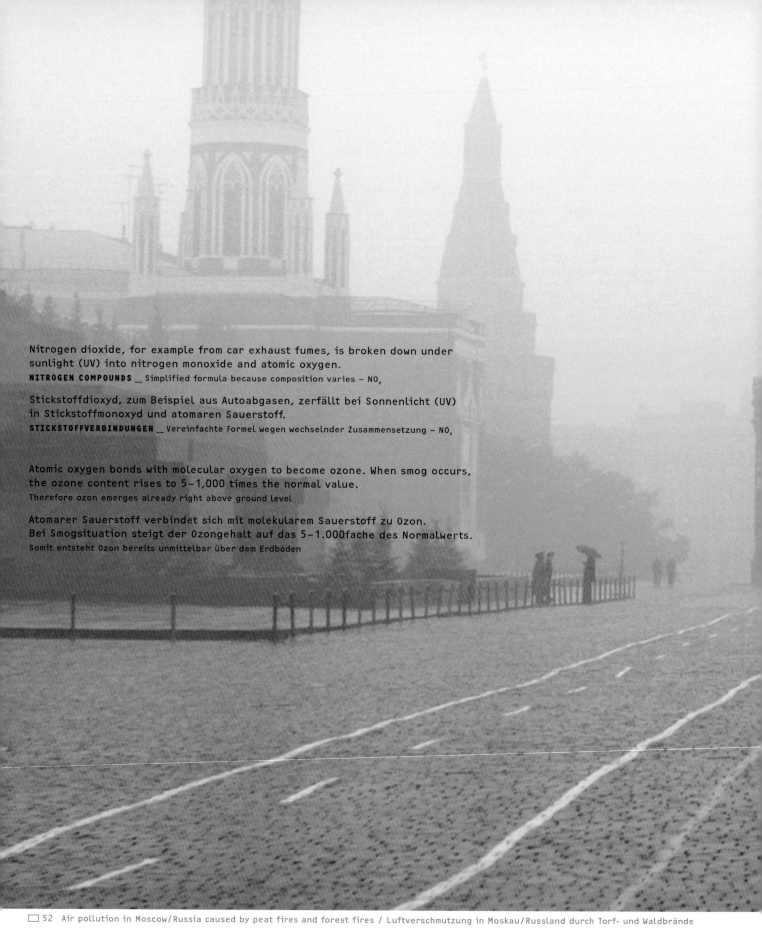

Nitrogen dioxide, for example from car exhaust fumes, is broken down under
sunlight (UV) into nitrogen monoxide and atomic oxygen.
NITROGEN COMPOUNDS __ Simplified formula because composition varies – NO_x

Stickstoffdioxyd, zum Beispiel aus Autoabgasen, zerfällt bei Sonnenlicht (UV)
in Stickstoffmonoxyd und atomaren Sauerstoff.
STICKSTOFFVERBINDUNGEN __ Vereinfachte Formel wegen wechselnder Zusammensetzung – NO_x

Atomic oxygen bonds with molecular oxygen to become ozone. When smog occurs,
the ozone content rises to 5–1,000 times the normal value.
Therefore ozon emerges already right above ground level

Atomarer Sauerstoff verbindet sich mit molekularem Sauerstoff zu Ozon.
Bei Smogsituation steigt der Ozongehalt auf das 5–1.000fache des Normalwerts.
Somit entsteht Ozon bereits unmittelbar über dem Erdboden

52 Air pollution in Moscow/Russia caused by peat fires and forest fires / Luftverschmutzung in Moskau/Russland durch Torf- und Waldbrände

> TEMPORAL PROPERTIES / ZEITLICHE EIGENSCHAFTEN

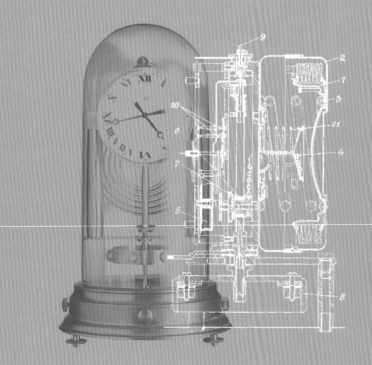

1 Expansion chamber / Expansionskammer
2 Brass cover / Messingbüchse
3 Spiral spring (counterweight) / Spiralfeder
4 Chain / Kettchen
5 Mainspring / Antriebsfeder
6 Pulley / Trommel
7 Small Spring / Kleine Feder
8 Balance wheel / Unruh
9 Elinvar wire / Elinvar-Draht
10 Escapement / Ankerhemmung
11 Winding spring / Aufzugsfeder

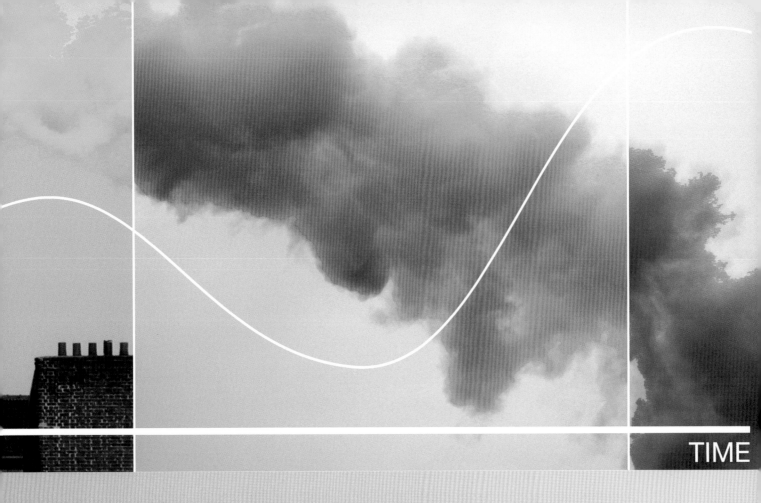

A clock called »Atmos« is made, powered by temperature difference in the surrounding air.
»AIR« CLOCK __ Invented by J.-L. Reutter, Neuenburg/Switzerland, 1928

Unter dem Namen »Atmos« wird eine Uhr hergestellt, die ihre Energie aus der Temperaturdifferenz der Umgebungsluft bezieht.
»LUFT«-UHR __ Erfinder ist J.-L. Reutter, aus Neuenburg/Schweiz, 1928

54 The Atmos Clock, functional diagram / Atmos-Uhr, Funktionszeichnung

Atmosphere – Airy Representation of the World

The artistic devices for representation continued to become more sophisticated well into the 19th century. John Constable's (1776–1837) rendering of weather conditions attained meteorological accuracy. Like the Dutch landscape painters who had preceded him by a century, he discovered the beauties of nature in the countryside. Constable's work sparked off a new, Romantic view of landscape, which sought to capture what was universally valid, eternal and permanent in grand vistas and the changing phenomena of the skies. Of course, the more precisely artists were able to represent, the more sophisticated became their brushwork in exploring all ramifications of reality and the more subtle the palette at their disposal for following the play of colour in the sky, the more unsatisfactory the results they obtained ultimately seemed to them. Banishing what transcends the temporal to a limited panel painting as meant drawing boundaries where there were none, representing outlines where forms and colours vanished in the haze of the atmosphere. For Camille Corot (1796–1875) the aggregate state of the world shifted: ›There is no firm line in nature,‹ he declared. ›It hovers and swims.‹ All Creation is in motion. ›We hover and swim, the vagueness of life is its salient feature.‹ >>>

55 John Constable (1776–1837), Cloud Study: Horizon of Trees. 1821

Atmosphäre – luftige Repräsentanz der Welt

Bis ins 19. Jahrhundert verfeinern sich die künstlerischen Darstellungsmittel. Die Wetterbilder von John Constable (1776–1837) erreichen meteorologische Präzision, und wie die holländischen Landschaftsmaler ein Jahrhundert vor ihm, entdeckt er das Naturschöne auf dem Lande. An Constables Werk entzündet sich eine neue Landschaftsromantik, die das Allgemeingültige, Ewige und Dauerhafte in den grandiosen Panoramen und wechselnden Himmelsphänomenen einzufangen sucht. Je genauer Künstler freilich darzustellen wussten, je differenzierter ihr Pinsel jeder Verästelung der Realität nachging und je subtiler ihre Palette den Farbspielen des Himmels folgte, desto ungenügender schienen ihnen schließlich die Resultate. Das Überzeitliche in ein begrenztes Tafelbild zu packen, hieß auch, Grenzen zu ziehen, wo keine waren, Umrisse darzustellen, wo Formen und Farben im Dunst der Atmosphäre verschwanden. Für Camille Corot (1796–1875) verschiebt sich der Aggregatszustand der Welt: »Es gibt keine feste Linie in der Natur«, erklärte er, sie »schwebt und schwimmt.« Die Schöpfung ist in Bewegung. »Wir schweben und schwimmen, das Vage ist die Eigentümlichkeit des Lebens.« >>>

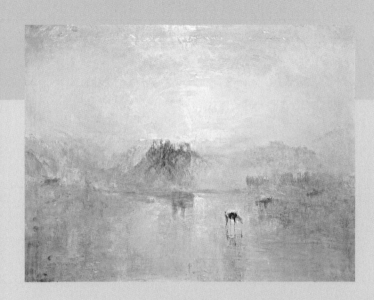

Fleeting clouds, moods created by light and the vagaries of the weather came to represent a formal challenge as the master craftsmen's certificate examination to be taken by watercolourists, who worked with brilliantly transparent layers of paint or by applying washes to achieve tonal subtlety. Contours dissolved, matter blurred, water, air and earth fused to form vibrant colour surfaces. What is the world if not light and colour, was the question asked by Impressionism. And what is painting if not an elemental colour event? The naturalistic handling of perspective, which followed the depth perception of the human eye from dark to light, had outlived its usefulness. In the colour accords of the Impressionists nature seemed to have been changed into a vibrant aggregate state anticipating the social movements that would shape modern life. It was not on the threshold of the 20th century, assailed by new discoveries in physiology and psychology that traditional assumptions were refuted. Even before Einstein and Freud artists were revealing the modern psyche. Turner's handling of clouds, water and light in his work dissolved the world into a swirl of subjective perception. William Turner's (1775–1851) stirring natural romanticism created new worlds, landscapes from light, movement and colour. His entire palette seems to have been seized by unrest. Water, air and fire whirl across his canvases. The (artistic) appropriation of the world was followed by its complete dematerialisation, which anticipated the fragmented and also atomizing view of the Moderns. □

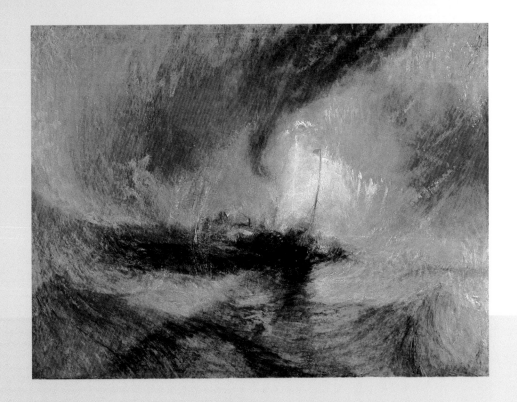

Flüchtige Wolken, Lichtstimmungen und wechselhafte Wetter werden zur formalen Herausforderung, als Meisterprüfung der Aquarellisten, die mit leuchtend-transparenten Farbenschichten oder lavierten Tönen arbeiteten. Konturen lösen sich auf, Materie verschwimmt, Wasser, Luft und Erde wachsen zusammen, bilden vibrierende Farbflächen. Was ist Welt anderes als Licht und Farbe, fragt der Impressionismus. Und Malerei anderes als ein elementares Farbereignis? Die naturalistische Perspektive hat sich überlebt, die der Schärfentiefe des menschlichen Auges von dunkel zu hell folgte. Im Farbklang der Impressionisten scheint die Natur in einen vibrierenden Aggregatszustand versetzt, der die gesellschaftliche Bewegung der Moderne vorwegnimmt. Nicht erst an der Schwelle des 20. Jahrhunderts, unter dem Ansturm neuer physikalischer und psychologischer Erkenntnisse, lösen sich tradierte Wahrheiten auf. Schon vor Einstein und Freud zeigen Künstler die moderne Psyche. Turners Wolken-, Wasser- und -Lichtarbeiten lösen die Welt in einem Wirbel subjektiver Wahrnehmung auf. William Turners (1775–1851) bewegte Naturromantik lässt neue Welten entstehen, Landschaften aus Licht, Bewegung, Farbe.

Die ganze Palette scheint von Unruhe ergriffen, Wasser, Luft und Feuer verwirbeln über die Leinwand. Nach der (künstlerischen) Aneignung der Welt erfolgt ihre vollständige Entmaterialisierung, die den fragmentierten und zugleich atomisierenden Blick der Moderne vorwegnimmt. □

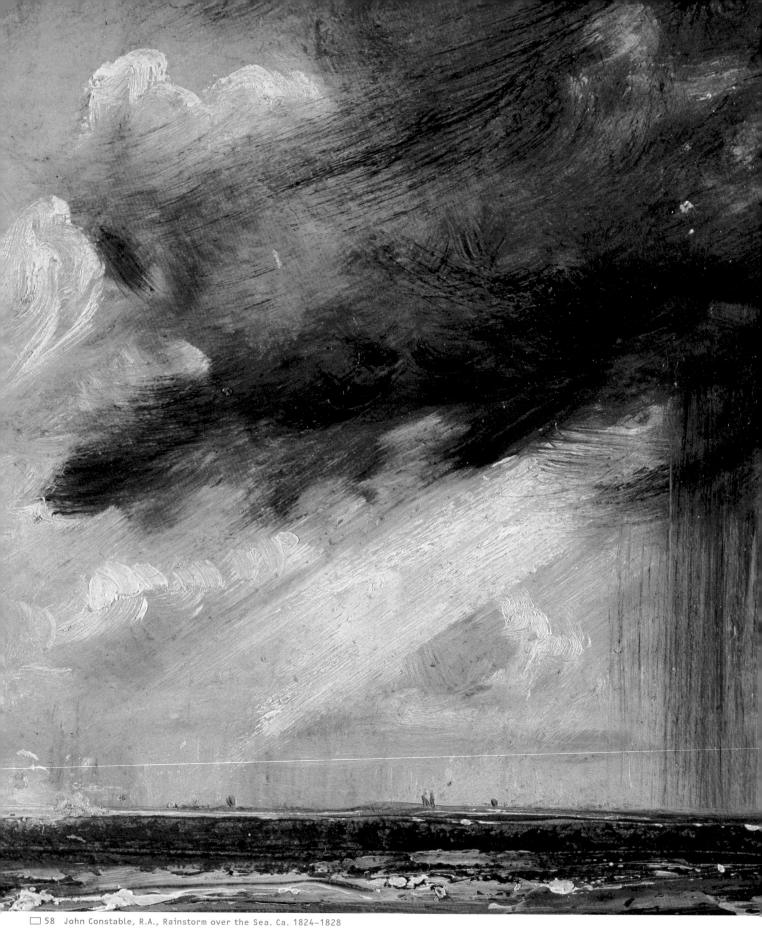

58 John Constable, R.A., Rainstorm over the Sea. Ca. 1824–1828

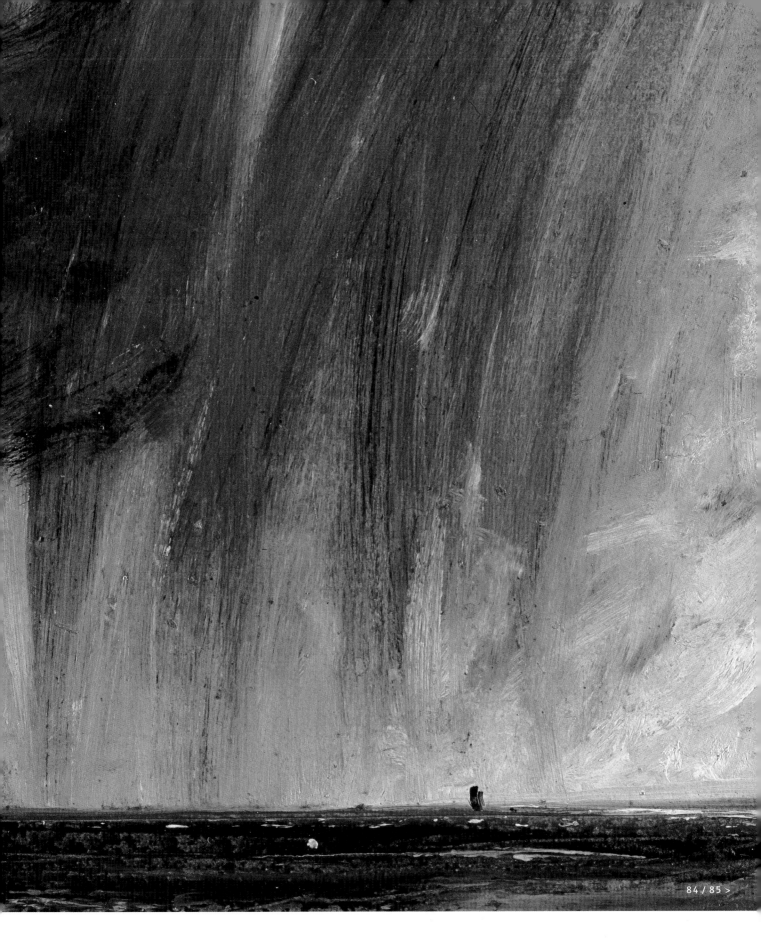

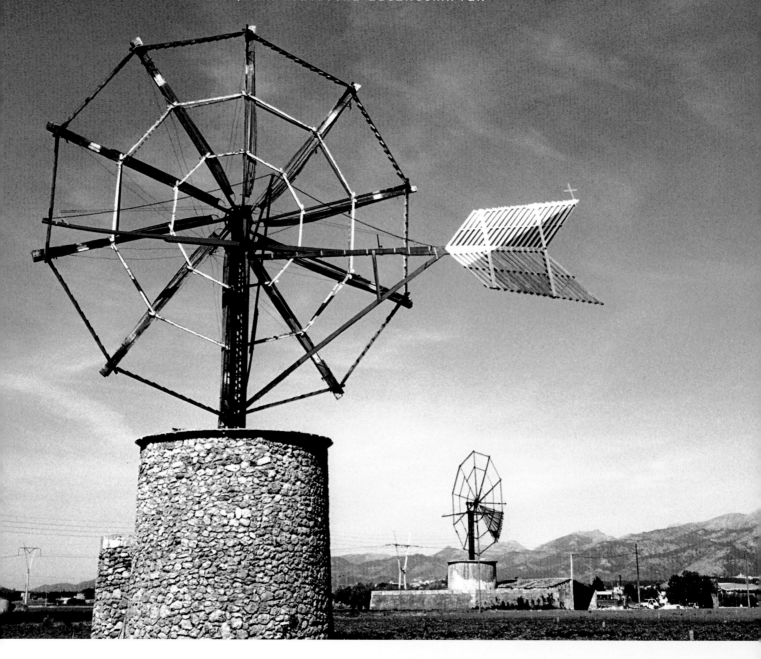

Wind wheels were first constructed in Arab countries with vertical axes, powered by sails. Wind wheels with horizontal axes have been used in Europe since the 12th century AD.

WIND WHEEL _ The first wind wheel was used to power an organ by Heron of Alexandria in 100 AD. They were in use in Persia from the 10th century AD

Windräder wurden zuerst in arabischen Ländern gebaut und hatten vertikale Achsen, von Segeln angetrieben. Horizontale Achsen wurden seit dem 12. Jh. n.Chr. in Europa verwendet.

WINDRAD _ Das erste Windrad wurde zum Betrieb einer Orgel durch Heron von Alexandria, 100 n.Chr., verwendet. In Persien wurden sie seit dem 10. Jh. n.Chr. genutzt

◁ 59 Wind wheels for drawing water on the S' Albufeira plain, Mallorca (Balearic Islands), Spain / Windräder zur Wasserförderung in der Ebene von

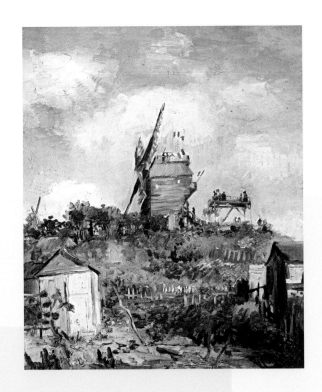

Since ca. 1180 in Normandy, then in 13th-century England, in the Netherlands since
the 15th century, in 19th century used in the US mainly for drawing water.
WIND WHEEL __ L. Euler and J. Smeaton worked in the 18th century AD on a theory of ideal wings.
The Wind wheels for drawing water were built in America by D. Hallady in 1854

Seit ca. 1180 in der Normandie, dann im 13. Jh. in England, in den Niederlanden
seit dem 15. Jh., im 19. Jh. in den USA besonders zum Wasserfördern verwendet.
WINDRAD __ L. Euler und J. Smeaton arbeiteten im 18. Jh. an einer Theorie der idealen Flügel.
Die Windräder zur Wasserförderung wurden in Amerika 1854 von D. Hallady konstruiert

S' Albufeira, Mallorca (Balearische Inseln), Spanien ▷ 60 Vincent van Gogh, Le Moulin de la Galette. 1886

The natural energy generated by air can be converted into rotary motion to up to a maximum 59.3%, even at theoretical loss-free transformation. To optimize wind use, an aerodynamic wing profile with variable pitch-control is necessary for keeping the number of revolutions constant.

WIND POWER __ Wind mills (as well as water wheels) were the most important source of energy before the steam engine

Die natürliche Strömungsenergie des Windes ist zu max. 59,3% in Drehbewegung umsetzbar, selbst bei theoretisch verlustfreier Umwandlung. Für optimale Windnutzung ist ein aerodynamisches Blattprofil mit variablen Anstellwinkeln zur Regelung der Drehzahlkonstanz nötig.

WINDKRAFT __ Windmühlen (neben Wasserrädern) waren vor Dampfmaschinen die wichtigsten Energieerzeuger

When airstream direction and speed are changed, the resulting change of spin converts air energy into turbine rotation.

GAS TURBINES __ With an efficiency of up to 96% replaced water wheels (75% efficiency) in the 19th century AD; first noted by Leonardo da Vinci in the 15th/16th centuries

Durch Richtungs- und Geschwindigkeitsänderung der strömenden Luft wird eine Dralländerung erzeugt, Energie entzogen.

GASTURBINEN __ Lösten mit Wirkungsgraden von bis zu 96% Wasserräder (mit 75%) im 19. Jh. ab; erste Erwähnung bei Leonardo da Vinci im 15./16. Jh.

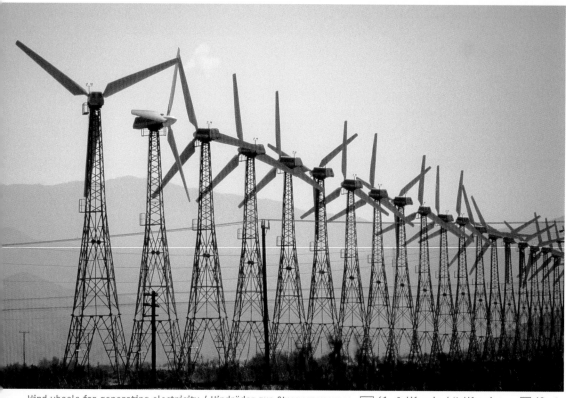

Wind wheels for generating electricity / Windräder zur Stromerzeugung: ◁◁◁ 61 California / Kalifornien ◁◁ 62 Growian. 1982 ◁ 63 Rudolf Bannasch,

In 1992 there were 1,211 plants in Germany with 183 MW capacity (358 mio. kWh/p.a.).
In California alone more than 15,000 with ca. 1,500 MW capacity have been installed.
WIND POWER _ Its contribution to the overall energy supply is still insignificant

1992 stehen in Deutschland 1.211 Anlagen mit 183 MW Leistung (358 Mio. kWh/p.a.).
In Kalifornien über 15.000 mit ca. 1.500 MW Leistung.
WINDKRAFT _ Ihr Beitrag zur gesamten Energieversorgung ist noch unbedeutend

In 1994 there were 2,617 plants in Germany with 643 MW capacity. Possible duration
of use at shores ca. 2,500 h/p.a., inland ca. 1.500 h/p.a.
WIND POWER _ 0.2 % contribution to overall German energy supply is still insignificant

1994 stehen in Deutschland 2.617 Anlagen mit 643 MW Leistung.
An den Küsten ca. 2.500 h/p.a., binnenländisch ca. 1.500 h/p.a. Nutzung möglich.
WINDKRAFT _ Der Beitrag von 0,2 % an der gesamten Energieversorgung in Deutschland ist noch unbedeutend

In 2004 there were 16,543 plants with 16,629 MW capacity in Germany.
Annual output >20 billion kWh.
WIND POWER _ Amounting to 4.09 % of overall energy supply is taking over water power (3.53 %)
as regenerative energy source in Germany for the first time

2004 stehen in Deutschland 16.543 Anlagen mit 16.629 MW Leistung.
Jahresproduktion >20 Milliarden kWh.
WINDKRAFT _ Löst erstmals mit 4,09 % an der gesamten Energieversorgung die Wasserkraft (3,53 %)
als größten regenerativen Energieträger in Deutschland ab

Argon is a colorless, odourless and tasteless noble gas that is chemically inert.
ARGON 16**Ar** _ From Greek <argós> »inert«

Argon ist ein geruch-, geschmack- sowie farbloses Edelgas, chemisch
reaktionsträge.
ARGON 16**Ar** _ Von griech. <argós> für »träge«

At $3.6*10^{-4}$ % in weight, Argon is the inert gas that most frequently occurs in the
earth's crust. Air consists of ca. 0.93 % in volume, or ca. 1.28 % in weight,
of free argon. No compounds known to date. Considerable amounts are in mineral
springs (like Karlsbad or Wildbad), mine gases (Straßfurt) and volcanic gases.
ARGON 36,38,40**Ar** _ Occurence on earth: 0.34 % ^{36}Ar; 0.06 % ^{38}Ar; 99.60 % ^{40}Ar

Argon ist mit $3,6*10^{-4}$ Gewichts % das häufigste Edelgas in der Erdrinde.
Luft besteht zu ca. 0,93 Volumen %, etwa 1,28 Gewichts %, aus freiem Argon. Bisher
sind keine Bindungen bekannt. Beträchtliche Mengen sind in Mineralquellen
(wie Karlsbad oder Wildbad), Grubengasen (Straßfurt) und vulkanischen Aus-
gasungen enthalten.
ARGON 36,38,40**Ar** _ Vorkommen auf der Erde: 0,34 % ^{36}Ar; 0,06 % ^{38}Ar; 99,60 % ^{40}Ar

Considerable amounts are used as protecting gas for electric welding, for
metal processing, and as filling for light bulbs or fluorescent lighting tubes.
ARGON 36,38,40**Ar** _ Occurence on earth: 0.34 % ^{36}Ar; 0.06 % ^{38}Ar; 99.60 % ^{40}Ar

In bedeutenden Mengen als Schutzgas beim elektrischen Schweißen, bei der
Metallverarbeitung sowie in Glühlampen und Leuchtstoffröhren verwendet.
ARGON 36,38,40**Ar** _ Vorkommen auf der Erde: 0,34 % ^{36}Ar; 0,06 % ^{38}Ar; 99,60 % ^{40}Ar

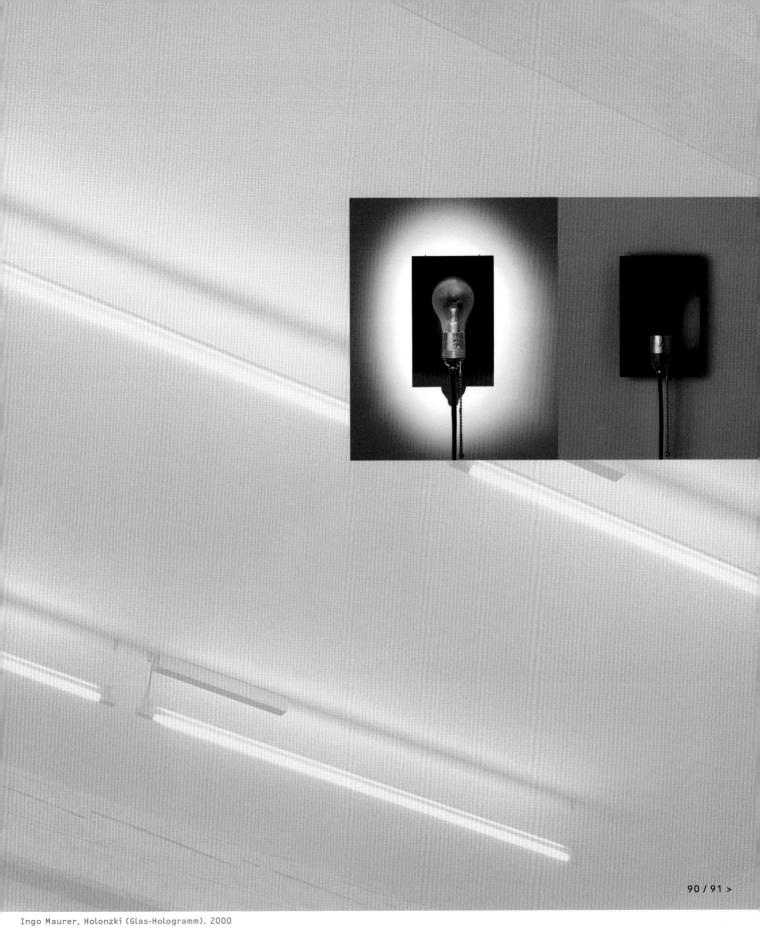

Ingo Maurer, Holonzki (Glas-Hologramm). 2000

The earth's atmosphere probably consisted initially of water vapor,
carbon dioxide, nitrogen and traces of gases.
OXYGENIUM 0 __ The earth's atmosphere initially lacked free oxygen

Ursprünglich bestand die Erdatmosphäre aus Wasserdampf, Kohlendioxyd,
Stickstoff und Spuren von Gasen.
OXYGENIUM 0 __ Ursprünglich mangelte es der Erdatmosphäre an freiem Sauerstoff

Free oxygen would have prevented the emergence of life, the formation of
amino acids from simple molecules.
BASIS __ Proteins are made of amino acids, which need an oxygen-free environment for bonding

Freier Sauerstoff hätte die Entstehung des Lebens, die Bildung von Aminosäuren
aus einfachen Molekülen, verhindert.
BASIS __ Proteine bestehen aus Aminosäuren, welche zur Bildung Sauerstoff-Freiheit benötigen

After cooling sufficiently, water vapor condensed at certain concentrations,
partly dissolving carbon dioxide.
OXYGENIUM 0 __ Too tightly bonded in minerals to be freed from earth or by photolysis

Wasserdampf kondensierte nach ausreichender Abkühlung bei bestimmten
Konzentrationen, Kohlendioxyd teilweise lösend.
OXYGENIUM 0 __ Zu fest an Mineralien gebunden, um aus der Erde oder durch Photolyse
freigesetzt zu werden

By 3.8 billion years ago, 50–60% of the oxygen we now have in the air,
although still bonded, had been formed.
ORIGIN __ Bonded oxygen in bacteria and their by-products

Bis vor 3,8 Milliarden Jahren wurde 50–60% des heutigen Luftsauerstoffs,
allerdings noch in gebundener Form, gebildet.
URSPRUNG __ Gebundener Sauerstoff in Bakterien und deren Ausscheidungen

68 Fluorescent tubes containing argon / Leuchtstoffröhren mit Argon-Gasfüllung

By 1.2–1.5 billion years ago, 1% of the present oxygen content level of the atmosphere had been reached.*
Not until all the Fe++ in the oceans had been converted to FeO could the former be dispersed into the atmosphere

Bis vor 1,2–1,5 Milliarden Jahren wurde 1% des heutigen Sauerstoffgehalts der Atmosphäre erreicht.*
Erst nachdem Sauerstoff das gesamte Fe++ der Ozeane in FeO gewandelt hatte, konnte jener in die Atmosphäre gelangen

The oxygen content of the atmosphere has been at its present level for about 320 million years.
OUTLOOK: Risk of change in the atmosphere from the »greenhouse effect«, which is caused by man

Seit ca. 320 Millionen Jahren ist der heutige Sauerstoffgehalt der Atmosphäre erreicht.
AUSBLICK: Drohende Veränderung der Atmosphäre durch den vom Menschen verursachten »Treibhauseffekt«

* The opposing theory of biogenic oxygen enrichment in the primordial atmosphere is advanced in the series published by the Kunst- und Ausstellungshalle der Bundesrepublik Deutschland, Forum/vol. 12, under the heading ›Luft‹ under 1. on pp. 32/33. Here an abiogenic process is assumed, contrary to the currently preferred scientific theory, which is: If the strength of the UV radiation from the primordial Sun on the atmosphere of the primordial earth had been 10,000 times stronger, free oxygen could have been generated by photolysis separating off steam and carbon dioxide.

* Die gegensätzliche These zur biogenen Sauerstoffanreicherung in der Uratmosphäre wird in der Schriftenreihe der Kunst- und Ausstellungshalle der Bundesrepublik Deutschland, Forum/Bd. 12, mit dem Titel »Luft«, unter 1. auf S. 32/33 vertreten. Hier wird im Gegensatz zur momentanen Auffassung der Wissenschaft ein abiogener Prozess angenommen: Wenn die Sonne in Urzeiten mit 10.000fach stärkerer UV-Einstrahlung auf die Erduratmosphäre eingewirkt hätte, dann könnte freier Sauerstoff durch photolytische Aufspaltung von Wasserdampf und Kohlendioxyd entstanden sein.

Sign the Sky!

The leap into the void, absolutely beginning over again – wasn't that what the Moderns had always propagated?
No holds barred, detached from the foundations of yesterday's society? Yves Klein's *Un homme dans l'espace*
(1960, fig. 70) rehearses man's breakthrough into a new dimension which had otherwise been denied to him:
the ether, the great void. He spread out his arms like wings and jumped off. The new man: an Icarus of the will, an
artist by assertion, the architect of worlds by vocation. ›It is the suggestion of bathing in a space that is wider than
the infinite,‹ is how Yves Klein described his striving to enlarge the two-dimensional reality of the panel painting,
to transcend boundaries and to make the viewer receptive to what was behind matter and sign. His works aimed
at the infinite and it is not a coincidence that the man who, mature before his time, had symbolically signed
the sky, who made blue, the colour of vastness, yearning and the firmament his own. I. K. B., International Klein
Blue, became the trade mark of his monochromes, which he extended into the third dimension with sponges.
Klein was no longer concerned with form or colour; what he was after was the essence of painting itself:
›In what I am doing I am essentially seeking that »transparency«, that »void« in which dwells the permanent
and absolute intellect, freed of all dimensions.‹ His Actions, experiments with materials, Anthropometries
(imprints of the human body) and Cosmogonies (traces left by wind and weather) were not written in the wind;
they formed traces of a new intellectual stance which many artists were eager to follow.
– At first glance, just an example of classical sports photography: A highboard diver rolls himself up into a ball,
his hands wrapped around his knees, a dark spot high in the air. It goes without saying that Alexander
Rodtschenko's *Diving into the Water* (1970/78, fig. 71) no longer pays tribute to a Socialist physical aesthetic but
rather works with the devices of abstraction. Top right: great density, concentrated energy, surrounded by nothing
but fluid space into which the person is diving. The athlete has become a dark something against a slightly clouded
sky, which looks like a blue screen in a film studio, as a surface on to which wishes and ideas can be projected.
A sky full of gold medals, a sky for the new man, who, for a second overcomes the force of gravity and, like Yury
Gagarin, orbits about the world as an independent satellite. >>>

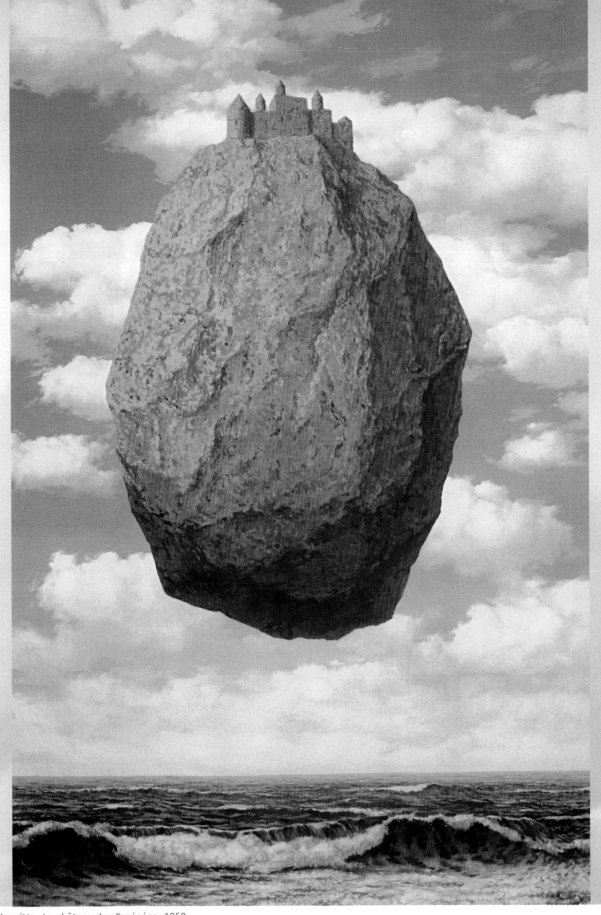

69 René Magritte, Le château des Pyrénées. 1959

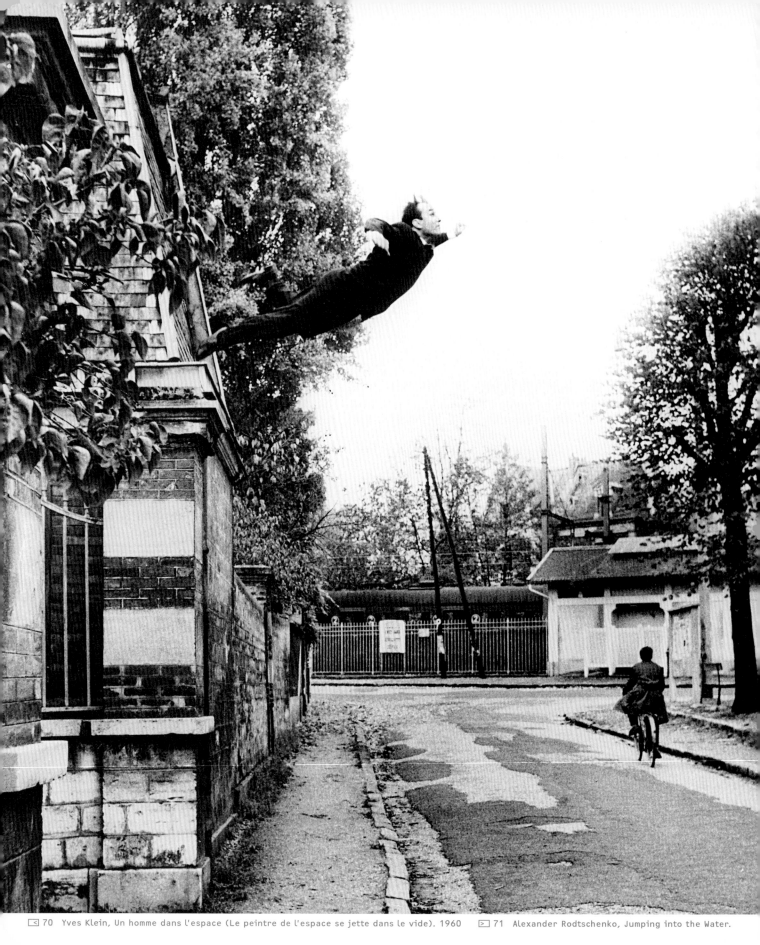

◁ 70　Yves Klein, Un homme dans l'espace (Le peintre de l'espace se jette dans le vide). 1960　▷ 71　Alexander Rodtschenko, Jumping into the Water.

Signier den Himmel!

Der Sprung ins Leere, der absolute Neuanfang – war es nicht das, was die Moderne immer propagiert hatte?
Voraussetzungslos, losgelöst von den Fundamenten einer Gesellschaft des Gestern? Yves Kleins *Un homme dans
l'espace* von 1960 (Abb. 70) probt den Aufbruch des Menschen in eine Dimension, die ihm sonst versagt ist: den
Äther, die große Leere. Er breitet die Arme aus wie Schwingen und stößt sich ab. Der neue Mensch: ein Ikarus des
Willens, ein Künstler durch Setzung, ein Weltenbauer durch Berufung. »Es ist die Suggestion eines Badens in
einem Raume, der weiter als das Unendliche ist«, beschreibt Yves Klein seine Versuche, die zweidimensionale Rea-
lität des Tafelbildes aufzuweiten, Grenzen zu transzendieren und seine Betrachter empfänglich zu machen für das,
was hinter Materie und Zeichen steht. Seine Arbeiten zielten auf das Unendliche, und es ist kein Zufall, dass sich
der Mann, der als Frühreifer schon symbolisch den Himmel signiert hatte, Blau, die Farbe der Weite, der Sehnsucht
und des Firmaments zu eigen macht. I.K.B., International Klein Blue, wird zum Markenzeichen seiner monochro-
men Arbeiten, die er durch Schwämme in die Dreidimensionalität verlängert. Klein geht es nicht mehr um Form,
nicht mehr um Farbe, es geht um die Essenz der Malerei selbst: »In meinem Tun bin ich vor allem auf der Suche
nach jener ›Durchsichtigkeit‹«, sagt Klein, »nach jener ›Leere‹, in welcher der beständige und absolute Geist lebt,
befreit von allen Dimensionen«. Seine Aktionen, Materialexperimente, Anthropometrien (Körperabdrücke) und
Kosmogonien (Spuren von Wind und Wetter) waren nicht in den Wind gesprochen, sie bildeten Spuren einer neu-
en Geisteshaltung, der viele Künstler bereitwillig folgten.
– Auf den ersten Blick ein Stück klassischer Sportfotografie: Ein Turmspringer kugelt sich ein, die Hände um
die Knie geballt, ein dunkler Fleck hoch in der Luft. Alexander Rodtschenkos *Sprung ins Wasser* (1970/78) huldigt
freilich nicht mehr einer sozialistischen Körperästhetik, sondern arbeitet mit abstrakten Gestaltungsmitteln.
Oben rechts: größte Dichte, geballte Energie, darum herum nichts als fließender Raum, in den der Mensch ein- >>>

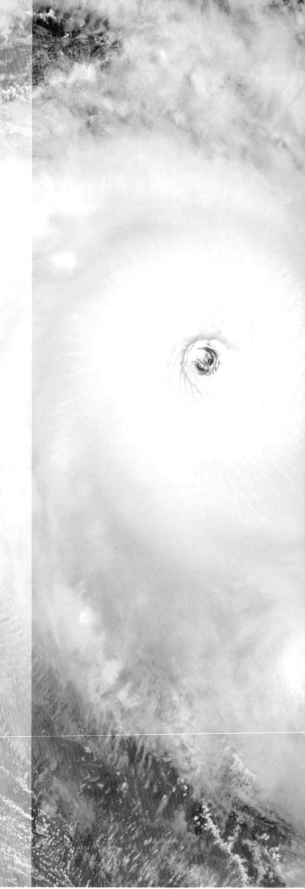

The atmosphere surrounds the solid earth and participates in its rotation; it is maintained by the force of gravity.
DEFINITION

Die Atmosphäre umgibt die feste Erde und nimmt an ihrer Rotation teil, sie wird durch Anziehung gehalten.
DEFINITION

In its highest strata, complex interaction with interplanetary space.
DEFINITION _ Gaseous masses which decrease in density and temperature the further they are from the surface of a planet or star

In ihren höchsten Schichten komplexe Wechselwirkungen mit dem interplanetaren Raum.
DEFINITION _ Gasmassen, die in Dichte und Temperatur von der Planeten- oder Sternoberfläche weg nach außen abnehmen

Due to very low heat conductivity, heat transport mainly takes place by exchange.
DEFINITION

Wegen der sehr geringen Wärmeleitfähigkeit findet der Wärmetransport besonders durch Austausch statt.
DEFINITION

Convection and turbulence cause masses of air to be interchanged between adjacent air strata.
DEFINITION

Zwischen benachbarten Luftschichten werden durch die von Konvektion und Turbulenz bewirkte Durchmischung Luftmengen ausgetauscht.
DEFINITION

Exchange of mass, heat, energy and water vapor, dust also transversely to the mean direction of wind.
DEFINITION

Austausch von Masse, Wärme, Energie und Wasserdampf, Staub auch quer zur mittleren Windrichtung.
DEFINITION

Each exchangeable entity leads to corresponding physical flow proportional to the gradient of the entity.
DEFINITION

Jede austauschbare Größe führt dabei zum entsprechenden, dem Gradienten dieser Größe proportionalen physikalischen Fluss.
DEFINITION

 72 Tropical Cyclone Ingrid approaching Cape York Peninsula, Australia, March 8, 2005. Wind speed close to 150 mph, with gusts, to 184 mph / Der tropische

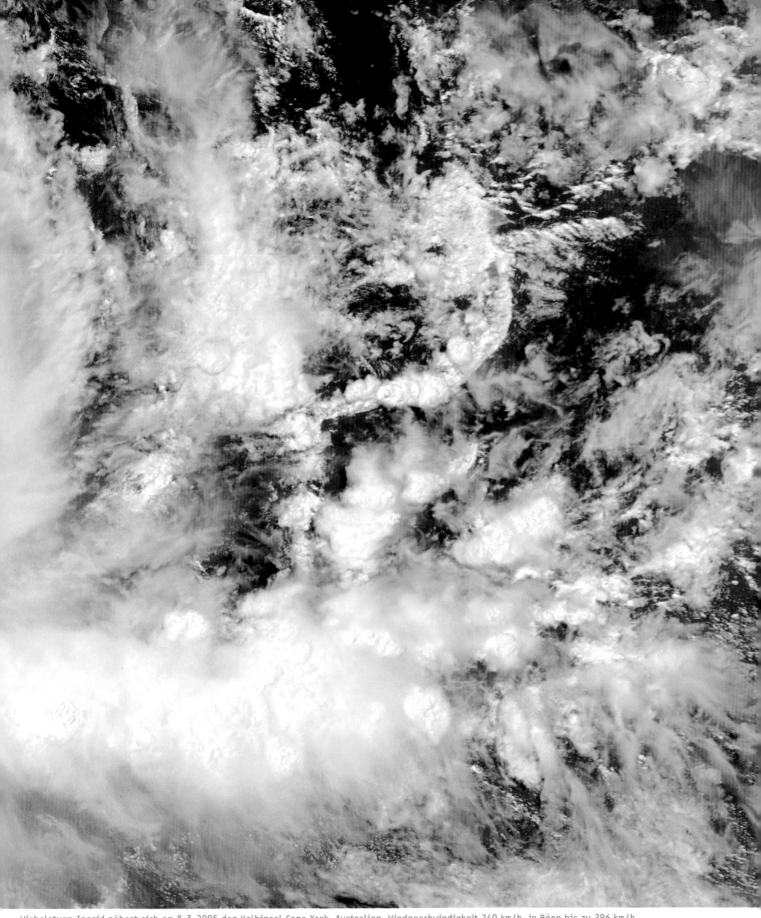

Wirbelsturm Ingrid nähert sich am 8.3.2005 der Halbinsel Cape York, Australien. Windgeschwindigkeit 240 km/h, in Böen bis zu 296 km/h

Only two years after the Sputnik Shock René Magritte was imagining a world liberated from the pull of gravity. In *Le château des Pyrénées* (1959, fig. 69), a massive boulder floats as if it had been transformed into an airship. This tongue-in-cheek assault on the laws of both gravity and logic – artistic levitation – was taken literally by Pop Art icon Andy Warhol. He overcame the mediated representation of the panel painting, as Roy Lichtenstein was still rehearsing it in *Spray* (1962, fig.106) – and thus took the medium of air into his possession as we experience it: three-dimensional, mutable and fleeting. His *Silver Clouds* (1966) are grouped like a flock of sheep clouds on the ceiling of the gallery. Otto Piene (fig. 96) lets off grotesquely formed hot-air sculptures into the sky in 1969. After conquering the comic, balloons with dialogue moved on to art and Hans Haacke's *Sky Line* (1967, fig. 98) links earth and ether like an umbilical cord. This was the era of communications theory, of emitter and receiver models, and art did not demur at writing signs in the sky that hit the eye. The balloon – common property of the masses and the expression of the cheerful protests of the 1960s – acquired a new dimension as an intellectual guy rope

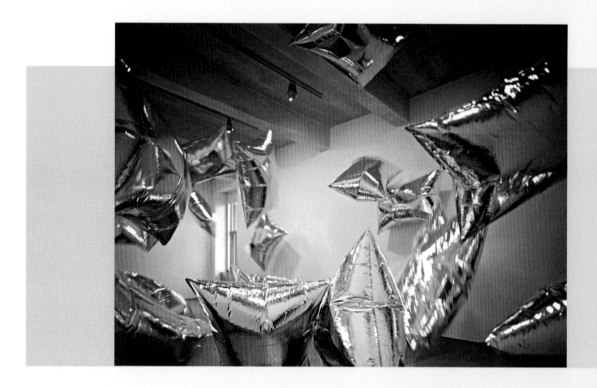

into new territory and – as needed – into the past. Philippe Durand's *Souvenir des Madeleines* (1994, fig. 101) shows the Moderns grown old, indulging in self-quotation and continuing to spin out the same old line. His recollections of the Proustian madeleine biscuit which in turn has associative powers of triggering off memories, makes the past appear a mere construct, unreal and intangible. Similarly Jeff Wall's 1993 *A Sudden Gust of Wind, (after Hokusai),* (fig.103). Everything is staged, the scene is as unreal or as palpably present as on stage. Photography has lost its documentary side but has gained something else: the power to evoke scenes and pictures that was once the preserve of the panel painting. A puff of wind surprises a group of people out in a field. Their hats and notepads whirl about in the air as if a divine emissary had permitted himsel a practical joke. A generation after Yves Klein, who was still physically taking possession of the sky, distance and intertextual play have crept into art. >>>

taucht. Der Sportler wird zum dunklen Etwas auf einem locker bewölkten Himmel, der wie ein Blue-Screen in einem Filmstudio wirkt, als Projektionsfläche für Wünsche und Vorstellungen. Ein Himmel voller Goldmedaillen, ein Himmel des neuen Menschen, der für einen Augenblick die Erdanziehung überwindet und wie Juri Gagarin die Welt als eigenständiger Satellit umkreist.

Eine Welt befreit von der Gravitation imaginiert René Magritte nur zwei Jahre nach dem Sputnik-Schock. *Le château des Pyrénées* von 1959 (Abb. 69) lässt einen mächtigen Gesteinsblock schweben, als hätte er sich in ein Luftschiff verwandelt. Die augenzwinkernde Attacke auf die Gesetze der Schwerkraft und Logik – künstlerische Levitation – nimmt Pop-Art-Heros Andy Warhol wörtlich. Er überwindet die vermittelte Darstellung des Tafelbildes, wie sie noch Roy Lichtenstein mit *Spray* von 1962 probt (Abb. 106) – und nimmt das Medium Luft so in Besitz, wie wir es erleben: dreidimensional, wandelbar und flüchtig. Seine *Silver Clouds* (1966) gruppieren sich wie eine Herde Schäfchenwolken an der Decke der Galerie, Otto Piene (Abb. 96) entlässt 1969 bizarr geformte Heißluftskulpturen in den Himmel, Sprechblasen erobern nach dem Comic auch die Kunst, und Hans Haackes *Sky Line* aus dem Jahr 1967 (Abb. 98) verbindet gleich einer Nabelschnur Erde und Äther. Es ist die Zeit der Kommunikationstheorie, der Sender-Empfänger-Modelle, und die Kunst lässt es sich nicht nehmen, Zeichen unübersehbar in den Himmel zu schreiben. Der Ballon – ein Massengut und Ausdruck des fröhlichen Protests der 1960er – gewinnt eine neue Dimension, als gedankliche Linie in neue Gefilde und – je nach Bedarf – in die Vergangenheit. >>>

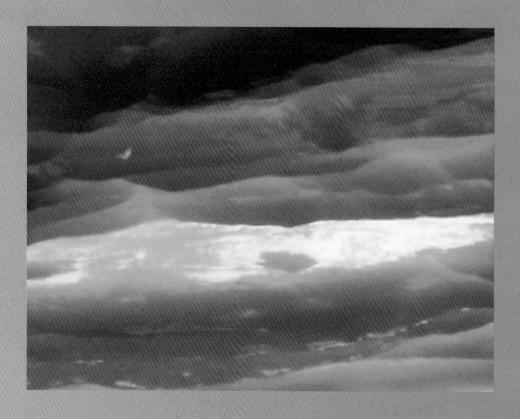

75 Annelies Štrba, Clouds. 2005 / Annelies Štrba, Wolken. 2005

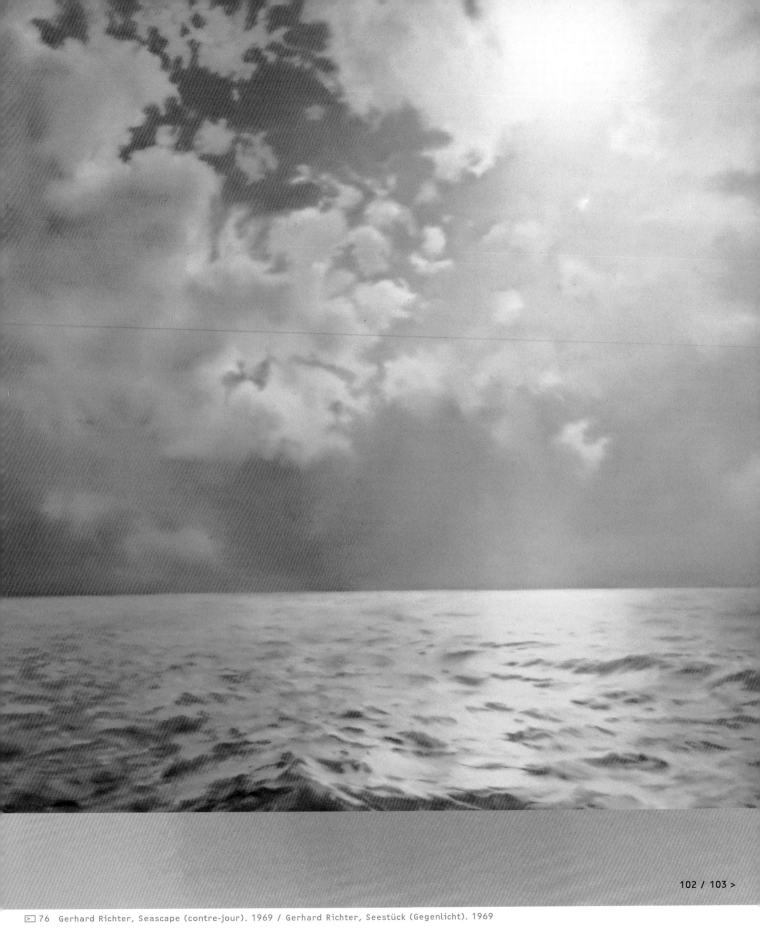

▷ 76 Gerhard Richter, Seascape (contre-jour). 1969 / Gerhard Richter, Seestück (Gegenlicht). 1969

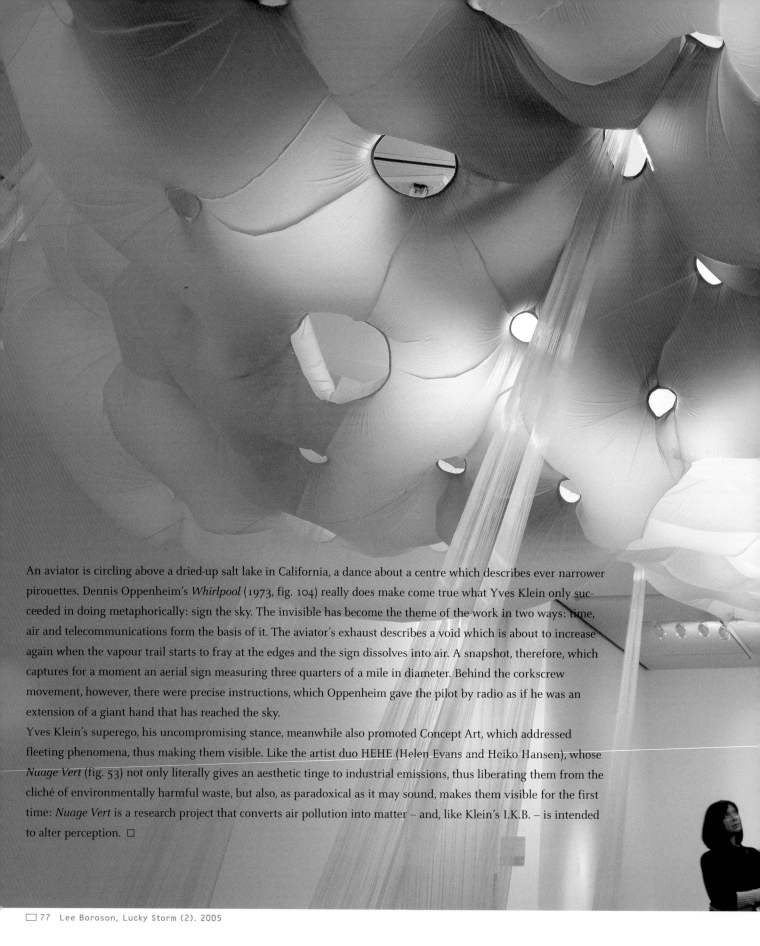

An aviator is circling above a dried-up salt lake in California, a dance about a centre which describes ever narrower pirouettes. Dennis Oppenheim's *Whirlpool* (1973, fig. 104) really does make come true what Yves Klein only succeeded in doing metaphorically: sign the sky. The invisible has become the theme of the work in two ways: time, air and telecommunications form the basis of it. The aviator's exhaust describes a void which is about to increase again when the vapour trail starts to fray at the edges and the sign dissolves into air. A snapshot, therefore, which captures for a moment an aerial sign measuring three quarters of a mile in diameter. Behind the corkscrew movement, however, there were precise instructions, which Oppenheim gave the pilot by radio as if he was an extension of a giant hand that has reached the sky.

Yves Klein's superego, his uncompromising stance, meanwhile also promoted Concept Art, which addressed fleeting phenomena, thus making them visible. Like the artist duo HEHE (Helen Evans and Heiko Hansen), whose *Nuage Vert* (fig. 53) not only literally gives an aesthetic tinge to industrial emissions, thus liberating them from the cliché of environmentally harmful waste, but also, as paradoxical as it may sound, makes them visible for the first time: *Nuage Vert* is a research project that converts air pollution into matter – and, like Klein's I.K.B. – is intended to alter perception. □

Philippe Durands *Souvenir des Madeleines* von 1994 (Abb. 101) zeigt die alt gewordene, sich selbst zitierende und weiterspinnende Moderne. Seine Erinnerung an Prousts Madeleine-Gespräch, das seinerseits erinnerungsaus-lösende Qualitäten besitzt, lässt die Vergangenheit als bloßes Konstrukt erscheinen, irreal und ungreifbar. Ähnlich Jeff Walls *A Sudden Gust of Wind (after Hokusai)* von 1993 (Abb. 103). Alles ist inszeniert, die Szene so irreal oder greifbar wie auf der Bühne, die Fotografie hat ihre dokumentarische Dimension verloren und etwas anders gewon-nen: die Kraft, Szenen und Bilder zu evozieren, wie sie dem Tafelbild vorbehalten waren. Ein Windstoß überrascht eine Gruppe auf freiem Feld. Hüte und Notizblätter verwirbeln in der Luft, als ob sich ein göttlicher Bote einen Jux erlaubt hätte. Eine Generation nach Yves Klein, der den Himmel als neue Dimension noch körperlich in Besitz nahm, haben sich Distanz und intertextuelles Spiel in die Kunst eingeschlichen.

Ein Flieger kreist über einem ausgetrockneten Salzsee in Kalifornien, ein Tanz um eine Mitte, die in immer enge-ren Pirouetten umschrieben wird. Dennis Oppenheims *Whirlpool* (1973, Abb. 104) macht wahr, was Yves Klein nur metaphorisch gelang: den Himmel zu signieren. Auf doppelte Weise wird das Unsichtbare zum Thema der Arbeit: Zeit, Luft und Telekommunikation bilden ihre Basis. Der Abgasstrahl des Fliegers umschreibt eine Leere, die gleich wieder zunehmen wird, wenn der Kondensstreifen an den Rändern brüchig wird und sich das Zeichen in Luft auflöst. Eine Momentaufnahme also, die ein Luftzeichen von einer dreiviertel Meile Durchmesser für einen Augen-blick fixiert. Hinter der korkenzieherartigen Bewegung aber stehen genaue Anweisungen, die Oppenheim dem Piloten über Funk mitteilt, als wäre er eine verlängerte Riesenhand, die den Himmel erreicht.

Yves Kleins Über-Ich, seine kompromisslose Haltung, beförderte indes auch Konzept-Kunst, die sich flüchtigen Phänomenen zuwandte und so erst sichtbar machte. Wie das Künstlerduo HEHE (Helen Evans und Heiko Hansen), deren *Nuage Vert* (Abb. 53) Industrieabgase nicht nur ästhetisch einfärben und so gleichsam vom Stereotyp der umweltschädlichen Abfallwirtschaft befreien, sondern, so paradox es klingt, als alltägliches Himmelsphänomen erst sichtbar macht: *Nuage Vert* ist ein Forschungsprojekt, das Luftverschmutzung materialisiert – und wie Kleins I.K.B. – darauf setzt, Wahrnehmung zu verändern. □

The concomitant flow of mass and heat reaches 10^6 times greater intensity and range in the vertical.
DEFINITION

Die zugehörigen Masse- und Wärmeflüsse haben in vertikaler Richtung eine 10^6fach höhere Stärke und Reichweite.
DEFINITION

Thus the physical exchange is responsible for extending the daily temperature curve upwards from the ground and the proportion of wind that is vertical.
DEFINITION

Somit ist der physikalische Austausch verantwortlich für die Ausbreitung der täglichen Temperaturwelle vom Erdboden nach oben und die vertikalen Windanteile.
DEFINITION

78 A foehn front at Lee (Norwegian coastal mountains) / Eine Föhnmauer in Lee (Norwegisches Küstengebirge)

In the horizontal physical exchange aims at equalizing the temperature
differences between the poles and the equator.
DEFINITION

In horizontaler Richtung zielt der physikalische Austausch auf Ausgleich
der Temperatur-Unterschiede zwischen Pol und Äquator.
DEFINITION

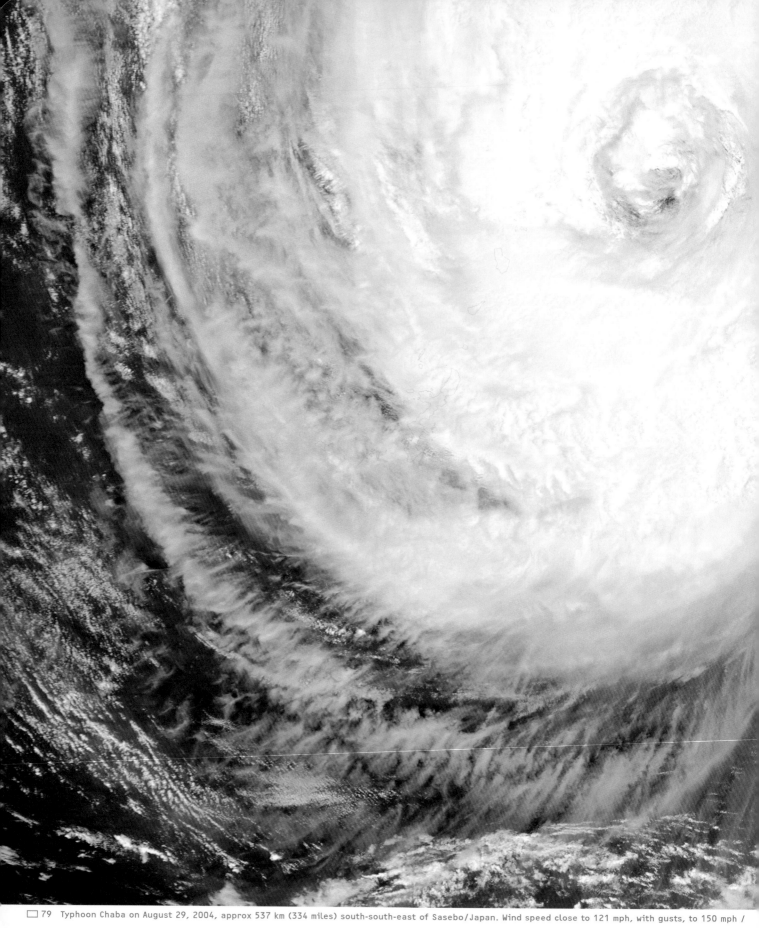

79 Typhoon Chaba on August 29, 2004, approx 537 km (334 miles) south-south-east of Sasebo/Japan. Wind speed close to 121 mph, with gusts, to 150 mph /

Corresponding exchange and transport processes occure in sea water.
DEFINITION

Entsprechende Durchmischungs- und Transportvorgänge laufen im
Meerwasser ab.
DEFINITION

The internal, molecular friction of air is low; – friction on the earth‹s surface
leads to deceleration and deflection to lower air pressure.
DEFINITION

Die innere, molekulare Reibung der Luft ist gering; – Reibung an der Erdober-
fläche bremst und lenkt zum tieferen Luftdruck hin ab.
DEFINITION

The baric law of wind describes the relation between wind direction and air pres-
sure: in the Northern hemisphere the wind blows clockwise around a high pressure
area, counterclockwise around a low pressure area (due to the Coriolis-force).
DEFINITION

Das barische Windgesetz beschreibt die Beziehung zwischen Windrichtung und
Luftdruck: Auf der Nordhalbkugel strömt der Wind im Uhrzeigersinn
um ein Hochdruckgebiet, gegen den Uhrzeigersinn um ein Tiefdruckgebiet
(in Folge der Coriolis-Kraft).
DEFINITION

So the friction on the earth's surface causes a spiral flow of air in the lower air
strata from high-pressure areas to low-pressure areas; – from which follows
the Buys-Ballot Law: if you turn your back to the wind, the low pressure is in front
of you and to your left (right in the Southern hemisphere).
DEFINITION

Dabei bewirkt in den untersten Luftschichten die Reibung an der Erdoberfläche,
dass die Luft spiralförmig vom Hoch- zum Tiefdruckgebiet strömt; – hieraus folgt
die Buys-Ballot-Regel: Wenn man dem Wind den Rücken zukehrt, liegt der tiefe
Druck links vorne (auf der Südhalbkugel rechts).
DEFINITION

Taifun Chaba am 29.8.2004, ca. 537 km südsüdwestlich von Sasebo/Japan. Windgeschwindigkeit 194 km/h, in Böen bis zu 241 km/h

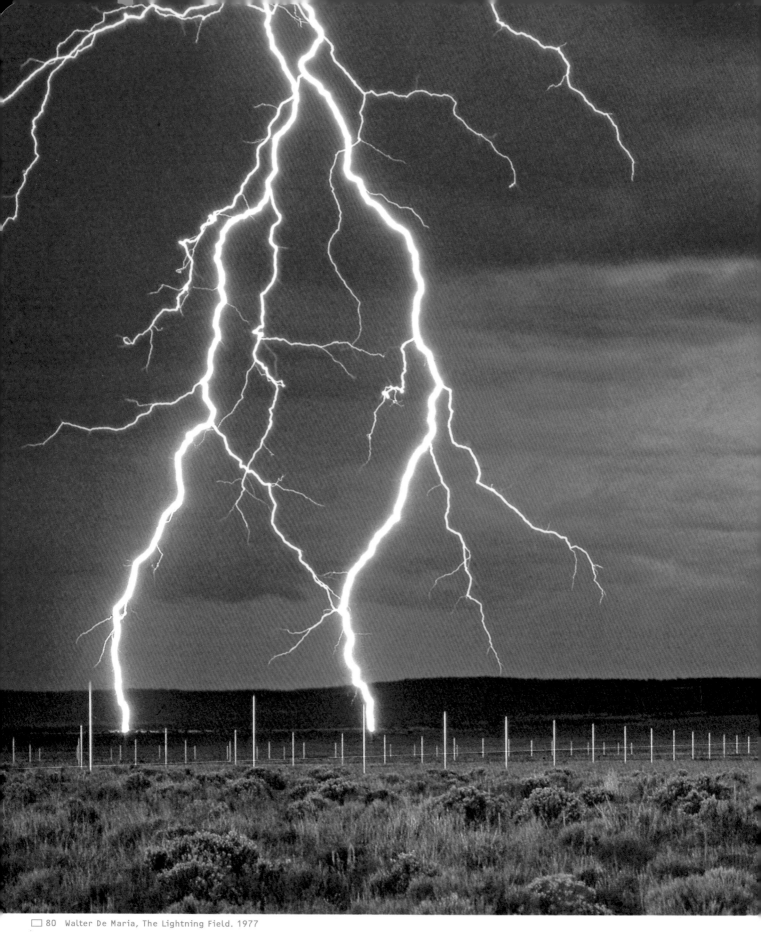

80 Walter De Maria, The Lightning Field. 1977

Ions of air are constantly generated in the atmosphere under the influences of radioactive, cosmic and short-wave UV radiation.
ATMOSPHERIC ELECTRICITY __ Denotes all natural electrical phenomena

Unter dem Einfluss radioaktiver, kosmischer und kurzwelliger UV-Strahlung werden in der Atmosphäre ständig Luftionen erzeugt.
ATMOSPHÄRISCHE ELEKTRIZITÄT __ Bezeichnet alle natürlich vorkommenden elektrischen Erscheinungen

These charge an electrical field, of which the vector is directing to the earth, which is why the earth has a negative charge. The field strength amounts to ca. 100 V/m on the earth's surface, diminishing exponentially with altitude and varying according to the time of day or season of the year.
ATMOSPHERIC ELECTRICITY __ Under undisturbed circumstances, without thunderstorms

Diese bauen ein elektrisches Feld auf, dessen Vektor auf die Erde gerichtet ist und weshalb die Erde negativ geladen sein muss. Die Feldstärke beträgt an der Erdoberfläche ca. 100 V/m, sie nimmt exponentiell mit der Höhe ab, schwankt mit dem Tages- und Jahresverlauf.
ATMOSPHÄRISCHE ELEKTRIZITÄT __ Bei ungestörten Verhältnissen, ohne Gewitter

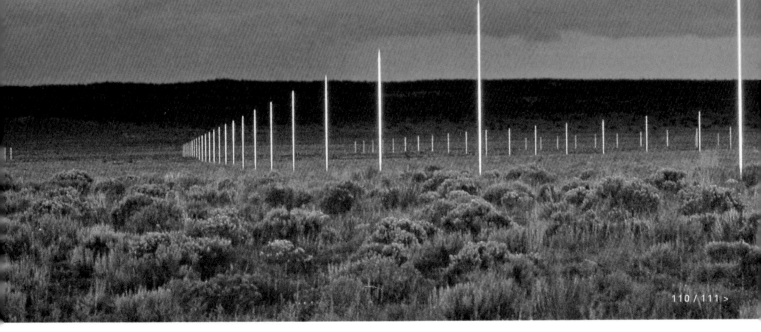

The potential difference between the earth's surface and the conducting
equalizing layer of the ionosphere amounts to ca. 200–400 kV.
ATMOSPHERIC ELECTRICITY_ Ground to lower ionosphere at 70-80 km altitude

Die Potentialdifferenz zwischen Erdoberfläche und leitender Ausgleichsschicht
in der Ionosphäre beträgt ca. 200–400 kV.
ATMOSPHÄRISCHE ELEKTRIZITÄT_ Boden zu unterer Ionosphäre bei 70-80 km Höhe

Consequently the resulting vertical electrical current between both conducting
strata amounts to ca. 1,500 A distributed all over the earth.
ATMOSPHERIC ELECTRICITY_ Ground to lower ionosphere at 70-80 km altitude

Somit beträgt der resultierende elektrische Vertikalstrom zwischen den beiden
leitenden Schichten über die ganze Erde verteilt ca. 1.500 A.
ATMOSPHÄRISCHE ELEKTRIZITÄT_ Boden zu unterer Ionosphäre bei 70-80 km Höhe

The transport of charges immediate seeks to equalize differences in charge.
However, the air's electrical field on undisturbed days remains, in the
atmosphere a process must be constantly operating so that differences in voltage
do not disappear.
ATMOSPHERIC ELECTRICITY_ At great potential gradients visible as discharge e.g. at the tops
of masts. Global thunderstorms constantly charge the earth negatively

Ladungstransport versucht Spannungsunterschiede sofort auszugleichen.
Da aber das luftelektrische Feld an ungestörten Tagen erhalten bleibt, muss in
der Atmosphäre ein ständiger Prozess wirksam sein, der die Spannungsdifferenzen
nicht verschwinden lässt.
ATMOSPHÄRISCHE ELEKTRIZITÄT_ Bei starkem Potentialgefälle als Entladung z.B. an Mastspitzen
sichtbar. Globale Gewittertätigkeit lädt die Erde ständig negativ auf

Faintly visible electrical gas discharge to the tips of pointed objects.
Occurs more frequently in mountains and at sea.
ST ELMO'S FIRE_ Named after Saint Erasmus (Roman Catholic)

Lichtschwache, büschelförmige elektrische Gasentladung an spitzen Gegenständen.
Auftreten häufiger im Gebirge und auf See.
ELMSFEUER_ Oder Eliasfeuer, benannt nach dem HL. Erasmus

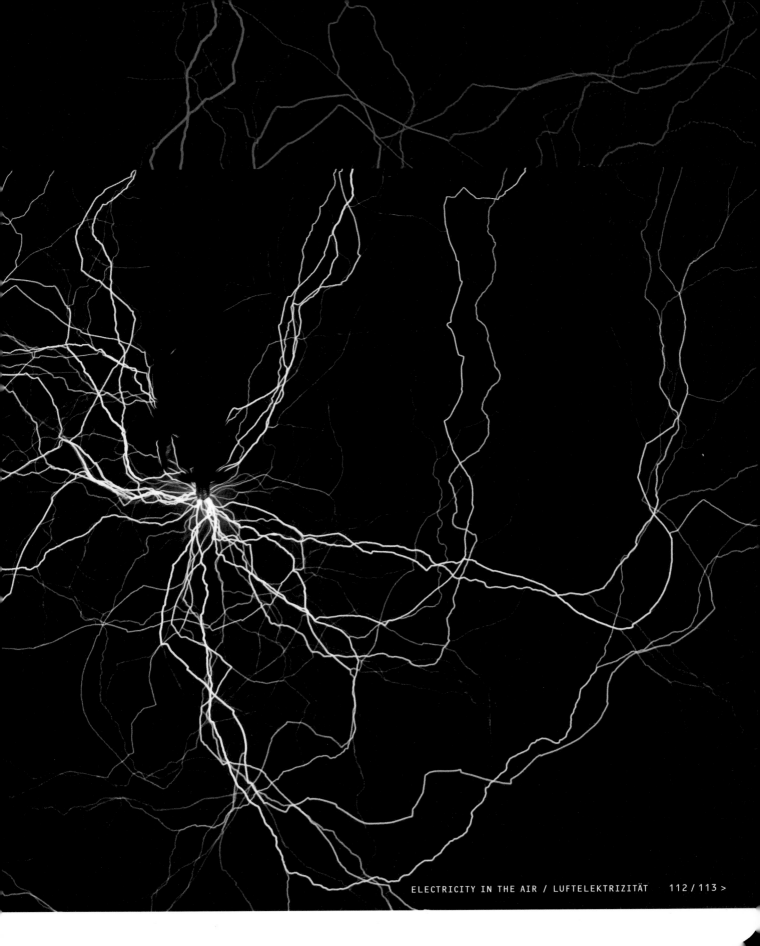

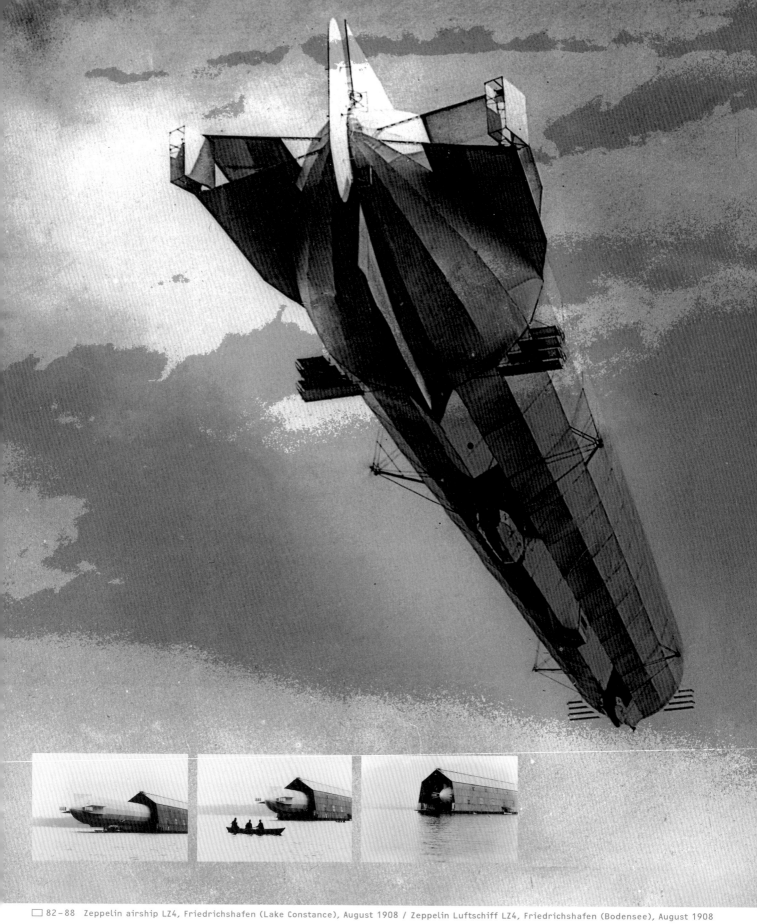

82–88 Zeppelin airship LZ4, Friedrichshafen (Lake Constance), August 1908 / Zeppelin Luftschiff LZ4, Friedrichshafen (Bodensee), August 1908

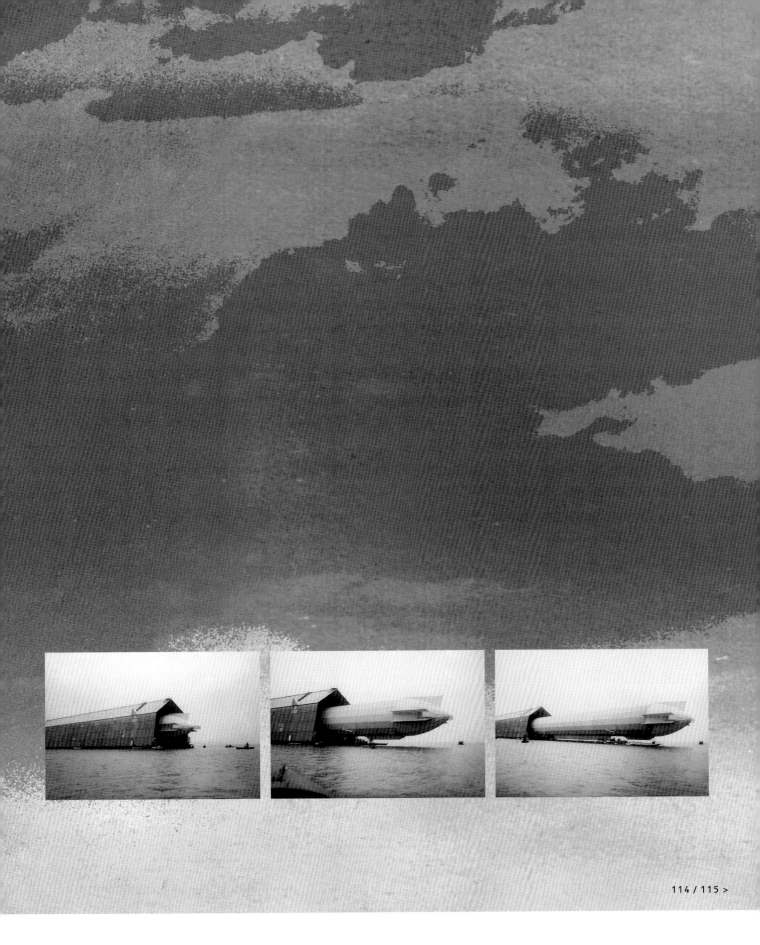

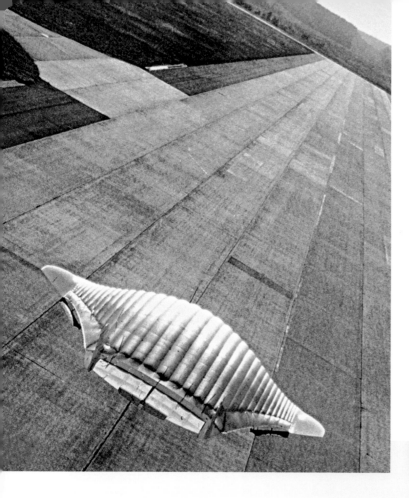

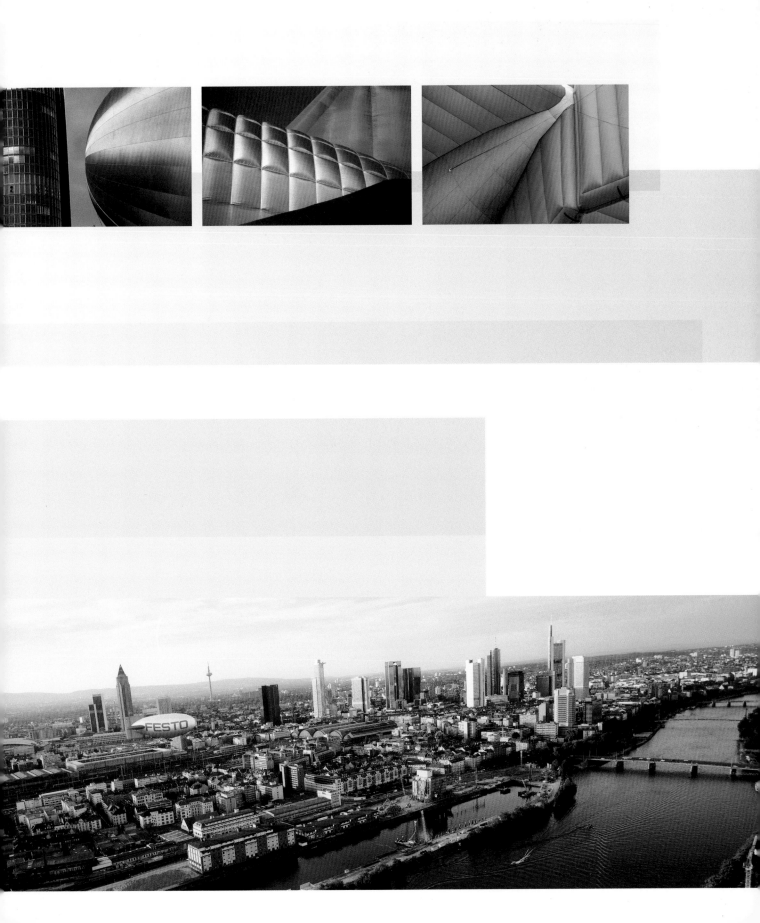

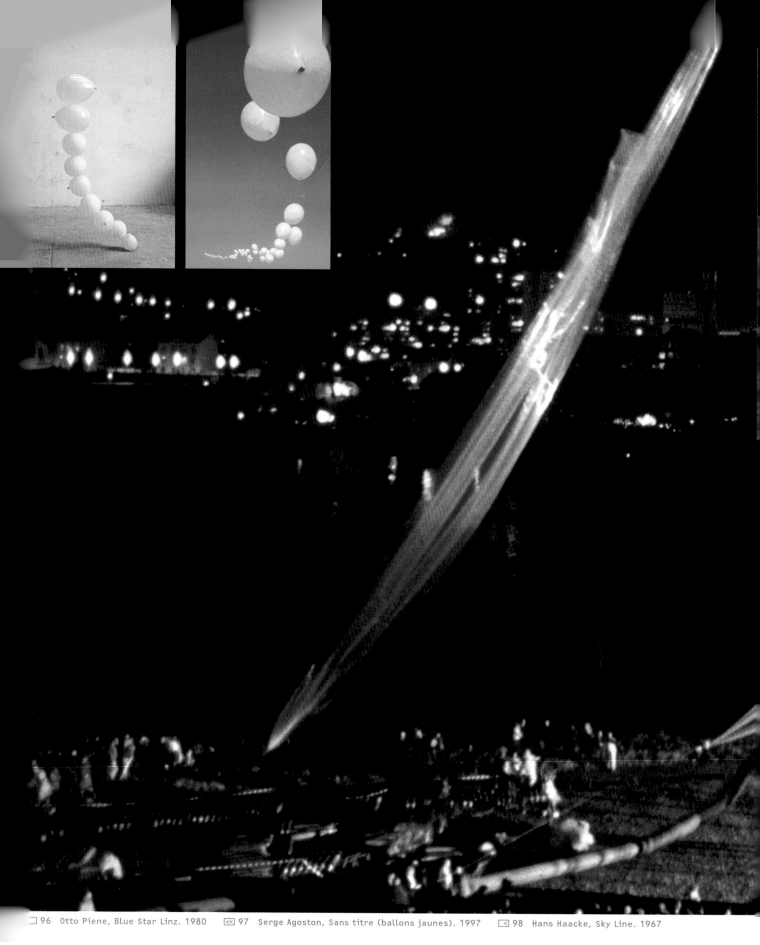

96 Otto Piene, Blue Star Linz. 1980 ⧉ 97 Serge Agoston, Sans titre (ballons jaunes). 1997 ⧉ 98 Hans Haacke, Sky Line. 1967

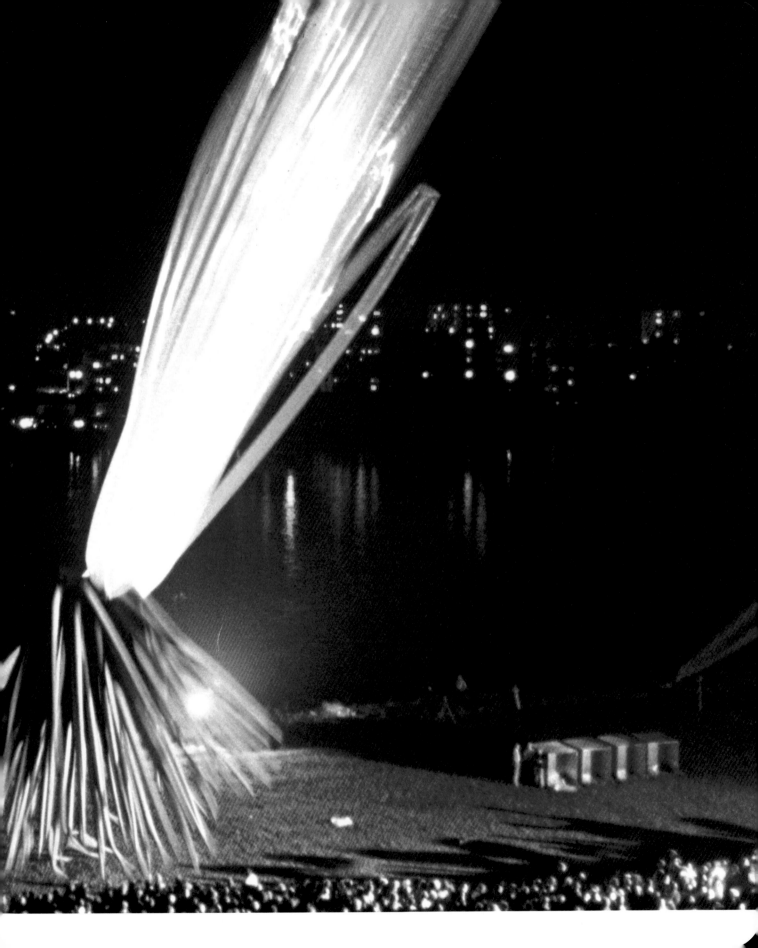

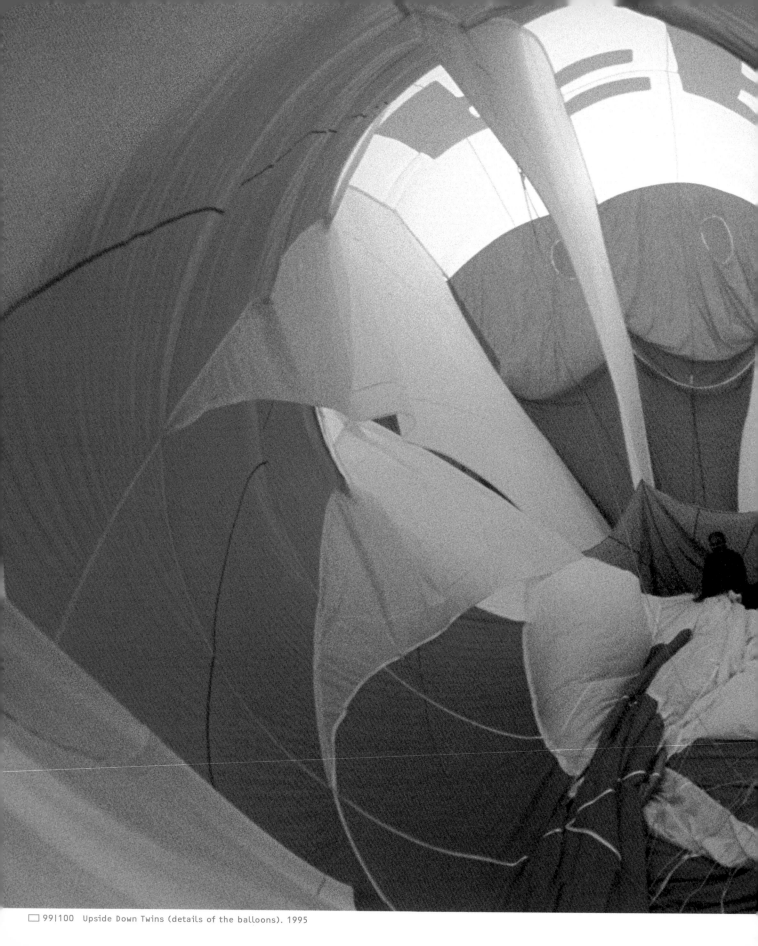

991100 Upside Down Twins (details of the balloons). 1995

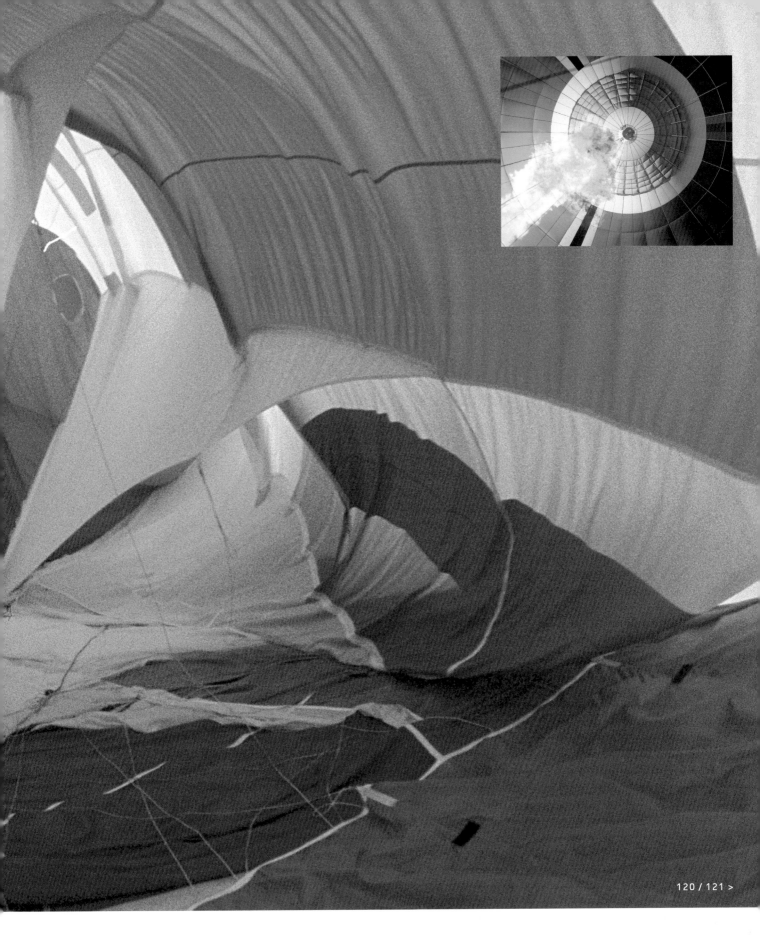

101 Philippe Durand, Cosette, Souvenir des Madeleines. 1994 ▷ 102 Javier Perez, Chemise d'air. 1994

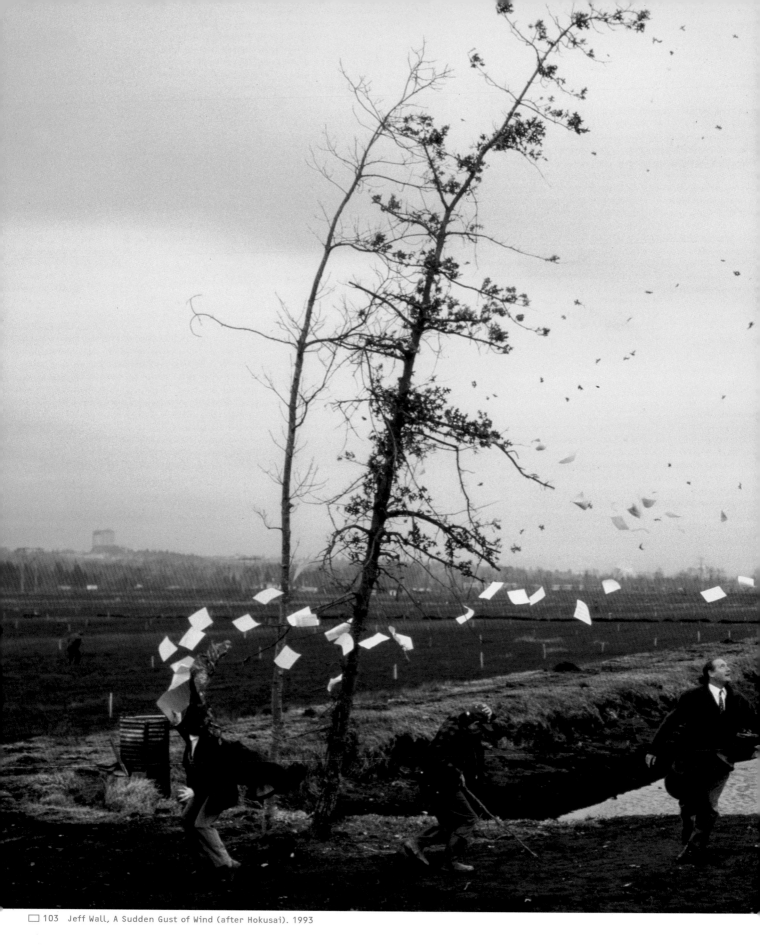

103 Jeff Wall, A Sudden Gust of Wind (after Hokusai). 1993

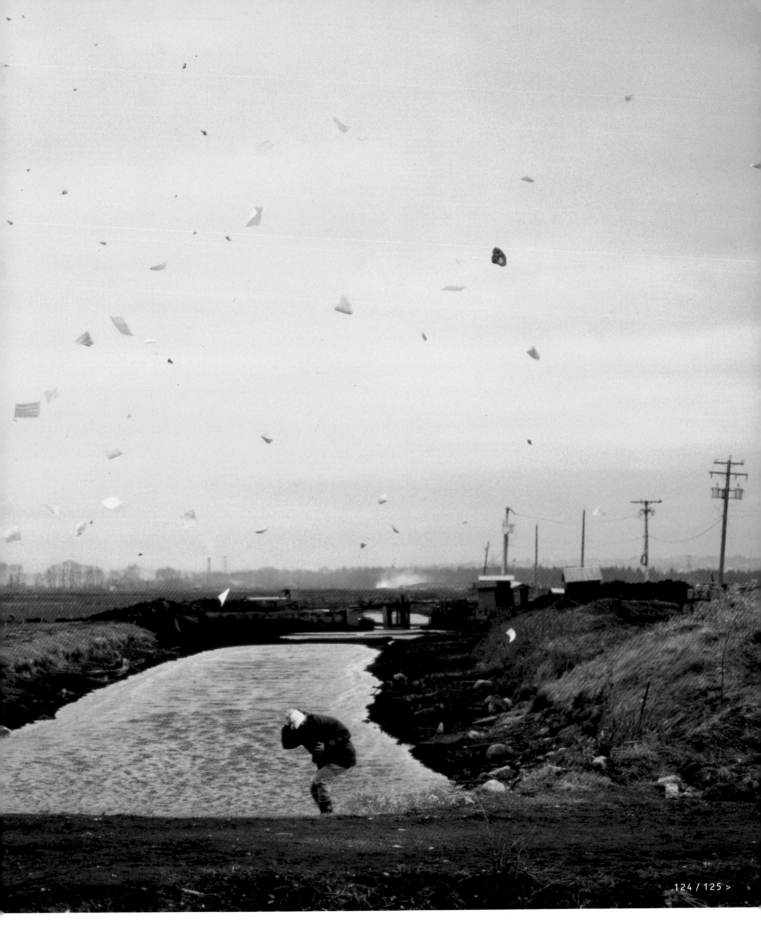

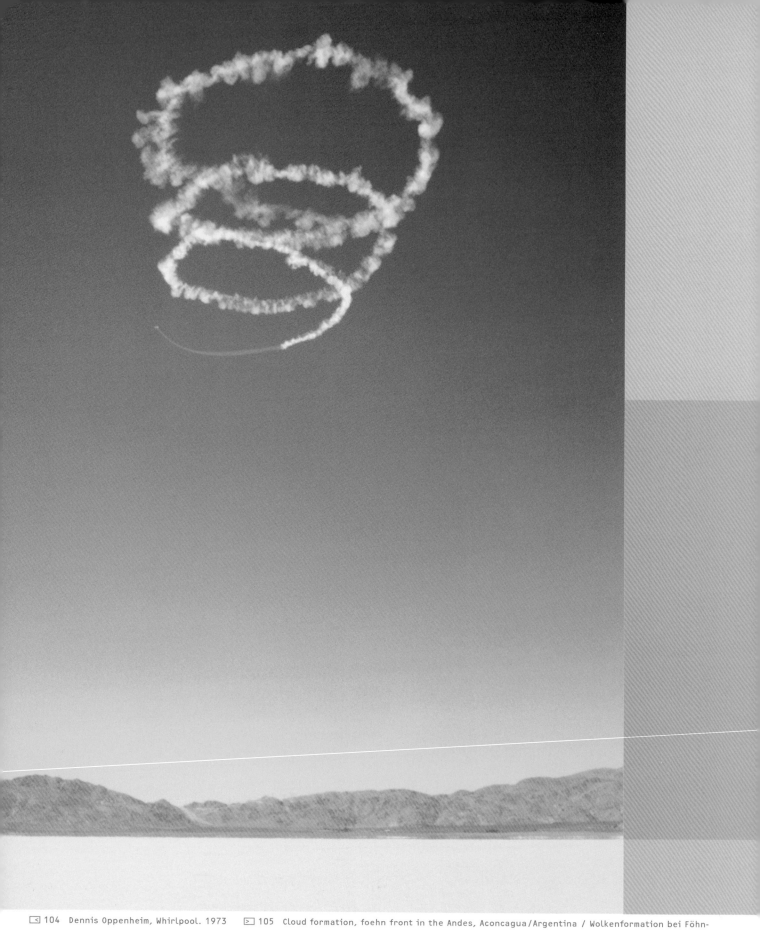

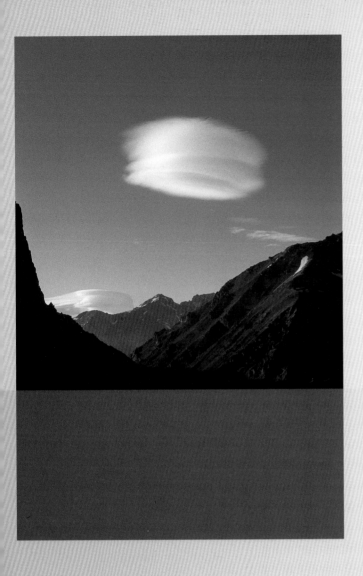

Wetterlage in den Anden, Aconcagua / Argentinien ▷▷ 106 Roy Lichtenstein, Spray. 1962

An inner and outer layer of soap protects the spherical water film of the soap
bubble. Without those, the 0.001-mm-thick film of water would either quickly
evaporate or collapse.
SURFACE TENSION

Eine innere und äußere Seifenschicht schützt den kugelförmigen Wasserfilm
der Seifenblase. Ohne diese würde der 0,001 mm dicke Wasserfilm rasch verdunsten
oder in sich zusammenfallen.
OBERFLÄCHENSPANNUNG

Soap molecules combine two polar properties. One end is hydrotropic,
the other hydrophobic.
SURFACE TENSION

Seifenmoleküle vereinen zwei polare Eigenschaften. Ein Ende ist hydrophil,
das andere hydrophob.
OBERFLÄCHENSPANNUNG

The soap particles align themselves with the hydrotropic ends pointing towards
the water and the hydrophobic (that is, lipotropic) ones away from it.
SURFACE TENSION

Die Seifenteilchen richten sich mit ihren hydrophilen Enden zum Wasser hin
und mit den hydrophoben (also lipophilen) vom Wasserfilm weg.
OBERFLÄCHENSPANNUNG

This creates a protective soap layer on both sides of the thin film of water.
SURFACE TENSION

Dadurch erhält die dünne Wasserschicht ihre schützende Seifenschicht auf
der Außen- und Innenseite.
OBERFLÄCHENSPANNUNG

108 Jiří Dokoupil, I love you. 2001

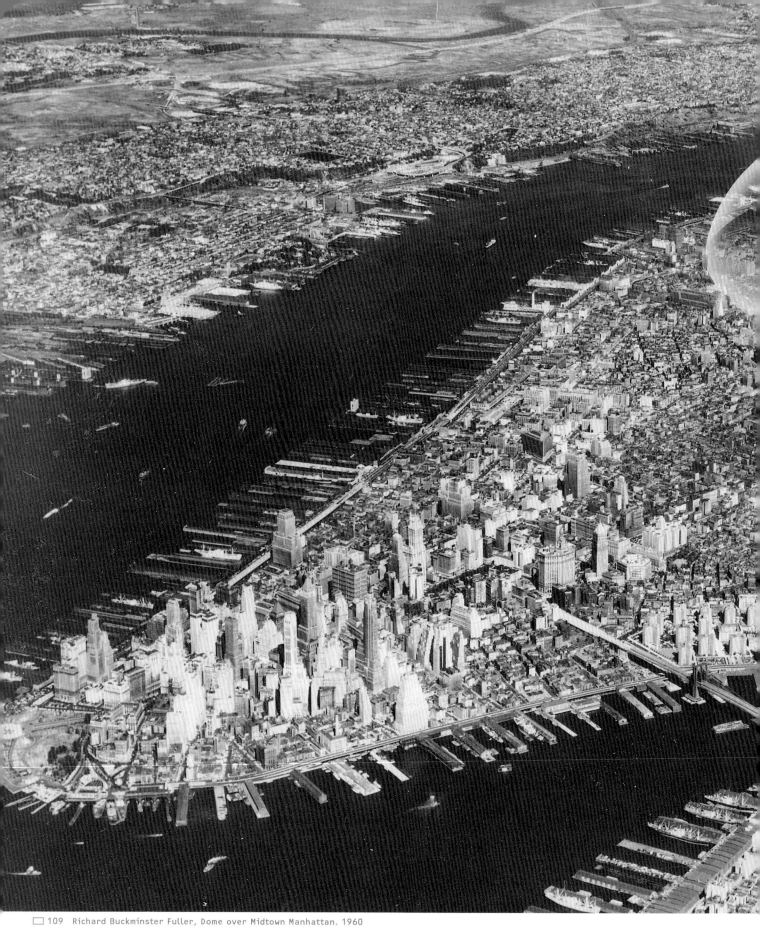

109 Richard Buckminster Fuller, Dome over Midtown Manhattan. 1960

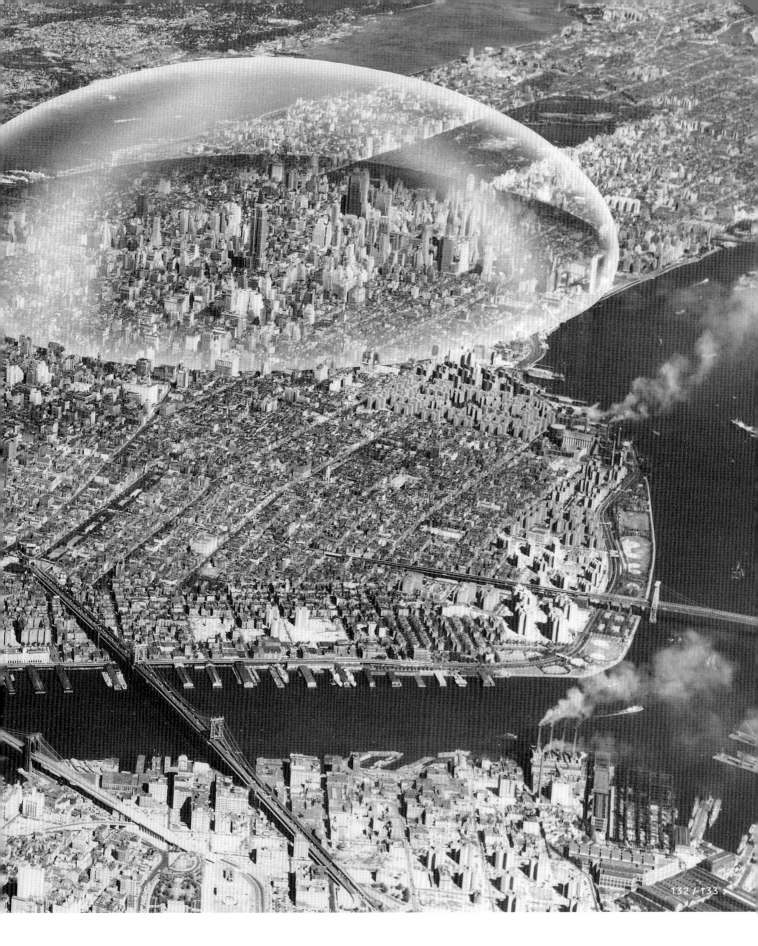

Dreamers, Mystics, Nutcases: Airspaces and Architectural Castles in the Air

As radiant as rock crystal at dawn is how Bruno Taut envisaged *Alpine Architectures* in 1919, remote from the perils of everyday life, temple precincts glittering in the stratosphere, which are an imaginary extension of his glass pavilion at the 1914 Cologne Werkbund exhibition. ›Coloured glass destroys hatred,‹ pronounced Paul Scheerbart in his book, *Glasarchitektur [Glass Architecture]* then and Taut provided the perfect realisation. Mosaics covered the walls, cascades poured down into an enigmatic basement, it glinted and glittered all over. Buildings like that were no longer of this world. They were consecrated to a new society, whose skylines were to link nature and society in a new way. In this Taut was not all that far from the dreams of Wenzel Hablik (fig. 111|112), who envisaged castles where others only saw ›bare cliffs‹ or pinnacles which ›soared into the clouds‹, as he wrote in his diary. Three years later, in 1912, Hablik published a portfolio of *Schaffenden Kräfte [Creative Powers]*, telling in etchings and texts of the creation of the first bodies from the void and the creation of the planets. Hablik's astronomical eye was unbounded, nothing held his pencil under constraint when he sketched flying machines with wheels and pro-pellers or aerial colonies which, floating far away from the earth's exhalations, were to bring forth the new man on their way to Mars. Although Hablik was enmeshed in proto-Fascist ideas, even Gropius raved about his flying settlements and propeller-driven architectural castles in the air: ›Send some more, that is ultimately what we want: utopia!‹ wrote Gropius on Wenzel's entries at an exhibition of the work of unknown architects in 1919. Hablik made entire small towns vanish into thin air, with all their workshops and dwellings, which he summarised in conical segments while propellers whirred above them and the bottom of the colony dwindled into ever finer mesh like a fish weir in a stream.

The Soviet Union also celebrated the new man. Incredibly modern, indeed utopian, was the *City of the Future* designed by Georgy Tikhonovich Kroutikov in 1928 as a hovering ring (fig. 113), borne up by air-screws and aerial floats, which were supposed to be filled with gas, a construction that would resurface forty years later in Kubrick's *2001: A Space Odyssey*. What glided through outer space to the strains of waltzes, began here, in a spectacular vision that was a vortex of technology and dreams. With Kroutikov's work for his final examinations at the renowned Moscow School of architecture and Design, the avant-garde utopian revolution in Soviet architecture peaked. Only a few years later these airy intellectual visions would be replaced by ostentatious stone buildings in the Stalinist gingerbread style. >>>

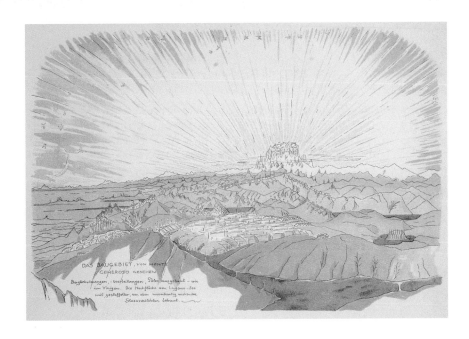

Träumer, Mystiker, Phantasten: Lufträume und architektonische Luftschlösser

Strahlend wie Bergkristalle bei Sonnenaufgang imaginiert Bruno Taut 1919 *Alpine Architekturen*, entrückt von den Fährnissen des Alltags, gleißende Tempelanlagen in Höhenluft, die seinen Glaspavillon der Kölner Werkbundausstellung von 1914 weiterdenken. »Farbiges Glas zerstört den Hass«, propagierte Paul Scheerbart damals in seinem Buch *Glasarchitektur*, und Taut lieferte die perfekte Umsetzung. Mosaike bedeckten die Wände, Kaskaden schossen in ein geheimnisvolles Untergeschoss, überall blinkte und glitzerte es. Solche Bauten waren nicht mehr von dieser Welt, waren Weihestätte einer neuen Gesellschaft, deren Stadtkronen Natur und Gesellschaft neu verbinden sollten. Damit war Taut nicht weit entfernt von den Träumen Wenzel Habliks (Abb. 111|112), der Schlösser sah, wo andere »nur nackten Fels« erkannten, oder Zinnen, die »in die Wolken ragten«, schrieb er in seinem Tagebuch. Drei Jahre später, 1912, gab Hablik eine Mappe der *Schaffenden Kräfte* heraus, erzählte in Radierungen und Texten von der Entstehung der ersten Körper aus dem Nichts und der Erschaffung der Planeten. Habliks astronomischer Blick kennt keine Grenzen, nichts hält seinen Bleistift, als er Flugmaschinen skizziert, mit Rädern und Propellern, oder Luftkolonien, die weit entfernt von den Ausdünstungen der Erde schweben und auf dem Weg zum Mars den neuen Menschen hervorbringen sollen. Während sich Hablik in protofaschistischen Gedanken verlor, zeigte sich selbst Gropius begeistert von seinen fliegenden Siedlungen und propellergetriebenen architektonischen Luftschlössern: »Senden Sie mehr, das ist letzten Endes das, was wir wollen: die Utopie!«, schrieb Gropius zu Wenzels Beiträgen zur Ausstellung für unbekannte Architekten im Jahre 1919. Ganze Kleinstädte ließ Hablik in den Lüften entschwinden, samt Werkstätten und Wohnräumen, die er in konischen Abschnitten zusammenfasste, während darüber Propeller wirbelten und der Boden der Kolonie wie in einer Fischreuse in immer feineren Strukturen auslief. >>>

At once more realistic and more poetic was the collaboration of Bodo and Heinz Rasch. Their 1928 Stuttgart *Hängehausstadt [City of Suspended Houses]* was intended to ground the floating city of the Moderns. They had suspended round, several-storeyed houses from masts like parts of a sailing vessel or a bridge on which people live – a principle, which also distinguished Richard Buckminster Fuller's *Dymaxion* House (1927).

Lightness was then the order of the day and in the late 1930s Bodo Rasch suggested constructing pneumatic walls for a sausage and chicken grill stand as a real flying building: a vast hog, filled with a lot of air and a wisp of material. The exhaust was supposed to escape from its nostrils and the customers were supposed to enter it through its haunches. Speaking architecture, which seeks to represent content by appearance.

Air architecture is sculptural and universal. It emerged in both East and West. Frank Lloyd Wright experimented in 1956 with a *Rubber Village Fiberthin Airhouse*, a green-field settlement that looked as if the Inuit had set up camp. By then Richard Buckminster Fuller had long since made a name for himself as the world master of light-weight space-frame architecture. His conjectural *Dome over Midtown Manhattan* (fig. 109) became the icon of a new idea of architecture – infinitely large and infinitely stable. Fuller not only produced dreams; he made actual structures. On the occasion of the fiftieth anniversary of the founding of Ford Motors in 1953, he crowned an factory lightwell that already existed in Dearborn, Michigan, with a new type of space-frame construction: a geodesic dome of light-weight rods forming octahedrons and tetrahedrons, which seemed to hang in the air like a bubble.

›Never before,‹ raved the architecture critic Nikolaus Pevsner, ›have there been forms like these.‹ In 1967 Fuller enlarged his network of light-weight rods to 76 metres, and, with the US pavilion at the 1967 Montreal Exhibition, he sent mankind into space, at least mentally. Ultra-light and floating. □

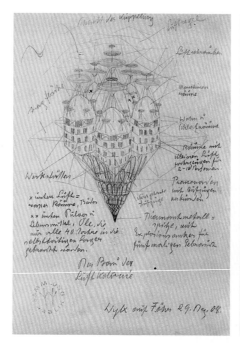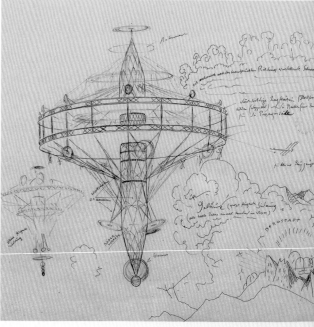

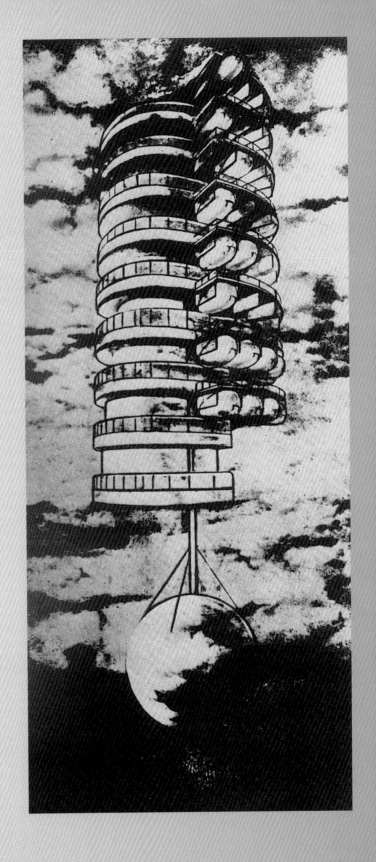

Wenzel Hablik, Luftgebäude. 1907/14 ▷ 113 Georgy Kroutikov, Hovering City. 1928 / Georgij Krutikov, Schwebende Stadt. 1928

Light reflected on both sides of the thin water film of a soap bubble creates interference colors.
INTERFERENCE COLORS

Durch Lichtreflexion an den beiden Seiten des dünnen Wasserfilms einer Seifenblase entstehen die Interferenzfarben.
INTERFERENZFARBEN

Light is normally white. White light consists of waves of varying length and, therefore, colours.
INTERFERENCE COLORS

Normalerweise ist Licht weiß. Weißes Licht besteht aus verschiedensten Wellenlängen und somit Farben.
INTERFERENZFARBEN

When certain wave lengths are reflected, their high and low points coincide and cancel each other out.
INTERFERENCE COLORS

Werden bestimmte Wellenlängen reflektiert, fallen deren Hochpunkte mit den Tiefpunkten zusammen und löschen sich somit aus.
INTERFERENZFARBEN

The distance between the reflecting planes, here the thickness of the water film, determines the lengths of the deleted waves.
INTERFERENCE COLORS

Der Reflexionsebenen-Abstand, also die Dicke des Wasserfilms, bestimmt die ausgelöschten Wellenlängen.
INTERFERENZFARBEN

Colour is determined by the lengths of the remaining wave lengths produced by interference patterns.
INTERFERENCE COLORS

Die Farbigkeit wird durch die übriggebliebenen Wellenlängen bestimmt, hervorgerufen durch Interferenzmuster.
INTERFERENZFARBEN

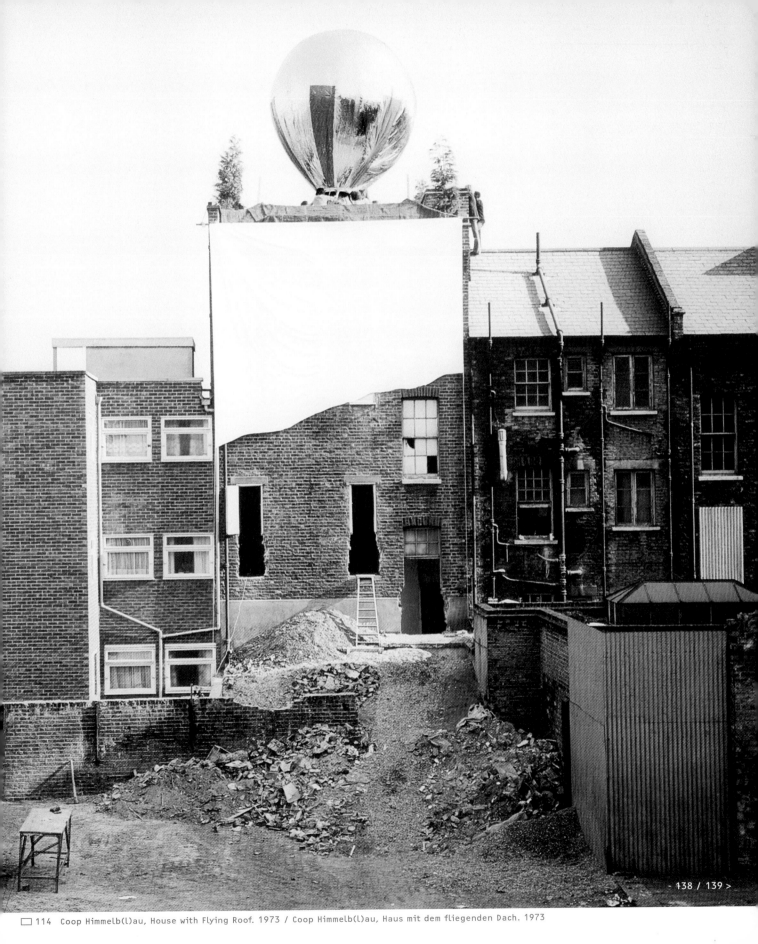

☐ 114 Coop Himmelb(l)au, House with Flying Roof. 1973 / Coop Himmelb(l)au, Haus mit dem fliegenden Dach. 1973

The atmospheric optics explains phenomena like the rainbow, blue sky, mirages, extra suns, halos, coronas, glories, red skies, the green flash.
ATMOSPHERIC OPTICS __ A field of physical optics

Die atmosphärische Optik erklärt Erscheinungen wie Regenbogen, Himmelsblau, Luftspiegelungen, Nebensonnen, Halos, Kränze, Glorien, Abendrot, Grüner Strahl.
ATMOSPHÄRISCHE OPTIK __ Teilgebiet der physikalischen Optik

The rainbow is a phenomenon that occurs when a light source behind an observer shines on a watery cloud in front of him.
ATMOSPHERIC OPTICS __ In his theory of the rainbow (1637), René Descartes explains the formation as the refraction and reflection of sun rays in rain drops

Der Regenbogen ist eine Erscheinung, die entsteht, wenn die Lichtquelle hinter dem Beobachter auf eine Wasserwolke vor ihm scheint.
ATMOSPHÄRISCHE OPTIK __ 1637 erklärt René Descartes in seiner Regenbogentheorie die Entstehung durch Brechung und Reflexion der Sonnenstrahlen in einzelnen Regentropfen

Auch die Sowjetunion feierte den neuen Menschen. Ungleich modern, ja utopisch, entwirft Georgij Tichonovic Krutikov 1928 die *Stadt der Zukunft* (Abb. 113) als schwebenden Ring, getragen von Luftschrauben und Auftriebs-körpern, die mit Gas gefüllt werden sollten, eine Konstruktion, die 40 Jahre später wieder auftauchen wird, als Raumstation in Stanley Kubricks *2001 – Odyssee im Weltall*. Was dort zu Walzerklängen durchs All glitt, hatte hier seinen Anfang, in einer spektakulären, Technologie und Träume verwirbelnden Vision. Krutikovs Abschlussarbeit von der renommierten Moskauer Architektur- und Designschule markierte den Höhe- und Wendepunkt des avant-gardistisch-utopischen Aufbruchs der Sowjetunion; wenige Jahre später waren die gedankenleichten Visionen durch repräsentative Steinbauten in Stalins Zuckerbäckerstil ersetzt.

Realistischer und poetischer zugleich arbeiteten Bodo und Heinz Rasch. Ihre Stuttgarter *Hängehausstadt* von 1928 wollte die schwebende Stadt der Moderne erden. Dazu hatten sie runde Etagenhäuser an Masten wie Teile eines Segelschiffs oder einer bewohnten Brücke aufgehängt – ein Prinzip, das auch Richard Buckminster Fullers *Dymaxion* House (1927) auszeichnete. Das Leichte hatte es der Zeit angetan, und Bodo Rasch schlug Ende der 1930er Jahre vor, pneumatische Wände für eine Wurst- und Hähnchenbraterei zu errichten, als wahrhaft fliegender Bau: ein gigantisches Schwein, mit viel Luft gefüllt und einem Hauch von Material, aus dessen Nüstern der Qualm hätte entweichen und durch dessen Hinterteil die Besucher eintreten sollen. Sprechende Architektur, die den Inhalt schon in der äußeren Form darzustellen sucht.

Luftarchitektur ist plastisch und universell. Sie entstand im Osten wie im Westen. Frank Lloyd Wright experimen-tierte 1956 mit dem *Rubber Village Fiberthin Airhouse*, einer Siedlung im Grünen, die aussah, als ob Inuit ihr Lager aufgeschlagen hätten. Zu dieser Zeit hatte Richard Buckminster Fuller längst als Leichtbauweltmeister von sich Reden gemacht. Sein spekulativer *Dome over Midtown Manhattan* (Abb. 109) wurde zur Ikone einer neuen Architekturauffassung – unendlich groß und unendlich stabil. Fuller produzierte nicht nur Träume, er schuf konkrete Bauten. Zum fünfzigjährigen Firmenjubiläum von Ford 1953 krönte er einen bestehenden Fabriklichthof in Dearborn, Michigan, mit einer neuartigen Konstruktion: einer geodätischen Kuppel aus zusammengesetzten Oktaedern und Tetraedern, die wie eine Blase in der Luft zu stehen schien. »Niemals zuvor«, schwärmte der Architekturkritiker Nikolaus Pevsner, »hat es ähnliche Formen gegeben«. 1967 weitete Fuller sein Stabnetzwerk auf 76 Meter und schickte mit dem Ausstellungspavillon der USA auf der *EXPO* in Montreal die Menschheit schon mal gedanklich ins Weltall. Ultraleicht und schwebend. □

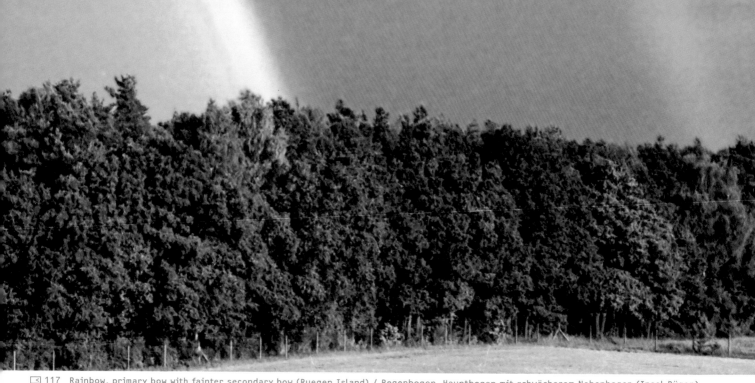

The rainbow consists of a luminous, usually coloured primary bow approx 42°
in radius and 1.5° in width.
ATMOSPHERIC OPTICS

Der Regenbogen besteht aus einem leuchtenden, meist bunten Hauptbogen
von etwa 42° Halbmesser und 1,5° Breite.
ATMOSPHÄRISCHE OPTIK

Often also of a second, fainter secondary bow approx 51° in radius and 3° in width.
ATMOSPHERIC OPTICS

Oft auch noch aus einem zweiten, lichtschwächeren Nebenbogen von etwa
51° Halbmesser und 3° Breite.
ATMOSPHÄRISCHE OPTIK

Sometimes additional secondary arcs occur inside the primary bow or outside
the secondary bow.
ATMOSPHERIC OPTICS

Zuweilen treten noch weitere Nebenbögen auf, die innerhalb des Hauptbogens
oder außerhalb des Sekundärbogens liegen können.
ATMOSPHÄRISCHE OPTIK

◁ 117 Rainbow, primary bow with fainter secondary bow (Ruegen Island) / Regenbogen, Hauptbogen mit schwächerem Nebenbogen (Insel Rügen)

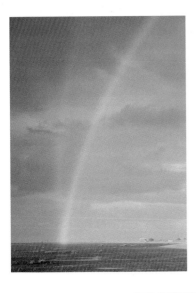

The common center of the primary and the secondary bow is on a straight line running from the center of the sun through the eye of the beholder.
ATMOSPHERIC OPTICS

Der gemeinsame Mittelpunkt von Haupt- und Nebenbogen liegt auf einer Geraden, die vom Sonnenmittelpunkt durch das Auge des Betrachters geht.
ATMOSPHÄRISCHE OPTIK

A full circle is sometimes visible from an elevated vantage point.
ATMOSPHERIC OPTICS

Von einem erhöhten Standpunkt ist gelegentlich ein voller Kreis sichtbar.
ATMOSPHÄRISCHE OPTIK

▷ 118 Split rainbow over the North Sea / Gespaltener Regenbogen über der Nordsee ▷▷ 119 Rainbow, Wendelstein (Bavaria) / Regenbogen, Wendelstein

The primary bow has the following color sequence going from inside outwards:
violet, indigo, blue, green, yellow, orange, red.
ATMOSPHERIC OPTICS

Der Hauptbogen hat die Farbfolge von innen nach außen: Violett, Indigo, Blau,
Grün, Gelb, Orange, Rot.
ATMOSPHÄRISCHE OPTIK

These are the proverbial seven colors of the rainbow. The color sequence
is reversed in the secondary bow.
ATMOSPHERIC OPTICS

Dies sind die sprichwörtlichen sieben Regenbogenfarben. Beim Nebenbogen
ist die Farbreihenfolge umgekehrt.
ATMOSPHÄRISCHE OPTIK

In between are all the intermediate colors without discrete boundaries so that
it is impossible to count the number of colors exactly.
ATMOSPHERIC OPTICS

Dazwischen liegen ohne scharfe Grenzen alle Zwischenfarben, so dass keine
genaue Farbanzahl anzugeben ist.
ATMOSPHÄRISCHE OPTIK

The refraction that occurs on a light ray entering or exiting a water droplet breaks it down into a continuous color spectrum.
ATMOSPHERIC OPTICS

Die bei Ein- und Austritt des Lichtstrahls im Wassertropfen stattfindende Brechung zerlegt diesen in ein kontinuierliches Farbspektrum.
ATMOSPHÄRISCHE OPTIK

Reflection directs the rays in the eye of the beholder. A single reflection in the droplet makes the primary rainbow.
ATMOSPHERIC OPTICS

Reflexion lenkt die Strahlen in das Auge des Betrachters. Einmalige Reflexion im Tropfen bildet den Hauptregenbogen.
ATMOSPHÄRISCHE OPTIK

Double reflection in the droplet formes the secondary rainbow.
ATMOSPHERIC OPTICS

Zweimalige Reflexion im Tropfen bildet den Nebenregenbogen.
ATMOSPHÄRISCHE OPTIK

Differences in width and color are caused inter alia by droplet size.
ATMOSPHERIC OPTICS

Unterschiede in Breite und Färbung werden unter anderem durch die Tropfengröße verursacht.
ATMOSPHÄRISCHE OPTIK

Diffraction is, however, the only adequate explanation for the exact color sequence, which varies with droplet size.
ATMOSPHERIC OPTICS __ In his 1838 rainbow theory, George Biddell Airy explains the phenomenon of the rainbow as the diffraction of the sun's rays in individual raindrops

Die genaue Farbenfolge, die mit der Tropfengröße veränderlich ist, kann aber nur mit der Beugung hinreichend erklärt werden.
ATMOSPHÄRISCHE OPTIK __ 1838 begründet George Biddell Airy in seiner Regenbogentheorie das Erscheinen eines Regenbogens durch die Beugung der Sonnenstrahlen in einzelnen Regentropfen

Grün, Gelb, Orange, Rot ⊡ 121 Double rainbow, Pirna/Germany / Doppelter Regenbogen, Pirna/Deutschland

Nearly white rainbows with a droplet size of <0.05 mm are called fog bows.
ATMOSPHERIC OPTICS

Fast weiße Regenbogen, bei einer Tropfengröße von <0,05 mm, heißen
Nebelregenbogen.
ATMOSPHÄRISCHE OPTIK

Rainbows caused by the moon are very rare,
faint and almost always white.
ATMOSPHERIC OPTICS

Vom Mond verursachte Regenbogen sind sehr selten,
lichtschwach und fast immer weiß.
ATMOSPHÄRISCHE OPTIK

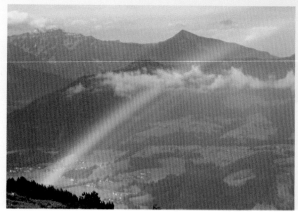

◁◁ 122 White fog bow, Schlaegl/Austria / Weißer Nebelbogen, Schlägl/Österreich ◁ 123 Rainbow, seen from the Unterberghorn (The Tyrol) /

Rainbowlike phenomena can frequently be seen at fountains and waterfalls.
ATMOSPHERIC OPTICS

Regenbogenähnliche Erscheinungen sieht man häufig an Springbrunnen und Wasserfällen.
ATMOSPHÄRISCHE OPTIK

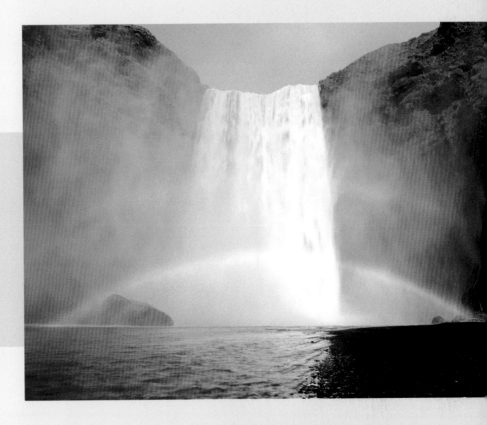

Regenbogen vom Unterberghorn aus (Tirol) ▷ 124 Rainbow at the Skogafoss waterfall, Iceland / Regenbogen vor dem Skogafoss Wasserfall, Island

Halos are in part splendidly colorful phenomena of atmospheric light caused by refraction or reflection, more rarely by diffraction.
ATMOSPHERIC OPTICS_ Halo – Latin <halos> »court around sun or moon«, same meaning of Greek <hálos>

Halos sind zum Teil farbenprächtige atmosphärische Lichterscheinungen, die durch Brechung oder Spiegelung entstehen, seltener durch Beugung.
ATMOSPHÄRISCHE OPTIK_ Halo – Lat. <halos> »Hof um Sonne oder Mond«, gleichbedeutend wie griech. <hálos>

They occur mainly as rings, strips or specks of light and can be observed when cloud cover is high and thin.
ATMOSPHERIC OPTICS_ Halos are caused by snow or ice crystals in cirrus or cirrostratus clouds

Sie treten am häufigsten als Ringe, Lichtstreifen oder -flecken auf und sind bei hoher, dünner Bewölkung zu beobachten.
ATMOSPHÄRISCHE OPTIK_ Halos werden verursacht durch Schnee- oder Eiskristalle in Zirrus oder Zirrostratus Wolken

Halos caused by reflection are always white or colorless and comprise anthelion, parhelion, sun pillar, light cross and circumhorizontal arc.
ATMOSPHERIC OPTICS

Spiegelungs-Halos sind stets weiß oder farblos, dazu gehören Gegensonne, Untersonne, Lichtsäule, Lichtkreuz und Horizontalkreis.
ATMOSPHÄRISCHE OPTIK

Refraction halos are always in the colors of the spectrum due to light dispersion, comprising ring halos, tangent arcs, parhelia or sundogs.
ATMOSPHERIC OPTICS

Brechungs-Halos sind wegen der Lichtzerlegung spektralfarben, dazu gehören Ring-Halos, Berührungsbögen, Nebensonnen.
ATMOSPHÄRISCHE OPTIK

The anthelion is a speck of light at the same height as the sun,
but in the opposite direction to it.
ATMOSPHERIC OPTICS

Die Gegensonne ist ein Lichtfleck in gleicher Höhe wie die Sonne,
aber in entgegengesetzter Richtung.
ATMOSPHÄRISCHE OPTIK

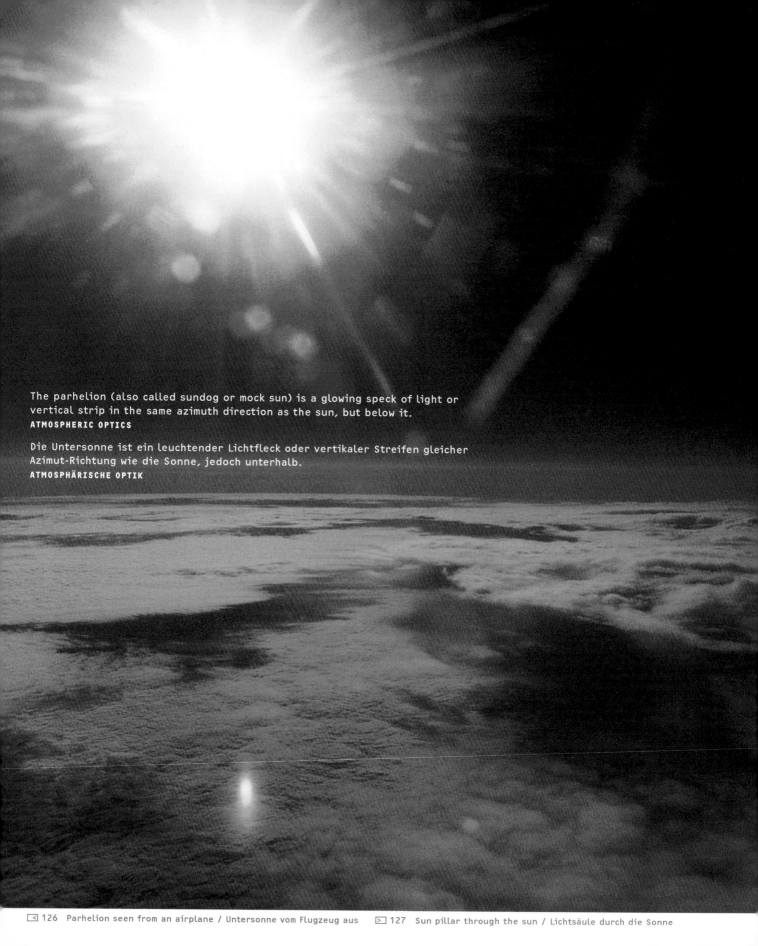

The parhelion (also called sundog or mock sun) is a glowing speck of light or vertical strip in the same azimuth direction as the sun, but below it.
ATMOSPHERIC OPTICS

Die Untersonne ist ein leuchtender Lichtfleck oder vertikaler Streifen gleicher Azimut-Richtung wie die Sonne, jedoch unterhalb.
ATMOSPHÄRISCHE OPTIK

◁ 126 Parhelion seen from an airplane / Untersonne vom Flugzeug aus ▷ 127 Sun pillar through the sun / Lichtsäule durch die Sonne

A sun pillar is a strongly glowing white vertical strip of light through the sun.
ATMOSPHERIC OPTICS

Die Lichtsäule ist ein stark leuchtender weißer, vertikaler Streifen durch
die Sonne.
ATMOSPHÄRISCHE OPTIK

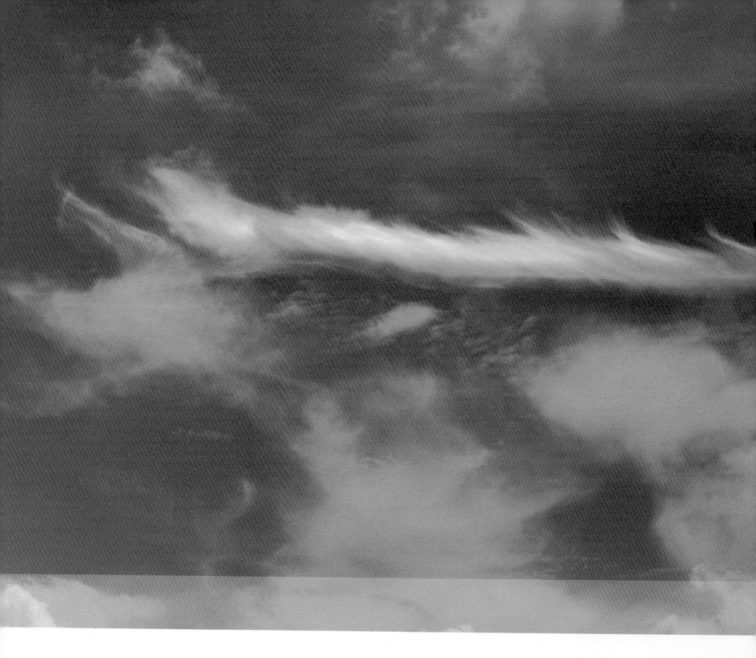

A light-cross occurs when a sun pillar and part of the horizontal arc intersect.
ATMOSPHERIC OPTICS

Das Lichtkreuz entsteht, wenn sich die Lichtsäule und ein Stück des Horizontalkreises schneiden.
ATMOSPHÄRISCHE OPTIK

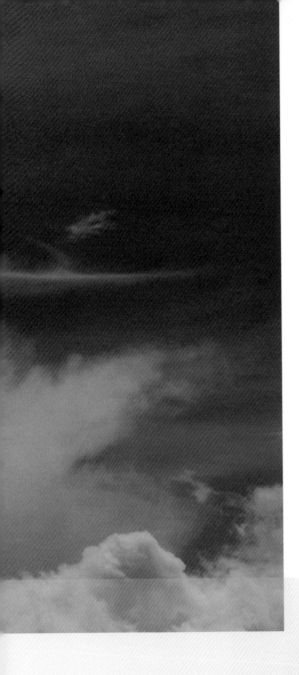

The horizontal circle runs horizontally through the sun and parhelia, if present,
as a whitish arc that is rarely completely formed.
ATMOSPHERIC OPTICS _ The horizontal arc decreases as the height of the sun increases

Der Horizontalkreis läuft als weißlicher Bogen, selten vollständig ausgebildet,
horizontal durch die Sonne und gegebenenfalls vorhandene Nebensonnen.
ATMOSPHÄRISCHE OPTIK _ Der Horizontalkreis wird mit zunehmender Sonnenhöhe kleiner

at the Moon (?), single-state print. 1572 / Lichtkreuz mit 22°-Halo am Mond (?), Einblatt-Druck. 1572 ▷ 130 Horizontal circle / Horizontalkreis

Ring halos occur as small and large circles, upper, lower and lateral tangent arcs, near both the zenith and the horizon.
ATMOSPHERIC OPTICS _ Little ring: 22°; large ring: 46°; rarely lateral or horizontal arcs

Das Ring-Halo gibt es als kleinen und großen Ring, obere, untere und seitliche Berührungsbögen, um den Zenit wie um den Horizont.
ATMOSPHÄRISCHE OPTIK _ Kleiner Ring: 22°; großer Ring: 46°; selten seitliche oder horizontale Bögen

◁ 131 Ring halo (22°) / Ring-Halo (22°) ◁◁ 132 Ring halo (22°), single-state print. 1556 / Ring-Halo (22°), Einblattdruck. 1556

These ring halos have a reddish inner rim or, compared with the much smaller corona, an inverted sequence of colors.

ATMOSPHERIC OPTICS __ 22° halo – this arc occurs most frequently, ca. 200 days p.a.

Die Ring-Halos weisen einen rötlichen Innenrand oder, gegenüber dem viel kleineren Kranz, eine umgekehrte Farbfolge auf.

ATMOSPHÄRISCHE OPTIK __ 22° Halo – dieser Ring tritt mit bis zu 200 Tagen p.a. am häufigsten auf

▷ 133 Ring halo (22°) / Ring-Halo (22°)

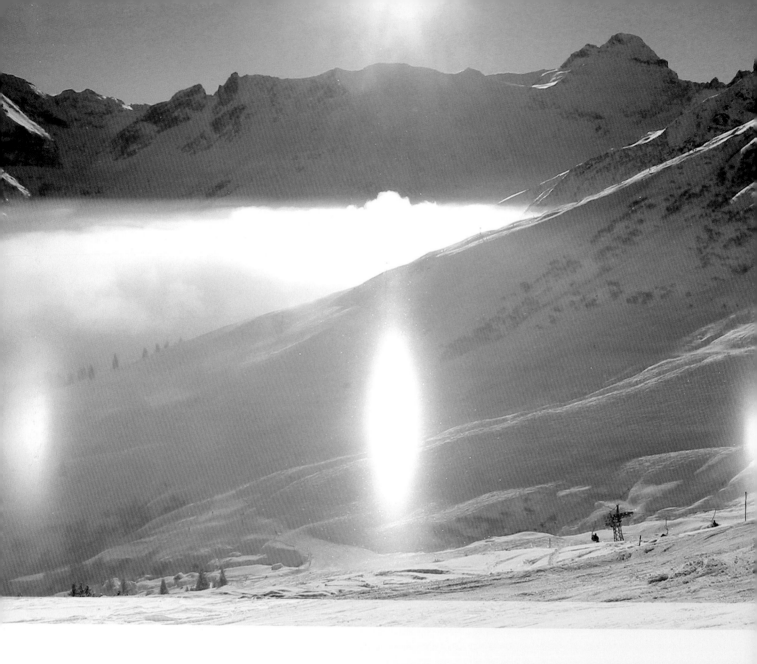

Sundogs or parhelia (mock suns) are specks of color with outwardly directed glowing tails that appear on either side of the sun.
ATMOSPHERIC OPTICS _ Sundogs: red faces the sun

Nebensonnen sind farbig erscheinende Flecken mit nach außen gerichtetem leuchtendem Schweif beiderseits der Sonne.
ATMOSPHÄRISCHE OPTIK _ Nebensonnen: Rot ist der Sonne zugewandt

Shadows that appear very large because clouds or fog are very close to the observer are called in German »Brockengespenst« (Specter of the Mount Brocken).
ATMOSPHERIC OPTICS __ Effect caused by miscalculating distances

Sehr groß erscheinende Schatten – da Wolken oder Nebel dem Beobachter sehr nahe sind – werden Brockengespenst genannt.
ATMOSPHÄRISCHE OPTIK __ Effekt durch nicht richtige Entfernungsabschätzung

The glory is a light phenomenon consisting of colored rings around the shadow of the observer or another object ...
ATMOSPHERIC OPTICS _ Color system of the glory from inside out: blue, green, yellow, red

Die Glorie ist eine aus farbigen Ringen bestehende Leuchterscheinung um den Schatten des Betrachters oder eines anderen Objektes ...
ATMOSPHÄRISCHE OPTIK _ Farbabfolge der Glorie von innen nach außen: Blau, Grün, Gelb, Rot

... onto a wall of fog or cloud surface on which the sun or moon shines, caused by bending on water droplets or ice crystals.
ATMOSPHERIC OPTICS _ Other objects can be e.g. an aeroplane or balloon

... auf einer von Sonne oder Mond beschienenen Nebelwand oder Wolkenoberfläche, verursacht durch Beugung an Wassertröpfchen oder Eiskristallen.
ATMOSPHÄRISCHE OPTIK _ Andere Objekte können z.B. ein Flugzeug oder Ballon sein

137 Quadruple corona around the Moon / Vierfacher Kranz um den Mond

ATMOSPHERIC OPTICS
Refracting, reflecting, diffraction of light, especially in water droplets and small ice crystals.

ATMOSPHÄRISCHE OPTIK
Brechung, Reflexion, Beugung von Licht besonders an Wassertröpfchen und Eiskristallen.

The corona differs from the halo in having a smaller diameter and a different
sequence of spectral colors.
ATMOSPHERIC OPTICS __ The corona is a light phenomenon caused by the diffraction of light
in water droplets or ice crystals

Der Kranz unterscheidet sich vom Halo durch einen geringeren Durchmesser
und eine andere Spektralfarbenfolge.
ATMOSPHÄRISCHE OPTIK __ Der Kranz ist eine Leuchterscheinung, die durch Beugung des Lichtes
an Wassertröpfchen oder Eiskristallen hervorgerufen wird

A sequential system of colored rings around the sun or moon. The innermost part
of the corona consists of a light, bluish white disc, called an aureole; the outer
rim radiates a faint reddish glow.
ATMOSPHERIC OPTICS __ Corona: from Latin for »crown«, Greek <koróne> for »ring«

System aufeinanderfolgender farbiger Ringe um Sonne und Mond. Der innerste
Teil des Kranzes ist eine helle, bläulich-weiße Scheibe, genannt Aureole, der Außen-
rand leuchtet schwach rötlich.
ATMOSPHÄRISCHE OPTIK __ Kranz: von lat. <corona> für »Krone«, griech. <koróne> für »Ring«

The refraction of light rays through changes of density in the vertical,
also in the horizontal of air strata with local variations in warmth.
ATMOSPHERIC REFRACTION __ By mainly vertical, or horizontal change of density

Brechung der Lichtstrahlen durch vertikale Dichteänderung, auch horizontal
an lokal unterschiedlich erwärmten Luftschichten.
ATMOSPHÄRISCHE LICHTBRECHUNG __ Durch vorwiegend vertikale oder
horizontale Richtung der Dichteänderung

The refraction of light rays between two terrestrial points causes mirages.
ATMOSPHERIC TERRESTRIAL REFRACTION

Lichtbrechung zwischen zwei irdischen Punkten bewirkt Luftspiegelungen.
ATMOSPHÄRISCHE IRDISCHE LICHTBRECHUNG

The astronomical refraction of light rays from stars in the earth's atmosphere
is zero at the zenith and increases towards the horizon,...
ATMOSPHERIC SPHERICAL REFRACTION __ Horizontal refraction 36'34.4"

Astronomische Brechung der Lichtstrahlen von Gestirnen in der Erdatmosphäre
fehlt im Zenit, wächst zum Horizont hin,...
ATMOSPHÄRISCHE SPHÄRISCHE LICHTBRECHUNG __ Horizontalrefraktion 36'34,4"

...therefore ›premature‹ or ›belated‹ rising or setting of celestial bodies.
ATMOSPHERIC SPHERICAL REFRACTION __ Horizontal refraction 36'34.4"

...deshalb ›verfrüht‹ oder ›verspätet‹ sich der Auf- oder Untergang eines
Himmelsobjekts.
ATMOSPHÄRISCHE SPHÄRISCHE LICHTBRECHUNG __ Horizontalrefraktion 36'34,4"

☐ 139–144 Sun deformed close to the horizon / Sonnenverformung in Horizontnähe

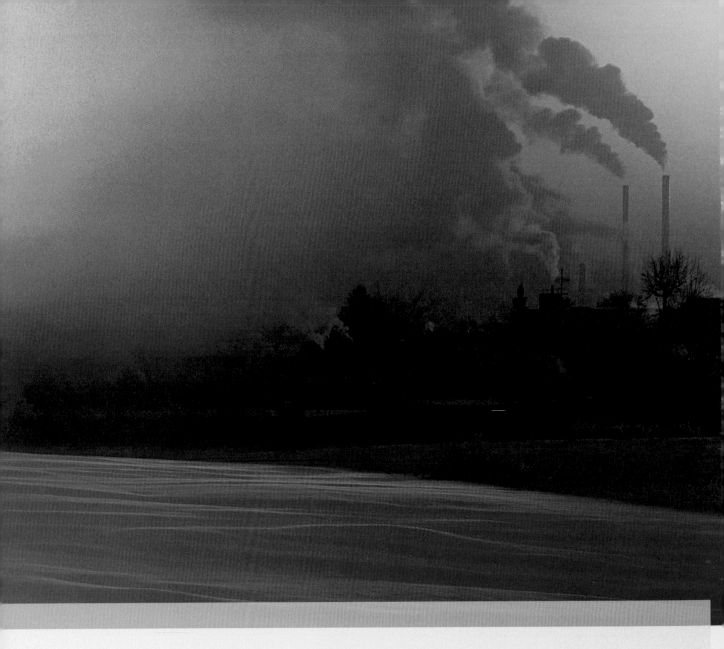

ATMOSPHERIC OPTICS
Interference with and scattering at air molecules (Rayleigh scattering) or aerosol particles (Mie scattering).

ATMOSPHÄRISCHE OPTIK
Interferenz und Streuung an Luftmolekülen (Rayleigh-Streuung), Aerosolteilchen (Mie-Streuung).

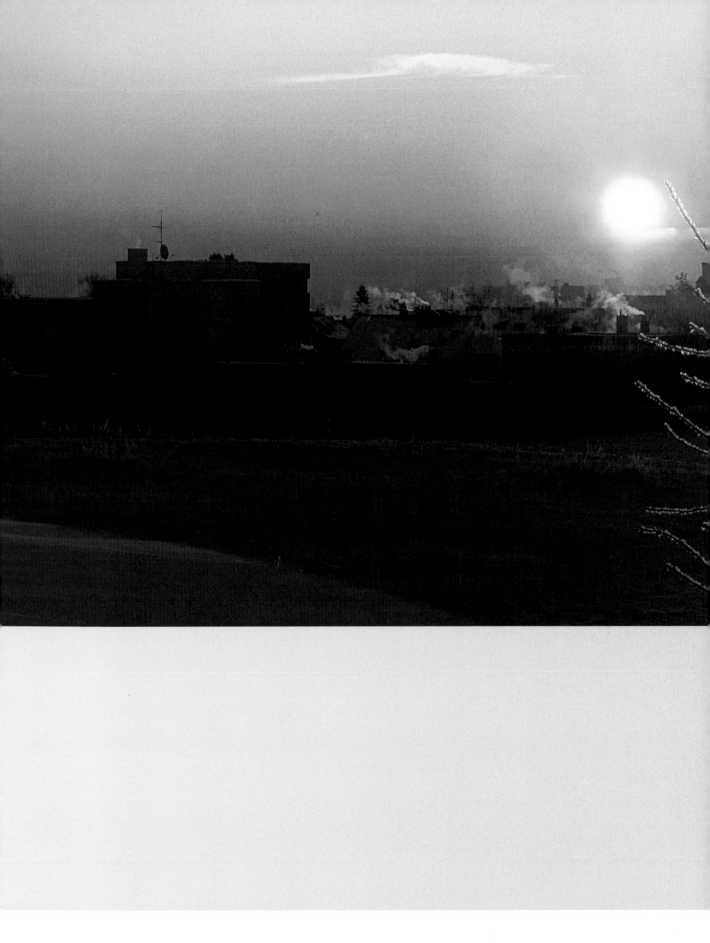

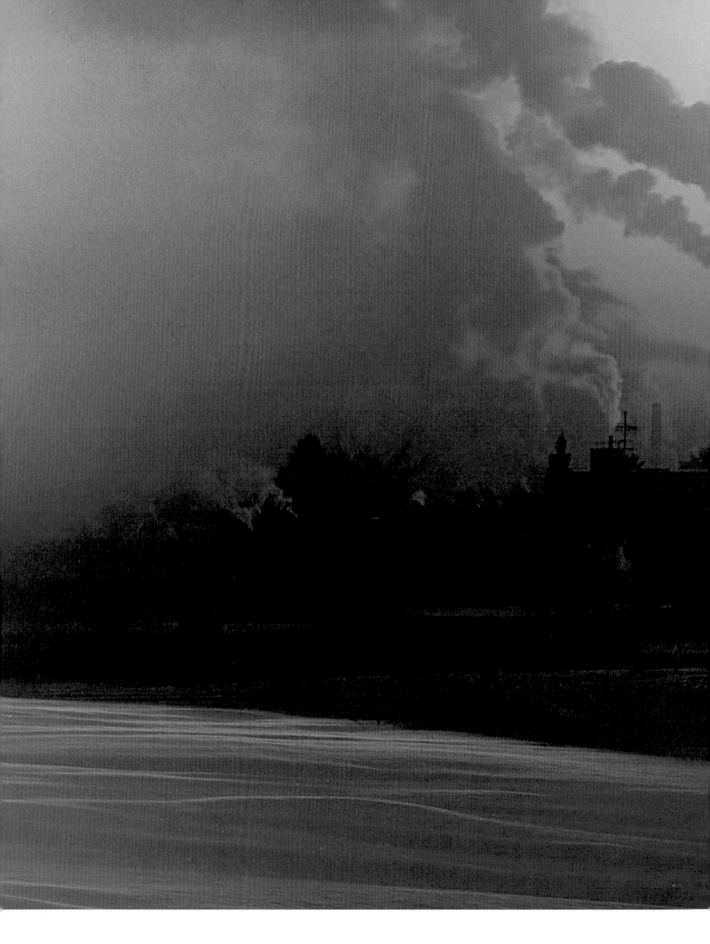

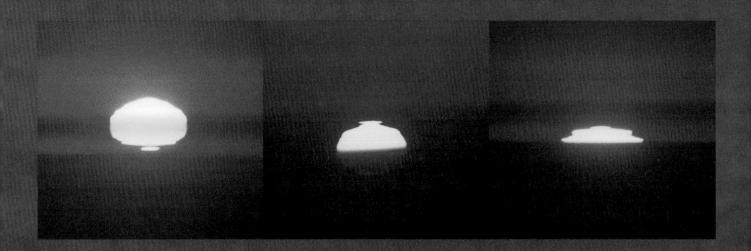

Since the apparent diameter of the sun roughly equals refraction at the horizon ...
ATMOSPHERIC SPHERICAL REFRACTION _ Horizontal refraction 36'34.4"

Da der scheinbare Sonnendurchmesser in etwa der Brechung im Horizont entspricht, ...
ATMOSPHÄRISCHE SPHÄRISCHE LICHTBRECHUNG _ Horizontalrefraktion 36'34,4"

...the sun has already set when it touches the horizon.
ATMOSPHERIC SPHERICAL REFRACTION _ Horizontal refraction 36'34.4"

...ist die Sonne in Wirklichkeit bei dessen Berührung bereits untergegangen.
ATMOSPHÄRISCHE SPHÄRISCHE LICHTBRECHUNG _ Horizontalrefraktion 36'34,4"

Atmospheric extinction is the diminution of sunlight or starlight as it travels through strata of air.
COLOR OF THE SKY

Atmosphärische Extinktion ist die Abschwächung des Sonnen- oder Sternenlichtes beim Durchgang durch die Luftschichten.
FARBE DES HIMMELS

Atmospheric extinction is based on absorption by carbon dioxide, ozone, water vapor et al as well as on both scattering at air molecules, haze particles and reflection on clouds or hovering particles.
COLOR

Atmosphärische Extinktion basiert auf Absorption durch Kohlendioxyd, Ozon, Wasserdampf und anderem sowie auf Streuung an Luftmolekülen und Dunstteilchen sowie Reflektion an Wolken und Schwebeteilchen.
FARBE

Atmospheric extinction depends on wavelength and increases from zenith to horizon.
COLOR

Atmosphärische Extinktion ist wellenlängenabhängig und nimmt vom Zenit zum Horizont hin zu.
FARBE

Since the blue tones in sunlight are most widely dispersed, the day sky looks
as if it were tinted blue.
COLOR

Da der Blauanteil des Sonnenlichtes am stärksten gestreut wird, erscheint der
Taghimmel blaugefärbt.
FARBE

Why does the sky look blue? Sunlight is scattered on the atmosphere's molecules
and particles: the intensity of scattered light is inversely proportional to the
fourth power of the wavelength.
COLOR __ Calculated for the first time under those conditions by J.W. Rayleigh in 1871 using
Maxwell's equations

Woher kommt das Himmelsblau? Das Sonnenlicht wird an den Molekülen der
Atmosphäre und deren Partikeln gestreut: Die Intensität gestreuten Lichts ist
umgekehrt proportional zur vierten Potenz der Wellenlänge.
FARBE __ 1871 erstmalig mit Hilfe der Maxwellschen Gleichungen von J.W. Rayleigh unter jenen
Bedingungen errechnet

Blue light is ca. five times more scattered than red one, hence the blue tint
the sky has during the day.
COLOR

Blaues Licht wird ca. fünfmal stärker gestreut als rotes, daher die Blaufärbung
des Taghimmels.
FARBE

However, when there is a lot of water vapor or haze in the atmosphere,
the sky appears whitish.
COLOR __ The whitish appearance can be explained by the Mie effect

Bei hohem Wasserdampf- oder Dunstanteil der Atmosphäre erscheint der Himmel
dagegen weißlich.
FARBE __ Die weißliche Erscheinung kann mit dem Mie-Effekt erklärt werden

When the sun is near the horizon, the path of its light rays through atmosphere
is very long.
COLOR __ The red of the western sky after sunset, correspondingly, the red before sunrise
in the eastern sky

Steht die Sonne in Horizontnähe, ist der Weg der Lichtstrahlen durch
die Atmosphäre sehr lang.
FARBE __ Abendrot im Westen nach Sonnenuntergang, entsprechend Morgenrot vor Sonnenaufgang
am östlichen Himmel

Therefore particularly short-wave light is scattered from the ›white‹ sunlight, ...
COLOR __ Blue and green as short-waved shares of sun light being scattered more according
to Rayleigh

Somit wird besonders kurzwelliges Licht aus den ›weißen‹ Sonnenstrahlen
herausgestreut, ...
FARBE __ Blau und Grün als kurzwellige Anteile des Sonnenlichtes werden gemäß Rayleigh stärker
gestreut

... so that the sun appears to be shining in long-wave red light. When forward
scattering is more pronounced, the observer perceives less blue und green
portions in sunlight.
COLOR __ Yellow and red can be mainly perceived in the direction of the setting or not quite risen
sun due to the Mie effect

... so dass die Sonne im langwelligen Rotlicht zu leuchten scheint. Durch stärkere
Vorwärtsstreuung nimmt der Betrachter weniger Blau- und Grünanteile im
Sonnenlicht wahr.
FARBE __ Gelb und Rot ist vorwiegend in Richtung der unter- oder noch nicht aufgegangenen Sonne
wahrzunehmen gemäß dem Mie-Effekt

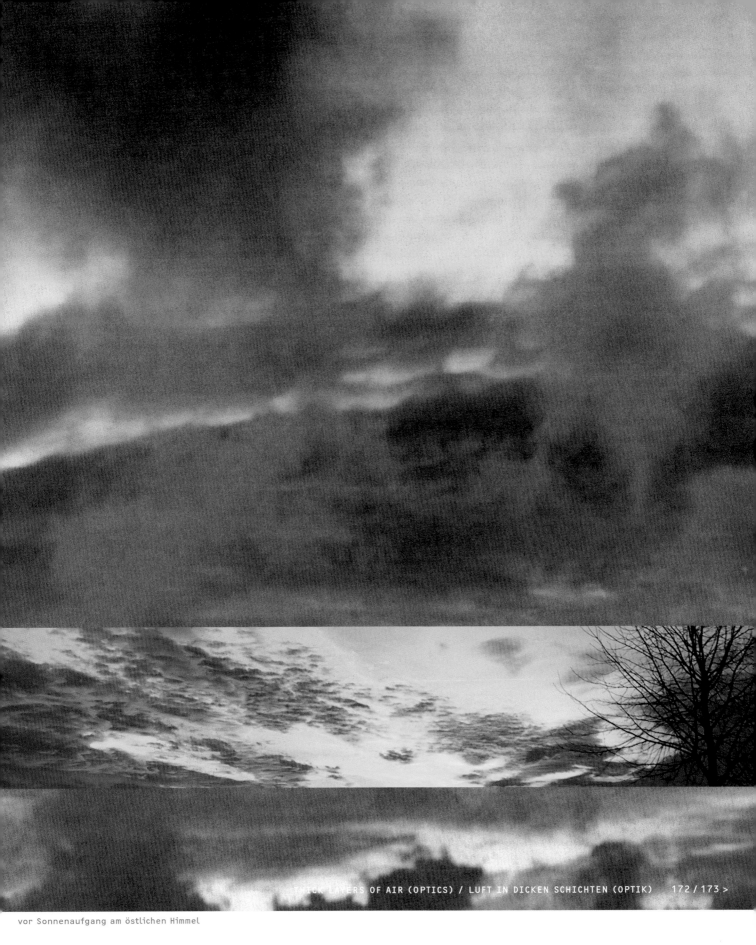

vor Sonnenaufgang am östlichen Himmel

The green (blue or red) flash is a refraction phenomenon of brief duration
on the upper rim of the setting sun.
ATMOSPHERIC OPTICS _ The green flash can also occur with the Moon, Venus, Jupiter or Saturn

Der grüne (blaue oder rote) Strahl ist ein kurzzeitiges Brechungsphänomen
am oberen Rand der untergehenden Sonne.
ATMOSPHÄRISCHE OPTIK _ Der grüne Strahl kann auch an Mond, Venus, Jupiter, oder Saturn
auftreten

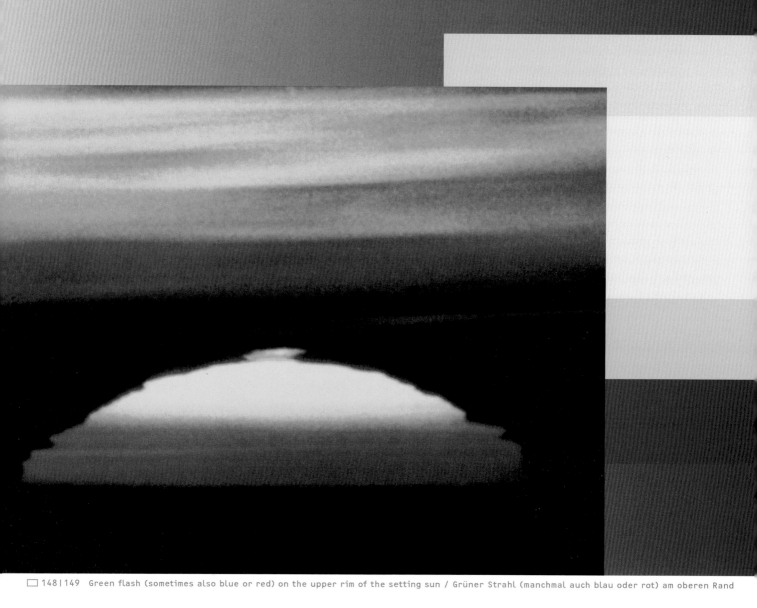

☐ 148|149 Green flash (sometimes also blue or red) on the upper rim of the setting sun / Grüner Strahl (manchmal auch blau oder rot) am oberen Rand

The color of the sky is determined by its context.
COLOR

Die Farbe des Himmels hängt vom Kontext ab.
FARBE

der untergehenden Sonne

Fluids of different densities mix chaotically, with schlieren caused by friction and shearing along the boundary layer.
BASIS _ Look right over the rim of your tea or coffee cup when its contents are still hot; – best in cold surroundings

Unterschiedlich dichte Fluide vermengen sich chaotisch in Schlieren durch Reibung und Scheren an der Grenzschicht.
BASIS _ Schauen Sie knapp über Ihre Tee- oder Kaffeetasse, wenn der Inhalt noch heiß ist; – am besten in kalter Umgebung

A mirage is an atmospheric phenomenon in which a distant object appears multiple and in part upside-down.
BASIS

Die Luftspiegelung ist eine atmosphärische Erscheinung, bei der ein entfernter Gegenstand mehrfach, teilweise auf dem Kopf stehend gesehen wird.
BASIS

It is caused by the total reflection of light rays at the boundary layer between air strata of differing temperature.
BASIS _ A mirage results from differences in optical density

Sie wird verursacht durch Totalreflektion von Lichtstrahlen an der Grenzfläche zwischen Luftschichten unterschiedlicher Temperatur.
BASIS _ Luftspiegelung resultiert aus der unterschiedlichen optischen Dichte

Mirage with downwards-directed reflection when air strata close to the ground are warmer than the ones above them.
BASIS _ Mirage with downwards-directed reflection mainly in desert regions with little vegetation or above asphalt in strong sun

Spiegelung nach unten, wenn die bodennahen Luftschichten wärmer sind als die darüberliegenden.
BASIS _ Luftspiegelung nach unten häufig in Wüstengebieten mit geringer Vegetation oder über Asphalt bei starker Sonneneinstrahlung

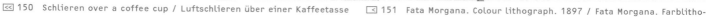

◁ 150 Schlieren over a coffee cup / Luftschlieren über einer Kaffeetasse ◁ 151 Fata Morgana. Colour lithograph. 1897 / Fata Morgana. Farblitho-

Superior mirage when air strata close to the ground are colder than the ones above them.
BASIS _ Superior mirage mainly in polar regions above snowy surfaces or above cold sea

Spiegelung nach oben, wenn die bodennahen Luftschichten kälter sind als die darüberliegenden.
BASIS _ Luftspiegelung nach oben häufig in Polargebieten über Schneeflächen oder über kalten Meeresgebieten

Fata morgana reflects the blue sky downwards, simulating water surfaces and deceptively shortening distances.
The name »fata morgana« derives from Italian for »fairy« and »morgana«, an Arab figure from a folk-tale; denotes mirages in the Strait of Messina

Eine Fata Morgana spiegelt den blauen Himmel nach unten, täuscht Wasserflächen und verkürzte Entfernungen vor.
Die Bezeichnung »Fata Morgana« setzt sich zusammen aus italienisch »fata« für »Fee« und »Morgana«, einer Gestalt aus dem arabischen Volksglauben; für Luftspiegelungen in der Straße von Messina

There are vortices in turbulent flow. They can be of microscopic size or encompass continents.
BASIS __ Look at whirlwinds or hurricanes from the perspective of space (cf. p. 98|99, 108|109)

In turbulenter Strömung finden sich Wirbel. Sie können mikroskopisch klein sein oder Kontinente umspannen.
BASIS __ Betrachten Sie Windhosen oder Wirbelstürme aus der Perspektive des Weltraums (vgl. S. 98|99, 108|109)

Laminar flow is uniform. When and how do fluids whirl into symmetrical or chaotic patterns?
BASIS __ Fluid dynamics

Laminare Strömung ist gleichmäßig. Wann und wie verwirbeln Fluide zu symmetrischen oder chaotischen Mustern?
BASIS __ Fluiddynamik

The Coriolis force causes whirlpools to turn clockwise in the Northern hemisphere and anti-clockwise in the Southern hemisphere.
BASIS __ The Coriolis force acts on all matter in movement such as fluid and gaseous currents, and on projectiles

Durch die Coriolis-Kraft drehen sich Wirbel auf der Nordhalbkugel rechts herum und auf der Südhalbkugel links herum.
BASIS __ Die Coriolis-Kraft wirkt auf alle Materie in Bewegung, wie flüssige als auch gasförmige Strömung, oder Geschosse

The Coriolis effect is an inert force which is weak compared to gravity.
BASIS __ Discovered by G.G. Coriolis, French engineer and physicist, 1835

Der Coriolis-Effekt ist eine Trägheitskraft, welche verglichen mit der Schwerkraft, gering ist.
BASIS __ Nachgewiesen 1835 von G.G. Coriolis, französischer Ingenieur und Physiker

The Coriolis force causes large air flows in the free atmosphere to deflect by almost 90° from the direction of the drop in pressure.
BASIS_ The Coriolis force deflects towards isobars

Coriolis-Kraft bewirkt, dass große Luftströmungen in freier Atmosphäre um fast 90° von der Richtung des Druckgefälles abweichen.
BASIS_ Coriolis-Kraft lenkt in Richtung der Isobaren ab

The Coriolis force causes large air flows close to the ground to deflect by almost 50° from the direction of the drop in pressure.
BASIS_ For example at latitude 50° at a speed of 1m/s by ca. 6° per km

Coriolis-Kraft bewirkt, dass große Luftströmungen in Bodennähe um fast 50° von der Richtung des Druckgefälles abweichen.
BASIS_ Zum Beispiel in 50° Breite bei einer Geschwindigkeit von 1m/s um etwa 6° pro km

Air flows are movements of air caused by pressure differences in the atmosphere.
BASIS _ Those are always directed from high to low pressure and deflected by the Coriolis force

Luftströmungen sind durch Druckunterschiede in der Atmosphäre hervorgerufene Bewegungen der Luft.
BASIS _ Diese sind immer vom hohen zum tiefen Druck hin gerichtet und durch die Coriolis-Kraft abgelenkt

Air flows are wandering waves originating at the boundary area of two layers of air of differing density.
BASIS _ Set in motion by gusts of wind

Luftwogen sind fortschreitende Wellen, die an der Grenzfläche zweier Luftschichten mit verschiedener Dichte entstehen.
BASIS _ Sie werden angeregt durch Windstöße

Air flows have great wavelengths (up to 1,000 m and more) and can often be ascertained from the shape of cloud formations.
BASIS _ Clouds originating in the crests of wave and dissolving in the troughs

Luftwogen haben große Wellenlängen (bis zu 1.000 m und mehr) und sind vielfach an der Wolkenbildung erkennbar.
BASIS _ Wolken, die in Wellenkämmen entstehen und sich in den Wellentälern auflösen

Air turbulence consists in air movements that form whirls and spirals of varying size.
BASIS _ Their dimension range from small turbulences to large high and low pressure systems

Luftwirbel sind Luftbewegungen (wirbel- und spiralförmig) verschiedener Größenordnungen.
BASIS _ Ihre Ausdehnung reicht von kleinen Turbulenzen zu großräumigen Hoch- und Tiefdrucksystemen

Air disturbance is irregular movement of air caused by turbulences so minuscule that they are virtually imperceptible.
EFFEKT _ Especially pronounced in unstable stratification and insolation

Luftunruhe ist nicht direkt wahrnehmbare unregelmäßige Luftbewegung, verursacht durch kleinste Turbulenzen.
EFFEKT _ Besonders bei labiler Schichtung und Sonneneinstrahlung ausgeprägt

Air disturbance causes small changes in density that cause fluctuating refraction.
EFFEKT _ Rapidly changing deflection of optical rays, creation of schlieren over hot surfaces

Luftunruhe verursacht leichte Dichteänderungen, die zu Schwankungen der Brechzahl führen.
EFFEKT _ Rasch veränderliche Ablenkungen optischer Strahlen, Schlierenbildung über heißen Flächen

Air disturbance is what makes the stars appear to twinkle when they are observed through the earth's atmosphere, especially near the horizon.
EFFEKT _ Caused in bubbles or schlieren with sizes of ca. 6–8 cm at altitudes of up to ca. 11 km

Luftunruhe verursacht das Sternenfunkeln bei Beobachtung durch die Erdatmosphäre, besonders in Horizontnähe.
EFFEKT _ Verursacht in Blasen oder Schlieren von ca. 6–8 cm Größe in bis zu ca. 11 km Höhe

☐ 153 Tornado (cyclone) off the south coast of Cyprus / Tornado (Wirbelsturm) vor der Südküste Zyperns

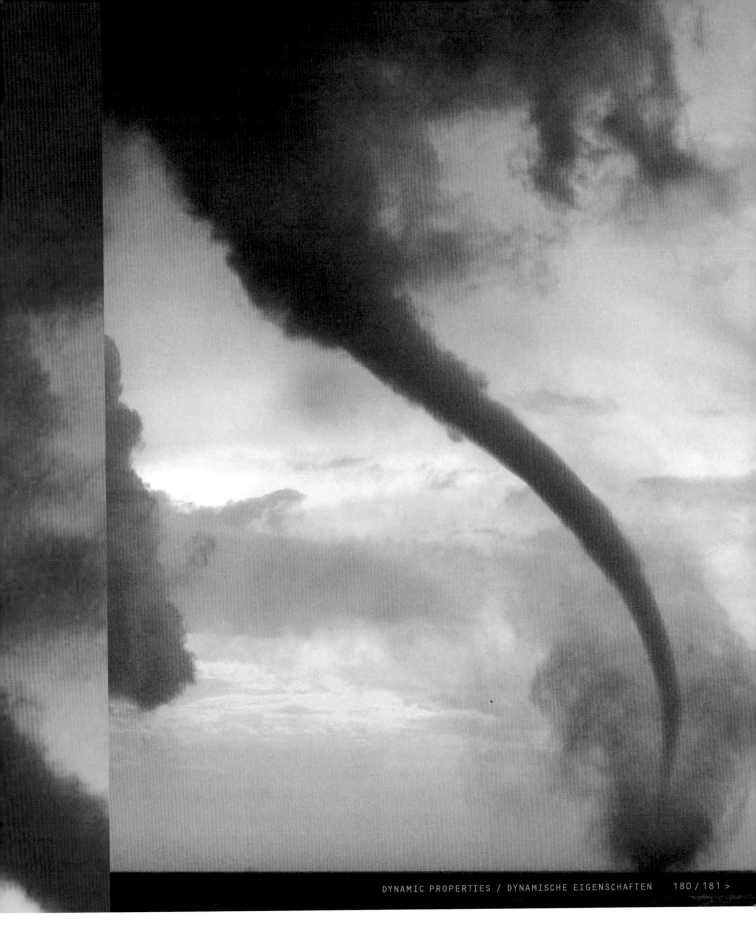

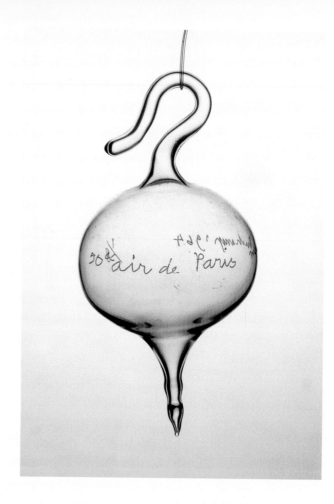

The World as Will and Idea

Grasping the intangible and forcing design from something amorphous was a tour de force that had to appeal to the champion chess player and proto-Conceptual artist Marcel Duchamp (1887–1968). He had made his first ready-made, a bicycle wheel mounted on a kitchen stool. The scandals caused by his having elevated a bottle rack and a urinal bowl signed ›R. Mutt‹ (the manufacturer) to the status of art works also lay behind him. Then that gifted *provocateur* sealed some air in glass. Not just any air but the quintessence of Paris, at least that is what the title, *Air de Paris* (1919), claims. It concerns air and, moreover, the special Paris ambience. Duchamp brought the piece to Walter Arensberg, who collected his work, like a souvenir or a scent flacon which had been brought by luxury liner from France across the Atlantic to America. A sealed phial, with ends deliquescing into tear-drop shapes. A piece of Paris, a whiff of the metropolis on the Seine and, above all, a space for associations which Duchamp was opening with it, which distilled an entire city to a piece of nothing. And yet Duchamp was concerned with everything rather than nothing, with the powers of realizing artistic statements. The object or actual content was of secondary importance. What mattered was the ability to open up spaces for thinking and possibilities. And what could be better suited to that than what we casually call air – a compound of all sorts of gases – which we need to live. >>>

Die Welt als Wille und Vorstellung

Das Ungreifbare zu fassen und etwas Formlosem Gestalt abzuringen, dieses Kunststück musste dem gewieften Schachspieler und Konzeptkünstler Marcel Duchamp (1887–1968) gefallen. Sein erstes Ready-made, das auf einem Hocker befestigte Fahr-Rad, lag sechs Jahre zurück, auch die Skandale um den zum Kunstwerk erhobenen Flaschentrockner und das Urinal, das er mit Richard Mutt signierte. Da gießt der begnadete Provokateur ein Stück Luft in Glas. Nicht irgendeine Luft, sondern Pariser Ausdünstungen, zumindest behauptet dies der Titel, *Air de Paris* (1919). Es geht um Air und mehr, es geht um Pariser Flair. Duchamp bringt das Stück zu seinem Sammler Walter Arensberg, wie ein Souvenir oder ein Parfumflakon, das aus Frankreich über den großen Teich nach Amerika verschifft wird. Eine geschlossene Phiole, deren Enden tropfenförmig zerfließen. Ein Stück Paris, ein Stück Atem der Seine-Metropole, vor allem ein Assoziationsraum, den Duchamp hiermit eröffnet, der eine ganze Stadt auf ein Stück Nichts verdichtet. Und doch geht es Duchamp nicht um nichts, sondern um alles, um die Kraft nämlich, künstlerische Setzungen Realität werden zu lassen. Der Gegenstand oder tatsächliche Inhalt ist völlig sekundär, wichtig ist die Fähigkeit, Denkräume und Möglichkeiten zu eröffnen. Und was könnte dafür besser geeignet sein, als das, was wir flüchtig als Luft bezeichnen – ein Gemisch verschiedenster Gase – die wir zum leben brauchen. Die Vorstellung unserer Welt als Ergebnis eines göttlichen Schöpfungsakts war zu allen Zeiten populär unter Künstlern, die sich als geniale Verlängerer dieses Gestaltwerdens sahen, das 20. Jahrhundert aber brachte sie an ihr logisches Ende. Kein Aufwand, kein Umweg mehr. Einfache Setzung. Wie König Midas, der alles zu Gold werden ließ, was er berührte, adelte der italienische Konzeptkünstler Piero Manzoni (1933–1963) alles zu Kunst; Fäkalien und seinen Atem. 1960 bläst er Ballons auf – und schafft allein mit seinem Odem Skulpturen, die quasi an seinem Sein und seiner Genialität teilhaben: *Fiato d'Artista*. Dieses neue Produkt bezeichnet er keck als Luftplastik – »undeterminierte Spheroide«, die sich nicht etwa über ihre Form definieren, sondern über ihre Entstehung. »Form ist ein Irrtum«, behauptet Manzoni, der somit sehr nahe an Duchamps willkürlich gefasste *Air de Paris* kommt, »die wesentliche Bedeutung pneumatischer Werke ist nicht die Form, sondern Werden.« Von der Lässigkeit des viel zu früh verstorbenen Italieners, der am Anfang stark von Yves Klein beeinflusst worden war, hat eine ganze Generation von Künstlern profitiert, allen voran ZERO und Fluxus. Kräne und Hubschrauber waren nötig, um die bis dato größte Luftskulptur aufzurichten und zu befüllen: 5.600 Kubikmeter Luft und Helium in einer Hülle aus Trevira schwebten schließlich wie eine gigantische Zigarre über der documenta 4. Christo und Jeanne-Claude hatten die *5,600 Cubic Meter Package* (1968, Abb. 157) entworfen. Seile verschnürten die Luft zu einem riesigen Paket, das in der Brise schwankte und zuckte. Wahrnehmung verändern und dem Unsichtbaren Gestalt geben, dafür schien Luft seit Duchamp der ideale Stoff. □

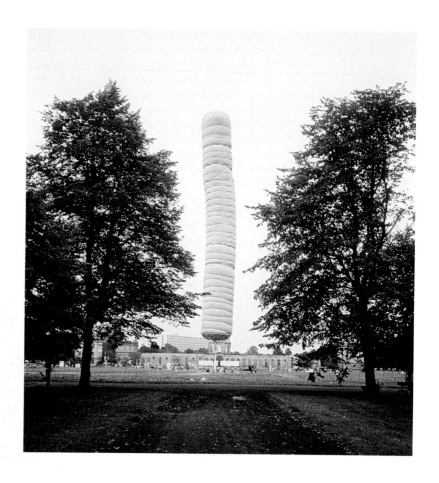

The idea of our world being the result of a divine act of creation has at all times been popular with artists, who have viewed themselves as brilliant extensions of this assumption of form. The 20th century, however, brought the idea to its logical conclusion. No elaboration, no devious ways round. Like King Midas, who turned everything he touched into gold, the Italian Conceptual artist Piero Manzoni (1933–1963) ennobled all simple things to be art; faeces and his breath. In 1960 he inflated balloons – and created with his breath alone sculptures which shared, as it were, in his existence and his brilliance: *Fiato d'Artista* (fig. 154|155). He impudently styled this new product air sculpture – ›indeterminate spheroids,‹ which were defined by genesis rather than form. ›Form is a fallacy,‹ maintained Manzoni, in this stance coming very close to Duchamp's arbitrarily defined *Air de Paris*; ›the essential meaning of pneumatic works is not form but becoming.‹ An entire generation of artists, first among them ZERO and Fluxus, benefited from the casualness of the Italian, who died young but from the outset was strongly influenced by Yves Klein.

Cranes and helicopters were needed to set up and inflate what was the biggest air sculpture ever known before it made its appearance: 5,600 m³ of air and helium in a bag made of Trevira finally floated like a gigantic cigar above documenta 4. Christo and Jeanne-Claude had designed this *5,600 Cubic Meter Package* (1968). Ropes tied up air into a vast parcel which swayed and quivered with every breeze. Since Duchamp air has seemed the ideal material for altering perception and giving form to the invisible. □

We owe our climate to the fact that air has – relative to water –
a very low thermal capacity.
AGGREGATE STATES

Unser Klima verdanken wir dem Umstand, dass Luft eine –
relativ zu Wasser – sehr geringe Wärmekapazität hat.
AGGREGATZUSTÄNDE

Who thinks when he is breathing air that he is inhaling bacterial
excretions 3.8 billion years old?

Wer denkt schon beim Atmen daran, dass man damit 3,8 Milliarden
Jahre alte bakterielle Ausscheidungen aufnimmt?

Free oxygen is a ›terrestrial fossil‹ that is 2 billion years old and
excreted by bacteria.

Freier Sauerstoff ist ein maximal 2 Milliarden Jahre altes »irdisches
Fossil«, Ausscheidungsprodukt von Bakterien.

Gases are also dissolved by water; the oxygen content and
carbon dioxide content are crucial for living beings.
ON EARTH

Auch Gase werden von Wasser gelöst; für Lebewesen ist der
Sauerstoff- und Kohlendioxyd-Gehalt bedeutsam.
AUF DER ERDE

Oxygen saturation is the highest concentration of solute oxygen in
water, dependent on temperature, pressure and solute substances.
ON EARTH

Sauerstoffsättigung ist die höchste Konzentration an gelöstem
Sauerstoff im Wasser, abhängig von Temperatur, Druck und gelösten
Stoffen.
AUF DER ERDE

Air can absorb water: the simplest example is air humidity.
ON EARTH

Luft kann Wasser aufnehmen: einfachstes Beispiel ist
die Luftfeuchtigkeit.
AUF DER ERDE

Air does not occur naturally in chemically pure form.
ON EARTH __ Just think of Karl Valentin's exhibit in his museum in Munich: a glass
bottle filled with Munich air

Luft kommt in der Natur nicht in chemisch reiner Form vor.
AUF DER ERDE __ Man denke an Karl Valentins Exponat in seinem Museum in
München, eine Glasflasche gefüllt mit Münchener Luft

Natural air is always polluted by aerosols. Even rain contains dust,
oxygen, nitrogen and inert gases (and traces of ammonium nitrate).
ON EARTH

Natürliche Luft ist stets mit Aerosolen verunreinigt. Sogar Regen
enthält Staub, Sauerstoff, Stickstoff und Edelgase (und auch
Spuren von Ammoniumnitrat).
AUF DER ERDE

Solid, fluid and gaseous substances which have a lastingly deleterious effect on air.
PARTICLES PER cm³ _ >500,000 over cities and industrial areas; >1,000 above open land; >100 over seas

Feste, flüssige sowie gasförmige Substanzen, welche die Luft nachhaltig verändern.
TEILCHEN PRO cm³ _ >500.000 über Städten und Industriegebieten; >1.000 über freiem Land; >100 über dem Meer

Assessment of toxidity for mammals, plants and bacteria, biodegradability and longevity.
CAUSES _ Natural causes are e.g. biological decomposition, volcanoes, dust storms

Bewertung ihrer Giftigkeit für Säugetiere, Pflanzen und Bakterien, biologische Abbaubarkeit und Langlebigkeit.
GRÜNDE _ Natürliche Gründe für eine Luftbelastung sind u.a. biologische Abbauprozesse, Vulkanausbrüche oder Staubstürme

Responsible for acid rain, high ozone concentrations, the ozone hole, the greenhouse effect, the cause of forest death and respiratory damage.
CAUSES _ Human caused factors are e.g. combustion in motor vehicles, industrial emissions, domestic heating and emissions of power plants

Verantwortlich für sauren Regen, hohe Ozonwerte, Ozonloch, Treibhauseffekt, sie verursachen Waldsterben, Atemwegsschädigungen.
GRÜNDE _ Vom Menschen verursachte Faktoren sind z.B. Verbrennungsprozesse in Fahrzeugen, Industrie- und Heizungsabgase, Emissionen von Kraftwerken

Absolute zero is the point at which no more thermal energy can be removed from a substance. The Kelvin scale begins at 0 K, which corresponds to –273.15 °C. Ice thaws at 273.15 K, the boiling point of water is 373.15 K.

ORIGIN _ Sir William Thomson, Lord Kelvin of Lards, 1848 thermodynamic definition of temperature

Der absolute Nullpunkt bezeichnet eine Temperatur, bei der sich von keinem Stoff mehr thermische Energie entfernen lässt.
An ihm beginnt die Kelvin-Skala mit 0 K, dies entspricht –273,15 °C.
Der Schmelzpunkt von Eis liegt bei 273,15 K, der Siedepunkt bei 373,15 K.

HERKUNFT _ Sir William Thomson, Lord Kelvin of Lards, thermodynamische Temperaturdefinition, 1848

The atmosphere can be classified by temperature distribution, ionisation or gas content. The air temperature is the temperature of the atmosphere heated by energy emissions from the earth's surface.

BASIS _ Measured under exclusion of any influences from radiation

Die Atmosphäre kann nach der Temperaturverteilung, der Ionisation oder der Gaszusammensetzung gegliedert werden. Die Lufttemperatur bezeichnet die Temperatur der Atmosphäre, die durch Energieabgabe der Erdoberfläche erwärmt wurde.

BASIS _ Gemessen unter Ausschluss jeglicher Strahlungseinflüsse

The highest air temperature is at 50 °C in deserts, the lowest near cold poles. Decreases by 0.65 °C per 100 m of altitude.

BASIS _ Poles of heat and cold, depending on altitude

Die höchste Lufttemperatur tritt mit 50 °C in den Wüsten, die tiefste an den Kältepolen auf. Abnahme um 0,65 °C pro 100 Höhenmeter.

BASIS _ Wärme- und Kältepole, Abhängigkeit von der Höhe

> AIR PRESSURE / LUFTDRUCK

Air pressure is the pressure the pull of gravitiy causes the
atmosphere to exert on the earth, measured by barometers in
hectopascals.
BASIS _ (1 hPa = 1 mbar) at sea level on an average 1,013.25 hPa, deviations
depending on the weather

Der Luftdruck ist der Druck den die Atmosphäre aufgrund der
Schwerkraft auf die Erde ausübt, gemessen mit Barometer in
Hektopascal.
BASIS _ (1 hPa = 1 mbar) in Meereshöhe durchschnittlich 1.013,24 hPa,
Abweichungen sind wetterbedingt

The highest value measured is 1,083.8 hPa (Agata/USSR,
31.12.1968), the lowest 856 hPa (Okinawa/Japan, September 1958).
BASIS _ (1 hPa = 1 mbar) at sea level on an average 1,013.25 hPa, deviation
depending on the weather

Der höchste gemessene Wert beträgt 1.083,8 hPa (Agata/UdSSR,
31.12.1968), der tiefste 856 hPa (Okinawa/Japan, September 1958).
BASIS _ (1 hPa = 1 mbar) in Meereshöhe durchschnittlich 1.013,24 hPa,
Abweichungen sind wetterbedingt

The greatest fluctuations in air pressure occur in tropical whirl-
winds, although generally in tropical regions fluctuations are minor
– compared to non-tropical regions.
BASIS _ (1 hPa = 1 mbar) at sea level on an average 1,013.25 hPa, deviation
depending on the weather. Equalling a mercury column 760 mm long and 1 cm^2
in cross-section area

Die größten Luftdruck-Schwankungen treten bei tropischen Wirbel-
stürmen auf, obwohl im Übrigen in den Tropen generell Schwankun-
gen geringer sind – verglichen mit außertropischen Gebieten.
BASIS _ (1 hPa = 1 mbar) in Meereshöhe durchschnittlich 1.013,24 hPa,
Abweichungen sind wetterbedingt. Dies entspricht einer Quecksilbersäule von
760 mm Länge und 1 cm^2 Querschnittsfläche

In the course of day there are atmospheric tides under gradient-
weak weather conditions.
BASIS

Im Tagesverlauf gibt es bei gradientenschwachen Wetterlagen
atmosphärische Gezeiten.
BASIS

The horizontal distribution is represented by isobars in weather
charts distinguishing between high and low pressure areas.
BASIS _ Distance of isobars from 5 to 5 hPa

Die horizontale Verteilung wird in Wetterkarten mittels Isobaren
dargestellt, dabei wird zwischen Hoch- und Tiefdruckgebieten unter-
schieden.
BASIS _ Abstand der Isobaren von 5 zu 5 hPa

The general circulation of the atmosphere, therefore, results
from the mean pressure distribution in connection with wind.
BASIS

In Zusammenhang mit dem Wind folgt somit aus der mittleren
Druckverteilung die allgemeine Zirkulation der Atmosphäre.
BASIS

The general circulation of the atmosphere results from differences
in heat distribution. Differences in air pressure resulting from
them cause air flows to form a complex fluid dynamic system under
the influence of the earth's rotation, the Coriolis force and
friction.
BASIS

Die allgemeine Zirkulation der Atmosphäre resultiert aus unter-
schiedlicher Wärmeverteilung. Daraus ergeben sich Luftdruckunter-
schiede, die zu Luftströmungen führen, welche unter Einwirkung
von Erdrotation, Coriolis- und Reibungskraft ein komplexes
fluiddynamisches System bilden.
BASIS

Three heat-transporting zones interact in the vertical along the
meridians: tropical, moderate and polar latitudes' circulations.
BASIS

Vertikal gibt es entlang der Meridiane Wechselwirkungen dreier
Wärmetransportzonen: tropische, gemäßigte und polare Breiten-
zirkulation.
BASIS

Consequently, planetary atmospheric pressure zones are formed
in the horizontal, from which wind systems arise.
BASIS

Horizontal ergeben sich somit planetarische Luftdruckgürtel aus
denen die Windsysteme resultieren.
BASIS

Atmospheric pressure distribution is characterized in each hemi-sphere by 4 zones, located parallel to latitude: Equatorial low-pressure trough with prevailing weak easterly, occasionally also westerly winds. Subtropical high-pressure belt with steady north-east or south-east trade winds towards the equatorial low-pressure trough. Subpolar low-pressure belt with prevailing westerly winds from the subtropical high-pressure belt (westerlies in moderate latitudes). Polar high-pressure zone with prevailing easterly winds towards the subpolar low-pressure trough (polar easterly winds).
BASIS

Die Luftdruckverteilung ist auf jeder Halbkugel durch 4 Gürtel gekennzeichnet, die parallel zu den Breitenkreisen angeordnet sind: Die äquatoriale Tiefdruckrinne mit vorwiegend schwachen östlichen, gelegentlich auch westlichen Winden. Der subtropische Hochdruck-gürtel mit beständigen Nordost- oder Südost-Passaten zur äqua-torialen Tiefdruckrinne. Die subpolare Tiefdruckrinne mit vorwie-gend westlichen Winden vom subtropischen Hochdruckgürtel (Westwinde gemäßigter Breiten). Die polare Hochdruckzone mit vorherrschend östlichen Winden zur subpolaren Tiefdruckrinne (polare Ostwinde).
BASIS

More or less stable wind systems result from the distribution of atmospheric pressure over land and sea and surface roughness. In addition, atmospheric pressure and wind systems are subject to strong seasonal fluctuation.
BASIS

Aufgrund der Luftdruck-, Land- und Meer-Verteilung und der Oberflächenrauheit ergeben sich mehr oder weniger beständige Wind-systeme. Zusätzlich unterliegen die Luftdruck- und Windsysteme starken jahreszeitlichen Schwankungen.
BASIS

Air density varies according to temperature and pressure. Like
atmospheric pressure, air density decreases with altitude.
BASIS _ 1.293 kg/m^3 at sea level

Luft tritt, abhängig von Temperatur und Druck, in verschiedenen
Dichten auf. Die Dichte nimmt nach oben ähnlich wie der Druck ab.
BASIS _ 1,293 kg/m^3 auf Meereshöhe

With ascending altitude density and pressure decrease at a steadily
declinig rate. Systematic changes according to both time of day
and season of the year and the activity of the sun.
BASIS _ From 100 km up with increasing altitude

Mit steigender Höhe nehmen Dichte und Druck immer langsamer ab.
Systematische Änderungen je nach Tages-, Jahreszeit und Sonnen-
aktivität.
BASIS _ Ab 100 km mit zunehmender Höhe

Beschleunigung: Die unerträgliche Leichtigkeit der Welt

Bereits die Futuristen hatten eine Welt der permanenten Beschleunigung gefordert: »We declare that the splendor
of the world has been enriched with a new form of beauty, the beauty of speed. / Wir erklären, dass die Herrlich-
keit der Welt durch eine neue Form von Schönheit bereichert wurde: die Schönheit der Geschwindigkeit. / A race-
automobile adored with great pipes like serpents with explosive breath ... a race-automobile with seems to rush
over exploding power is more beautiful than the Victory of Samothrace. / Ein Rennauto mit riesigen, schlangen-
gleichen Rohren und explosivem Atem ... ein Rennauto, das über explodierendes Pulver zu rauschen scheint ist
schöner als die Nike von Samothrake«, erklärte Marinetti in seinem Gründungsmanifest des Futurismus von 1908.
Die Ästhetik der Stromlinie überrollte das frühe 20. Jahrhundert. Der Verkehr – für Le Corbusier »auf die Straßen
geworfenes Dynamit« – bestimmte die Stadtplanung. Antike Bildhauerkunst konnte es nicht mehr mit der
modernen Schönheit eines Wagens aufnehmen, wohl aber René Laliques Art-Decó-Arbeiten. Seine Kühlerfigur
Sieg (um 1930) pflügt durch den Raum. Starre, weit aufgerissene Augen, offener Mund. Die Haare flattern nicht
mehr in der Brise einer moderaten Kutschfahrt, sie sind zu einem Fächerstrahl verdichtet, den der Fahrtwind
formt. Solche Geschwindigkeit wurde erst möglich durch eine geniale Erfindung: Luft trägt den Wagen auf seiner
rasanten Fahrt. Kein Wunder, dass die Reifenindustrie dem Pneu ein Denkmal besonderer Art setzt: das Michelin-
Männchen ist mehr als das Logo der französischen Marke, es wird eine eigenständige Figur, *Bibendum-Männchen*,
kurz *Bib-Männchen* genannt, nachdem Édouard Michelin die anthropomorphe Gestalt einiger Reifen bemerkt
hatte. Dabei übernahmen sie lediglich den Slogan eines bayerischen Werbeplakats – »nunc est bibendum« – für
ihren Reifenmann, der triumphierend einen Pokal mit Glassplittern und Nägeln hochhält und damit verkündet: >>>

☐ 158 René Lalique, Victory (figure for car bonnet). Ca. 1930 / René Lalique, Sieg (Kühlerfigur). Ca. 1930

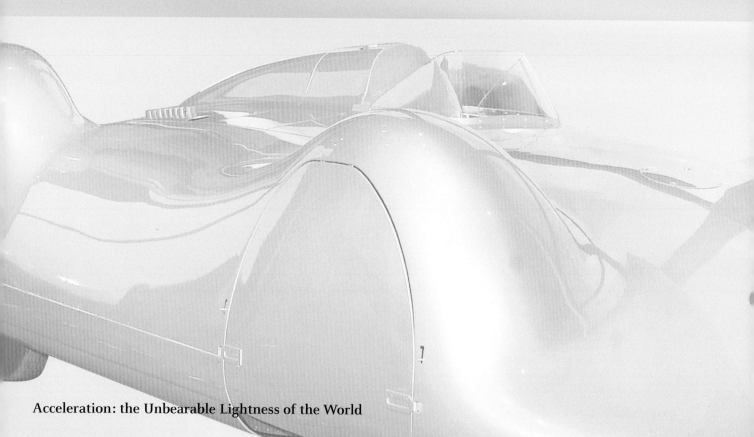

Acceleration: the Unbearable Lightness of the World

The Futurists had been among the first to call for a constantly accelerating world: ›We declare that the splendour of the world has been enriched with a new form of beauty, the beauty of speed. / A racing car adorned with great pipes like serpents with explosive breath ... a racing car which seems to roar over exploding powder is more beautiful than the Victory of Samothrace,‹ proclaimed Marinetti in his 1908 manifesto that marked the founding of Futurism. The aesthetic of streamlining overran the early 20th century. Traffic – for Le Corbusier ›dynamite hurled into the streets‹ – was the determinant of urban planning. And, even though the classical art of sculpture could no longer compete with the beauty of a car, René Lalique's Art Déco works could. His *Victory* (ca. 1930, fig. 158), a figure to be placed on a car bonnet, ploughs through space. Staring with eyes wide open, open-mouthed. Her hair no longer flutters in the breeze stirred by moderately-paced carriage travel; they have condensed into a beam fanned and formed by the wind of speed. Such speeds were only made possible by a brilliant discovery: air speeds the motor car on its way. No wonder that the tyre industry immortalised the pneumatic tyre with a monument of a very special kind: the Michelin Man was more than just the logo of the French brand. It became an autonomous figure in its own right: *Bibendum, Bib* for short, after Édouard Michelin had noticed that some tyres piled up made an anthropomorphic figure. All they actually did was take over the slogan from a Bavarian advertizing poster – ›nunc est bibendum‹ – for their tyre man, who triumphantly holds up a goblet filled with splinters of glass and nails. *Bib*, that symbol of manhood in resplendent white, was originally made up of forty tyres. Downsized later to twenty-six, he became a popular icon for generations of drivers. >>>

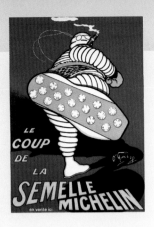

Ich schlucke alle Hindernisse der Straße. Bestand der weiße Prachtkerl *Bib* erst aus 40 Reifen, speckte er später

auf 26 ab und wurde zum Sympathieträger ganzer Generationen von Autofahrern.

Kunst und Leben schlugen getrennte Wege ein, und erst die Pop Art hatte wieder die Unverfrorenheit, der

automobilen Gesellschaft Paroli zu bieten. Das Auto, Statussymbol und Lebensmittelpunkt Amerikas, stand plötz-

lich wieder hoch im Kurs, wenn auch ironisch gebrochen. Bob Watts *casual events* von 1964 sind eine absurde,

liebevolle Hymne auf die Rituale der Beweglichkeit, Konzeptkunst, die dem täglichen Leben abgelauscht war:

drive car to filling station // inflate right front tire* / continue to inflate until tire blows out / change tire / drive

home / *if car is a newer model drive home on blown out tire (Fahren Sie zur Tankstelle / Füllen Sie den rechten

Vorderreifen mit Luft / Weiter aufpumpen, bis er explodiert / Wechseln Sie den Reifen / *Wenn es sich um ein

neueres Modell handelt, fahren Sie mit dem geplatzten Reifen nach Hause). Ganz gleich ob Stau oder Ölpreis-

schock, das Auto blieb eine Traummaschine, die grenzenlose Freiheit versprach, jene Freiheit, die man am besten

am Steuer eines Convertibles genoss.

Geschwindigkeit? Das waren für Automobilisten Gaspedal und Motor, während die Karosserie Flügel entwickelte,

als könnte der Wagen jederzeit abheben. Für die schönsten Heckflossen stand eine Marke, Cadillac. Der *Eldorado*

von 1959 katapultierte das Automobildesign auf eine neue Umlaufbahn: Das Gefährt des Weltraumfahrt-Zeitalters

musste schweben, zumindest das Gefühl verleihen, frei dahinzugleiten. Der *Eldorado* war das genaue Gegenteil der

Stromlinienform – eine wuchtige, brummelnde Maschine – genau das, was der Automobilist liebte. Schon in

den 1930er Jahren hatten die Stromlinien-Rennwagen der Auto Union bewiesen, was Aerodynamik im Fahrzeug-

bau tatsächlich hieß – fließende Formen eines ultraleichten Autos, das wie eine Flunder auf der Straße lag und

auf der Teststrecke über 400 Stundenkilometer erreichte. Selbst die Räder verschwanden unter der vollverkleideten

Karosserie, die das Auto zum Projektil werden ließ. Endlich hatte sich Marinettis Postulat erfüllt, Schönheit

entsprang der Geschwindigkeit. □

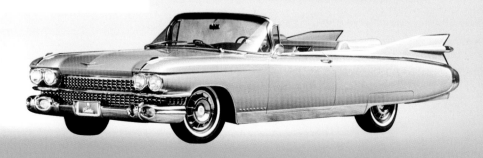

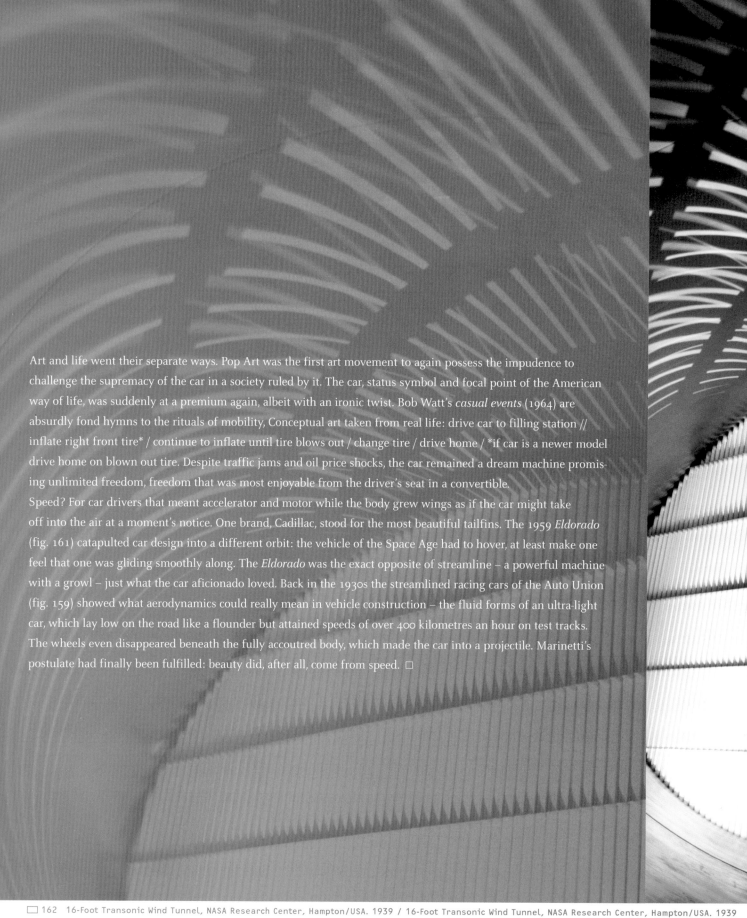

Art and life went their separate ways. Pop Art was the first art movement to again possess the impudence to challenge the supremacy of the car in a society ruled by it. The car, status symbol and focal point of the American way of life, was suddenly at a premium again, albeit with an ironic twist. Bob Watt's *casual events* (1964) are absurdly fond hymns to the rituals of mobility, Conceptual art taken from real life: drive car to filling station // inflate right front tire* / continue to inflate until tire blows out / change tire / drive home / *if car is a newer model drive home on blown out tire. Despite traffic jams and oil price shocks, the car remained a dream machine promising unlimited freedom, freedom that was most enjoyable from the driver's seat in a convertible.

Speed? For car drivers that meant accelerator and motor while the body grew wings as if the car might take off into the air at a moment's notice. One brand, Cadillac, stood for the most beautiful tailfins. The 1959 *Eldorado* (fig. 161) catapulted car design into a different orbit: the vehicle of the Space Age had to hover, at least make one feel that one was gliding smoothly along. The *Eldorado* was the exact opposite of streamline – a powerful machine with a growl – just what the car aficionado loved. Back in the 1930s the streamlined racing cars of the Auto Union (fig. 159) showed what aerodynamics could really mean in vehicle construction – the fluid forms of an ultra-light car, which lay low on the road like a flounder but attained speeds of over 400 kilometres an hour on test tracks. The wheels even disappeared beneath the fully accoutred body, which made the car into a projectile. Marinetti's postulate had finally been fulfilled: beauty did, after all, come from speed. □

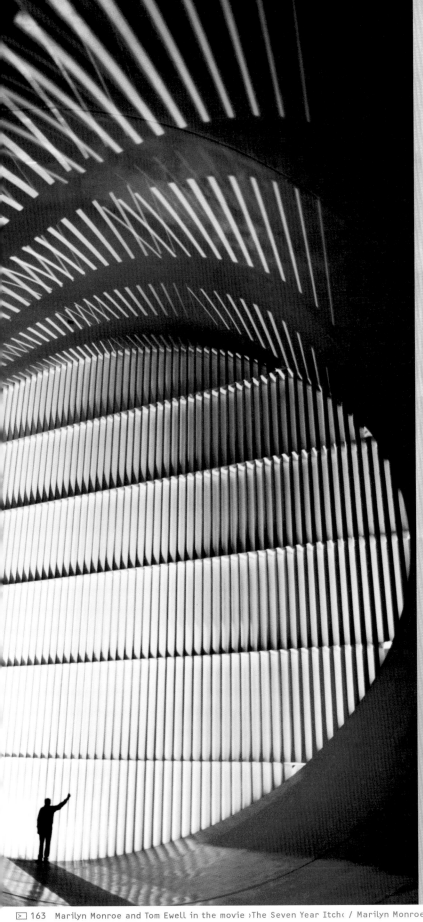

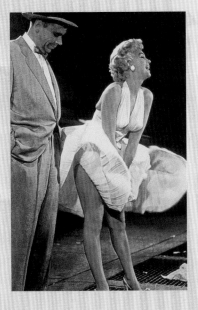

▷ 163 Marilyn Monroe and Tom Ewell in the movie ›The Seven Year Itch‹ / Marilyn Monroe und Tom Ewell in dem Film »Das verflixte siebente Jahr«. 1955

Habitat! Pneumatic Protest

Everything seemed possible, no goal was too remote. The 1960s reached for the stars. While the Russians and Americans floated through space in shapeless spacesuits and tiny tin cans, Stanley Kubrick created the ultimate metaphor for the future: the space station rotating through space to the strains of Johann Strauss's *Beautiful Blue Danube*. The new way of life has never been portrayed more elegantly – as a clean, technical capsule. And never again so menacingly: HAL, the intelligent computer on board, represented both promise and ruin. No wonder that architecture, too, sought ways of expressing an age promising expansion and enhanced awareness that had, for the first time ever, realised that there were limits to growth. A society was in a state of protest against everything old and suddenly architects were working on portable mini-worlds which would afford those who lived in them protection from a menacing and threatened environment. The Viennese group Haus-Rucker-Co propagated radical consciousness raising with semi-pneumatic, semi-hardshelled configurations supposed to protect people, such as *Mind-Expander 1* (1967) or *Ballon für Zwei* [*Balloon for two*]. The loving couple as the foetuses of a new world: all that was possible. The revolution reached even the lowliest of huts. The *Gelbes Herz* [Yellow Heart] (1968, fig. 173) was after all, supposed to throb to the beat of a better world. Society, as known up to that point, bounded by walls, dissolved. Architecture switched to experimenting with materials and forms, in this not unlike developments in the other arts. The key to them was the pneumatic principle, which allowed for airy, mutable conditions, soft, cuddly and universally deployable. Architecture no longer stood for home and hearth, stones and hunting boundaries. Building was now utopian. The world breathed and so did the new castles in the air.

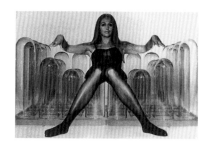

Paris, Vienna and London saw the continual formation of new groups linked by one common factor: revolt against the establishment. Their weapons: plastic and elastic. Whether they were called Archigram and created icons for the onset of the Space Age, Coop Himmelb(l)au or Structures Gonflables, who in 1968 were suggesting completely pneumatic interiors and structures which would make wall and shelf, table and floor all one, the scope of their thought was directly proportional to the air pressure of their configurations. Coop Himmelb(l)au put up airy dream houses and the soft room of 1970. A volcanic social eruption confronted dissatisfaction with >>>

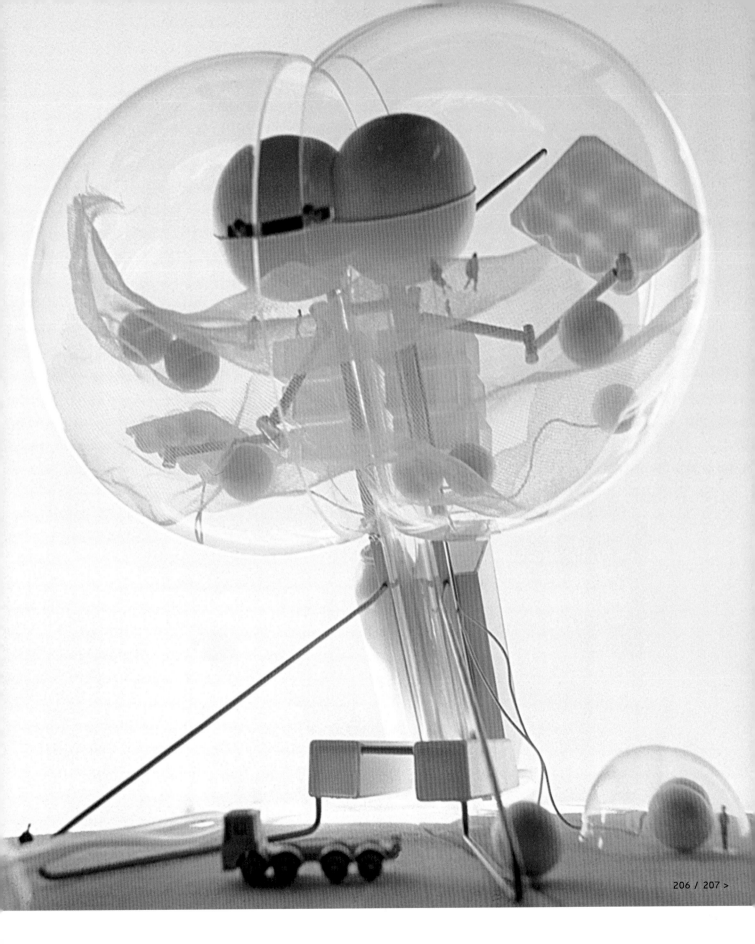

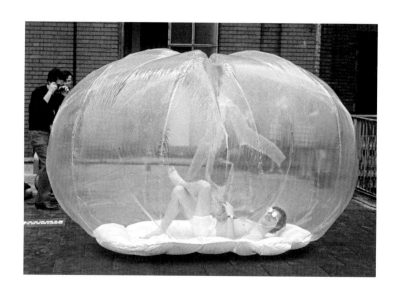

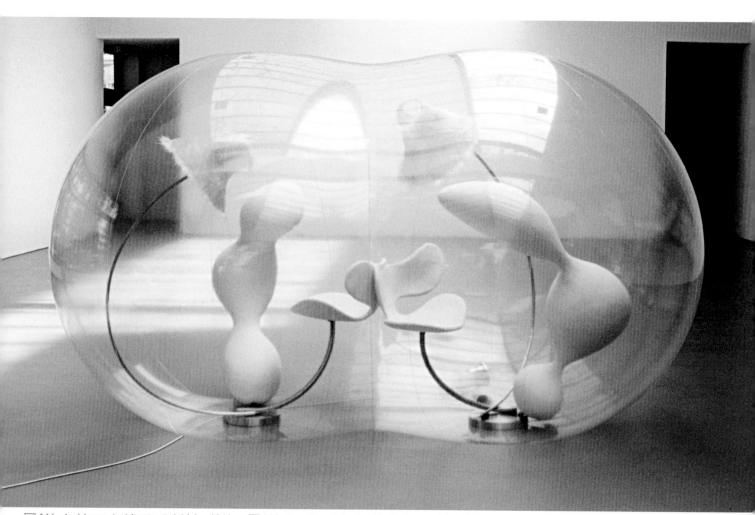

166 Archigram Architects, Cuishicle. 1966 167 Dorothee Golz, Double hollow world. 1999 / Dorothee Golz, Doppelhohlwelt. 1999

Habitat! Pneumatischer Protest

Alles schien möglich, kein Ziel zu fern. Die 1960er griffen nach den Sternen. Während Russen und Amerikaner in unförmigen Raumanzügen und winzigen Blechbüchsen durchs All schwebten, schuf Stanley Kubrick die ultimative Metapher der Zukunft: die zu Johann Strauß' *Schöner blauer Donau* durchs All rotierende Raumstation. Eleganter war das Neue nie mehr dargestellt worden – als cleane technische Hülle. Und nie mehr so bedrohlich: HAL, der intelligente Bordcomputer, war zugleich Verheißung und Verderbnis. Kein Wunder, dass auch die Architektur Ausdruck suchte für eine Zeit, die Expansion und Bewusstseinserweiterung versprach und erstmals die Grenzen des Wachstums erkannte. Eine Gesellschaft befand sich im Protest gegen das Alte, und plötzlich arbeiteten Architekten an portablen Miniwelten, die ihren Bewohnern Schutz boten vor einer bedrohlichen, selbst bedrohten Umwelt. Radikale Bewusstseinserweiterung propagierte die Wiener Gruppe Haus-Rucker-Co mit halb pneumatischen, halb hartschaligen Gebilden, die den Menschen schützen sollten, mit dem *Mind-Expander 1* von 1967 oder dem *Ballon für Zwei*. Das Liebespaar als Föten einer neuen Welt, auch das war möglich. Aufbruch war in der kleinsten Hütte. Das *Gelbe Herz* von 1968 (Abb. 173) sollte schließlich im Takt einer besseren Welt pulsieren. Die Gesellschaft, wie man sie bisher kannte, begrenzt von Mauern, löste sich auf. Architektur verlagerte sich auf Material- und Formexperimente, nicht unähnlich der Entwicklung der Künste. Schlüssel dafür war das Pneu-Prinzip, das leichte, veränderbare Situationen erlaubte, weich, anschmiegsam und universell einsetzbar. Architektur war nicht länger Haus und Herd, Steine und Jägerzaun – Bauen hieß nun Utopie. Die Welt atmete, und die neuen Luftschlösser taten das auch.

In Paris, Wien und London fanden sich immer neue Gruppen zusammen, die vor allem eines verband: die Revolte gegen das Bestehende. Ihre Mittel: Plaste und Elaste. Ob sie nun Archigram hießen und Ikonen schufen für den Aufbruch des Space Age, Coop Himmelb(l)au oder Structures Gonflables, die 1968 vollständig pneumatische Interieurs und Bauten vorschlugen, die Wand und Regal, Tisch und Boden eins werden ließen, die Spannkraft ihrer Gedanken war direkt proportional zum Luftdruck ihrer Gebilde. Coop Himmelb(l)au errichteten luftige Traumhäuser oder den weichen Raum von 1970. Eine gesellschaftliche Eruption setzte dem Ungenügen an einer alternden Moderne Neues entgegen: bunte, fröhliche Welten des gesellschaftlichen Miteinanders, der engagierten Diskussion. »Nicht sesshaft werden, von Eigentum nichts wissen wollen«, beschrieb Gernot Nalbach seine Beweggründe, ein pneumatisches Haus zu bauen, das mit geringstem Aufwand überall entstehen sollte. Johanna und Gernot Nalbachs *Pneumatisches Haus* von 1962 verwendete Halbzeuge aus der Industrie. Wände und Dach bestanden aus je einer gespannten Membran, das Möbel aus einer Luftmatratze. 1965/66 folgte *Pneumo City*, wandelnde Räume. Pulsierende Architektur, die auch schon mal, wie Theo Botschuijvers und Jeffrey Shaws *Three Pavilions* (Abb. 181–184) von 1971 bewies, Erde und Rasen zu pneumatischen Wucherungen werden ließ. Eine Generation später spielt Simone Decker in ihrem Video *Air Bag* (1998, Abb. 180) mit der Urangst zu ersticken. Die Tüte über dem Kopf als Sinnbild des Atems und letztes, tödliches Habitat. □

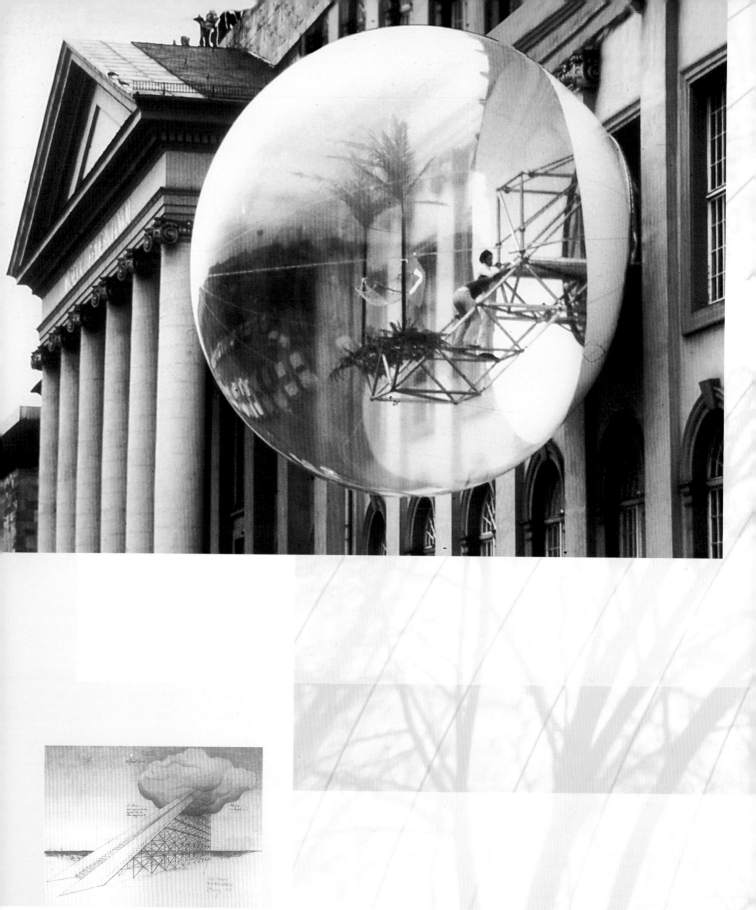

Haus-Rucker-Co: ☐ 168 Exhibition Cover – Survival in a Polluted Environment / Ausstellung Cover – Überleben in verschmutzter Umwelt

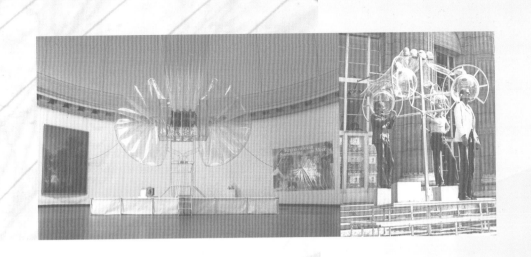

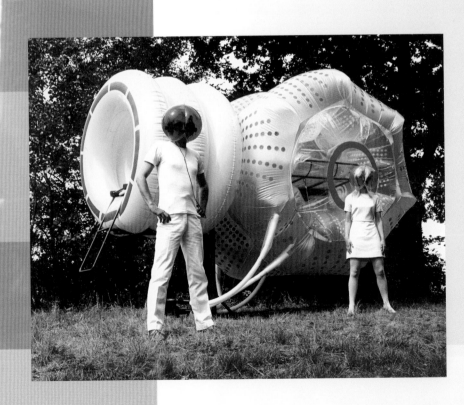

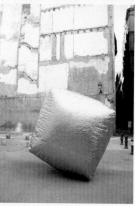

ageing Modernism with something new: colourful, cheerful worlds of social togetherness, commited discussion. ›Don't settle down, have nothing to do with possessions,‹ was how Gernot Nalbach described his motives for building a pneumatic house, which could be put up anywhere with a minimum of fuss and bother. Johanna and Gernot Nalbach's 1962 *Pneumatic House* used industrially manufactured unfinished steel bars, aptly called blooms in English. Walls and roof consisted of one taut membrane each, the furniture was an air mattress. It was followed in 1965/66 by *Pneumo City*, roaming rooms. Pulsing architecture, which could on occasion, as *Three Pavilions* (1971, fig. 181–184) by Theo Botschuijver and Jeffrey Shaw proved, cause the earth and lawns to sprout pneumatic protuberances. A generation later Simone Decker played on the elemental fear of suffocation in her video *Air Bag* (1998, fig. 180). A bag over one's head as the symbol of breath and one's final, deadly habitat. □

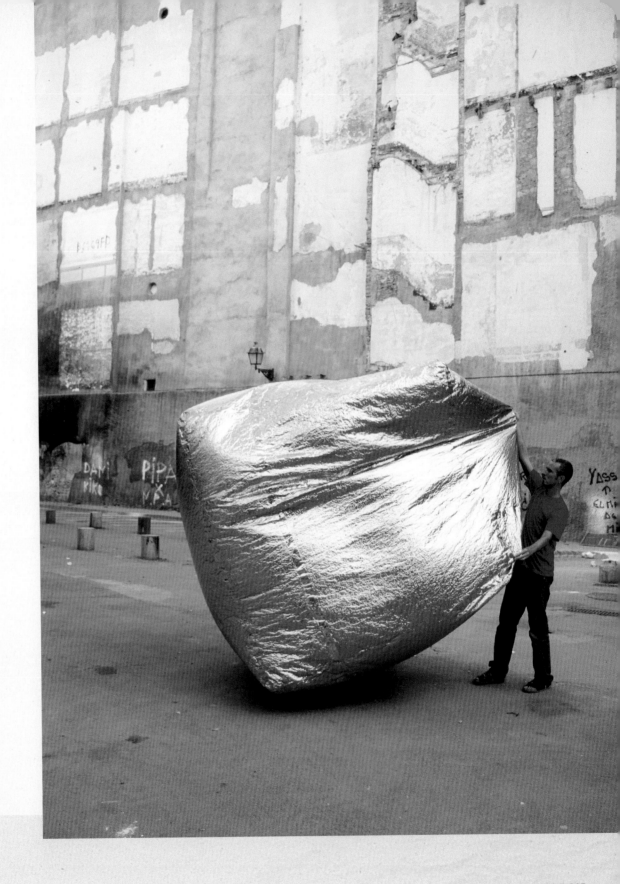

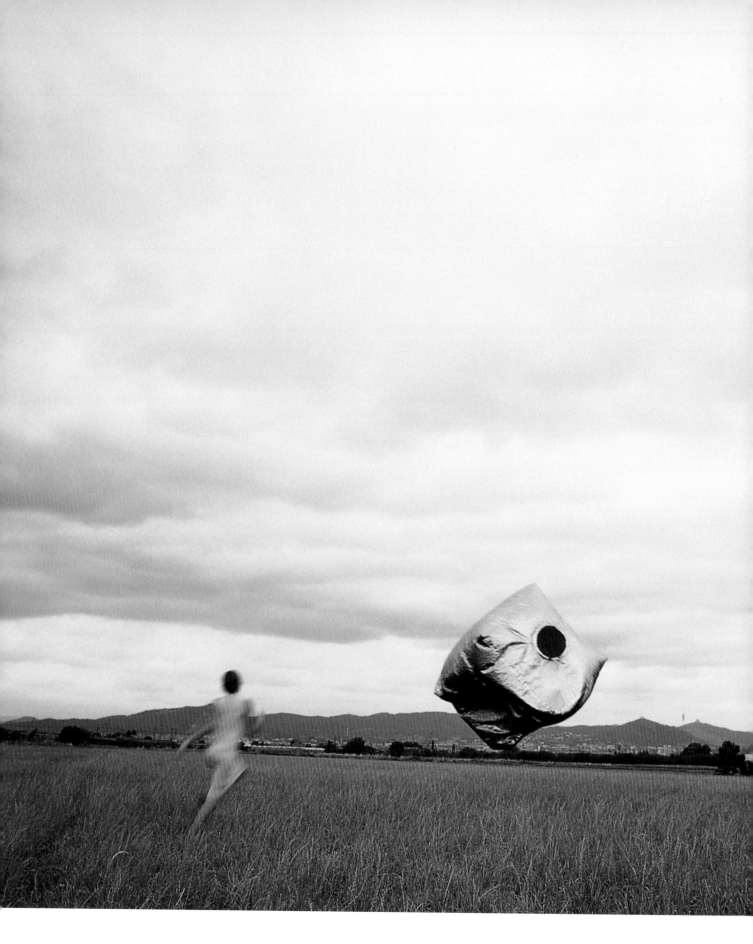

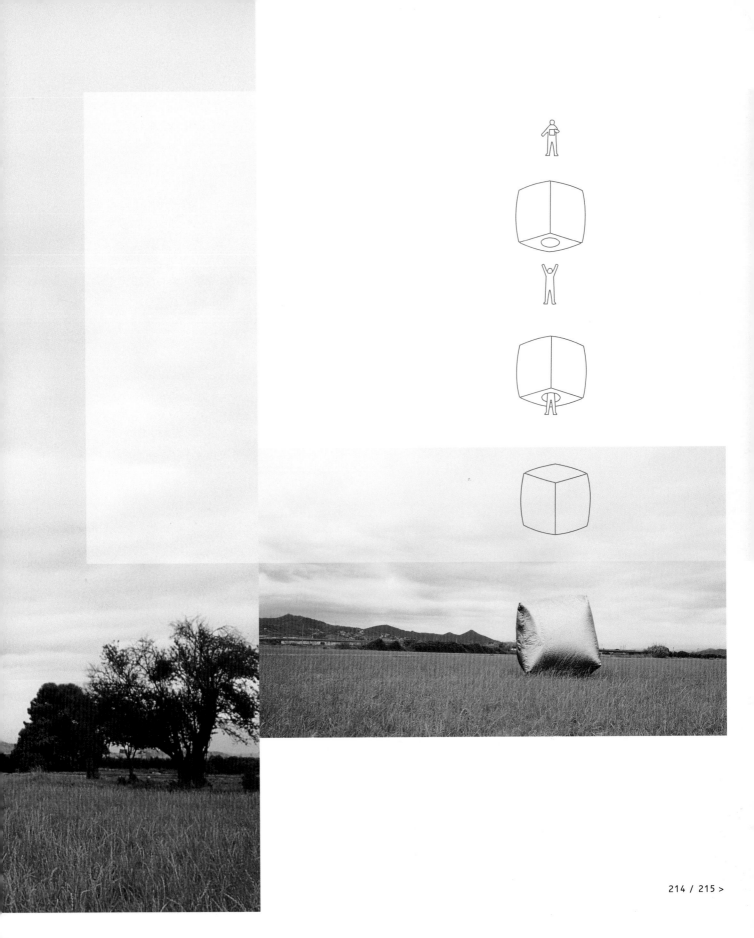

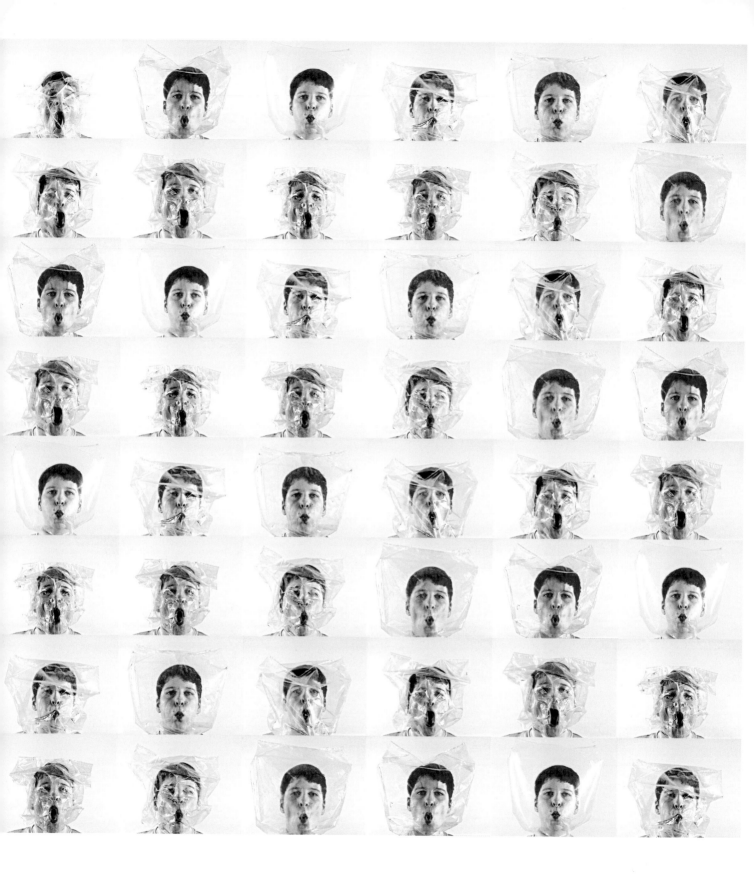

180 Simone Decker, Air Bag. 1998

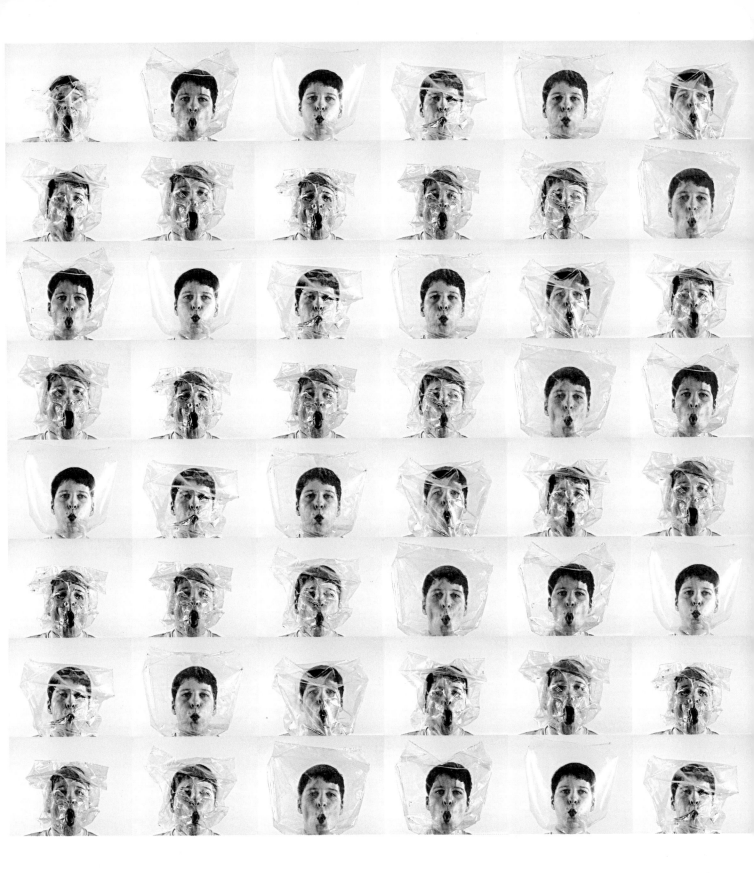

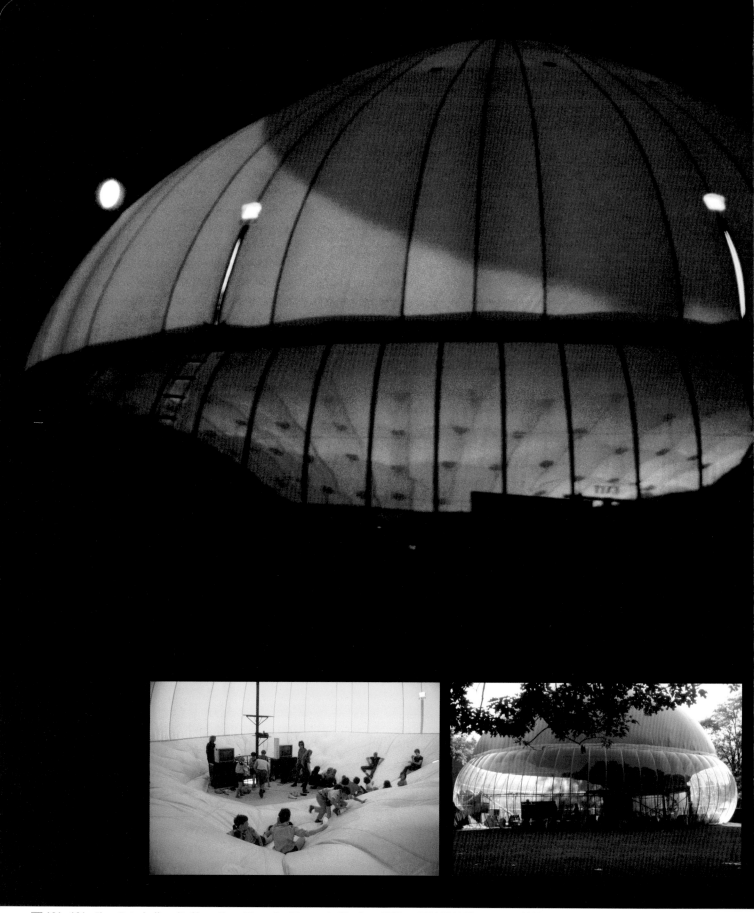

181–184 Theo Botschuijver/Jeffrey Shaw, Three Pavilions – Auditorium. 1971 ▷ 185|186 Cocoon. 1998

Blow It Up! The World Is Round

If the 1950s had any sex appeal, it was summed up in Marilyn Monroe, her skirt blown up from below by the hot air wafting from a subway ventilation shaft. The lightness with which Billy Wilder directed *The Seven Year Itch* (USA 1955) was years ahead of Jane Fonda's appearance as *Barbarella* (1968), replete with airy costume, flying plush cave and transparent avian jail. And still a lot had been happening. The 1960s were pschedelically hungry for love and unfathomably colourful. Anyone seeking to capture their essence is bound to come across the translucent, colourful and inflatable experiments in form which catapulted their designers into the midst of society. Blow it up! In 1967 De Pas, D'Urbino, Lomazzi and Scolari created the original of what would become a widespread, reasonably priced and universal piece of seat furniture for everyone: the inflatable armchair *Blow*. A plump seat cushion between two U-shaped rolls of PVC and air from which a head-rest seemed to grow. As if the designers had cut an inflatable dinghy in half and then folded it together like a sandwich. So simple it was a creation of genius, easy to produce and soon encountered in every household. The lifestyle was changing. Suddenly no one sat any more. Instead figures lounged and lolled about a psychedelic living landscape. The Protest Generation had found its medium of expression: round, spherical and cuddly, plastic and air for a new world of togetherness.

Gaetano Pesce's *Donna* (1969) brought the swelling forms of the day to a logical conclusion. His seat furniture mutated into Superwoman. The head of the seated person sank between two massive mammaries, the body rested on broad hips, the hands rested on the knees of a seat sculpture which had absorbed the free sex and body aware-ness of an entire generation. The world was plump and filled with air, thanks to new materials such as polyurethan foam. Yet there might be a valve somewhere to keep the Creator's breath from being dissipated as there was in Quasar's (Nguyen Manh Khanh) brilliant 1967 design for an inflatable self-suspending lamp (*Suspension Aérospace*) von 1967, whose shade consisted half of a translucent material and half of opaque. It was not simply suspended from the ceiling but floated in the room and the valve protruded from the plastic shade like an inquisitive feeler investigating the new environment. >>>

Blow it up! Die Welt ist rund

Wenn es so etwas wie Sex-Appeal der 1950er Jahre gab, dann ist dieser personifiziert in der über dem Lüftungs-
schacht der U-Bahn tänzelnden Marilyn Monroe. Die Leichtigkeit, mit der Billy Wilder *Das verflixte siebente Jahr*
(*The Seven Year Itch*, USA 1955) inszenierte, nahm Jane Fondas Auftritt als *Barbarella* (1968) samt luftigem
Kostüm, fliegender Plüschhöhle und transparentem Vogel-Gefängnis um Jahre vorweg. Und doch hatte sich viel
getan. Die 1960er Jahre zeigten sich psychedelisch-liebeshungrig und unberechenbar bunt. Wer ihre Essenz
sucht, stößt unwillkürlich auf jene transluzenten, farbenfrohen und schwellenden Formexperimente, die Designer
in die Mitte der Gesellschaft katapultierten. Blow it up! De Pas, D'Urbino, Lomazzi und Scolari schufen 1967 die

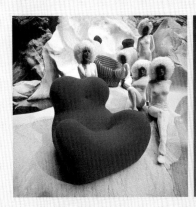 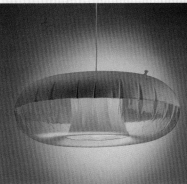

Urform des massenhaft verbreiteten, preiswerten und universellen Möbels, den aufblasbaren Sessel *Blow*.
Ein pralles Sitzkissen zwischen zwei U-förmigen Wülsten aus PVC und Luft, aus denen eine Nackenstütze zu
wachsen schien. Als hätten die Designer ein Schlauchboot in der Mitte zerschnitten und danach wie ein Sandwich
zusammengeklappt. Genial einfach, leicht zu produzieren und bald in jedem Haushalt zu finden. Das Leben
verändert sich. Plötzlich sitzt niemand mehr, da räkeln und lümmeln sich Gestalten in einer psychedelischen
Wohnlandschaft. Die Protestgeneration hatte ihren Ausdruck gefunden: rund, kugelig und kuschelig, Kunststoffe
und Luft für eine neue Welt des Miteinander. >>>

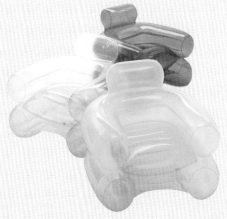

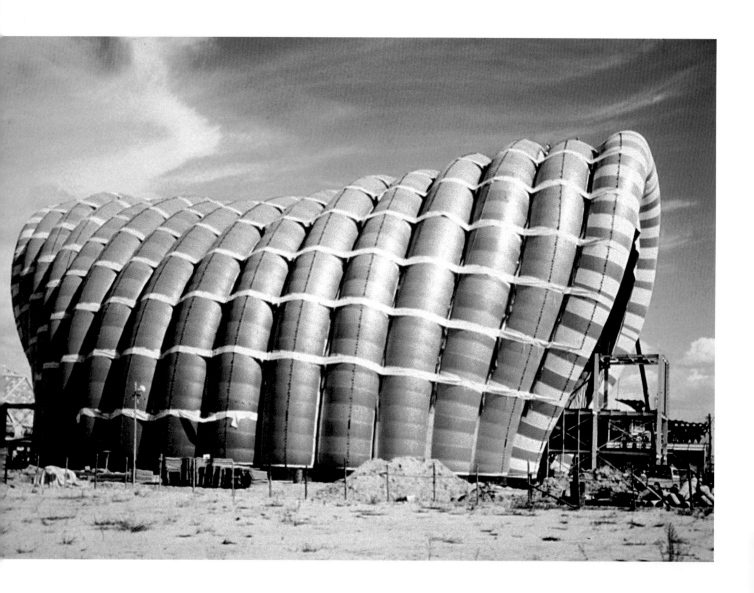

Now it seemed to be official: the world was round, soft and inflatable. But what was supposed to come afterwards? Utopias have a habit of vanishing into thin air in no time at all or of turning into dystopias. That was what happened to the dreams of the 1960s, the cheerful Commune in its spherical pneumatic dwelling. Anyone trying to classify the powerful legacy of that era in contemporary terms cannot avoid two salient facts: there were precursors, such as Walter Bird's *Radome*, which had reduced the pneumatic principle to the simplest form imaginable back in 1948: to simple domes stabilised by an excess of internal air pressure above the pressure in the atmosphere outside. The revolution had yielded to pragmatism. Yutaka Murata's *Fuji Pavilion* 1970 marks a turnaround in pneumatic architecture: big, original opalescent. After the 1970s oil crisis, PVC became more expensive and was no longer considered beneficial to the environment. There were naturally still some memorabilia left over from the good old days, such as hair-dryers one sat under and air mattresses, but they were gathering dust in cellars. >>>

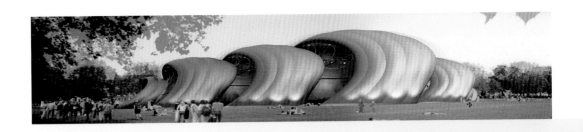

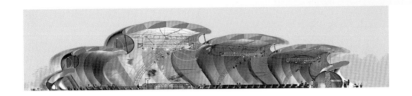

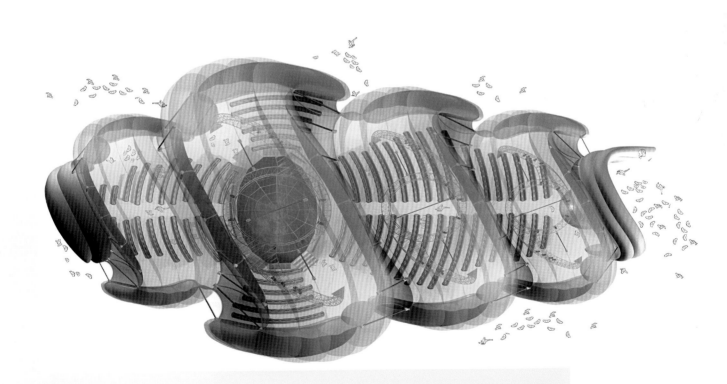

Contemporary design by Nick Crosbie for one has long since attained a state of casual irony. What otherwise was a miniature inflatable lifebelt doing as an egg cup or a bowl for fruit that unfurls like a bunch of banana leaves or an indestructable mirror with an air-filled frame? If there were ever new approaches at the interface of design and architecture, it was here: as a non-toxic high-tech bubble of Vitroflex. One hundred and twenty tonnes of water stabilised *Airquarium* (2000), a plastic dome. No seats anywhere to be seen. Nothing but air supports this eight-metre-high hemisphere. Axel Thallemer, who founded Festo Corporate Design in 1994, has added water and air as casually to the canon of building materials as if they were wood or stone. Structure and skin – the skin and bones of a building – are one and the same.

Art opened up new dimensions: Simone Decker's *Chewing in Venice* (1999, fig. 228–230) possesses the lightness otherwise only encounted in fashion designers such as Jean Paul Gaultier with his *Mad Max Collection* and Hussein Chalayan with his balloon costumes (fig. 224|245), who used air as their material and source of inspiration. A bubble-gum bubble in the city on the lagoon, of indefinable size and artificially pink in a world of appearances that was just as artificial. Ironic twists are also provided by Philippe Parreno's *Speech Bubbles* (1997, fig. 208, 210), detached from comic books, whose emptiness of content corresponds to equally empty interiors as if routine clichés had set out on their own to lay down a carpet of verbal trivia. Takashi Murakami's lurid *Mr. DOB* (1994, fig. 226) and Momoyo Torimitsu's double installation *Somehow I Don't Feel Comfortable* (2000, fig. 227) are not only informed by the discrepancy between incommen-surably inflated dimensions and normal interior spaces. More importantly, they embody the worldwide triumph of Japanese Manga culture, which, freed from the two-dimensional, makes liberal use of plastic, an equally trivial, everyday and ubiquitous material. Hans Hemmert put a friendly face on what would otherwise be cuteness blown up to startlingly menacing dimensions in his 1998 *Gelbe Skulpturen* |Yellow Sculptures, fig. 236–241|. His larger than lifesize lemons are lively and interact with their environment whereas the 1996 installation *Unterwegs* |Underway, fig. 234| captures the peculiar meaninglessness of modern travel. The world – vanished and vanquished. Nature and the car morph into an artificial, cloying yellow landscape down to the last detail. Lost and imprisoned in it, the neatly dressed driver has nothing left but the delusion that he is in control. □

Gaetano Pesces *Donna* von 1969 (Abb. 188) brachte die schwellenden Formen der Zeit zu einem logischen End-
punkt. Sein Sessel mutierte zur Überfrau. Der Kopf des Sitzenden versank zwischen zwei Riesenbrüsten, der
Körper ruhte auf der ausladenden Hüfte, die Hände auf den Knien einer Sitzskulptur, die freie Sexualität und
Körperbewusstsein einer ganzen Generation in sich aufgenommen hatte. Die Welt war prall und luftgefüllt
dank neuartiger Materialien wie Polyurethan-Schaum. Und irgendwo steckte vielleicht doch ein Ventil, das den
Atem des Schöpfers vor dem Verströmen bewahrte, wie in Quasars (Nguyen Manh Khanh) genialem Entwurf
einer aufblasbaren Hängelampe (*Suspension Aérospace*, Abb. 189) von 1967, deren Schirm je zur Hälfte aus trans-
luzentem und opakem Material bestand. Sie hing nicht mehr einfach von der Decke, sie schwebte im Raum,
und das Ventil lugte wie ein vorwitziger Fühler des Neuen aus dem Plastikschirm hervor.

Nun schien es offiziell: Die Welt war rund, weich und aufblasbar. Aber was sollte danach kommen? Utopien haben
die Angewohnheit, sich nach kurzer Zeit in Luft aufzulösen oder in Dystopien umzuschlagen. Nicht anders erging
es den Träumen der 1960er Jahre, der fröhlichen Kommune im kugeligen Pneubau. Wer aus heutiger Sicht ver-
sucht, die gewaltige Hinterlassenschaft der Epoche zu ordnen, muss erkennen: Es gab Vorläufer wie Walter Birds
Radome, die schon 1948 das Prinzip Pneu auf die denkbar einfachste Form gebracht hatten, einfache Kuppeln, die
mit Überdruck stabilisiert wurden. Der Aufbruch hat Pragmatismus Platz gemacht. Yutaka Muratas *Fuji Pavilion*
(Abb. 191) von 1970 zeigt den Wendepunkt der Pneuarchitektur, groß, fantasievoll und schillernd. Nach dem
Ölschock der 1970er wurde PVC teuer und galt als nicht mehr umweltverträglich. Natürlich gibt es noch Andenken
und Memorabilien an die gute alte Zeit, Trockenhaube und Luftmatratze, aber die verstauben im Keller. Zeitge-
mäßes Design von Nick Crosbie etwa hat längst den Zustand gelassener Ironie erreicht. Was, bitte, sollte sonst ein
Miniaturschwimmreifen als Eierbecher, eine Fruchtschale, die sich wie ein Büschel Bananenblätter auffaltet oder
ein unzerbrechlicher Spiegel mit Luftrahmen? Wenn es neue Ansätze an der Nahtstelle von Design und Architek-
tur gibt, dann hier: als ungiftige High-Tech-Blase aus Vitroflex. 120 Tonnen Wasser verleihen der Kunststoff-Kuppel
Airquarium (2000) Standfestigkeit. Keine Stützen, nirgends. Nichts als Luft trägt die acht Meter hohe Halbkugel.
Axel Thallemer, der Festo corporate Design 1994 gründete, fügt Wasser und Luft so selbstverständlich in den
Kanon der Baustoffe, als wären sie Holz oder Stein. Konstruktion und Hülle – Haut und Knochen des Gebäudes –
fallen zusammen. >>>

◁◁ 198 Inflate, Office in a bucket. 2004 ◁ 199–201 Alan Parkinson (Architects of Air), Luminaria Sculptures (Eggopolis 1990, Meggopolis 1994)

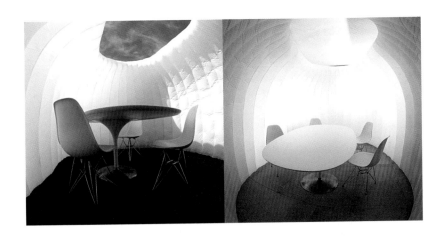

Neue Dimensionen eröffnet die Kunst: Simone Deckers *Chewing in Venice* (1999, Abb. 228–230) besitzt jene Leichtigkeit, mit der sonst nur Modeschöpfer wie Jean Paul Gaultier mit seiner *Mad Max Collection* oder Hussein Chalayan mit Ballon-Kostümen (Abb. 224|245) Luft als Material und Inspirationsquelle einsetzten. Eine Kaugummiblase in der Lagunenstadt, undefinierbar groß und künstlich rosa in einer gleichfalls künstlichen, aber akzeptierten Scheinwelt. Ironische Brechungen bieten auch Philippe Parrenos *Speech Bubbles* (Abb. 208, 210) von 1997, losgerissene Comic-Blasen, deren Inhaltsleere mit ebenfalls menschenleeren Interieurs korrespondiert, als hätten sich Alltagsphrasen verselbstständigt und zu einem Wortteppich der Nichtigkeiten ausgebreitet. Takashi Murakamis greller *Mr. DOB* (Abb. 226) von 1994 und Momoyo Torimitsus Doppelinstallation *Somehow I Don't Feel Comfortable* (Abb. 227) aus dem Jahr 2000 leben nicht nur von der Differenz aus unangemessener, aufgeblähter Größe und normalen Innenräumen, sie verkörpern vor allem den weltweiten Siegeszug der japanischen Manga-Kultur, die sich aus dem Zweidimensionalen befreit und bedienen sich dafür des gleichfalls trivialen, alltäglichen und ubiquitären Plastiks. Das plötzlich bedrohlich große Niedliche hat Hans Hemmert mit seinen *Gelben Skulpturen* (Abb. 236–241) von 1998 ins Freundliche gewendet. Seine überlebensgroßen Zitronen sind lebendig und interagieren mit ihrer Umwelt, während die Installation *Unterwegs* (Abb. 234) von 1996 die seltsame Leere modernen Reisens einfängt. Die Welt – verschwunden. Natur und Auto verschwimmen zu einer künstlichen, alle Details ausfüllenden Gelblandschaft. □

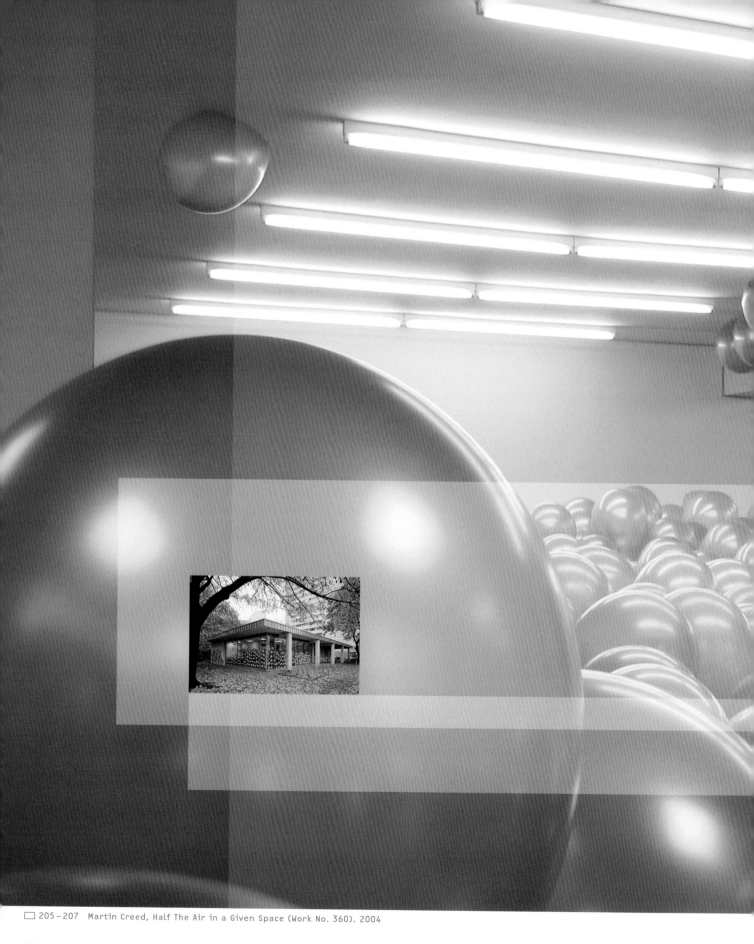

205–207 Martin Creed, Half The Air in a Given Space (Work No. 360). 2004

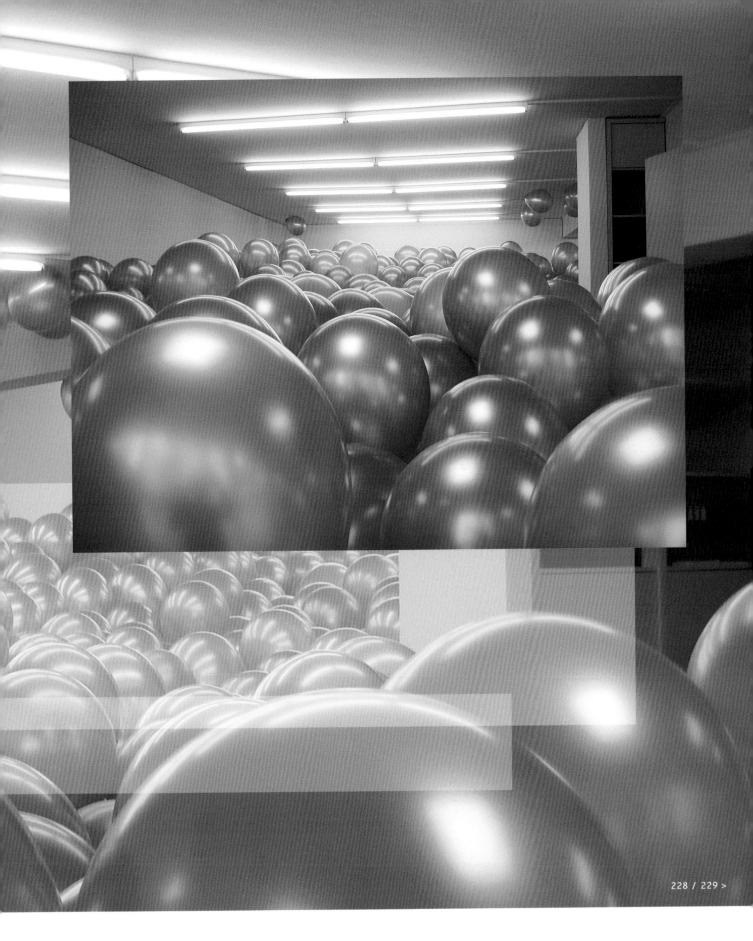

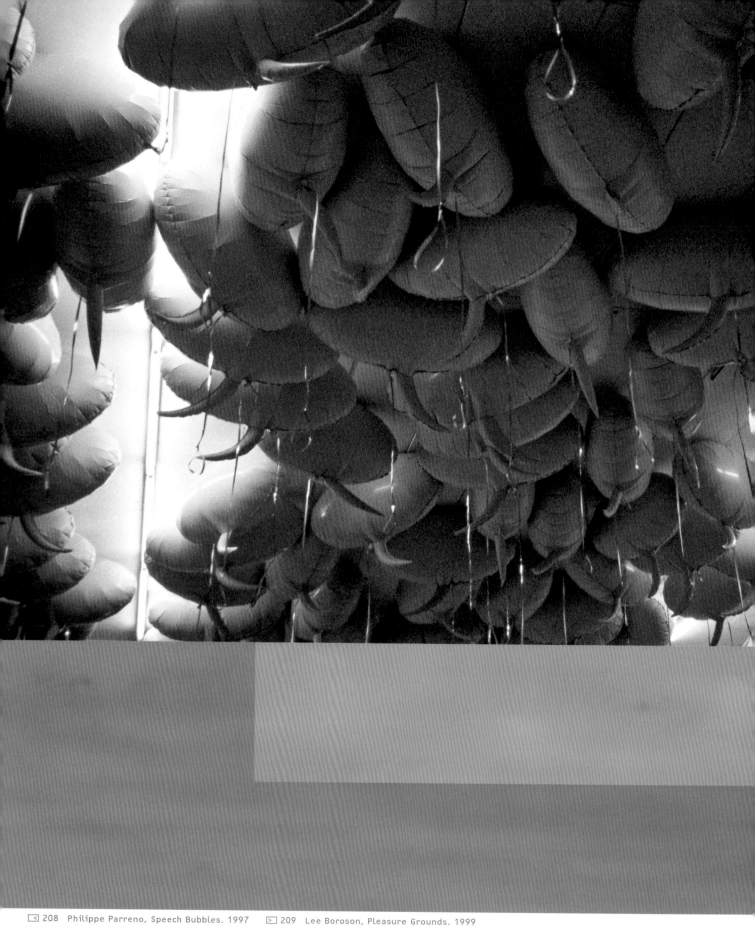

208 Philippe Parreno, Speech Bubbles. 1997 ▷ 209 Lee Boroson, Pleasure Grounds. 1999

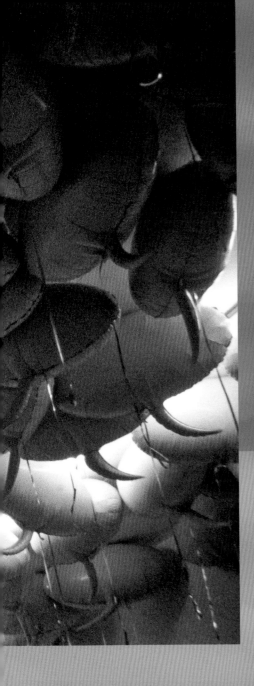

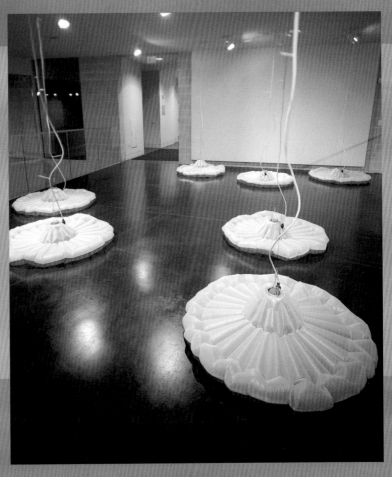

Philippe Parreno, Speech Bubbles. 1997

Brownian movement is the proof that molecular movement in a liquid depends on its temperature.
BASIS _ R. Brown, British botanist, discovers (1827) the movement of pollen on water; effect proven by A. Einstein in 1905.

Die Brownsche Bewegung ist der Beweis, dass die Molekülbewegung in einem Fluid temperaturabhängig ist.
BASIS _ R. Brown, britischer Botaniker, entdeckt 1827 die Bewegung von Pollen auf der Wasseroberfläche; dieser Effekt wurde durch A. Einstein 1905 bewiesen

Molecules of impurities in the air («industrial snow») or dust particles can be the seeds for conversion to solid state.
BASIS _ Freezing point of water as the fix point of thermodynamic Kelvin to degree Celsius temperature scale at an atmospheric pressure of 612 Pa

Moleküle von Luftverunreinigenden Substanzen («Industrieschnee») oder Staubteilchen können als Keim für den Wechsel in den festen Zustand dienen.
BASIS _ Die Verfestigung von Wasser dient als Fixpunkt der thermodynamischen Kelvin zur Grad Celsius Temperaturskala bei atmosphärischem Druck von 612 Pa

Molecules of impurities in the air (»industrial snow«)
or dust particles can be the seeds for conversion
to solid state.

BASIS _ Freezing point of water as the fix point of thermodynamic
Kelvin to degree Celsius temperature scale at an atmospheric
pressure of 612 Pa

Moleküle von luftverunreinigenden Substanzen
(»Industrieschnee«) oder Staubteilchen können als
Keim für den Wechsel in den festen Zustand dienen.

BASIS _ Die Verfestigung von Wasser dient als Fixpunkt der
thermodynamischen Kelvin zur Grad Celsius Temperaturskala bei
atmosphärischem Druck von 612 Pa

Brownian movement is the proof that molecular movement
in a liquid depends on its temperature.

BASIS _ R. Brown, British botanist, discovers (1827) the movement
of pollen on water; effect proven by A. Einstein in 1905

Die Brownsche Bewegung ist der Beweis, dass die Mole-
külbewegung in einem Fluid temperaturabhängig ist.

BASIS _ R. Brown, britischer Botaniker, entdeckt 1827 die Bewegung
von Pollen auf der Wasseroberfläche; dieser Effekt wurde durch
A. Einstein 1905 bewiesen

0 °C = 273.15 K ENERGY LEVEL / ENERGIESTUFE

The realm of air is movement and processes; however, these are not as light and fluid as they seem.

BASIS _ Three-quarters of the earth are covered by water

Das Reich der Luft ist das der Bewegung und Prozesse, jedoch sind diese nicht so leicht und fließend, wie es erscheint.

BASIS _ Drei Viertel der Erde sind wasserbedeckt

0 °C = 273.15 K ENERGY LEVEL / ENERGIESTUFE

Air has been circling the globe for about 1.5 billion years and circles daily through us.

BASIS _ Three-quarters of the earth are covered by water

Seit rund 1,5 Milliarden Jahren durchläuft Luft den globalen Kreislauf, und täglich uns.

BASIS _ Drei Viertel der Erde sind wasserbedeckt

The realm of air is movement and processes; however,
these are not as light and fluid as they seem.
BASIS _ Three-quarters of the earth are covered by water

Das Reich der Luft ist das der Bewegung und Prozesse,
jedoch sind diese nicht so leicht und fließend, wie
es erscheint.
BASIS _ Drei Viertel der Erde sind wasserbedeckt

Air has been circling the globe for about 1.5 billion
years and circles daily through us.
BASIS _ Three-quarters of the earth are covered by water

Seit rund 1,5 Milliarden Jahren durchläuft Luft den
globalen Kreislauf, und täglich uns.
BASIS _ Drei Viertel der Erde sind wasserbedeckt

Steam is gaseous water and invisible. What is usually taken for steam is actually fog. Minuscule, extremely finely distributed water droplets in air. An emulsion of liquid water in gas.

BASIS _ Three-quarters of the earth are covered by water

Wasserdampf ist gasförmiges Wasser und unsichtbar. Was meist für Dampf gehalten wird, ist tatsächlich Nebel. Winzige, feinstverteilte Wassertröpfchen in der Luft. Eine Emulsion von flüssigem Wasser in Gas.

BASIS _ Drei Viertel der Erde sind wasserbedeckt

Clouds are visible accumulations of steam condensation by-products floating in the free atmosphere.

BASIS _ Very small water droplets less than 0.02 mm in diameter and/or ice crystals

Wolken sind sichtbare, in der freien Atmosphäre schwebende Ansammlungen von Wasserdampfkondensationsprodukten.

BASIS _ Sehr kleine Wassertröpfchen, Durchmesser unter 0.02 mm und/oder Eiskristalle

0 °C = 273.15 K ENERGY LEVEL / ENERGIESTUFE

Steam is gaseous water and invisible. What is usually
taken for steam is actually fog. Minuscule, extremely
finely distributed water droplets in air. An emulsion
of liquid water in gas.
BASIS __ Three-quarters of the earth are covered by water

Wasserdampf ist gasförmiges Wasser und unsichtbar.
Was meist für Dampf gehalten wird, ist tatsächlich
Nebel. Winzige, feinstverteilte Wassertröpfchen in der
Luft. Eine Emulsion von flüssigem Wasser in Gas.
BASIS __ Drei Viertel der Erde sind wasserbedeckt

0 °C = 273.15 K ENERGY LEVEL / ENERGIESTUFE

Clouds are visible accumulations of steam condensation
by-products floating in the free atmosphere.
BASIS __ Very small water droplets less than 0.02 mm in diameters
and/or ice crystals

Wolken sind sichtbare, in der freien Atmosphäre
schwebende Ansammlungen von Wasserdampfkondensa-
tionsprodukten.
BASIS __ Sehr kleine Wassertröpfchen, Durchmesser unter
0,02 mm und/oder Eiskristalle

In order for clouds to form in the atmosphere, humid
air must drop below the thawing point of water in the
presence of condensation seeds.
BASIS _ Steam molecules aggregate on condensation seeds

Damit sich Wolken in der Atmosphäre bilden können,
muss feuchte Luft unter den Taupunkt fallen und müssen
Kondensationskerne da sein.
BASIS _ Dampfmoleküle lagern sich an Kondensationskerne an

Clouds differ in form and altitude depending on the
velocity of the vertical movement causing them. Division
into 10 characteristic types with several classes and
subgroups according to shape.
BASIS _ Luke Howard's cloud scheme with Latin terminology was
published in 1803

Wolken werden aufgrund der Stärke der Vertikalbewe-
gung, die sie entstehen lässt, nach Form und Höhe
unterschieden. Gestaltabhängig werden 10 charakte-
ristische Typen mit mehreren Klassen und Unterarten
unterschieden.
BASIS _ Luke Howards' Wolkenschema mit lateinischer Namensgebung
wurde 1803 veröffentlicht

Clouds differ in form and altitude depending on the velocity of the vertical movement causing them. Division into 10 characteristic types with several classes and subgroups according to shape.

BASIS _ Luke Howard's cloud schema with Latin terminology was published in 1803.

Wolken werden aufgrund der Stärke der Vertikalbewegung, die sie entstehen lässt, nach Form und Höhe unterschieden. Gestaltabhängig werden 10 charakteristische Typen mit mehreren Klassen und Untergruppen unterschieden.

BASIS _ Luke Howards Wolkenschema mit lateinischer Namensgebung wurde 1803 veröffentlicht.

In order for clouds to form in the atmosphere, humid air must drop below the thawing point of water in the presence of condensation seeds.

BASIS _ Steam molecules aggregate on condensation seeds

Damit sich Wolken in der Atmosphäre bilden können, muss feuchte Luft unter den Taupunkt fallen und müssen Kondensationskerne da sein.

BASIS _ Dampfmoleküle lagern sich an Kondensationskerne an

< 244 / 340 >

0 °C = 273.15 K ENERGY LEVEL / ENERGIESTUFE

grey, uniform cloud layer with lower boundary mainly below 600 m, from which only small droplets can precipitate.
LOWER LEVEL: 0-2 km _ Water clouds, stratus, changing at lower temperatures to mixed clouds

graue, gleichförmige Wolkenschicht mit tiefer Unter-grenze meist unter 600 m, aus der nur kleintropfiger Niederschlag fallen kann.
UNTERES STOCKWERK: 0-2 km _ Wasserwolken, Stratus, werden bei tieferen Temperaturen Mischwolken

0 °C = 273.15 K ENERGY LEVEL / ENERGIESTUFE

grey or whitish, non-isomorphically aggregated cloud layer with deep, coarse structures.
LOWER LEVEL: 0-2 km _ Water clouds, stratocumulus, changing at lower temperatures to mixed clouds

graue oder weißliche, ungleichförmig zusammen-gewachsene Wolkenschicht mit tiefen, groben Strukturen.
UNTERES STOCKWERK: 0-2 km _ Wasserwolken, Stratokumulus, werden bei tieferen Temperaturen Mischwolken

OBERES STOCKWERK
UPPER LEVEL

TROPOSPHÄRE

MITTLERES STOCKWERK
MEDIUM LEVEL

UNTERES STOCKWERK
LOWER LEVEL

km
19
18
17
16
15
14
13
12
11
10
9
8
7
6
5
4
3
2
1
0

km

19

18

17

16

15

14

13 TROPOPAUSE -

12

11

10

9

UPPER LEVEL
OBERES STOCKWERK

8 0 °C = 273.15 K ENERGY LEVEL / ENERGIESTUFE

Grey, uniform cloud layer with lower boundary mainly
below 600 m, from which only small droplets can
7 precipitate.
LOWER LEVEL: 0–2 km __ Water clouds, **stratus**, changing at lower
temperatures to mixed clouds 0 °C = 273.15 K ENERGY LEVEL / ENERGIESTUFE
6
Grey or whitish, non-isomorphically aggregated cloud
Graue, gleichförmige Wolkenschicht mit tiefer Unter- layer with deep, coarse structures.
grenze meist unter 600 m, aus der nur kleintropfiger LOWER LEVEL: 0–2 km __ Water clouds, **stratocumulus**, changing at
5 Niederschlag fallen kann. lower temperatures to mixed clouds
UNTERES STOCKWERK: 0–2 km __ Wasserwolken, **Stratus**, werden
bei tieferen Temperaturen Mischwolken Graue oder weißliche, ungleichförmig zusammen-
4 gewachsene Wolkenschicht mit tiefen, groben Strukturen.
UNTERES STOCKWERK: 0–2 km __ Wasserwolken, **Stratokumulus**,
werden bei tieferen Temperaturen Mischwolken

3

2

1

LOWER LEVEL
UNTERES STOCKWERK

0

TROPOSPHERE
MEDIUM LEVEL
MITTLERES STOCKWERK

0 °C = 273.15 K ENERGY LEVEL / ENERGIESTUFE

Grey to dark grey, uniformly textureless cloud layer with
uneven lower boundary, lasting precipitation.
LOWER LEVEL: 0–2 km __ Water clouds, nimbostratus, changing at
lower temperatures to mixed clouds

Graue bis dunkelgraue, gleichmäßig strukturlose
Wolkenschicht mit uneinheitlicher Untergrenze, aus der
anhaltender Niederschlag fällt.
UNTERES STOCKWERK: 0–2 km __ Wasserwolken, Nimbostratus,
werden bei tieferen Temperaturen Mischwolken

0 °C = 273.15 K ENERGY LEVEL / ENERGIESTUFE

Densely piled clouds with sharp perimeters, almost
horizontal, dark lower boundaries, bright white in
sunlight.
LOWER LEVEL: 0–2 km __ Water clouds, cumulus, changing at lower
temperatures to mixed clouds

Dichte, scharf abgegrenzte Haufenwolken mit nahezu
horizontaler, dunkler Untergrenze, leuchtend weiß
im Sonnenlicht.
UNTERES STOCKWERK: 0–2 km __ Wasserwolken, Kumulus, werden
bei tieferen Temperaturen Mischwolken

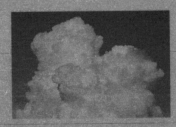

km

19

18

17

16

15

14

TROPOPAUSE 13

12

11

10

9

8 UPPER LEVEL / OBERES STOCKWERK

7

6 TROPOSPHERE

5

4 MEDIUM LEVEL / MITTLERES STOCKWERK

3

2

1 LOWER LEVEL / UNTERES STOCKWERK

OBERES STOCKWERK
UPPER LEVEL

MITTLERES STOCKWERK
MEDIUM LEVEL

UNTERES STOCKWERK
LOWER LEVEL

TROPOSPHÄRE

0 °C = 273.15 K ENERGY LEVEL / ENERGIESTUFE

Densely piled clouds with sharp perimeters, almost horizontal, dark lower boundaries, bright white in sunlight.

LOWER LEVEL: 0–2 km _ Water clouds, cumulus, changing at lower temperatures to mixed clouds

Dichte, scharf abgegrenzte Haufenwolken mit nahezu horizontaler, dunkler Untergrenze, leuchtend weiß im Sonnenlicht.

UNTERES STOCKWERK: 0–2 km _ Wasserwolken, Kumulus, werden bei tieferen Temperaturen Mischwolken

0 °C = 273.15 K ENERGY LEVEL / ENERGIESTUFE

Grey to dark grey, uniformly textureless cloud layer with uneven lower boundary, lasting precipitation.

LOWER LEVEL: 0–2 km _ Water clouds, nimbostratus, changing at lower temperatures to mixed clouds

Graue bis dunkelgraue, gleichmäßig strukturlose Wolkenschicht mit uneinheitlicher Untergrenze, aus der anhaltender Niederschlag fällt.

UNTERES STOCKWERK: 0–2 km _ Wasserwolken, Nimbostratus, werden bei tieferen Temperaturen Mischwolken

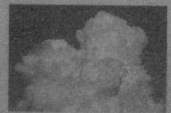

0 °C = 273.15 K ENERGY LEVEL / ENERGIESTUFE

Higher, coarser patches of white or grey cloud of flattened structure.
MEDIUM LEVEL: 2-7 km _ Water clouds, altocumulus, changing at lower temperatures to mixed clouds

Höhere, gröbere Wolkenfelder aus flachen weißen oder grauen Strukturen.
MITTLERES STOCKWERK: 2-7 km _ Wasserwolken, Altokumulus, werden bei tieferen Temperaturen Mischwolken

0 °C = 273.15 K ENERGY LEVEL / ENERGIESTUFE

Massively piled clouds with anvil-shaped upper boundary, from which showers fall, with thunderstorms.
LOWER LEVEL: 0-2 km _ Water clouds, cumulonimbus, changing at lower temperatures to mixed clouds

Mächtig aufgetürmte Haufenwolken mit ambossförmiger Obergrenze, aus der Schauer-Niederschläge fallen, mit Gewitter.
UNTERES STOCKWERK: 0-2 km _ Wasserwolken, Kumulonimbus, werden bei tieferen Temperaturen Mischwolken

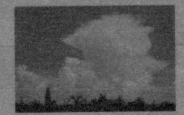

km
19
18
17
16
15
14
13
12
11
10
9
8
7
6
5
4
3
2
0

TROPOPAUSE

TROPOSPHERE

OBERES STOCKWERK / UPPER LEVEL

MITTLERES STOCKWERK / MIDDLE LEVEL

UNTERES STOCKWERK / LOWER LEVEL

km

19

18

17

16

15

14

13 — TROPOPAUSE -

12

11

10

9

8 — UPPER LEVEL / OBERES STOCKWERK

0 °C = 273.15 K ENERGY LEVEL / ENERGIESTUFE

Higher, coarser patches of white or grey cloud of
flattened structure.
MEDIUM LEVEL: 2-7 km __ Water clouds, **altocumulus**, changing
at lower temperatures to mixed clouds

Höhere, gröbere Wolkenfelder aus flachen weißen oder
grauen Strukturen.
MITTLERES STOCKWERK: 2-7 km __ Wasserwolken, **Altokumulus**,
werden bei tieferen Temperaturen Mischwolken

7

0 °C = 273.15 K ENERGY LEVEL / ENERGIESTUFE

Massively piled clouds with anvil-shaped upper
boundary, from which showers fall, with thunderstorms.
LOWER LEVEL: 0-2 km __ Water clouds, **cumulonimbus**, changing
at lower temperatures to mixed clouds

6

Mächtig aufgetürmte Haufenwolken mit ambossförmiger
Obergrenze, aus der Schauer-Niederschläge fallen,
mit Gewitter.
UNTERES STOCKWERK: 0-2 km __ Wasserwolken, **Kumulonimbus**,
werden bei tieferen Temperaturen Mischwolken

5 — TROPOSPHERE

4 — MEDIUM LEVEL / MITTLERES STOCKWERK

3

2

1 — LOWER LEVEL / UNTERES STOCKWERK

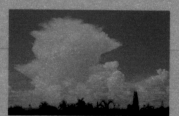

0

0 °C = 273.15 K ENERGY LEVEL / ENERGIESTUFE

Spots, fields or layers of small white flocular or
spherical clouds arranged in rows or ribs.
UPPER LEVEL: 7–13 km _ Ice clouds, cirrocumulus,
consist almost entirely of ice crystals

Flecken, Felder oder Schichten mit kleinen, weißen
Wolkenflecken oder -bällchen, die in Reihen oder
Rippen angeordnet sind.
OBERES STOCKWERK: 7–13 km _ Eiswolken, Cirrocumulus,
bestehen fast ausschließlich aus Eiskristallen

0 °C = 273.15 K ENERGY LEVEL / ENERGIESTUFE

Greyish or bluish, even cloud layer covering large
areas of sky, with a watery sun showing through in
places.
MEDIUM LEVEL: 2–7 km _ Water clouds, altostratus, changing
at lower temperatures to mixed clouds

Graue oder bläuliche, gleichmäßige Wolkenschicht die
große Teile des Himmels bedeckt, stellenweise kann
die Sonne verwaschen gesehen werden.
MITTLERES STOCKWERK: 2–7 km _ Wasserwolken, Altostratus,
werden bei tieferen Temperaturen Mischwolken

km

19

18

17

16

15

14

TROPOPAUSE 13

12

11

10

9

UPPER LEVEL / OBERES STOCKWERK 8

7

6

TROPOSPHERE 5

4

MEDIUM LEVEL / MITTLERES STOCKWERK 3

2

LOWER LEVEL / UNTERES STOCKWERK 1

0

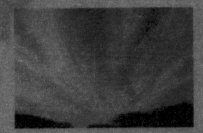

km

19

18

17

16

15

14

13 TROPOPAUSE

12

11

10

9

8

7

6

5

4

3

2

1

0

0 °C = 273.15 K ENERGY LEVEL / ENERGIESTUFE

A thin, white veil of ice clouds, usually blanketing
the whole sky and causing halo phenomena.
UPPER LEVEL: 7–13 km _ ice clouds, cirrostratus, consist
entirely of ice crystals

Dünner, weißer Eiswolkenschleier, der meist den
ganzen Himmel überzieht und Halo-Erscheinungen
hervorruft.
OBERES STOCKWERK: 7–13 km _ Eiswolken, Zirrostratus,
bestehen ausschließlich aus Eiskristallen

0 °C = 273.15 K ENERGY LEVEL / ENERGIESTUFE

Turbulence causes feathery clouds of ice, which are
white and silkily glossy, to be formed from single strands
or tufts.
UPPER LEVEL: 7–13 km _ ice clouds, cirrus, are also formed from
an airplane condensation trail

Durch Turbulenz entstehen aus einzelnen Fasern oder
Büscheln gebildete Federwolken aus Eis, die weiß und
seidig glänzen.
OBERES STOCKWERK: 7–13 km _ Eiswolken, Zirrus, entstehen auch
aus Kondensstreifen von Flugzeugen

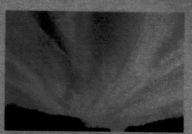

UPPER LEVEL
OBERES STOCKWERK

TROPOSPHERE

MEDIUM LEVEL
MITTLERES STOCKWERK

LOWER LEVEL
UNTERES STOCKWERK

0 °C = 273.15 K ENERGY LEVEL / ENERGIESTUFE

Polar regions 3–8 km, temperate latitudes 7–13 km,
tropics 6–18 km altitude.
UPPER LEVEL _ Ice clouds (cirrocumulus, cirrostratus, cirrus)
consisting mainly or entirely of ice

Polargebiete 3–8 km, mittlere Breiten 7–13 km,
Tropen 6–18 km Höhe.
OBERES STOCKWERK _ Eiswolken (Zirrokumulus, Zirrostratus,
Zirrus) bestehen überwiegend oder völlig aus Eis

0 °C = 273.15 K ENERGY LEVEL / ENERGIESTUFE

Polar regions 2–4 km, temperate latitudes 2–7 km,
tropics 2–8 km altitude.
MEDIUM LEVEL _ Water clouds (altocumulus, altostratus)
changing at lower temperatures to mixed clouds

Polargebiete 2–4 km, mittlere Breiten 2–7 km,
Tropen 2–8 km Höhe.
MITTLERES STOCKWERK _ Wasserwolken (Altokumulus, Altostratus)
werden bei tieferen Temperaturen Mischwolken

km

19

18

17

16

15

14

13 TROPOPAUSE

12

11

10

9

8 UPPER LEVEL / OBERES STOCKWERK

7

6 TROPOSPHERE

5

4 MEDIUM LEVEL / MITTLERES STOCKWERK

3

2

1 LOWER LEVEL / UNTERES STOCKWERK

0

0 °C = 273.15 K ENERGY LEVEL / ENERGIESTUFE

Polar regions 5-8 km, temperate latitudes 7-13 km,
tropics 6-18 km altitude.
UPPER LEVEL Ice clouds (cirrocumulus, cirrostratus, cirrus)
consisting mainly of snow or ice.

Polargebiete 5-8 km, mittlere Breiten 7-13 km,
Tropen 6-18 km Höhe.
OBERES STOCKWERK Eiswolken (Cirrocumulus, Cirrostratus,
Cirrus) hauptsächlich bestehend aus Schnee und Eis.

0 °C = 273.15 K ENERGY LEVEL / ENERGIESTUFE

Polar regions 2-4 km, temperate latitudes 2-7 km,
tropics 2-8 km altitude
MEDIUM LEVEL Water clouds (altocumulus, altostratus)
changing at lower temperatures to mixed clouds

Polargebiete 2-4 km, mittlere Breiten 2-7 km,
Tropen 2-8 km Höhe.
MITTLERES STOCKWERK Wasserwolken (Altocumulus, Altostratus)
werden bei tieferen Temperaturen Mischwolken

km

19
18
17
16
15
14
13 TROPOPAUSE
12
11
10
9
8 UPPER LEVEL
 OBERES STOCKWERK
7
6
5 TROPOSPHERE
4
3 MEDIUM LEVEL MITTLERES STOCKWERK
2 LOWER LEVEL
1 LOWER LEVEL UNTERES STOCKWERK
0

0 °C = 273.15 K ENERGY LEVEL / ENERGIESTUFE

Water clouds have sharp contours and look compact.
BASIS _ Water clouds (stratus, stratocumulus, altocumulus)
changing at lower temperatures to mixed clouds

Wasserwolken haben scharfe Ränder und sehen
kompakt aus.
BASIS _ Wasserwolken (Stratus, Stratokumulus, Altokumulus) werden
bei tieferen Temperaturen Mischwolken

0 °C = 273.15 K ENERGY LEVEL / ENERGIESTUFE

Mixed clouds have partly sharp, partly diffuse contours
and look light to dark grey, depending on their volume.
BASIS _ Mixed clouds (altostratus, nimbostratus, cumulonimbus) are
the main source of precipitation in temperate latitudes

Mischwolken haben teils scharfe, teils diffuse Ränder
und sehen hell- bis dunkelgrau aus, je nach deren
Volumen.
BASIS _ Mischwolken (Altostratus, Nimbostratus, Kumulonimbus)
sind in gemäßigten Breiten wesentlich für Niederschläge

0 °C = 273.15 K ENERGY LEVEL / ENERGIESTUFE

Ice clouds have diffuse or frayed contours, are fibrous
or veil-like in appearance and are glossy white and silky.
BASIS _ Ice clouds (cirrus, cirrostratus, cirrocumulus), cirri are
often caused by airplane exhaust

Eiswolken haben diffuse oder ausgefranste Umrisse,
sehen faser- oder schleierförmig aus, sind weiß und
seidig glänzend.
BASIS _ Eiswolken (Zirrus, Zirrostratus, Zirrokumulus), Zirren bilden
sich häufig durch Flugzeugabgase

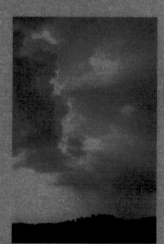

0 °C = 273.15 K ENERGY LEVEL / ENERGIESTUFE

The sun's rays shining through gaps in the clouds to
form light strips is a sign that precipitation will occur.
BASIS _ Scattered or reflected on ice or water particles in haze
contrasting with darker cloud shadows

Bilden durch Wolkenlücken einfallende Sonnenstrahlen
helle Streifen, so ist dies ein Vorzeichen von
Niederschlag.
BASIS _ Gestreut oder reflektiert an Eis- oder Wasserpartikeln
von Dunst, im Kontrast mit dunkleren Wolkenschatten

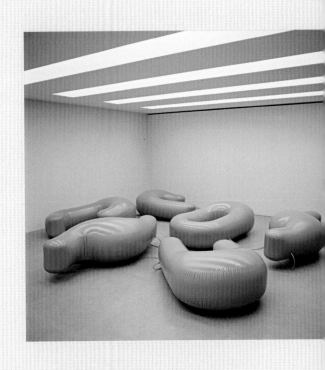

☐ 222 Lang/Baumann, Comfort #2. 2001

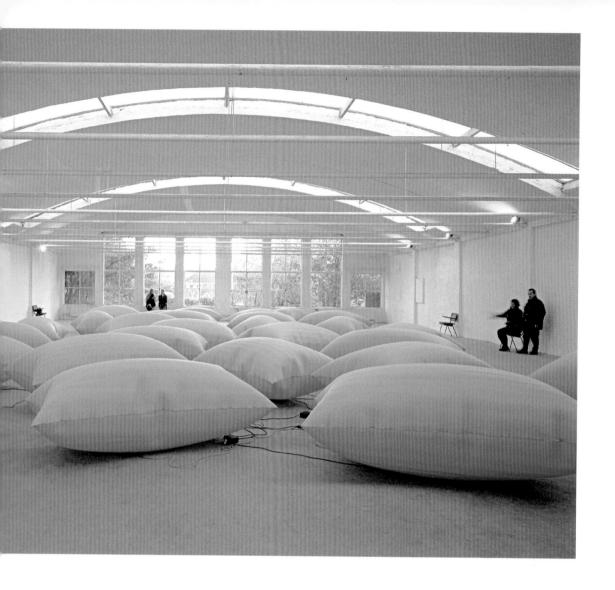

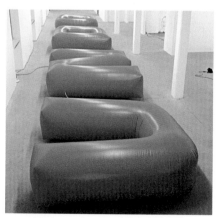

223 Lang/Baumann, Breathing Pillows. 1995 224 Lang/Baumann, undo. 1997 225 Gregor Schilling/Axel Thallemer, Sleep – Air cushion. 2002

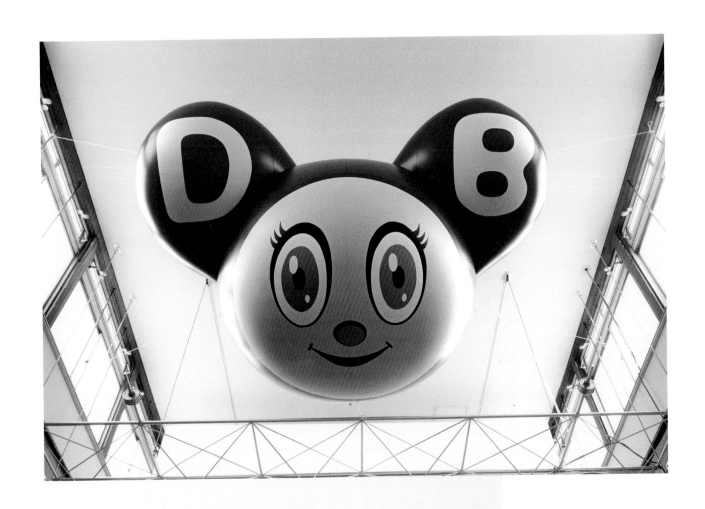

226 Takashi Murakami, Mr. DOB. 1994 227 Momoyo Torimitsu, Somehow I Don't Feel Comfortable. 2000

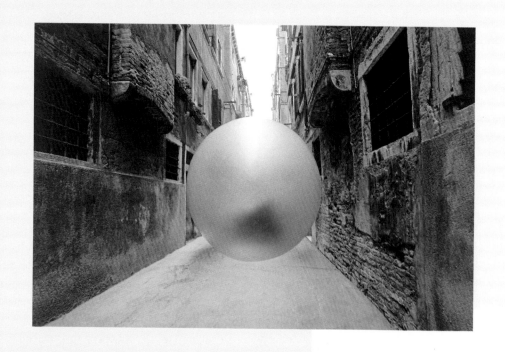

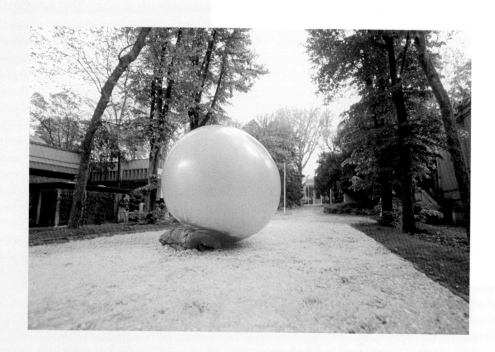

◁ 228 Simone Decker, Chewing in Venice – Chewing gum Largo. 1999 ◁◁ 229 Simone Decker, Chewing in Venice – Chewing gum Misericordia. 1999

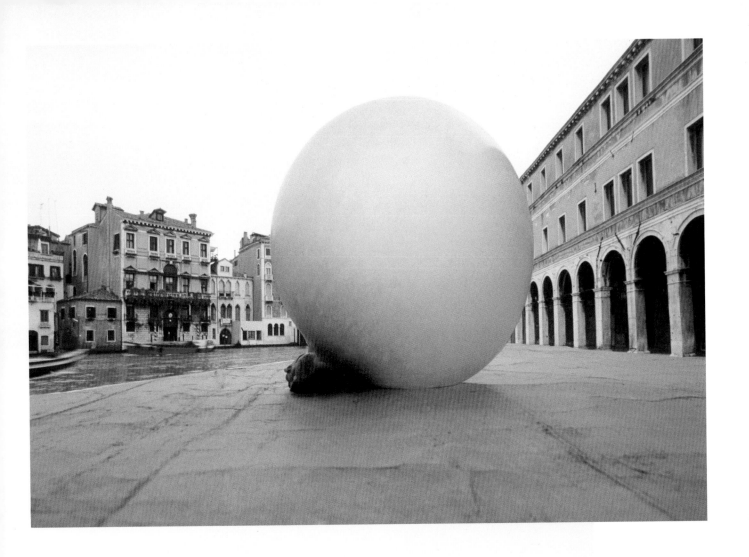

▷ 230 Simone Decker, Chewing in Venice – Chewing gum Rialto. 1999 ▷▷ 231 Simone Decker, Bubble (Ring). 1995

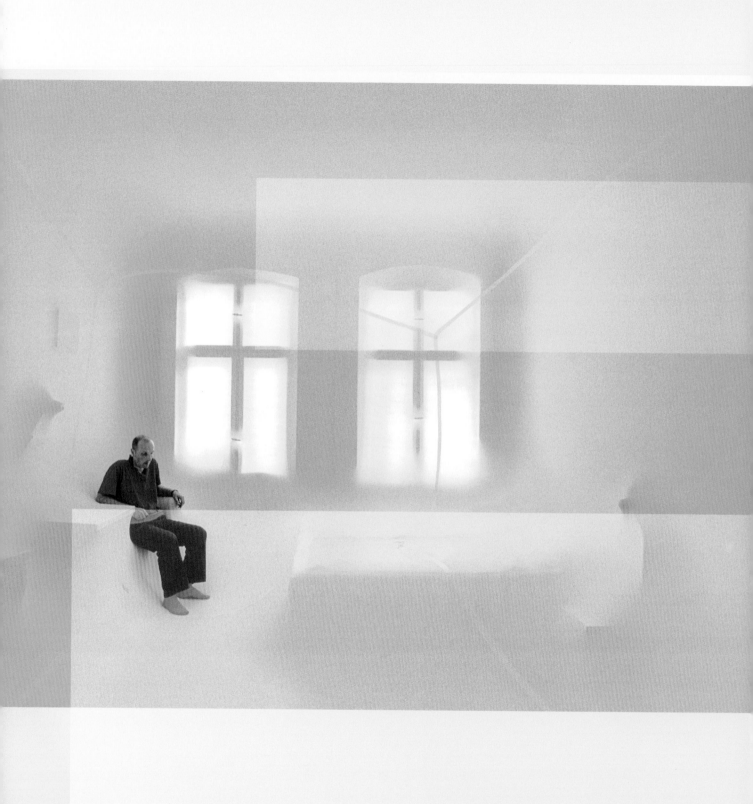

◁ 232 Hans Hemmert, Samstag-Nachmittag, zuhause in Neukölln. 1995 ▷ 233 Hans Hemmert, Ohne Titel. 1998

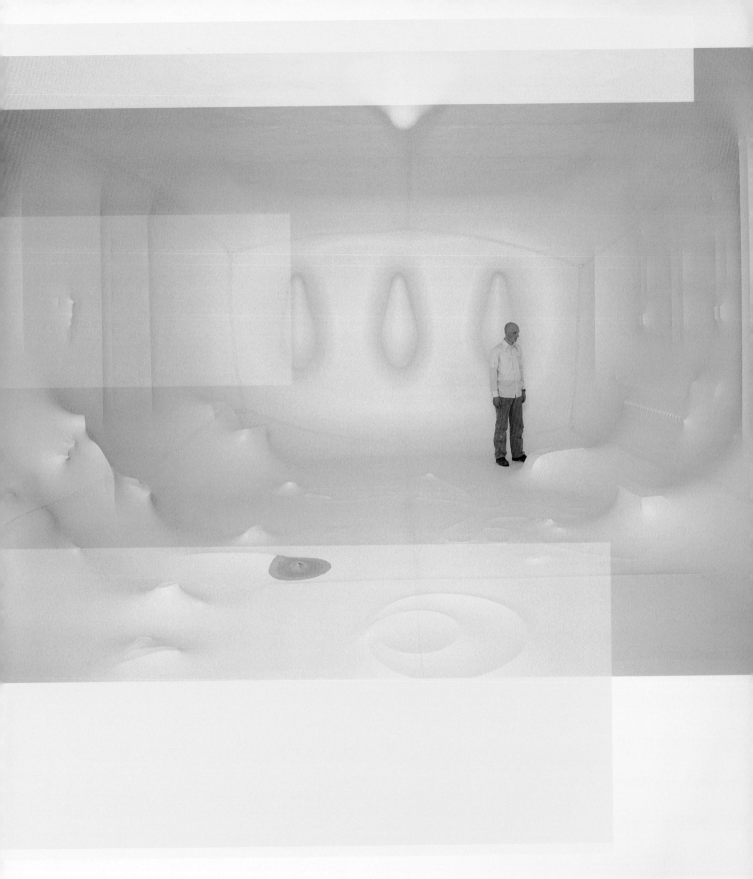

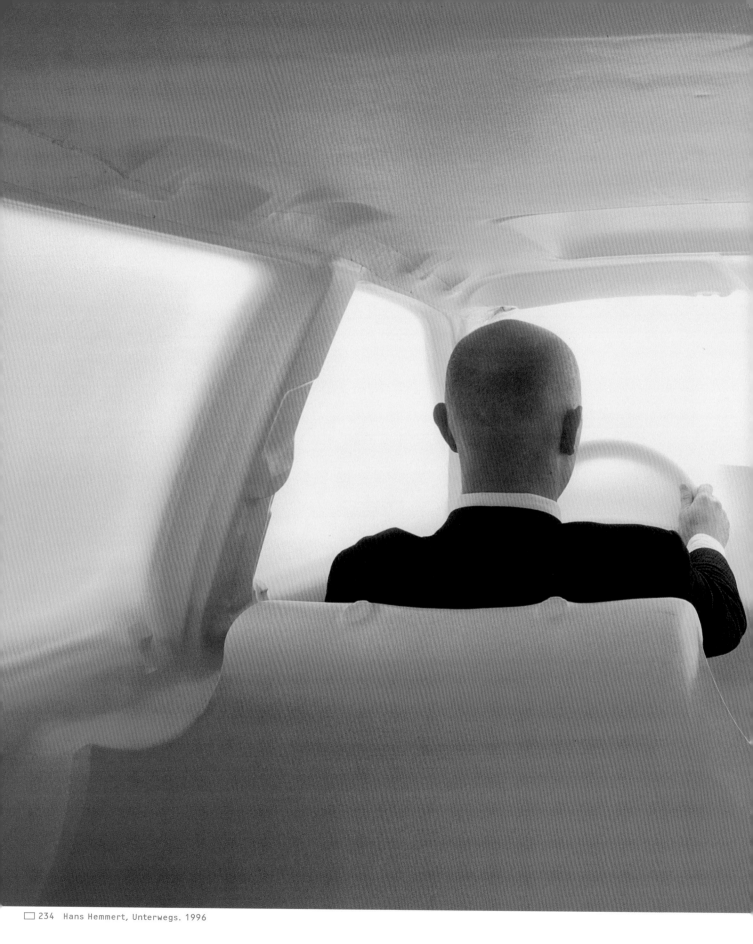

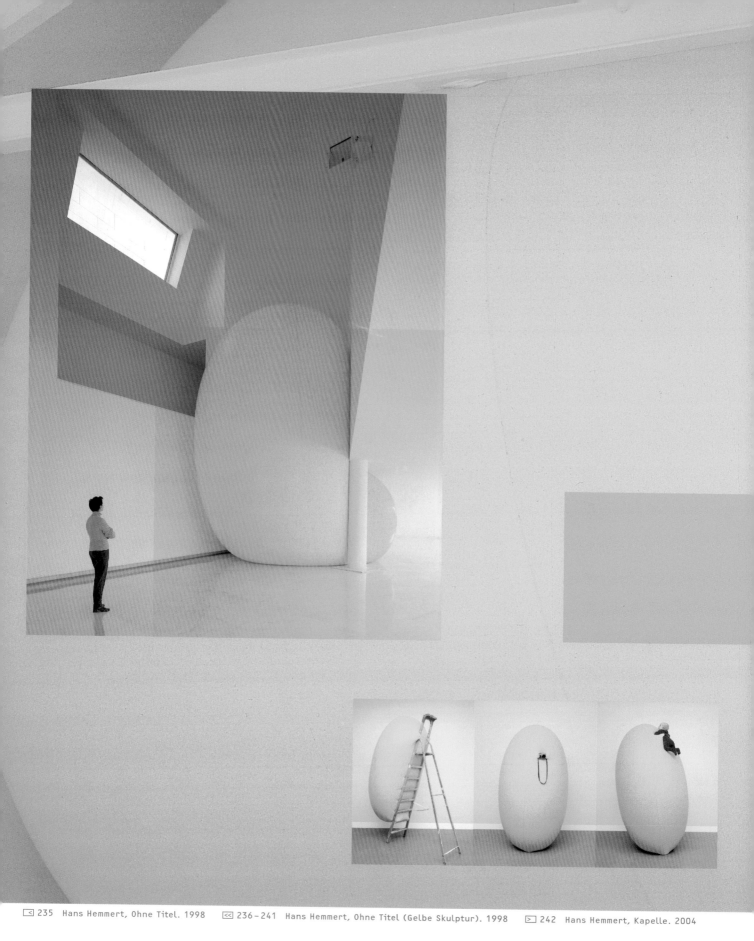

◁ 235 Hans Hemmert, Ohne Titel. 1998 ◁◁ 236–241 Hans Hemmert, Ohne Titel (Gelbe Skulptur). 1998 ▷ 242 Hans Hemmert, Kapelle. 2004

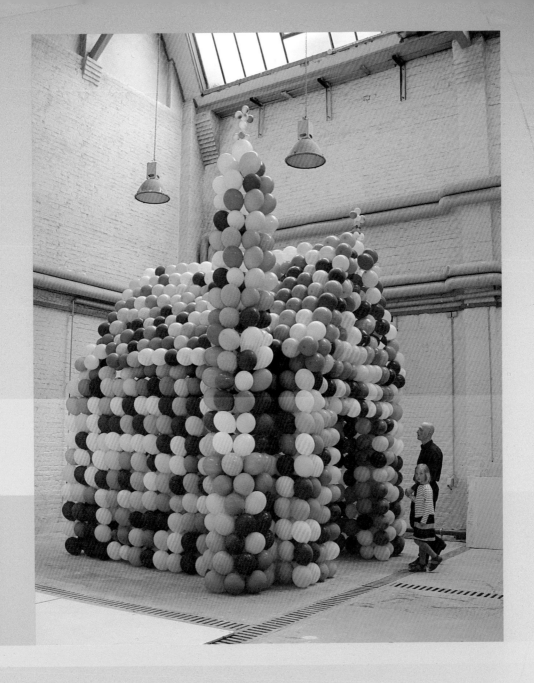

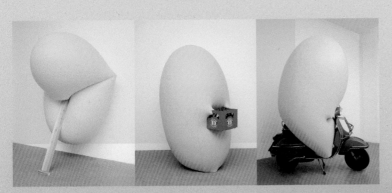

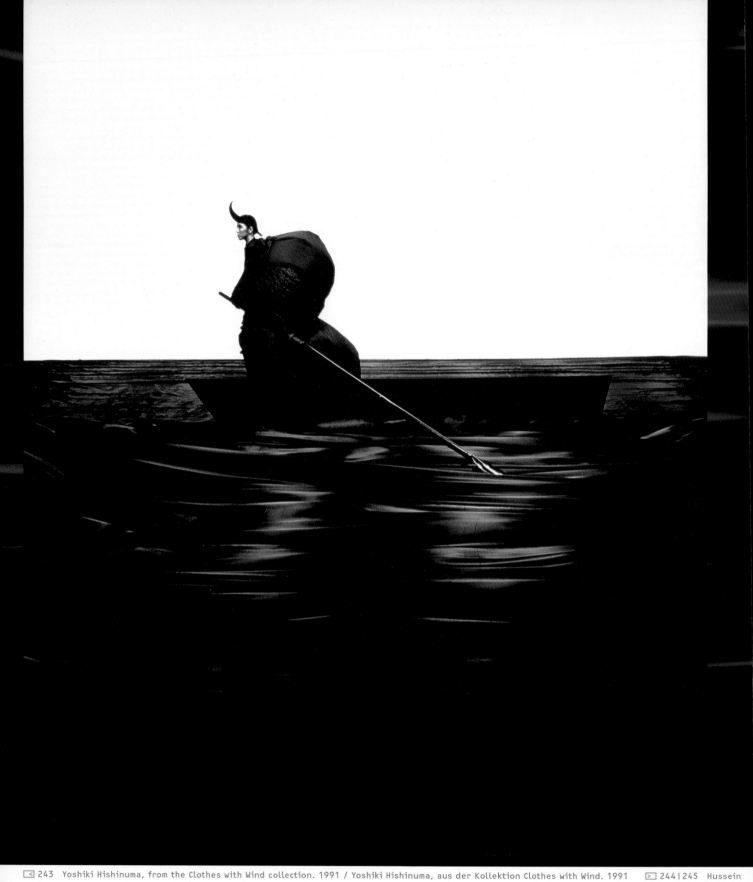

an, from the Kinship Journeys collection. Autumn/Winter 2003/2004 / Hussein Chalayan, Kollektion Kinship Journeys. Herbst/Winter 2003/2004

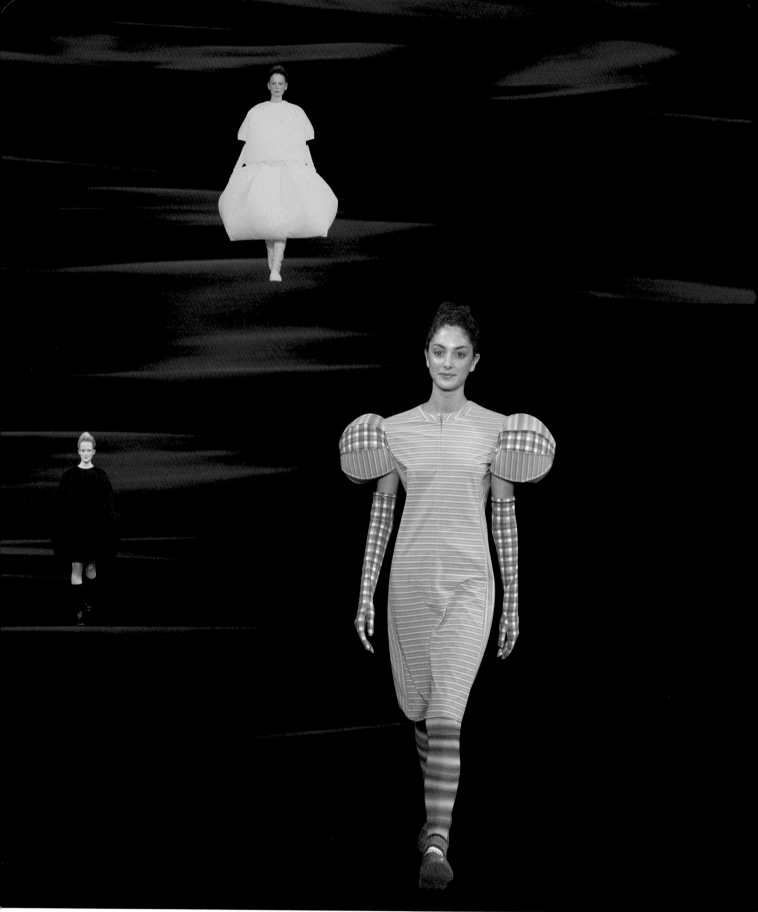

□ 246–249 Issey Miyake (Naoki Takizawa), Autumn/Winter 2000/2001 collection / Issey Miyake (Naoki Takizawa), Kollektion Herbst/Winter 2000/2001

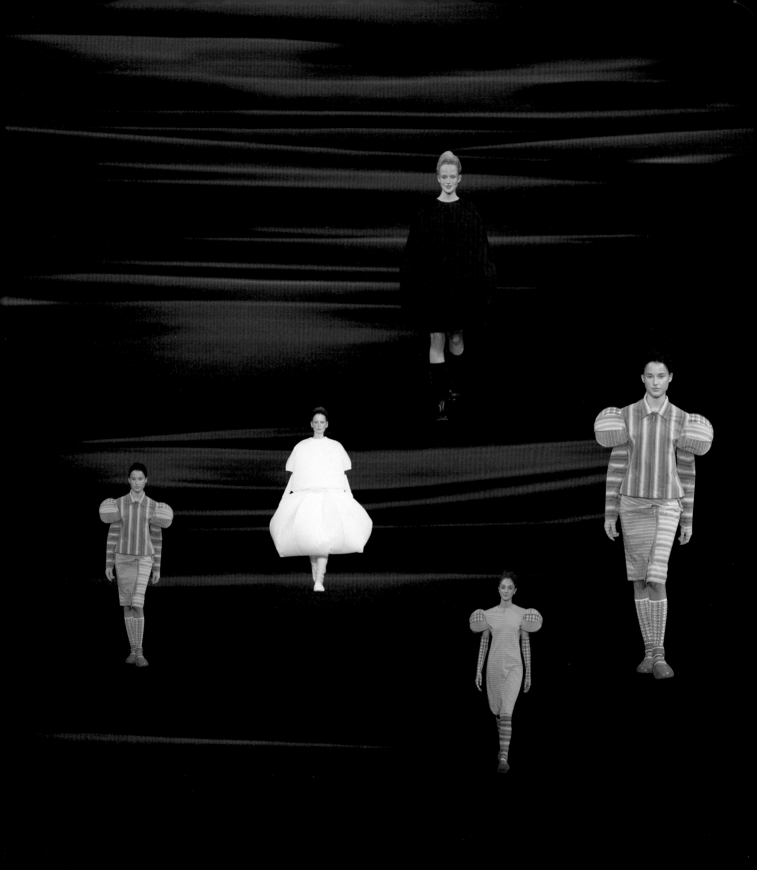

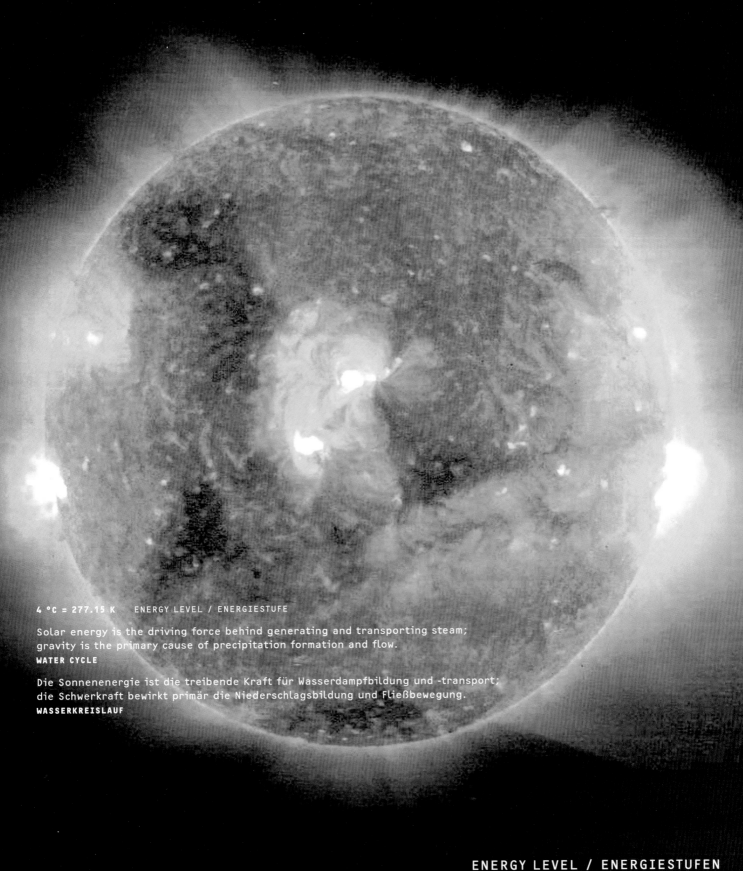

4 °C = 277.15 K ENERGY LEVEL / ENERGIESTUFE

Solar energy is the driving force behind generating and transporting steam; gravity is the primary cause of precipitation formation and flow.
WATER CYCLE

Die Sonnenenergie ist die treibende Kraft für Wasserdampfbildung und -transport; die Schwerkraft bewirkt primär die Niederschlagsbildung und Fließbewegung.
WASSERKREISLAUF

ENERGY LEVEL / ENERGIESTUFEN

4 °C = 277.15 K ENERGY LEVEL / ENERGIESTUFE

About a fourth of the total solar energy absorbed by
the earth maintains the water cycle.
WATER CYCLE

Von der gesamten von der Erde aufgenommenen
Sonnenenergie dient etwa ein Viertel zur Aufrecht-
erhaltung des Wasserkreislaufs.
WASSERKREISLAUF

4 °C = 277.15 K ENERGY LEVEL / ENERGIESTUFE

Air temperature, humidity and movement (winds) deter-
mine the amount of evaporation.
WATER CYCLE

Lufttemperatur, Luftfeuchtigkeit und Luftbewegung
(Winde) bestimmen die Höhe der Verdunstung.
WASSERKREISLAUF

4 °C = 277.15 K ENERGY LEVEL / ENERGIESTUFE

The water cycle, influenced by climatic changes, is one
of the most important links in the climate system.
WATER CYCLE

Der Wasserkreislauf, beeinflusst durch Klimaänderun-
gen, ist eines der wichtigsten Glieder im Klimasystem.
WASSERKREISLAUF

25 °C = 298.15 K ENERGY LEVEL / ENERGIESTUFE

In the troposphere the heat from the earth's radiation and atmospheric radiation is converted into motion.
TROPOSPHERE _ Altitude **0 km**, temperature at the equator

In der Troposphäre wird die von der Strahlung der Erde und Atmosphäre stammende Wärme in Bewegung umgesetzt.
TROPOSPHÄRE _ Höhe **0 km**, Temperatur am Äquator

25 °C = 298.15 K ENERGY LEVEL / ENERGIESTUFE

This motion-driven energy (wind systems, whirlwinds) causes our weather.
TROPOSPHERE _ Altitude **0 km**, temperature at the equator

Diese Bewegungsenergie (Windsysteme, Wirbelstürme) verursacht unser Wetter.
TROPOSPHÄRE _ Höhe **0 km**, Temperatur am Äquator

25 °C = 298.15 K ENERGY LEVEL / ENERGIESTUFE

The amount of energy transformed daily surpasses all the available energy sources on earth by many times the power of ten.
TROPOSPHERE _ Altitude **0 km**, temperature at the equator

Die hier täglich umgesetzte Energie ist viele Zehnerpotenzen größer als alle bisher verfügbaren irdischen Energiequellen.
TROPOSPHÄRE _ Höhe **0 km**, Temperatur am Äquator

25 °C = 298.15 K ENERGY LEVEL / ENERGIESTUFE

Thorough mixing by strong horizontal and vertical exchange, temperature drops by 5–7 °C per km increase in altitude.
TROPOSPHERE _ Altitude **0 km**, temperature at the equator

Starke Durchmischung durch horizontalen und vertikalen Austausch, Temperaturabfall 5–7 °C pro km Höhenzuwachs.
TROPOSPHÄRE _ Höhe **0 km**, Temperatur am Äquator

14 °C = 287.15 K ENERGY LEVEL / ENERGIESTUFE

Temperature inversion caused by the radiation and friction of the earth's surface occurs frequently in the ground layer.
TROPOSPHERE _ Peplosphere, altitude **1–2 km**, temperature at the equator

In der Grundschicht findet eine häufige Temperaturumkehr statt, resultierend aus Strahlungs- und Reibungseinfluss der Erdoberfläche.
TROPOSPHÄRE _ Peplosphäre, Höhe **1–2 km**, Temperatur am Äquator

14 °C = 287.15 K ENERGY LEVEL / ENERGIESTUFE

Daily changes in temperature and the influence exerted by friction on the wind are mainly confined to this layer.
TROPOSPHERE _ Peplosphere, altitude **1–2 km**, temperature at the equator

In dieser Schicht spielt sich hauptsächlich der tägliche Verlauf der Temperatur und der Reibungseinfluss auf den Wind ab.
TROPOSPHÄRE _ Peplosphäre, Höhe **1–2 km**, Temperatur am Äquator

km
1000
900
800
700
EXOSPHERE
600
500
400
300
200
THERMOSPHERE
100
MESOPAUSE
90
80
70
MESOSPHERE
60
50
STRATOPAUSE
40
30
STRATOSPHERE
20
TROPOPAUSE
10
TROPOSPHERE
0

-20 °C = 253.15 K ENERGY LEVEL / ENERGIESTUFE

Upper boundary of the troposphere. Below the tropo-
pause are belt-like undulating zones in which the
highest wind speeds occur ...

TROPOPAUSE _ Altitude **8 km** in the polar regions, altitude **16–17 km**
in the Tropics; temperature at the equator at 8 km altitude

Obergrenze der Troposphäre. Unterhalb der Tropopause
treten bandförmig gewellte Zonen höchster Windge-
schwindigkeit auf ...

TROPOPAUSE _ Höhe **8 km** in Polarregionen, Höhe **16–17 km** in
Tropenregionen; Temperatur am Äquator in 8 km Höhe

-40 °C = 233.15 K ENERGY LEVEL / ENERGIESTUFE

... in temperate latitudes, which are subject to the
greatest extremes in tropospheric air masses.

TROPOPAUSE _ Altitude **8 km**, temperature in summer in the polar
regions

... in mittleren Breiten, die an die stärksten tropo-
sphärischen Luftmassengegensätze gebunden sind.

TROPOPAUSE _ Höhe **8 km**, Temperatur im Sommer im Polargebiet

-75 °C = 198.15 K ENERGY LEVEL / ENERGIESTUFE

There the prevailing jet streams reach speeds of more
than 400 km/h, sometimes more than 600 km/h.

TROPOPAUSE _ Altitude **16 km**, temperature in the Tropics. Length
of the jet streams some 1,000 km, some 100 km wide, the vertical
extension is several kilometers!

Die dort herrschenden Strahlströme erreichen Geschwin-
digkeiten von über 400 km/h, manchmal mehr als
600 km/h.

TROPOPAUSE _ Höhe **16 km**, Temperatur in den Tropen. Die Strahl-
ströme haben eine Länge von einigen 1.000 km; sie sind einige
100 km breit, die vertikale Ausdehnung beträgt einige Kilometer!

km

1000
900
800
700
600 EXOSPHERE
500
400
300
200
100
90 THERMOSPHERE
80 MESOPAUSE
70
60 MESOSPHERE
50 STRATOPAUSE
40
30 STRATOSPHERE
20 TROPOPAUSE
10 TROPOSPHERE
0

−80 °C = 193.15 K ENERGY LEVEL / ENERGIESTUFE

The jet stream is an intense, unstable undulating zone
in the lower stratosphere that runs from west to east.
STRATOSPHERE _ Altitude **17 km**, temperature in the Tropics

Der Strahlstrom ist ein intensives, nicht beständiges,
von West nach Ost gerichtetes ondulierendes Band in der
unteren Stratosphäre
STRATOSPHÄRE _ Höhe **17 km**, Temperatur in den Tropen

−85 °C = 188.15 K ENERGY LEVEL / ENERGIESTUFE

The stratosphere cools off during winter polar nights
to −65 °C to −85 °C, in summer it heats up to −40 °C.
STRATOSPHERE _ Altitude **>20 km**, temperature in the polar regions

In der Winterpolarnacht kühlt die Stratosphäre auf
−65 °C bis −85 °C ab, im Sommer erwärmt sie sich
auf −40 °C.
STRATOSPHÄRE _ Höhe **>20 km**, Temperatur im Polargebiet

−62 °C = 211.15 K ENERGY LEVEL / ENERGIESTUFE

Compared to the tropical stratosphere this is very
strong annual fluctuation.
STRATOSPHERE _ Altitude **>20 km**, summer temperature in the Tropics

Gegenüber der tropischen Stratosphäre ist dies eine
sehr starke jährliche Schwankung.
STRATOSPHÄRE _ Höhe **>20 km**, Sommer-Temperatur in den Tropen

−40 °C = 233.15 K ENERGY LEVEL / ENERGIESTUFE

This overheating reverses the direction of the current
during the summer to flow east instead of west.
STRATOSPHERE _ Altitude **>20 km**, summer temperature in the polar
regions

Diese Überwärmung dreht im Sommer die Luftströmungen
von westliche auf östliche Richtungen.
STRATOSPHÄRE _ Höhe **>20 km**, Sommer-Temperatur im Polargebiet

−62 °C = 211.15 K ENERGY LEVEL / ENERGIESTUFE

Beyond the tropopause, wind and humidity rapidly decre-
ase so that the stratosphere is virtually cloud-free.
STRATOSPHERE _ At altitudes of **25-30 km** only scattered
mother-of-pearl clouds

Oberhalb der Tropopause nehmen Wind und Feuchte rasch
ab, so dass die Stratosphäre praktisch wolkenfrei ist.
STRATOSPHÄRE _ Nur in Höhen von **25-30 km** gibt es vereinzelt
Perlmutterwolken

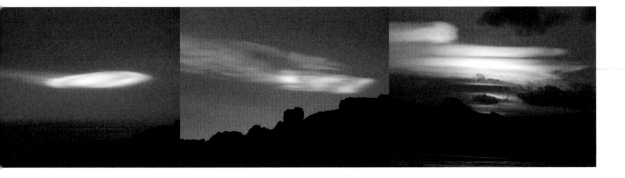

km
1000
900
800
700
EXOSPHERE
600
500
400
300
200
100
90
THERMOSPHERE
80
MESOPAUSE
70
60
MESOSPHERE
STRATOPAUSE
50
40
30
STRATOSPHERE
20
TROPOPAUSE
10
TROPOSPHERE
0

-10 °C = 263.15 K ENERGY LEVEL / ENERGIESTUFE

In the upper stratosphere temperatures rise sharply
due to ultraviolet-ray absorption in the ozone layer
(20–35 km).
STRATOSPHERE _ Sound-waves terminate at altitudes of up to
ca. 40 km

In der oberen Stratosphäre steigen die Temperaturen
durch UV-Absorption in der Ozonschicht (20–35 km)
stark an.
STRATOSPHÄRE _ In Höhen bis **ca. 40 km** enden Schallwellen

10 °C = 283.15 K ENERGY LEVEL / ENERGIESTUFE

Atmospheric pressure and air density, which have fallen
to $1/10$ of ground values at the tropopause, diminish to
$1/1000$ in the stratopause.
STRATOPAUSE _ Maximum temperature at **ca. 45 km** altitude

Luftdruck und -dichte, die bis zur Tropopause auf
ca. $1/10$ der Bodenwerte gefallen sind, nehmen in der
Stratopause bis auf $1/1000$ ab.
STRATOPAUSE _ Maximale Temperatur in **ca. 45 km** Höhe

-80 °C = 193.15 K ENERGY LEVEL / ENERGIESTUFE

The temperature again decreases rapidly. Altitudes
of 55–70 km are the upper limit of dawn and dusk and
for meteors.
MESOSPHERE _ Minimum temperature at an altitude of **ca. 80 km** in
temperate latitudes

Die Temperatur nimmt wieder rasch ab. In 55–70 km Höhe
ist die Obergrenze der Dämmerung und für Meteore.
MESOSPHÄRE _ Minimale Temperatur der Atmosphäre in **ca. 80 km** Höhe
in mittleren Breiten

-80 °C = 193.15 K ENERGY LEVEL / ENERGIESTUFE

The term »meteor« denotes cosmic solids or meteoro-
logical phenomena (except clouds) in the earth's
atmosphere.
MESOSPHERE _ Greek <metéoron> for sky-/air-phenomena,
<metéoros> for »hovering in air«

Mit dem Begriff »Meteor« werden kosmische Körper oder
meteorologische Phänomene (außer Wolken) in der Erd-
atmosphäre bezeichnet.
MESOSPHÄRE _ Griech. <metéoron> für eine Himmels-/Lufterscheinung,
<metéoros> für »in der Luft schwebend«

-80 °C = 193.15 K ENERGY LEVEL / ENERGIESTUFE

Lower boundary of the ionosphere at mesopause.
Noctilucent clouds form here.
MESOPAUSE _ Minimum temperature at **ca. 80 km** altitude in temperate
latitudes

Die Untergrenze der Ionosphäre liegt etwa bei der Meso-
pause. Hier bilden sich die leuchtenden Nachtwolken.
MESOPAUSE _ Minimale Temperatur in **ca. 80 km** Höhe in mittleren
Breiten

km
1000
900
800
700
600
500
400
300
200
100
90
80
70
60
50
40
30
20
10
0

EXOSPHERE
THERMOSPHERE
MESOSPHERE
STRATOSPHERE
TROPOSPHERE

MESOPAUSE
STRATOPAUSE
TROPOPAUSE

Scattered sunlight makes noctilucent clouds show up silvery, bluish white or reddish orange against the darkness.

MESOPAUSE _ Noctilucent clouds often occur in summer below the cool mesopause at altitudes of **ca. 65–95 km** in northern latitudes

Leuchtende Nachtwolken heben sich durch gestreutes Sonnenlicht silbrig-weiß, bläulich-weiß oder orangerot gegen die Dunkelheit ab.

MESOPAUSE _ Leuchtende Nachtwolken treten unterhalb der kalten Mesopause in **ca. 65–95 km** Höhe in nördlichen Breiten oft während des Sommers auf

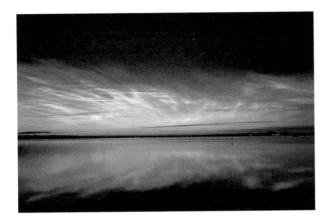

-80 °C = 193.15 K ENERGY LEVEL / ENERGIESTUFE

Polar lights are predominately green and red lines of atomic oxygen, blue-violet lines are composed of molecular nitrogen.

Due to corpuscular radiation they flicker visibly in polar regions, altitude **ca. 70–1,000 km**, attaining maximum intensity at an altitude of **100 km**

Polarlicht ist dominiert durch grüne und rote Linien atomaren Sauerstoffs, blau-violette Linien entstehen durch molekularen Stickstoff.

Durch Korpuskularstrahlung flackert es sichtbar in Polargebieten, zwischen **ca. 70–1.000 km** Höhe. Hellste Lichtstrahlung des Polarlichtes bei **100 km** Höhe

km
1000
900
800
700
EXOSPHERE
600
500
400
300
200
100
THERMOSPHERE
90
MESOPAUSE
80
70
MESOSPHERE
60
50
STRATOPAUSE
40
30
STRATOSPHERE
20
TROPOPAUSE
10
TROPOSPHERE
0

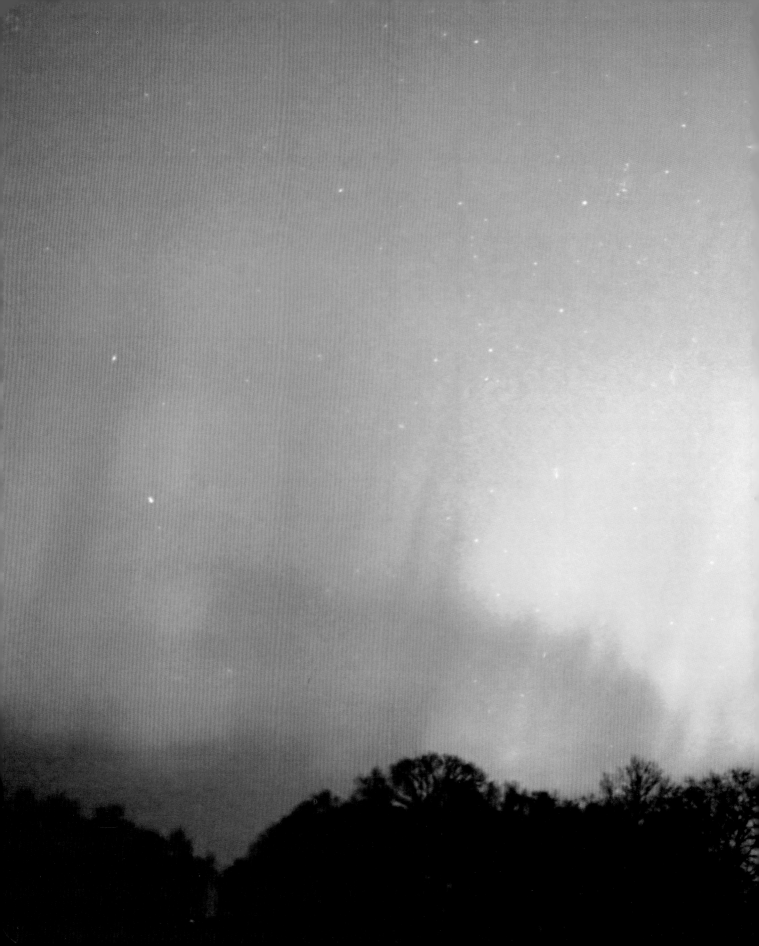

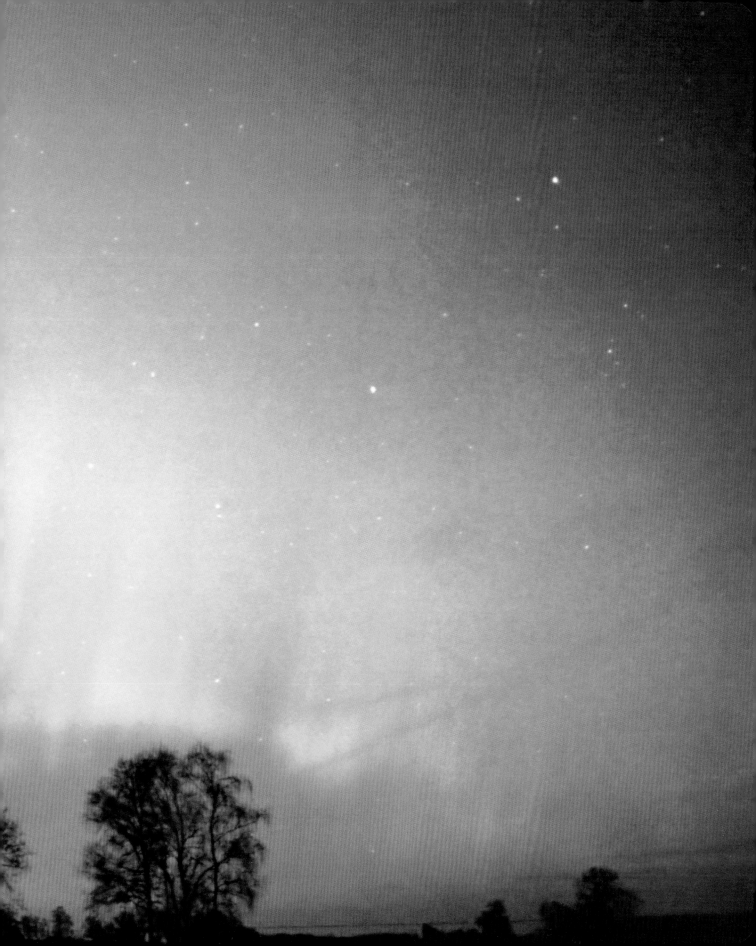

km
1000
900
800
700

EXOSPHERE

600
500
400

300

200

100

90

THERMOSPHERE

80 MESOPAUSE

70

60

MESOSPHERE

50 STRATOPAUSE

40

30

STRATOSPHERE

20 TROPOPAUSE

10

TROPOSPHERE

0

-80 °C = 193.15 K ENERGY LEVEL / ENERGIESTUFE

By day the ionosphere still extends to slightly below
the mesopause, by night its ionisation starts to be
noticeable from 90 km.
THERMOSPHERE __ Minimum temperature at an altitude of **ca. 80 km**
in temperate latitudes

Die Ionosphäre reicht tagsüber noch etwas unterhalb
der Mesopause hinab, nachts beginnt deren Ionisierung
merklich erst ab 90 km.
THERMOSPHÄRE __ Minimale Temperatur in **ca. 80 km** Höhe in
mittleren Breiten

>550 °C = >823.15 K ENERGY LEVEL / ENERGIESTUFE

Above the mesopause the temperature rises sharply
in thermosphere, which has no distinguishable upper
boundary.
THERMOSPHERE __ Or ionosphere, temperature at an altitude of
ca. 200 km, at minimum sunspot activity

Oberhalb der Mesopause steigt die Temperatur in der
Thermosphäre, die keine bestimmte Obergrenze hat,
stark an.
THERMOSPHÄRE __ Oder Ionosphäre, Temperatur in **ca. 200 km** Höhe,
bei Sonnenflecken-Minimum

>750 °C = >1,023.15 K ENERGY LEVEL / ENERGIESTUFE

Motion processes, caused by tidal forces and electric
fields, influenced by magnetic fields.
THERMOSPHERE __ Or ionosphere, temperature at an altitude of
ca. 400 km, at minimum sunspot activity

Bewegungsvorgänge, hervorgerufen durch Gezeitenkräf-
te und elektrische Felder, beeinflusst durch magnetische
Felder.
THERMOSPHÄRE __ Oder Ionosphäre, Temperatur in **ca. 400 km** Höhe,
bei Sonnenflecken-Minimum

>1,000 °C = >1,273.15 K ENERGY LEVEL / ENERGIESTUFE

Processes of ionisation are depending on zenith angle
of the sun, therefore upon geographic latitude, the time
of day and the season of the year.
THERMOSPHERE __ Or ionosphere, temperature at **ca. 200 km** altitude,
at maximum sunspot activity

Ionisierungsprozesse hängen vom Zenitwinkel der
Sonne, also von geographischer Breite, Tages- und
Jahreszeit ab.
THERMOSPHÄRE __ Oder Ionosphäre, Temperatur in **ca. 200 km** Höhe,
bei Sonnenflecken-Maximum

>1,250 °C = >1,523.15 K ENERGY LEVEL / ENERGIESTUFE

Motion processes are depending on the direction of
earth's magnetic field, that is on magnetic latitude and
are, therefore, very complex.
THERMOSPHERE __ Or ionosphere, temperature at an altitude of
ca. 400 km, at maximum sunspot activity

Die Bewegungsprozesse hängen von der Richtung des
erdmagnetischen Feldes, also von der magnetischen Brei-
te ab, sind deshalb sehr kompliziert.
THERMOSPHÄRE __ Oder Ionosphäre, Temperatur in **ca. 400 km** Höhe,
bei Sonnenflecken-Maximum

<2,000 °C = <2,273.15 K ENERGY LEVEL / ENERGIESTUFE

Temperatures can be hardly interpreted by the kinetic theory of gases; they correspond to the thermal oscillations of neutral gas particles, electrons and ions. The »temperatures« of these are likely to vary.
THERMOSPHERE _ Or ionosphere, temperature at altitudes of over **200 km** altitude, at maximum sunspot activity

Die Temperaturen sind kaum noch mit der kinetischen Gastheorie zu deuten, sie entsprechen den thermischen Schwingungen der Neutralgasteilchen, Elektronen und Ionen. Unterschiedliche »Temperaturen« dieser Bestandteile sind wahrscheinlich.
THERMOSPHÄRE _ Oder Ionosphäre, Temperatur in über **200 km** Höhe, bei Sonnenflecken-Maximum

<2,000 °C = <2,273.15 K ENERGY LEVEL / ENERGIESTUFE

Above thermosphere the density of charge carriers diminishes much more slowly than down below...
THERMOSPHERE _ Ionisation maximum at **250-350 km** altitude

Oberhalb der Thermosphäre nimmt die Dichte der Ladungsträger viel langsamer ab als nach unten...
THERMOSPHÄRE _ Ionisationsmaximum in **250-350 km** Höhe

<2,000 °C = <2,273.15 K ENERGY LEVEL / ENERGIESTUFE

...concomitantly the degree of ionisation (ratio of charged to uncharged particles) increases with altitude.
THERMOSPHERE _ Ionisation maximum at an altitude of **250-350 km**

...gleichzeitig nimmt der Ionisierungsgrad (Verhältnis der geladenen zu ungeladenen Teilchen) nach oben zu.
THERMOSPHÄRE _ Ionisationsmaximum in **250-350 km** Höhe

<2,000 °C = <2,273.15 K ENERGY LEVEL / ENERGIESTUFE

The four layers in which ions and electrons are concentrated reflect radio waves.
THERMOSPHERE _ D 80 km, E 130 km, F_1 200 km, F_2 300 km altitude

Die vier Schichten, in denen Ionen und Elektronen konzentriert sind, reflektieren Radiowellen.
THERMOSPHÄRE _ D 80 km, E 130 km, F_1 200 km, F_2 300 km Höhe

<2,000 °C = <2,273.15 K ENERGY LEVEL / ENERGIESTUFE

Gas molecules are mainly ionised here. Particles moving radially outwards at sufficiently high speeds can escape from earth's gravitational field into interplanetary space. The Van Allen Belts are also located above that.
EXOSPHERE _ Dissipation sphere from **ca. 400 km** altitude represents the transition from the earth's atmosphere to interplanetary space

Gasmoleküle sind hier weitestgehend ionisiert. Teilchen mit ausreichend großer Geschwindigkeit radial nach außen, können vom Schwerefeld der Erde in den interplanetaren Raum entweichen. Darüber befinden sich auch die Van-Allen-Gürtel.
EXOSPHÄRE _ Dissipationssphäre ab **ca. 400 km** Höhe bildet den Übergang von der Erdatmosphäre in den interplanetaren Raum

km
1000
900
800
760
600
500
400
EXOSPHERE
300
200
100
THERMOSPHERE
90
MESOPAUSE
80
70
60
MESOSPHERE
STRATOPAUSE
50
40
30
STRATOSPHERE
20
TROPOPAUSE
TROPOSPHERE
10
0

<2,000 °C = <2,273.15 K ENERGY LEVEL / ENERGIESTUFE

The loss of helium has been proved because there is
considerably less of it in the atmosphere than was
formed in geological time.
EXOSPHERE __ At altitudes above **600–1,000 km** helium predominates;
beyond that hydrogen up to **2,000 km**

Der Verlust von Helium ist nachgewiesen, da es in der
Atmosphäre wesentlich weniger gibt, als in geologischer
Zeit gebildet wurde.
EXOSPHÄRE __ In Höhen von über **600–1.000 km** herrscht Helium vor,
darüber bis **2.000 km** Wasserstoff

km

1000

900

800

700

EXOSPHERE

600

500

400

300

200

100

THERMOSPHERE

90

80 MESOPAUSE

70

MESOSPHERE

60

50 STRATOPAUSE

40

30

STRATOSPHERE

20 TROPOPAUSE

10

TROPOSPHERE

0

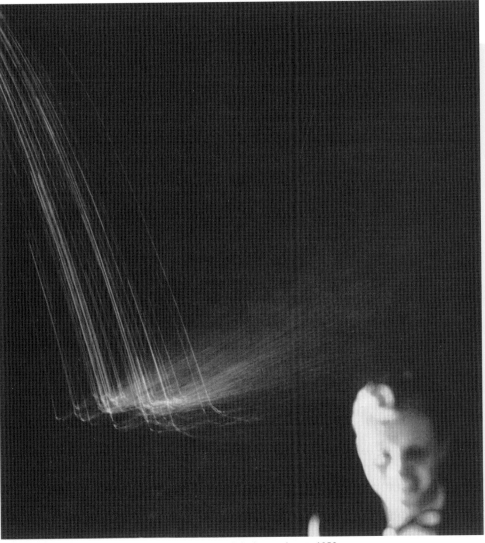

Creative Experiments

Two men are kneeling like boys preparing for their first communion on the factory floor: Werner Ruhnau and Yves Klein. It was 1959 and the artist and the architect were collaborating on an outrageous project: walls of air (fig. 258|259). Above them, a man dressed in a lab coat is on a chair and is spraying water into the air but they remain dry. Ruhnau wanted to open up the just completed Gelsenkirchen theatre to the city with a massive hot air curtain of the kind familiar from German department stores and thus, like Ludwig Meidner before him, bring city and street together to form a single theatre surface on which the citizen would have become actor, director and spectator rolled into one of what was going on. In the smoky atmosphere of the Ruhr Region Werner Ruhnau and Yves Klein were dreaming of ›good air, clear walls of fire and forests of water.‹ They ultimately arrived at the idea of ›ensuring good weather by means of meteorological interventions‹: giant turbines were to dispel rain clouds and rockets shooting silver iodide pellets were to force the storm front to rain itself out. A radical suggestion, which failed to be realised primarily due to the enormous cost of keeping it in operation but at the same time represented the most consistent continuation of Modernism and its core precept that less was more. The Existentialist theatre of disillusion encountered a generation of architects shaped by the war, who wanted to set new beginnings in dematerialised architecture and the nakedness of Paradise before the Fall.

Air has today really become a building material like concrete or steel. Axel Thallemer, who headed Festo Corporate Design until 2004, has added corners and edges to the round pneumatic structure, as he did in 1996 with *Airtecture* (fig. 271|272), an air-supported structure of the second generation, with the stability of the building ensured by external pneumatic muscles, instead of internal air pressure being higher than normal atmospheric pressure. Forty Y-columns stabilize the cubic core. External forces exerted against the building are counteracted by increasing the pressure in computer-controlled pneumatic muscles made of polyamide fibre and silicon tubing to make them contract. This stunning high-tech tour de force has revived the pneumatic structure in the form of a naturally ventilated and lighted factory with 375 square metres of floor area and six-metre-high walls. The ceiling is supported by airbeams, pressurised air-filled chambers. Between them are pieces of transparent membrane inflated at lower than atmospheric pressure. *Airtecture* marks a quantum leap in the history of the >>>

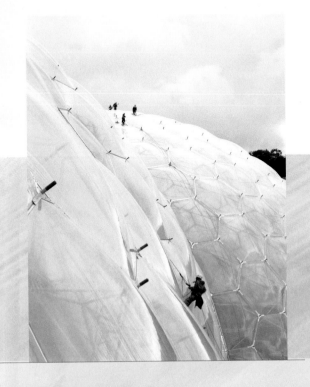

Kreative Experimente

Zwei Männer knien wie Konfirmanden in einer Werkshalle, Werner Ruhnau und Yves Klein. Wir schreiben

das Jahr 1959, und der Künstler sowie der Architekt arbeiten an einem unerhörten Projekt: Wänden aus Luft

(Abb. 258|259). Über ihnen, auf einem Stuhl, sprüht ein Mann mit Laborkittel Wasser in die Luft, sie aber bleiben

trocken. Mit einem gewaltigen Luftvorhang, wie man ihn von Kaufhäusern kennt, wollte Ruhnau das eben fertig

gestellte Gelsenkirchener Theater zur Stadt öffnen und so wie Ludwig Meidner vor ihm die Stadt und die Straße

zusammenbringen, zu einer einzigen Theaterfläche, auf der der Bürger zugleich Schauspieler, Regisseur und

Betrachter des Geschehens geworden wäre. Im qualmenden Ruhrgebiet träumten Werner Ruhnau und Yves Klein

von »guter Luft, klaren Feuerwänden und Wasserwäldern«, schließlich kamen sie auf den Gedanken, »den Wetter-

schutz mittels meteorologischer Eingriffe sicherzustellen«: gewaltige Turbinen sollten Regenwolken vertreiben

und Silberjodidraketen Sturmfronten zum Abregnen zwingen. Ein radikaler Vorschlag, der nicht zuletzt an den

gewaltigen Betriebskosten scheiterte, aber zugleich die konsequenteste Fortschreibung der Moderne und ihres

zentralen Diktums, wonach weniger zugleich mehr sei. Das existentialistische Theater der Leere traf auf eine vom

Krieg geformte Architektengeneration, die den Neuanfang proben wollte, in immaterieller Architektur und

paradiesischer Nacktheit.

Luft ist heute tatsächlich Baustoff geworden wie Beton oder Stahl. Axel Thallemer, der Festo Corporate Design

bis 2004 leitete, verleiht der runden Pneuhalle Ecken und Kanten, wie 1996 mit *Airtecture* (Abb. 271|272), >>>

pneumatic structure. In the pragmatic context, contemporary large-scale projects using air as a medium are being blow up to entirely new dimensions. They represent acceptance of the fact that no purely pneumatic structures are being built but rather hybrids such as Nicholas Grimshaw's *Leicester Space Centre* (fig. 260), which is supported by a firm framework, or the spectacular greenhouses of the *Eden Project* in St Austell (fig. 261), Cornwall (both 2001). The applied pneumatic loading gleams like the retina of a gigantic insect eye. The focus has long been on unusual surface textures, on maximizing impact, and air is part of an aesthetic which is supposed to look light and flexible to match a society producing job nomads and people working flexitime at home, who can log into the available data infrastructure anywhere at all times. Branson/Coates' *Powerhouse::UK* (1998, fig. 270) has air-bags over a steel frame. The most recent application of this principle is encountered in Herzog & de Meuron's >>>

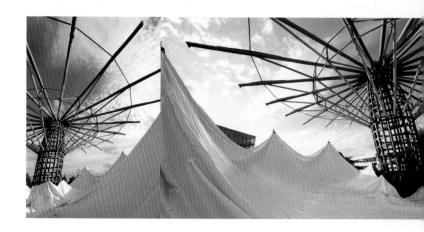

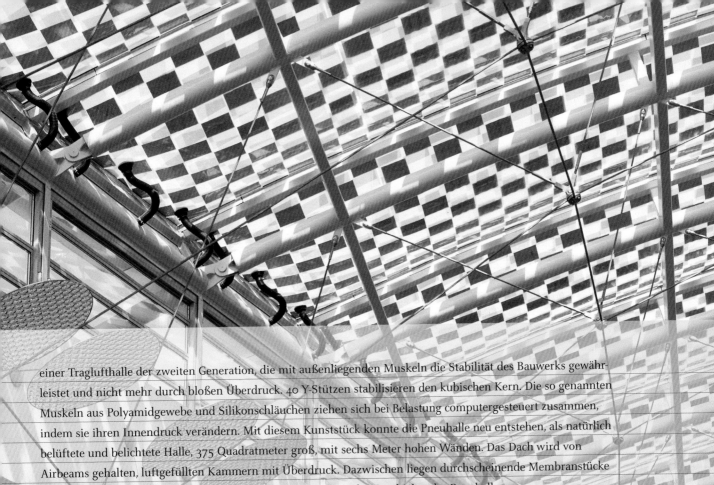

einer Traglufthalle der zweiten Generation, die mit außenliegenden Muskeln die Stabilität des Bauwerks gewähr-
leistet und nicht mehr durch bloßen Überdruck. 40 Y-Stützen stabilisieren den kubischen Kern. Die so genannten
Muskeln aus Polyamidgewebe und Silikonschläuchen ziehen sich bei Belastung computergesteuert zusammen,
indem sie ihren Innendruck verändern. Mit diesem Kunststück konnte die Pneuhalle neu entstehen, als natürlich
belüftete und belichtete Halle, 375 Quadratmeter groß, mit sechs Meter hohen Wänden. Das Dach wird von
Airbeams gehalten, luftgefüllten Kammern mit Überdruck. Dazwischen liegen durchscheinende Membranstücke
mit Unterdruck. *Airtecture* markiert einen Quantensprung in der Geschichte der Pneuhalle.

Pragmatisch stoßen heutige Großprojekte, die sich Luft als Medium bedienen, in neue Größendimensionen vor.
Dass dabei keine reinen Pneubauten entstehen, sondern Hybride wie Nicholas Grimshaws *Leicester Space Center*
von 2001 (Abb. 260), das sich auf ein festes Gerüst stützt, oder die spektakulären Gewächshäuser des *Eden Projects*
in Cornwall aus dem gleichen Jahr (Abb. 261), nehmen sie billigend in Kauf. Die applizierten Pneus glänzen wie die
Netzhaut eines gigantischen Insektenauges. Längst geht es um ungewöhnliche Oberflächen, um maximale Wirkung,
und Luft ist Teil einer Ästhetik, die leicht und beweglich aussehen soll wie die Gesellschaft der Job-Nomaden und
flexiblen Internet-Arbeiter, die sich jederzeit und überall in die vorhandene Dateninfrastruktur einklinken. Branson/
Coates' *Powerhouse::UK* von 1998 (Abb. 270) fährt über einem Stahlrahmen Luftpolster aus wie Airbags. Das
Prinzip lässt sich bis zu Herzog & de Meurons Münchner *Allianz-Arena* (2005, Abb. 266–269) verfolgen, die sich mit
einem Ring aus Pneus umgibt und so die eigentliche Schale aus Beton transzendiert. Nachts verwandelt sich das
Stadion in einen gleißenden Informationsscreen, der rot, weiß und blau leuchtet und nur noch von PTWs
geplantem *Olympischen Schwimmzentrum* in Peking übertroffen wird (Abb. 273|274). Das gesamte Gebäude scheint
sich in einen Wall aus Seifenblasen zu verwandeln, der über einem Tragwerk aus Stäben errichtet wurde.

Wer die Architektur der letzten Jahre genauer betrachtet, wird feststellen müssen, dass sie sich nicht nur verfeinert
und medialisiert, sie scheint auch vom Drang besessen, sich aufzulösen und ihre materiellen Fesseln abzuschütteln. >>>

Atrienüberdachung Festo TechnologieCenter. 2001

Munich *Allianz Arena* which is surrounded by a belt of pneumatic loading, thus transcending the actual concrete shell. At night the stadium changes into a glaring information screen, glowing in red, white and blue. It will be surpassed, however, by PTWs' planned *Olympic swimming center* in Beijing (fig. 273|274). The entire building seems to change into a wall of soap bubbles built over a tubular frame.

If one looks more closely at the architecture of recent years, one realizes that it has not only made itself more sophisticated and telegenic. It also seems to be possessed with an urge to dissolve and shake off the shackles of material. Toyo Ito's *Tower of the Winds* (1986, fig. 281–284) becomes a sculpture of pulsing light at night. Shigeru Ban's *Curtain Wall House* (1995, fig. 262) is a literal take on that modern classic, the curtain wall façade, with bolts of material fluttering in the breeze, and Peter Haimerl's *Castle of Air* (2004, fig. 275|276) completely dissolves, at least in visual terms, the outlines of the pavilion. Mirrored steel surfaces reveal nothing but scenery and air and endless refractions and reflections. Jeff Koons' *Rabbit* (1986) radically changed the frame of reference. Sewn, inflated surfaces – of stainless steel. What was light and airy has become permanent and heavy. The commonplace inflatable rabit embodies the victory of the pneumatic structure over classic materials, just as, conversely, Eduardo Chillida's *Wind Combs* (1997, fig. 290) is an attempt to clutch the intangible by extreme means: with steel tongs against air currents – a wonderfully poetic idea.

Ephemeral architectural sculptures, worlds upside-down, heavy lightness and lightness in heaviness, illusions of the sort disseminated by Diller & Scofidio with the *Blur Building* (fig. 277–280) at *Expo '02 Switzerland*: a platform in a lake surrounded by a hazy cloud of water droplets obscuring its outlines so that it became a phantom, continually changing form and consigned to the forces of nature, the wind wafting over the water. ☐

☐ 266–269 Herzog & de Meuron, Allianz Arena, Munich. 2005 / Herzog & de Meuron, Allianz Arena München. 2005

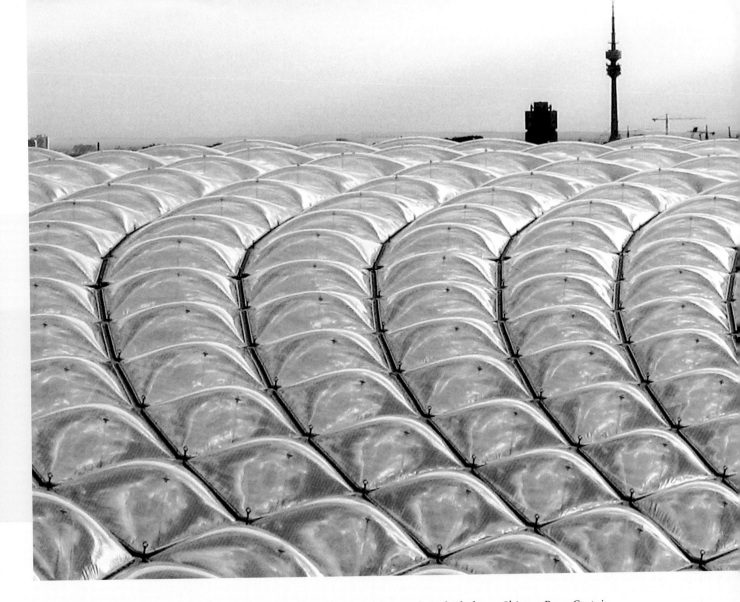

Toyo Itos *Turm der Winde* (1986, Abb. 281–284) wird abends eine pulsierende Lichtskulptur, Shigeru Bans *Curtain Wall House* von 1995 nimmt die Vorhangfassade der klassischen Moderne wörtlich und lässt Stoffbahnen in der Brise flattern, und Peter Haimerls *Castle of Air* von 2004 (Abb. 275|276) löst die Umrisse des Pavillons zumindest optisch völlig auf. Verspiegelte Stahlflächen zeigen nichts als Landschaft und Luft und endlose Brechungen und Reflexionen. Auch Jeff Koons *Rabbit* (1986) ändert die Bezugsgrößen radikal. Nähte, aufgeblähte Oberflächen – in Edelstahl. Was leicht und luftig war, ist nun permanent und schwer. Der ordinäre Aufblashase verkörpert den Sieg des Pneus über klassische Materialien, wie umgekehrt Eduardo Chillidas *Windkämme* von 1997 (Abb. 290) mit äußersten Mitteln versuchen, das Ungreifbare zu fassen: mit stählernen Zangen gegen den Luftstrom – ein wunderbarer, poetischer Gedanke.

Ephemere Architektur-Skulpturen, verkehrte Welten, das schwere Leichte und das Leichte im Schweren, Illusionen, wie sie Diller & Scofidio mit dem *Blur Building* (Abb. 277–280) auf der *Expo 02 Schweiz* ausbreiteten: eine Plattform im See, die von einer Dunstwolke umgeben die Umrisse verliert, zu einem Phantom wird, ständig seine Form ändernd und nur den Kräften der Natur überlassen, dem Wind, der übers Wasser weht. □

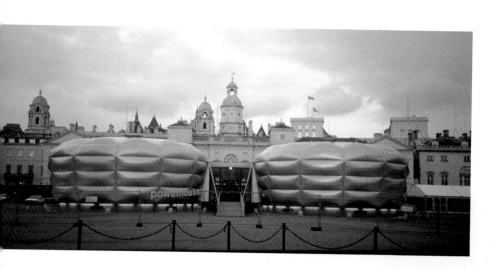

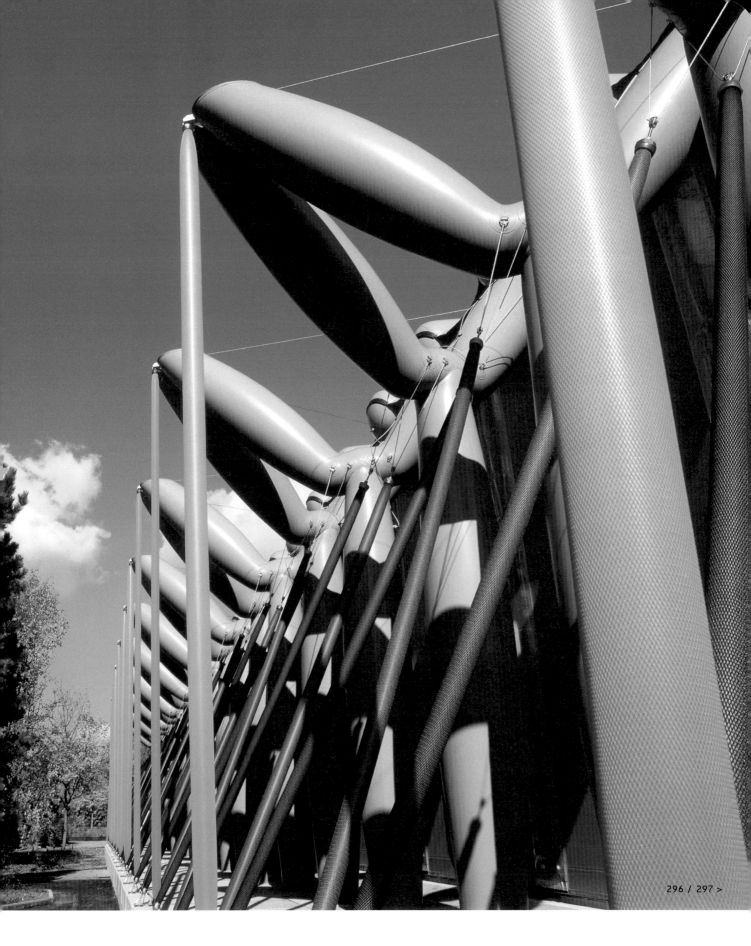

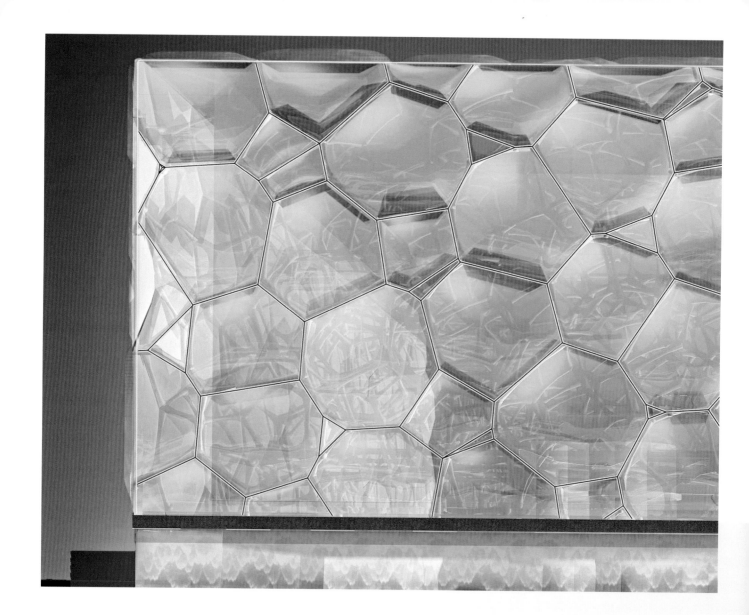

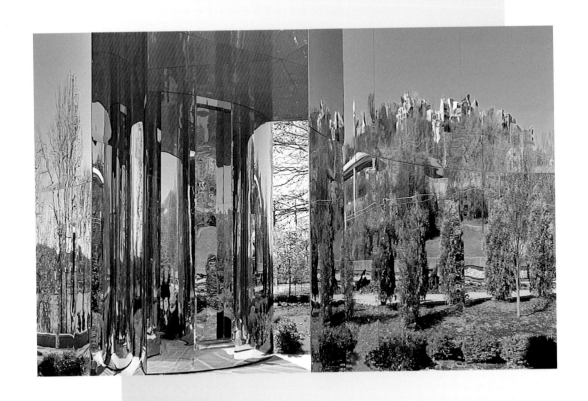

zentrum Peking 2008 ▷ 275|276 Peter Haimerl, Castle of Air. 2003/2004

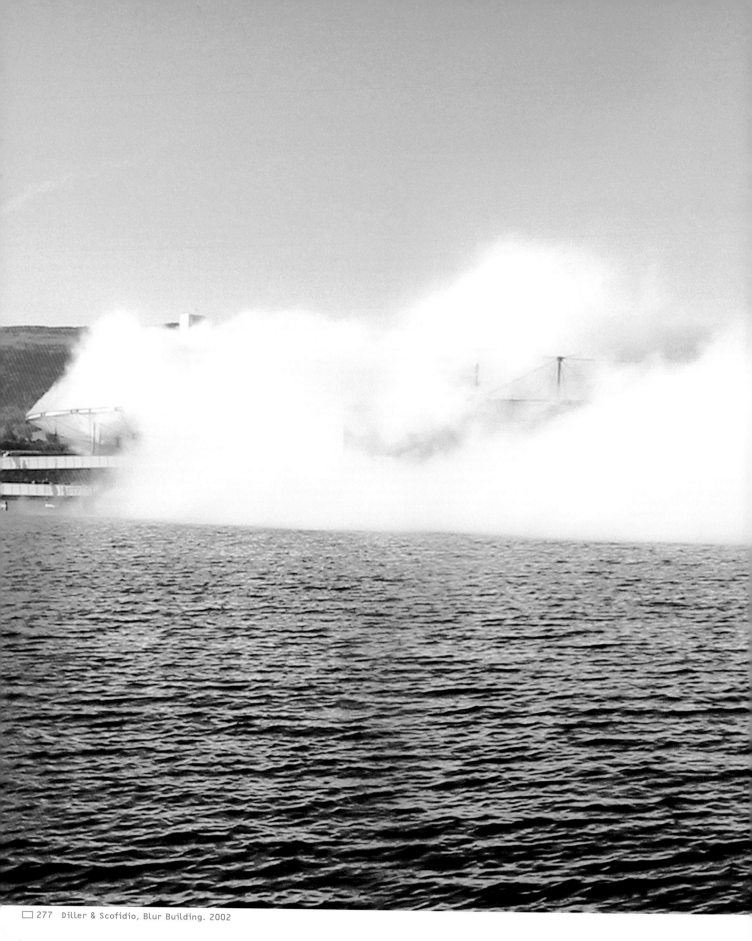

277 Diller & Scofidio, Blur Building. 2002

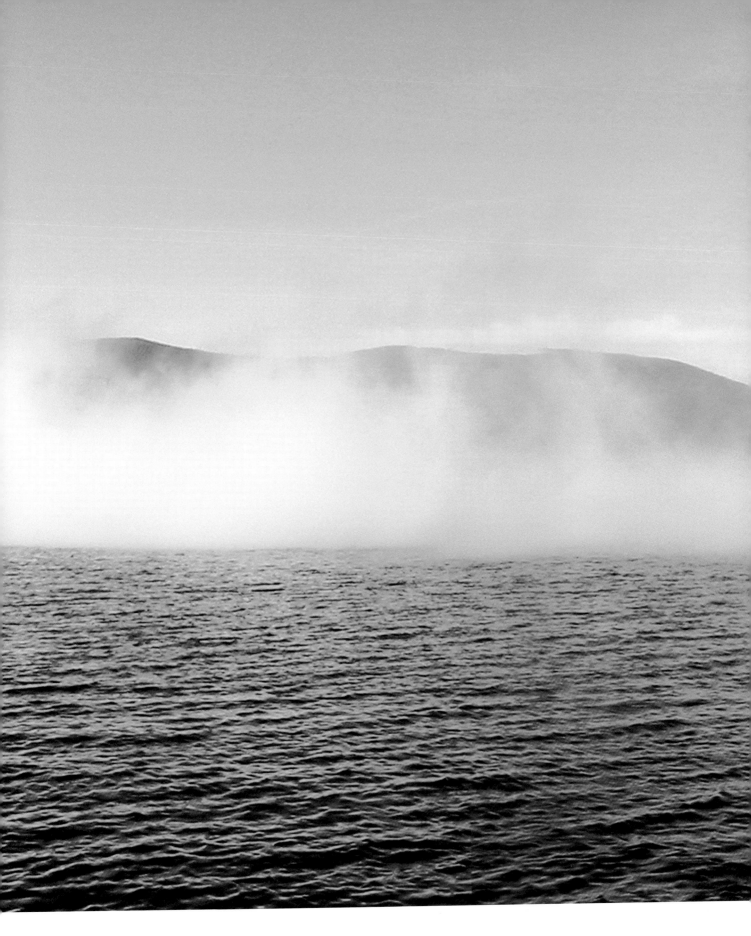

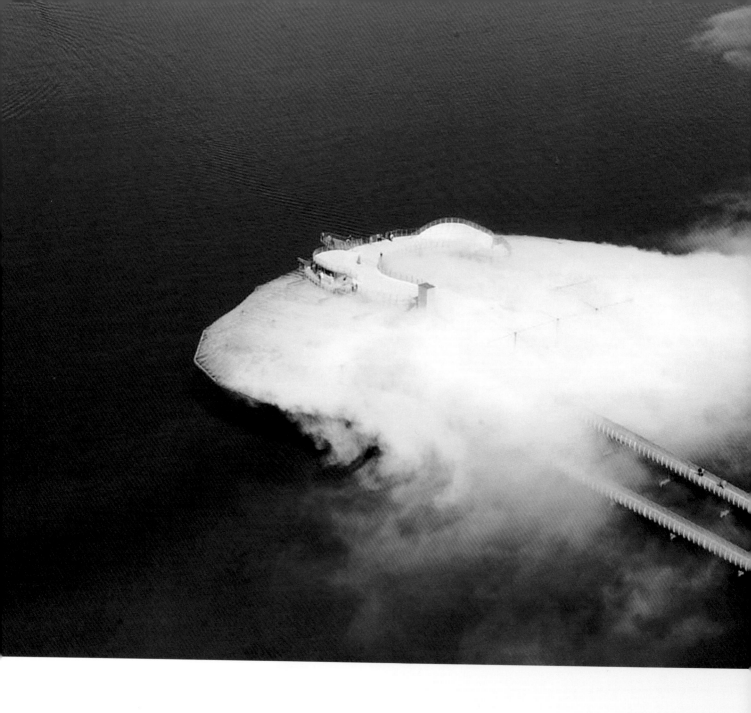

278–280 Diller & Scofidio, Blur Building. 2002

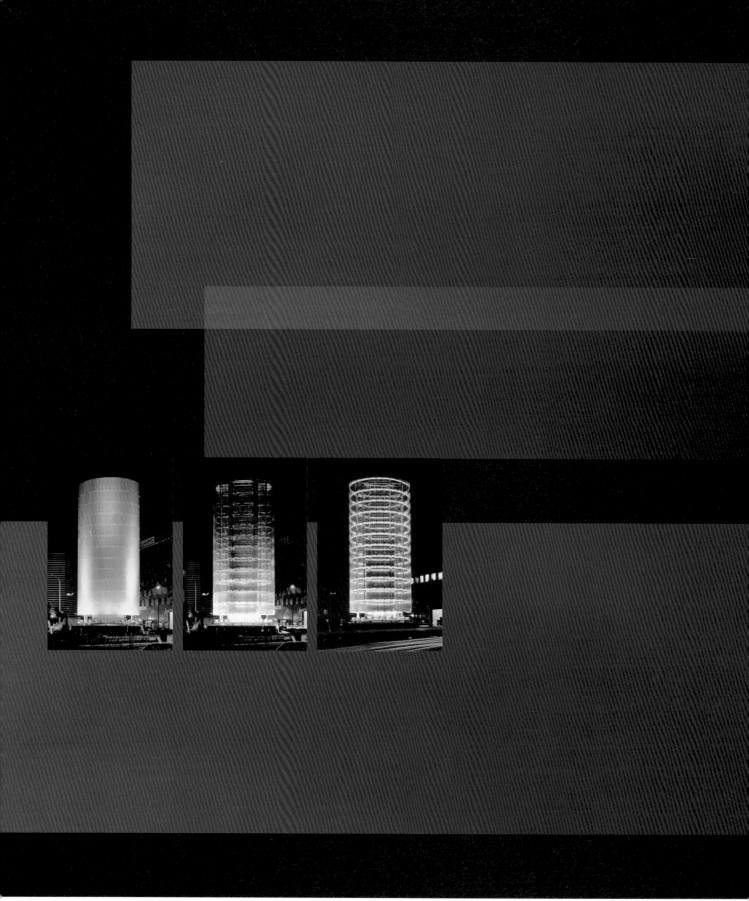

□ 281–284 Toyo Ito, Tower of the winds, Yokohama. 1986 / Toyo Ito, Turm der Winde, Yokohama. 1986

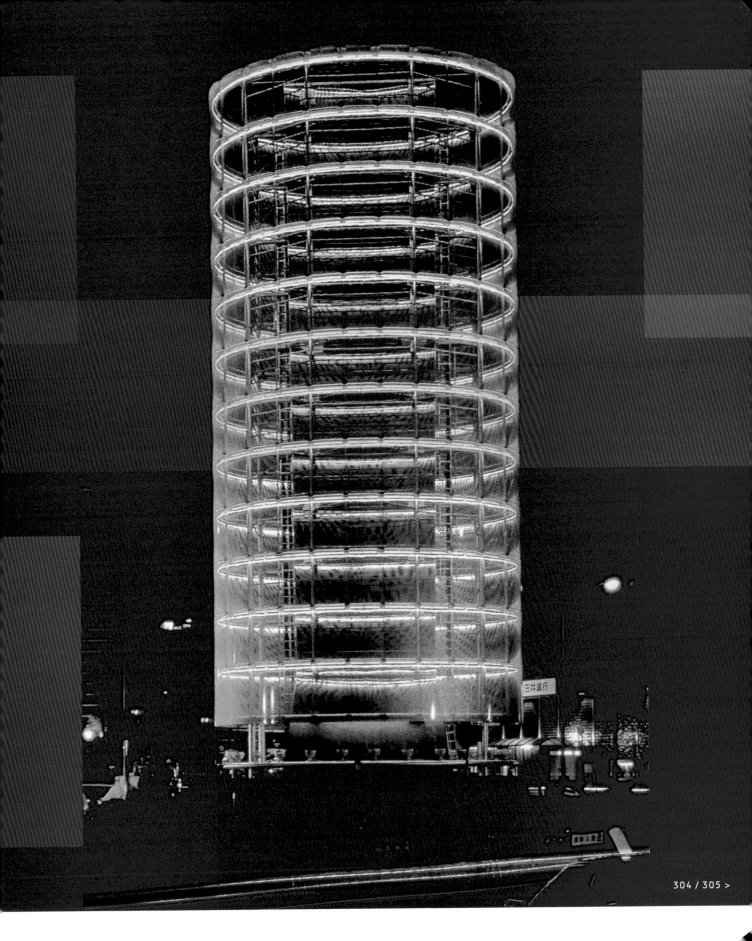

285 Wilhelm Koch, Airparc – Pneu-Haufen (heap of tyre tubes). 2004 286 Wilhelm Koch, Airparc – Pneu-Thron (tyre-tube throne). 2004

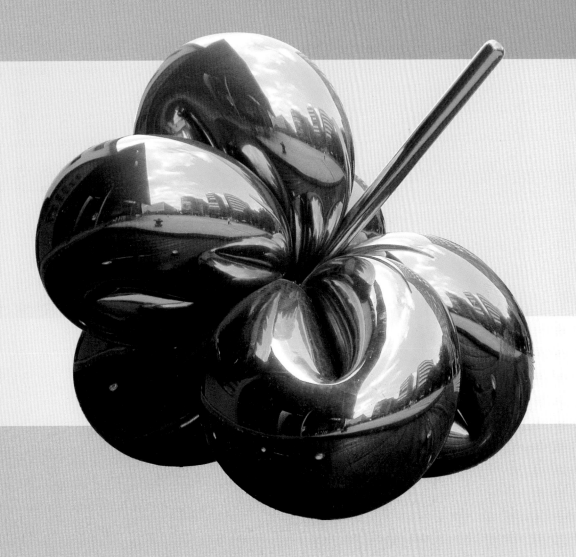

◁◁◁ 287 Klaus Illi, Pneumatic Mirror. 2004 / Klaus Illi, Pneumatischer Spiegel. 2004 ▷ 288 Jeff Koons, Balloon Flower. 1999/2001

◁ 289 Yves Klein, Le vent du voyage (Cosmogonie). 1960 ▷ 290 Eduardo Chillida, Peine del viento (wind combs). 1977 /

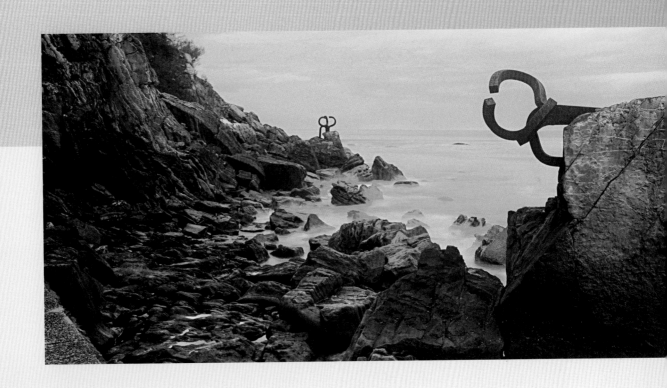

Eduardo Chillida, Peine del viento (Windkämme). 1977

Sometimes, when the weather draws up white-grey silk, one really does not know where the water ends and the sky begins...

Manchmal, wenn das Wetter weißgraue Seide aufzieht, weiß man wirklich nicht, wo das Wasser aufhört und der Himmel anfängt...

· Martin Walser, German writer, Lake Constance

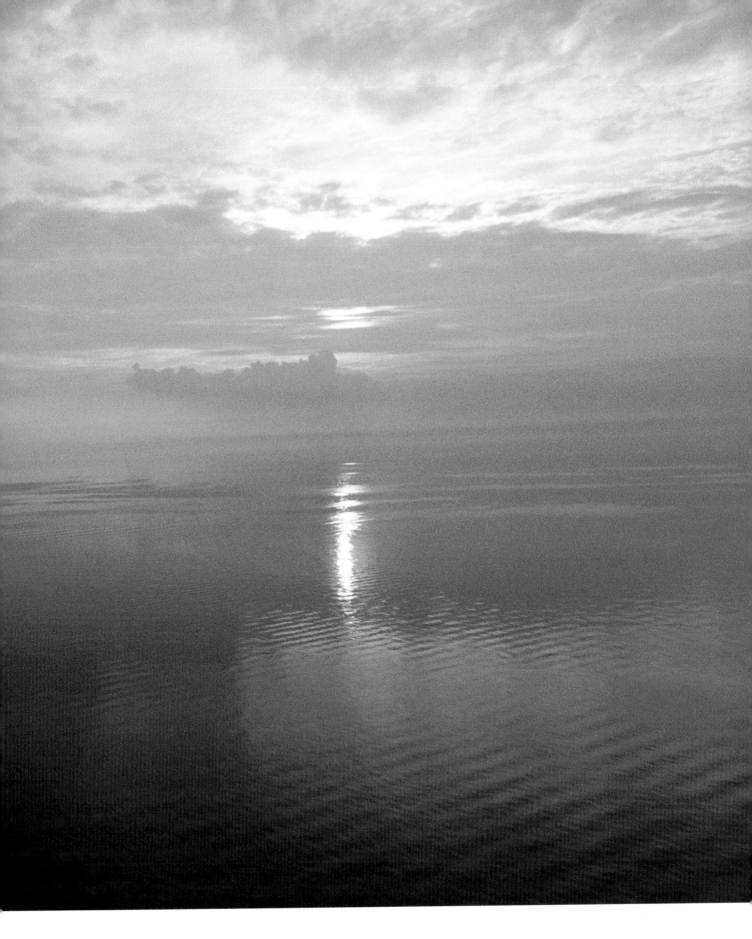

Keep it clean somehow!
APPEAL

Haltet sie irgendwie rein!
AUFRUF

> APPENDIX / ANHANG

> SURVEY OF PICTURES WITH CAPTIONS_PHOTO CREDITS
BILDÜBERSICHT MIT LEGENDEN_BILDNACHWEIS

The numerals refer to the figure numbers
// Die Ziffern verweisen auf die Abbildungs-Nummern

001 The five Chinese elements (water, fire, wood, metal, earth)
// Die fünf chinesischen Elemente (Wasser, Feuer, Holz, Metall, Erde)

002 Shu, God of the air. Headrest from the grave of Tutankhamen, 18th dynasty, ivory
// Luft-Gott Schu. Kopfstütze aus dem Grab des Tutanchamun, 18. Dynastie, Elfenbein
© Courtesy, Ägyptisches Museum, Kairo. Photo Richard Wilkinson

003|004 Giovanni da Bologna (1529–1608), Mercury. 1564
Plinth (detail) with the head of a wind deity puffing up his cheeks to blow. Bronze
// Giovanni da Bologna (1529–1608), Merkur. 1564
Sockel (Detail) mit dem Kopf eines blasenden Windgottes. Bronze
© akg-images, Rabatti-Dominie

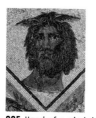

005 Head of a wind deity. Roman mosaic, 2nd century AD
Found: Thugga (Dougga, Tunisia)
// Kopf eines Windgottes. Römisches Mosaik, 2. Jh. n. Chr.
Fundort: Thugga (Dougga, Tunesien)
© akg-images, Gilles Mermet

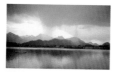

006 Rain over Lake Hopfen, East Allgäu (Bavaria)
// Regen über dem Hopfensee, Ostallgäu (Bayern)
© Ullstein Bild, Caro Riedmüller

007 Wolfgang Kilian (1581–1662), Mundus elementaris/Mundus intelligentiarum
Christian allegorical representation of the world with the planet system, the signs of the zodiac and deity. Copperplate engraving, undated, 27.3 x 21.8 cm
// Wolfgang Kilian (1581–1662), Mundus elementaris/Mundus intelligentiarum
Christlich-allegorische Darstellung des Weltbildes mit Planetensystem, Tierkreis und Göttlichem Wesen. Kupferstich, undatiert, 27,3 x 21,8 cm
© akg-images

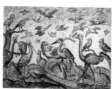

008 Matthäus Merian the Elder (1593–1650), The Fifth Day of Creation. 1630
The creation of the animals of the air. Copperplate engraving.
From: Johann Ludwig Gottfried, Historische Chronica, Frankfurt a. M., 1630
// Matthäus Merian d.Ä. (1593–1650), Der fünfte Schöpfungstag. 1630
Die Erschaffung der Tiere der Luft. Kupferstich.
Aus: Johann Ludwig Gottfried, Historische Chronica, Frankfurt a.M., 1630

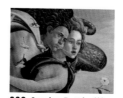

009 Sandro Botticelli (1445–1510), The Birth of Venus. 1482
Detail: The heads of the wind deities Zephyr and Aura. Tempera on canvas, approx 172.5 x 278.5 cm
// Sandro Botticelli (1445–1510), Die Geburt der Venus. 1482
Detail: Die Köpfe der Windgötter Zephyr und Aura. Tempera auf Leinwand, ca. 172,5 x 278,5 cm
© akg-images

010 The four elements of Empedocles (earth, air, fire and water). 1472
Coloured woodcut. From a 1472 edition of Lucretius' ›De rerum natura‹
// Die vier Elemente des Empedokles (Erde, Luft, Feuer und Wasser). 1472
Kolorierter Holzschnitt.
Aus: Lukrez, De rerum natura, Buchausgabe 1472
© Ullstein Bild, Granger Collection

011|013 Pinturicchio (1454–1513), Enea Silvio Piccolomini Departing for the Council of Basle. 1507
Fresco on the walls of the Piccolomini Library in Siena Cathedral, Siena/Italy
// Pinturicchio (1454–1513), Auszug Enea Silvio Piccolominis zum Konzil nach Basel. 1507
Fresko, Ausmalung der Piccolomini-Bibliothek im Dom zu Siena/Italien
© Foto Lensini Siena (Opera della Metropolitana aut. no. 734, III, 6)

012 Pietro Perugino (ca. 1445–1523), Portrait of Francesco delle Opere. 1494
Florence, Galleria degli Uffizi
// Pietro Perugino (ca. 1445–1523), Bildnis des Francesco delle Opere. 1494
Florenz, Galleria degli Uffizi
© Ullstein Bild, Granger Collection

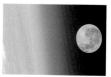

014 The Moon and the Earth's atmosphere
// Der Mond und die Erdatmosphäre
© Courtesy, Earth Sciences and Image Analysis Laboratory, NASA Johnson Space Center

015 Albrecht Dürer (1471–1518), Armillary sphere. 1525
Woodcut, illustration to the translation of Claudius Ptolemy by Willibald Pirkheimer, Strasbourg (Johannes Grüninger) 1525.
// Albrecht Dürer (1471–1518), Die Armillarsphäre. 1525
Holzschnitt, Illustration zu der Übersetzung des Ptolemäus von Willibald Pirkheimer, Straßburg (Johannes Grüninger) 1525

016 High-altitude helium balloon
Stratosphären-Ballon
© Getty Images. Photo by Chris Miller

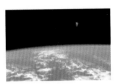

017 Earth from space, with Challenger astronaut McCandless. 1984
In February 1984 astronaut Bruce McCandless II went further away from the safety of his space shuttle than any astronaut before him. Following a series of test manœuvres inside and above Challenger's payload bay doors, McCandless floated approx 100 m (20 feet) away from Orbiter in ›free flight‹.
// Erde vom All aus, mit Challenger-Astronaut McCandless. 1984
Im Februar 1984 entfernte sich der Astronaut Bruce McCandless weiter weg von seiner Raumfähre als dies jemals ein Astronaut tat. Nach mehreren vorbereitenden Manövern im Inneren und über der Nutzlastraumluke, entfernte sich McCandless »frei schwebend« bis auf eine Entfernung von ca. 100 m vom Raumschiff.
© Courtesy, Earth Sciences and Image Analysis Laboratory, NASA Johnson Space Center

018 Mt Etna erupting (Sicily). 2001
Europe's biggest active volcano
// Ausbruch des Ätna (Sizilien). 2001
Größter noch tätiger Vulkan Europas
© Ullstein Bild, Alfio Garozzo

019 Nuclear bomb exploding on the Marshall Islands, then a US Trust Territory. 1952
// Atombomben-Explosion auf den Marshall-Inseln, USA. 1952
© Ullstein Bild

020 Atomic mushroom cloud. First atomic bomb test, 16 July 1945, near Alamogordo, New Mexico, USA
// Atom-Pilzwolke. Erster Atombombentest am 16. Juli 1945 bei Alamogordo, New Mexiko, USA

021 Water vapor
// Wasserdampf
© Photo by Heike Schiller, raumzeit3 Stuttgart

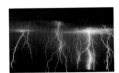

022 Lightning during a thunderstorm
// Blitze während eines Gewitters
© Ullstein Bild, kpa

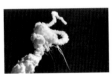

023 Challenger space shuttle exploding after the start from Cape Canaveral, USA, January 28, 1986
// Explosion des Challenger Space Shuttle nach dem Start von Cape Canaveral, USA, 28.1.1986
© Ullstein Bild, AP

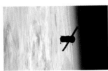

024 An unmanned Progress 14 supply vehicle leaves the International Space Station (ISS) on July 30, 2004
Its payload is refuse and unneeded equipment to be burnt up on reentry to the Earth's atmosphere
// Unbemanntes Versorgungsfahrzeug Progress 14 verlässt am 30.7.2004 die International Space Station (ISS)

An Bord Müll und nicht mehr benutzte Ausrüstung, die durch den Wiedereintritt in die Erdatmosphäre verbrannt werden
© Courtesy, Earth Sciences and Image Analysis Laboratory, NASA Johnson Space Center

025 Atoms: A scale model showing the relative sizes of the components of air
// Atome: Modell der Größenverhältnisse der Bestandteile von Luft

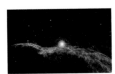

026 Western end of the Veil Nebula (known as NGC 6960 or Witch's Broom Nebula)
The supernova explosion is thought to have occured about 10,000 years ago, this nebula is the remnant
// Westliches Ende des Veil Nebels (auch als NGC 6960 oder Hexenbesen-Nebel bekannt)
Es wird vermutet, dass die Supernova-Explosion vor etwa 10.000 Jahren stattfand, dieser Nebel ist der Überrest
© Courtesy, Earth Sciences and Image Analysis Laboratory, NASA Johnson Space Center

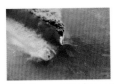

027 The spectacular eruption of Mt Etna (Sicily) on October 30, 2002
Astronauts from the ISS-5 mission crew were able to observe and photograph the eruption plume ascending from the mantle
// Vulkanausbruch des Ätna (Sizilien) am 30.10.2002
Astronauten der ISS-5 Besatzung fotografierten die Eruptionswolke
© Courtesy, Earth Sciences and Image Analysis Laboratory, NASA Johnson Space Center

028 The Sun
// Die Sonne
© Courtesy, Earth Sciences and Image Analysis Laboratory, NASA Johnson Space Center

029 | 031 Upside Down Twins (details of the balloons). 1995
Upside Down Balloon:
Lead design: Prospective Concepts. Nylon fabric, coated on one side with PU; membrane engineering: Don Cameron, membrane made by Nick Purvis, both Cameron Balloons Ltd
Hot Air Balloon:
Lead design: Axel Thallemer, Festo Corporate Design. Nylon fabric, coated on one side with PU, membrane engineering: Don Cameron, membrane made by Nick Purvis, both Cameron Balloons Ltd
Twin balloons: Next to the ›classical‹ balloon with a gondola or basket suspended from the membrane there is a second balloon which is ›standing on its head‹, i.e., the basket or gondola is above the balloon, which is suspended from it
// Upside Down Twins (Details der Ballons). 1995
Upside Down Balloon:
Design Prospective Concepts. Nylon, einseitig mit PU beschichtet, Membran-Konstruktion Don Cameron, Membran-Anfertigung Nick Purvis, beide Cameron Balloons Ltd.
Hot Air Balloon:
Design Axel Thallemer, Festo Corporate Design. Nylon, einseitig mit PU beschichtet, Membran-Konstruktion Don Cameron, Membran-Anfertigung Nick Purvis, beide Cameron Balloons Ltd.
Zwillingsballons: Neben dem »klassischen« Ballon mit an der Membran hängendem Korb, steht der zweite Ballon »auf dem Kopf«, d.h. der Korb befindet sich über dem Ballon, dieser hängt daran nach unten
© Courtesy, Festo Corporate

030 Inflatable balloon basket. 1998
Lead design: Axel Thallemer, membrane engineering: Udo Rutsche, both Festo Corporate Design; membrane made by Dirk Hebeler, Deutsche Schlauchboot. Polyamide fabric coated with Hypalon, length 1.44 m, width 1.26 m, height 1.33 m, 80 kg.
Unlike the traditional wickerwork balloon baskets, which have remained unchanged for nearly two centuries, the new gas balloon gondola represents an innovative further development based on the technology of pneumatic structures.
// Aufblasbarer Ballonkorb. 1998
Design Axel Thallemer, Membran-Konstruktion Udo Rutsche, beide Festo Corporate Design, Membran-Anfertigung Dirk Hebeler, Deutsche Schlauchboot.
Polyamid-Gewebe, Hypalonbeschichtet, Länge 1,44 m, Breite 1,26 m, Höhe 1,33 m, 80 kg.
Im Gegensatz zu den traditionellen Ballonkörben aus Weidengeflecht, die seit annähernd 200 Jahren nicht verändert wurden, stellt der neue Gasballonkorb eine innovative Weiterentwicklung, basierend auf der Technologie Pneumatischer Strukturen, dar.
© Courtesy, Festo Corporate Design

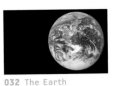

032 The Earth
Photographed by the Apollo 17 crew on their way to the Moon in 1972. First photograph of the Antarctic ice cap
// Die Erde
Fotografiert von der Apollo 17 Besatzung während des Flugs zum Mond 1972. Erstes Foto von der Eiskappe des Südpols
© Courtesy, Earth Sciences and Image Analysis Laboratory, NASA Johnson Space Center

033 Molten lava from
Mt Etna (Sicily)
// Glühende Lava des Ätna
(Sizilien)
© Ullstein Bild

034 | 035 Fuel cell,
functional diagram and use
in a motor vehicle
// Brennstoffzelle, Funk-
tionsschema und Nutzung
im Pkw
© Courtesy, DaimlerChrysler
AG

036 Surf breaking on the
coast (magmatic rock) of
La Palma (Canary Islands)
// Meeresbrandung an der
Küste (Lavagestein) von
La Palma (Kanarische
Inseln)
© Ullstein Bild, Moenkebild

037 Giant kelp seaweed
(Macrocystis pyrifera)
Air bladders buoy the
fronds upwards towards
the surface of the sea
to absorb energy from
the Sun
// Riesenkelp-Algen
(Macrocystis pyrifera)
Durch mit Luft gefüllte
Schwimmkörper treiben die
Algen-Blätter an die Was-
seroberfläche, um dort die
Sonnenenergie aufzunehmen

038 Picasso triggerfish
(Rhinecanthus aculeatus)
// Picasso Drückerfisch
(Rhinecanthus aculeatus)
© Wilhelma Stuttgart. Photo
by Dieter Jauch

039 Ozone hole over the
Antarctic, September 3,
2000
On September 3, 2000 a
NASA spectrometer detected
the largest ozone hole ever
observed hitherto over the
Antarctic. The hole expand-
ed to a size of approx 28.3
million square kilometres.
// Ozonloch über der
Antarktis, 3.9.2000
Mit einem Spektrometer
der NASA wurde das bis
dahin größte jemals bemerk-
te Ozonloch über der Ant-
arktis entdeckt (28,3 Millio-
nen Quadratkilometer).
© Courtesy, Earth Sciences
and Image Analysis Labora-
tory, NASA Johnson Space
Center

040 Changes in carbon
monoxide distribution in
the lower atmosphere
during a period of six
months Measurements by
MOPITT sensor (Measure-
ments of Pollution in the
Troposphere) on board
the satellite TERRA
// Die Veränderungen der
Kohlenmonoxid-Verteilung in
der unteren Atmosphäre des
Globus im Verlauf von sechs
Monaten.
Messungen des MOPITT
(Measurements of Pollution
In The Troposphere) Sen-
sors an Bord des Satelliten
TERRA
© Courtesy, NASA EOS
Program

041 Rape field in flower,
Teutschenthal (Saxony-
Anhalt), May 9, 2005
// Blühendes Rapsfeld,
Teutschenthal (Sachsen-
Anhalt), 9.5.2005
© Ullstein Bild, Schellhorn

042 ›In the air I brew ruin
/ And all that breathes
– must die.‹ Woodcut, 1850
Johann Gottfried Flegel
(1815–1881) after a dra-
wing by Carl Gottlieb Mer-
kel (1817–1897). From the
series: [Pictures of Death
or the Dance of Death for
All Estates], Leipzig
(W. Engelmann and R. Wei-
gel), 1850
// »In der Luft koch' ich
Verderben / Und was athmet
– es muß sterben«. Holz-
schnitt, 1850
Von Johann Gottfried Flegel
(1815–1881) nach Zeichnung
von Carl Gottlieb Merkel
(1817–1897). Aus der Fol-
ge: Bilder des Todes oder
Todtentanz für alle Stände,
Leipzig (W. Engelmann und
R. Weigel), 1850
© akg images

043 Whipped cream from the
aerosol can (nitrous oxide
or laughing-gas as a pro-
pellant)
// Schlagsahne aus der
Sprühdose (Lachgas als
Treibmittel)
© Photo by Heike Schiller,
raumzeit3 Stuttgart

044 Sparks discharged by
a tesla coil
// Funken-Entladung einer
Tesla-Spule
© Courtesy, Rapp Instruments

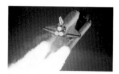

045 Atlantis Space Shuttle
starting on the STS-27 mis-
sion on December 2, 1988
The shuttle consumed more
than 1.59 million pounds
of fuel before it reached
orbit.
// Das Atlantis Space Shut-
tle startet am 2.12.1988 zur
STS-27 Mission.
Bis das Shuttle seine Flug-
bahn im Orbit erreicht
hat, verbraucht es mehr
als 1,59 Millionen Pfund
Treibstoff
© Courtesy, Earth Sciences
and Image Analysis Labora-
tory, NASA Johnson Space
Center

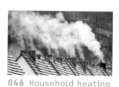

046 Household heating
emissions
// Emission von Haushalts-
feuerungen
© Ullstein Bild, Meye

047 Woman wearing a
respirator
// Frau mit Atemschutz
© Ullstein Bild, Gezett

048 Car exhaust fumes
// Autoabgase
© Ullstein Bild, Oed

049 Winter smog: air pol-
lution in Manhattan, New
York/USA, January 1, 1970
// Winter-Smog: Luftver-
schmutzung in Manhattan,
New York/USA, 1.1.1970
© Ullstein Bild, Feininger

050 Summer smog: a view
over the smoggy city of Los
Angeles, July 2, 2003
// Sommer-Smog: Blick über
die smog-verhangene Stadt
Los Angeles, 2.7.2003
© Ullstein Bild, Tanner

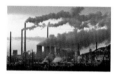

051 Air pollution caused by
industrial emissions over
the Ruhr, November 20,
2000
// Luftverschmutzung
durch Industrieabgase über
dem Ruhrgebiet, 20.11.2000
© Ullstein Bild

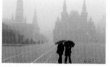

052 Air pollution in Moscow
caused by peat fires and
forest fires, September 17,
2002
// Luftverschmutzung in
Moskau durch Torf- und
Waldbrände, 17.9.2002
© Ullstein Bild, AP

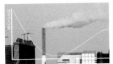

053 Helen Evans and Heiko Hansen (HEHE Association), Nuage Vert (Green Cloud). 2002
From the Pollstream art project that proposes ways of utilizing technology to visualize or materialize pollution. Pollstream speculates on aesthetic and contextual ways of materializing pollution to alter perception.
// Helen Evans and Heiko Hansen (HEHE Association), Nuage Vert. 2002
Innerhalb des Kunstprojektes Pollstream, welches Ansätze sucht, die Umweltverschmutzung zu visualisieren bzw. begreifbar zu machen. Pollstream thematisiert die ästhetischen und kontextuellen Möglichkeiten, die Umweltverschmutzung materiell zu verändern, um dadurch auch ihre Wahrnehmung zu verändern
© Courtesy, HEHE Association, Paris

054 The Atmos Clock, functional diagram
As air temperature rises, a mixture of a liquid and a gas expands in the compression chamber, which so compresses a spring. When temperature falls, the mixture is compressed and the spring relaxes. This little to and fro is sufficient to wind up the Atmos clock.
// Atmos-Uhr, Funktionszeichnung
Bei steigender Lufttemperatur dehnt sich eine Mischung aus einer Flüssigkeit und einem Gas in der Expansionskammer aus, die dadurch eine Spiralfeder zusammendrückt. Fällt die Temperatur, verdichtet sich das Gemisch und die Spiralfeder entspannt sich wieder. Schon durch dieses kleine hin und her wird die Atmos-Uhr aufgezogen
© Courtesy, Jäger-LeCoultre

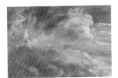

055 John Constable (1776–1837), Cloud Study: Horizon of Trees. 1821
Oil on paper laid on board, 25.8 x 30.5 cm
// John Constable (1776–1837), Cloud Study: Horizon of Trees. 1821
Öl auf Papier, auf Holz aufgezogen, 25,8 x 30,5 cm
© Royal Academy of Arts, London

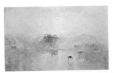

056 William Turner (1775–1851), Norham Castle, Sunrise. Ca. 1845
Oil on canvas, 90.8 x 122 cm
// William Turner (1775–1851), Norham Castle, Sunrise. Ca. 1845
Öl auf Leinwand, 90,8 x 122 cm
© Tate Collection, London

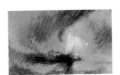

057 William Turner (1775–1851), Snow Storm: Steam-Boat off a Harbour's Mouth. 1842
Oil on canvas, 91.4 x 122 cm
// William Turner (1775–1851), Snow Storm: Steam-Boat off a Harbour's Mouth. 1842
Öl auf Leinwand, 91,4 x 122 cm
© Tate Collection, London

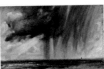

058 John Constable, R.A. (1776–1837), Rainstorm over the Sea. Ca. 1824–1828
Oil on paper, canvas lined, 23.5 x 32.6 cm
// John Constable, R.A. (1776–1837), Rainstorm over the Sea. Ca. 1824–1828
Öl auf Papier, auf Leinwand aufgezogen, 23,5 x 32,6 cm
© Royal Academy of Arts, London

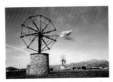

059 Wind wheels for drawing water on the S' Albufeira plain, Mallorca (Balearic Islands), Spain
// Windräder zur Wasserförderung in der Ebene von S' Albufeira, Mallorca (Balearische Inseln), Spanien
© Ullstein Bild, Schulz

060 Vincent van Gogh (1853–1890), Le Moulin de la Galette. 1886
Oil on canvas, 46 x 38 cm
// Vincent van Gogh (1853–1890), Le Moulin de la Galette. 1886
Öl auf Leinwand, 46 x 38 cm
© Courtesy, Glasgow Art Gallery and Museum

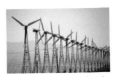

061 Wind-driven wheels for generating electricity, California/USA
// Windräder zur Stromerzeugung in Kalifornien/USA
© Photo by MM-Vision, Matthias Michel

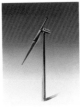

062 Growian wind wheel (single-blade rotor). 1982
Design: Werk Design Kern und Schirrmacher, manufacturer: MBB Drehflügler und Verkehr, Munich/Germany
// Growian Windenergieanlage (Einblattrotor). 1982
Design Werk Design Kern und Schirrmacher, Hersteller MBB Drehflügler und Verkehr, München
© Courtesy, Die Neue Sammlung in der Pinakothek der Moderne, Munich

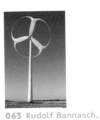

063 Rudolf Bannasch, Schlaufenpropeller (›loop propeller‹, photomontage)
Development Rudolf Bannasch, EvoLogics
The functional design of the bird wing was the model for this new type of propeller construction, influenced by bionics. The construction as a ring causes an aerodynamically optimized boundary vortex zone. Of outstanding relevance is the drastic reduction of sounds
// Rudolf Bannasch, Schlaufenpropeller (Photomontage)
Entwicklung Rudolf Bannasch, EvoLogics
Der Vogelflügel stand Pate für eine neuartige Propellerkonstruktion, in der bionischen Umsetzung wurde aus dem Handschwingen-Fächer ein schlankes Schlaufenband. Der Ringschluss ermöglicht eine aerodynamisch optimierte Randwirbelzone. Von herausragender Bedeutung ist die drastische Reduktion der Geräusche
© Courtesy, EvoLogics GmbH

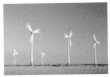

064 Wind-driven wheels for generating electricity, Schoenfeld (Brandenburg), September 1, 2004
// Windräder zur Stromerzeugung in Schoenefeld (Brandenburg), 1.9.2004
© Ullstein Bild, Caro/Ruffer

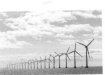

065 Mittelgrunden offshore wind farm
Germany's first wind farm in the North Sea off Borkum, commissioning in 2001
// Offshore-Windpark Mittelgrunden
Erster Windpark Deutschlands in der Nordsee bei Borkum, Inbetriebnahme 2001
© Ullstein Bild, ddp

066|068 A fluorescent tube is often misleadingly called a neon lamp, although it actually doesn't contain neon but argon
// Leuchtstoffröhren werden oft fälschlicherweise als Neonröhren bezeichnet, obwohl sie kein Neon sondern Argon enthalten

067 Ingo Maurer, Holonzki (glass hologram). 2000
Design Eckard Knuth, Ingo Maurer. Glass, metal, transformer, 13 x 18 cm
// Ingo Maurer, Holonzki (Glas-Hologramm). 2000
Design Eckard Knuth, Ingo Maurer. Glas, Metall, Transformator, 13 x 18 cm
© Courtesy, Ingo Maurer

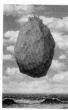

069 René Magritte (1898–1967), Le château des Pyrénées. 1959
Oil on canvas, 200 x 130 cm
// René Magritte (1898–1967), Le château des Pyrénées. 1959
Öl auf Leinwand, 200 x 130 cm
© Courtesy, The Israel Museum, Jerusalem; © VG Bild-Kunst, Bonn 2005

070 Yves Klein (1928–1962), Un homme dans l'espace (Le peintre de l'espace se jette dans le vide). 1960
Photograph
// Yves Klein (1928–1962), Un homme dans l'espace (Le peintre de l'espace se jette dans le vide). 1960
Photographie
© Courtesy, Yves Klein Archive, Paris; © VG Bild-Kunst, Bonn 2005. Photo by Harry Shunk

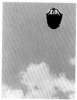

071 Alexander Rodtschenko (1891–1956), Jumping into the Water. 1970/78
Photograph (Reprint). Museum Ludwig, Cologne
// Alexander Rodtschenko (1891–1956), Der Sprung ins Wasser. 1970/78
Photographie (Reprint). Museum Ludwig, Köln
© Courtesy, Rheinisches Bildarchiv; © VG Bild-Kunst, Bonn 2005

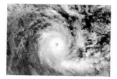

072 Tropical Cyclone Ingrid approaching Cape York Peninsula, Australia, March 8, 2005
Cyclone Ingrid was just below gale force 5 when the Moderate Resolution Imaging Spectroradiometer (MODIS) on NASA's Aqua satellite captured this image. Ingrid had winds of 240 km/h (150 mph) with gusts to 296 km/h (184 mph). The image reveals Ingrid's large, clear eye, through which dark ocean water is clearly visible.
// Der tropische Wirbelsturm Ingrid nähert sich am 8.3.2005 der Halbinsel Cape York, Australien
Ingrid hatte Sturmstärke 5, als der Moderate Resolution Imaging Spectroradiometer (MODIS) vom NASA-Satelliten Aqua aus dieses Bild machte. Ingrid erreichte Windgeschwindigkeiten von 240 km/h, in Böen bis zu 296 km/h. Die Aufnahme zeigt klar erkennbar das große Auge, durch das hindurch auch der dunkle Ozean erkennbar ist.
© NASA image, courtesy of Jeff Schmaltz

073 Andy Warhol (1928–1987), Silver Clouds. 1966
Polyester foil filled with helium, each 99 x 150 x 38 cm
// Andy Warhol (1928–1987), Silver Clouds. 1966
Mit Helium gefüllte Polyesterfolie, je 99 x 150 x 38 cm
© Courtesy, The Andy Warhol Museum, Pittsburgh

074 Yayoi Kusama, Clouds. 1984
Mixed media
// Yayoi Kusama, Clouds. 1984
Verschiedene Materialien
© Yayoi Kusama, courtesy of Robert Miller Gallery, New York

075 Annelies Štrba, Clouds. 2005
Inkjet on canvas, 125 x 168 cm. Private collection
// Annelies Štrba, Wolken. 2005
Inkjet auf Leinwand, 125 x 168 cm. Privatbesitz
© Courtesy, Annelies Štrba

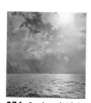

076 Gerhard Richter, Seascape (contre-jour). 1969
Oils on canvas, 200 x 200 cm. Staatliche Kunstsammlungen Kassel
// Gerhard Richter, Seestück (Gegenlicht). 1969
Öl auf Leinwand, 200 x 200 cm. Staatliche Kunstsammlungen Kassel
© Courtesy, Gerhard Richter

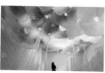

077 Lee Boroson, Lucky Storm (2). 2005
Nylon fabric, monofilament, stainless steel, blower, gold. Installation view
// Lee Boroson, Lucky Storm (2). 2005
Nylon, Monofilament, Edelstahl, Gebläse, Gold. Installationsansicht
© Courtesy, The Tang Teaching Museum and Art Gallery, Skidmore College, Saratoga Springs, New York. Photo by Arthur Evans

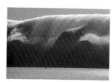

078 A foehn front at Lee (Norwegian coastal mountains)
// Eine Föhnmauer in Lee (Norwegisches Küstengebirge)
© Photo by Axel Hennig

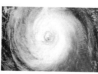

079 Typhoon Chaba on August 29, 2004, approx 537 km (334 miles) south-south-east of Sasebo/Japan
It was moving west-north-west at 15 km/h (9 mph). Maximum sustained wind speed close to 194 km/h (121 mph) with gusts to 241 km/h (150 mph)
// Taifun Chaba am 29.8.2004, ca. 537 km süd-südwestlich von Sasebo/Japan
Er bewegte sich mit einer Geschwindigkeit von 15 km/h westnordwestlich. Die durchschnittliche Windgeschwindigkeit lag bei 194 km/h, mit Böen von bis zu 241 km/h
© NASA image, courtesy of Jacques Descloitres

080 Walter De Maria, The Lightning Field. 1977
Quemado, New Mexico
// Walter De Maria, The Lightning Field. 1977
Quemado, New Mexico
© Courtesy, Dia Art Foundation. Photo by John Cliett

081 Electricity discharge under AC high tension (Lichtenberg figures)
// Elektrische Entladung bei hoher Wechselspannung (Lichtenberg-Figuren)
© Courtesy, Institut für Energieübertragung und Hochspannungstechnik (IEH), Universität Stuttgart. Photo by Frank Eppler

082 – 088 Zeppelin airship LZ4, Friedrichshafen (Lake Constance), August 1908
Glass plate, 14 x 21 cm
// Zeppelin Luftschiff LZ4, Friedrichshafen (Bodensee), August 1908
Glasplatte, 14 x 21 cm
© Courtesy, Haus der Geschichte Baden-Württemberg

089 – 091 Prospective Concepts, Stingray. 1998
Designed and manufactured by Prospective Concepts Stingray has been conceived as a hybrid aerial vehicle, a combination of aeroplane and airship, which can take off vertically and land almost anywhere. Wingspan 13 m, length 9.4 m, volume 68 m³, wing surface 70 m², driven by 2 Rotax 582 motors, performance each 64 hp/47 kW, speed at take-off 47 km/h, top speed 130 km/h
// Prospective Concepts, Stingray. 1998
Designed und hergestellt von Prospective Concepts Stingray ist konzipiert als Hybrid-Luftfahrzeug, eine Kombination aus Flugzeug und Luftschiff, das aus dem Stand abheben und an nahezu jedem Platz landen kann. Flügelspannweite 13 m, Länge 9,4 m, Volumen 68 m³, Flügelfläche 70 m², angetrieben von 2 Rotax 582 Motoren, Leistung je

64 PS/47 kW, Startgeschwindigkeit 47 km/h, Höchstgeschwindigkeit 130 km/h
© Courtesy, Festo Corporate Design

092–095 Hot Air Airship. 2001
Lead Design: Axel Thallemer, Festo Corporate Design. Membrane material: nylon fabric coated with aluminium, membrane engineering: Karl-Ludwig Busemeyer, membrane made by Jürgen Leisten, both GEFA-FLUG
Length 40 m, diameter 12 m, volume 3,000 m³.
Three passengers can be transported in addition to the pilot. The airship can – unlike balloons – circle in flight to land where it took off
// Hot Air Airship. 2001
Design Axel Thallemer, Festo Corporate Design. Membran-Material der Hülle: aluminiumbeschichtetes Nylongewebe, Membran-Konstruktion Karl-Ludwig Busemeyer, Membran-Anfertigung Jürgen Leisten, beide GEFA-FLUG
Gesamtlänge 40 m, Durchmesser 12 m, Volumen 3.000 m³.
Es können neben dem Piloten drei Personen befördert werden. Das Luftschiff kann – im Gegensatz zu Ballons – Rundflüge mit ein und demselben Start- und Landeplatz durchführen
© Courtesy, Festo Corporate Design

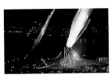

096 Otto Piene, Blue Star Linz. 1980
Blue Dacron spinnaker sailcloth lined with polyethylene, 92 cone pulleys, mast length 60 m, greatest diameter 19 m. Conceived for the Sky Art Symphony during the Ars Electronica Festival, Linz/Austria, 1980
// Otto Piene, Blue Star Linz. 1980
Blaues Dakron-Spinnakertuch mit Polyäthylenfutter, 92 Konusse, Halslänge 60 m, größter Durchmesser

19 m. Konzipiert für die Sky Art Symphony während des Ars Electronica Festivals in Linz/Österreich, 1980
© Courtesy, Ars Electronica Center/Brucknerhaus Linz; © VG Bild-Kunst, Bonn 2005

097 Serge Agoston, Sans titre (ballons jaunes). 1997
Balloons, helium
// Serge Agoston, Sans titre (ballons jaunes). 1997
Ballons, Helium
© Courtesy, Serge Agoston

098 Hans Haacke, Sky Line. 1967
White balloons, helium, nylon fishing line. Public Events, Kinetic Environment I and II, Conservatory Pond, July 23, and Sheep Meadow, October 29, 1967, Central Park, New York
// Hans Haacke, Sky Line. 1967
Weiße Ballons, Helium, Nylonschnur. Public Events, Kinetic Environment I and II, Conservatory Pond, 23.07., und Sheep Meadow, 29.10.1967, Central Park, New York
© Courtesy, Paula Cooper Gallery, New York; © VG Bild-Kunst, Bonn 2005

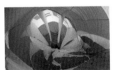

099|100 Upside Down Twins (detail of the balloons). 1995
// Upside Down Twins (Detail der Ballons). 1995
cf. 29, 31
© Courtesy, Festo Corporate Design

101 Philippe Durand, Cosette, Souvenir des Madeleines. 1994
// Philippe Durand, Cosette, Souvenir des Madeleines. 1994
© Courtesy, Philippe Durand; © VG Bild-Kunst, Bonn 2005

102 Javier Perez, Chemise d'air. 1994
Organdi, balloons, helium, 185 x 145 x 80 cm
// Javier Perez, Chemise d'air. 1994
Organdi, Ballons, Helium, 185 x 145 x 80 cm
© Courtesy, Faux Mouvement

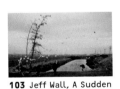

103 Jeff Wall, A Sudden Gust of Wind (after Hokusai). 1993
Photographic transparency and light box, 250 x 397 x 34 cm
// Jeff Wall, A Sudden Gust of Wind (after Hokusai). 1993
Dia und Lichtkasten, 250 x 397 x 34 cm
© Tate Collection, London, and Jeff Wall

104 Dennis Oppenheim, Whirlpool. 1973
In the summer of 1973, Dennis Oppenheim stood in El Mirage Dry Lake in California/USA, issuing radio instructions to an aircraft flying overhead. While discharging a liquid nitrogen vapor trail, the aircraft executed a circle three quarters of a mile in diameter. The pilot was then instructed to continue the maneuver but, with each revolution, he was to both reduce the diameter of the circle and lose height.
Iris Print (signed limited edition, 2001), 55.9 cm x 40.6 cm
// Dennis Oppenheim, Whirlpool. 1973
Im Sommer 1973 stand Dennis Oppenheim mit einem Funkgerät im El Mirage Dry Lake in Kalifornien/USA und gab per Funk Anweisungen an ein über ihm fliegendes Flugzeug. Dieses zeichnete hinter sich einen Kondensstreifen aus flüssigem Stickstoff, während es einen Kreis mit einem Durchmesser von einer 3/4 Meile (ca. 1,2 km) flog. Der Pilot sollte das Manöver nun wiederholen, nach jeder Runde jedoch mit kleinerem Durchmesser und in geringerer Höhe fliegen.
Iris Print (signierte, limitierte Edition, 2001), 55,9 cm x 40,6 cm
© Photo edition www.eyestorm.com

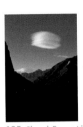

105 Cloud Formation, foehn front in the Andes, Aconcagua, Argentina
// Wolkenformation bei Föhn-Wetterlage in den Anden, Aconcagua/Argentinien
© Photo by Wolfgang Hinz

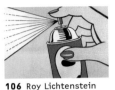

106 Roy Lichtenstein (1923–1997), Spray. 1962
Acrylic on canvas, 91.5 x 173.5 cm
// Roy Lichtenstein (1923–1997), Spray. 1962
Acryl auf Leinwand, 91,5 x 173,5 cm
© Courtesy, Staatsgalerie Stuttgart; © VG Bild-Kunst, Bonn 2005

107 Soap bubble
// Seifenblase
© Photo by MM-Vision, Matthias Michel

108 Jiří Dokoupil, I love you. 2001
Acryl and soap bubbles on canvas, 138 x 525 cm
// Jiří Dokoupil, I love you. 2001
Acryl und Seifenblasen auf Leinwand, 138 x 525 cm
© Courtesy, Galerie Bruno Bischofberger, Zurich; © VG Bild-Kunst, Bonn 2005. Photo by Roland Reiter/Werner Schnüring

109 Richard Buckminster Fuller (1895–1983), Dome over Midtown Manhattan. 1960
Photomontage showing the dome, which was to be over two miles in diameter
// Richard Buckminster Fuller (1895–1983), Dome over Midtown Manhattan. 1960
Photomontage mit der Kuppel, die einen Durchmesser von über drei Kilometern haben sollte
© Courtesy, The Estate of R. Buckminster Fuller

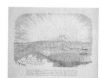

110 Bruno Taut (1880–1938), Alpine Architectures. 1919 Coloured drawing
// Bruno Taut (1880–1938), Alpine Architekturen. 1919 Farbzeichnung
© Courtesy, Technische Universität München / Munich Technical University

111 Wenzel Hablik (1881–1934), Building an aerial colony. 1908
Pencil, 22.5 x 18.1 cm
// Wenzel Hablik (1881–1934), Bau einer Luftkolonie. 1908
Bleistift, 22,5 x 18,1 cm
© Wenzel Hablik Museum, Itzehoe

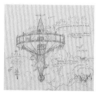

112 Wenzel Hablik (1881–1934), Aerial building, large flying settlements. 1907/14
India ink, coloured pencil on tracing paper, 35.5 x 37.4 cm
// Wenzel Hablik (1881–1934), Luftgebäude, große fliegende Siedlungen. 1907/14
Tusche, Farbstift auf Transparentpapier, 35,5 x 37,4 cm
© Wenzel Hablik Museum, Itzehoe

113 Georgy Kroutikov, Hovering City. 1928
// Georgij Krutikov, Schwebende Stadt. 1928
© Courtesy, private collection, Moscow

114 Coop Himmelb(l)au, House with Flying Roof. 1973
Wolf D. Prix, Helmut Swiczinsky, realised in London, Polygon Road
// Coop Himmelb(l)au, Haus mit dem fliegenden Dach. 1973
Wolf D. Prix, Helmut Swiczinsky, realisiert in London, Polygon Road
© Courtesy, Coop Himmelb(l)au, Vienna

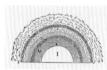

115 Diagram from René Descartes, Principia Philosophia. 1664
Illustrating his view of the earth's structure before the formation of mountains and oceans; the layers include the earth's crust, air, water and metals
// Diagramm von René Descartes, Principia Philosophia. 1664
Illustration seiner Sicht der Struktur der Erde vor der Enstehung von Bergen und Ozeanen; die Schichten bestehen aus der Erdkruste, Luft, Wasser und Metallen

116 The four elements of Empedocles (earth, air, fire and water) and the Ptolemaic solar system. 1496
Coloured woodcut from Philippe de Mantegat's »Judicium cum tractibus planetarii«, Milan, 1496
// Die vier Elemente des Empedokles (Erde, Luft, Feuer und Wasser) und das Ptolemäische Sonnensystem. 1496
Farbholzschnitt aus dem »Judicium cum tractibus planetarii« des Philippe de Mantegat, Mailand, 1496
© Ullstein Bild, Granger

117 Rainbow, primary bow with fainter secondary bow, at Bergen (Ruegen Island), June 6, 1999
// Regenbogen, Hauptbogen mit schwächerem Nebenbogen, in Bergen (Insel Rügen), 6.6.1999
© Photo by Heino Bardenhagen

118 Split rainbow over the North Sea, August 16, 1999
// Gespaltener Regenbogen über der Nordsee, 16.8.1999
© Photo by Matthias Zscharnack

119 Rainbow, seen from the Wendelstein (Bavaria), Germany, August 2, 2000
// Regenbogen, vom Wendelstein (Bayern)/Deutschland aus, 2.8.2000
© Photo by Claudia Hinz

120 Colour sequence of the primary bow: violet, indigo, blue, green, yellow, orange, red (going from the inside)
// Regenbogen-Farben des Hauptbogens: Violett, Indigo, Blau, Grün, Gelb, Orange, Rot (von innen nach außen).
© Photo by Holger Lau

121 Double rainbow, Pirna, Germany, July 30, 1998
// Doppelter Regenbogen. Pirna/Deutschland, 30.7.1998
© Photo by Holger Lau

122 White fog bow, Schlaegl/Austria, October 4, 1996
// Weißer Nebelbogen, Schlägl/Österreich, 4.10.1996
© Photo by Karl Kaiser

123 Rainbow, seen from the Unterberghorn, Kössen (The Tyrol), Austria
// Regenbogen vom Unterberghorn aus, Kössen (Tirol), Österreich
© Photo by Wolfgang Hinz

124 Rainbow at the Skogafoss waterfall, Iceland
// Regenbogen vor dem Skogafoss Wasserfall, Island
© Ullstein Bild, KPA

125 Very bright anthelion, Cologne/Germany, June 9, 2001
// Sehr helle Gegensonne, Köln/Deutschland, 9.6.2001
© Photo by Benjamin Kühne

126 Parhelion seen from an airplane over Denmark, August 25, 1998
// Untersonne vom Flugzeug aus über Dänemark, 25.8.1998
© Photo by Holger Lau

127 Sun pillar through the sun
// Lichtsäule durch die Sonne
© Photo by Mirko Nitschke

128 Circumhorizontal bow, Obertilliach (East Tyrol), Austria, July 1, 2004
// Zirkumhorizontalbogen, oberhalb von Obertilliach (Osttirol), Österreich, 1.7.2004
© Photo by Carsten Plückhahn

129 Light cross with 22° halo at the Moon (?), single-state print. 1572
Seen near Beffort. Wilhelm Berck, Neue Zeitung, December 22, 1572
// Lichtkreuz mit 22°-Halo am Mond (?), Einblatt-Druck. 1572
Gesehen nahe Beffort. Wilhelm Berck, Neue Zeitung, 22.12.1572
© Courtesy, Mark Vornhusen

130 Horizontal circle
// Horizontalkreis
© Photo by Wolfgang Hinz

131 Ring halo (22°), November 2001
// Ring-Halo (22°), November 2001
© Photo by Claudia Hinz

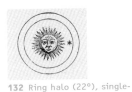

132 Ring halo (22°), single-state print. 1556
On May 2, 1556 in Nuremberg, a broadsheet reported on a celestial phenomenon; a 22° ring halo is shown: single-state print. 1556
// Ring-Halo (22°), Einblattdruck. 1556
Eine Flugschrift berichtet am 2.5.1556 in Nürnberg von einer Himmelserscheinung, abgebildet ist ein 22°-Ring-Halo
© Courtesy, Mark Vornhusen

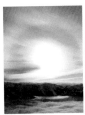

133 Ring halo (22°)
// Ring-Halo (22°)
© Photo by Wolfgang Hinz

134 Sundogs or parhelia with outwardly directed glowing tails, flanking the sun, Elm Ski Resort (Canton Glarus), Switzerland
// Nebensonnen mit nach außen gerichtetem leuchtendem Schweif, beiderseits der Sonne, Skigebiet Elm (Kanton Glarus), Schweiz
© Photo by Thomas Seekirchner

135 ‚Specter of the Brocken' and glory
// Brockengespenst mit Glorie
© Photo by Claudia Hinz

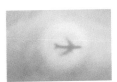

136 Glory around the shadow of an airplane
// Glorie um den Schatten eines Flugzeuges
© Photo by Bertram Kuhn

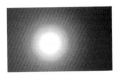

137 Quadruple corona around the Moon, January 28, 2002
// Vierfacher Kranz um den Mond, 28.1.2002
© Photo by Benjamin Kühne

138 Winter scenery in Swabia, Germany
The panorama picture illustrates changes in the colour of sunlight caused by Rayleigh and Mie scattering
// Winterlandschaft im Schwäbischen
Das Panoramabild veranschaulicht die Farbveränderungen des Sonnenlichts durch die Rayleigh- und Mie-Streuung
© Courtesy, Festo AG & Co. KG. Photo by Franz Schumacher

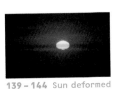

139 – 144 Sun deformed close to the horizon
Izaña Observatory, Tenerife Island (Canary Islands), Spain
// Sonnenverformung in Horizontnähe
Observatorium Izaña auf Teneriffa (Kanarische Inseln), Spanien
© Photo by Jürgen Rendtel

145 Clouds and haze in the sky
// Wolken und Dunst am Himmel
© Photo by MM-Vision, Matthias Michel

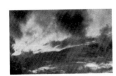

146 Red in the western sky after sunset
// Abendrot im Westen nach Sonnenuntergang
© Photo by Gerald Berthold

147 Red before sunrise in the eastern sky
November 14, 2002, Bardowick near Lueneburg/Germany
// Morgenrot vor Sonnenaufgang am östlichen Himmel 14.11.2002, Bardowick bei Lüneburg/Deutschland
© Photo by Marc Volquardsen

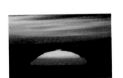

148 Green flash (sometimes also blue or red) on the upper rim of the setting sun, January 12, 1999
// Grüner Strahl (manchmal auch blau oder rot) am oberen Rand der untergehenden Sonne, 12.1.1999
© Photo by Peter Pammer

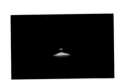

149 Green flash (sometimes also blue or red) on the upper rim of the setting sun, July 6, 2002. Izaña Observatory, Tenerife Island (Canary Islands), Spain
// Grüner Strahl (manchmal auch blau oder rot) am oberen Rand der untergehenden Sonne, 6.7.2002. Observatorium Izaña auf Teneriffa (Kanarische Inseln), Spanien
© Photo by Jürgen Rendtel

150 Schlieren over a coffee cup
// Luftschlieren über einer Kaffeetasse
© Photo by Heike Schiller, raumzeit3 Stuttgart

151 Fata Morgana. Colour lithograph. 1897
Collector card, Liebig Company's Meat Extract. From the ›Light Phenomena‹ series. Printed by Gebr. Klingenberg, Detmold
// Fata Morgana. Farblithographie. 1897
Sammelbildchen Liebigs Fleisch-Extract. Aus der Serie »Lichterscheinungen«. Druck Gebr. Klingenberg, Detmold
© akg-images

152 Superior mirage off the south coast of Crete, October 20, 1997
// Luftspiegelung nach oben vor der Südküste Kretas, 20.10.1997
© Photo by Holger Lau

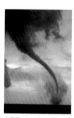

153 Tornado (cyclone) off the south coast of Cyprus, January 1, 2003
// Tornado (Wirbelsturm) vor der Südküste Zyperns, 27.1.2003
© Courtesy, Ullstein Bild, Reuters

154|155 Piero Manzoni (1933–1963), Fiato d'Artista. 1960
Balloon, wood, 18 x 18 cm
// Piero Manzoni (1933–1963), Fiato d'Artista 1960 Ballon, Holz, 18 x 18 cm
© Courtesy, Archivio Opera Piero Manzoni, Milan;
© VG Bild-Kunst, Bonn 2005.
154: Photo by Orazio Bacci

156 Marcel Duchamp (1887–1968), Air de Paris. 1919/1964
Glass phial, ready-made, height 13.3 cm
// Marcel Duchamp (1887–1968), Air de Paris. 1919/1964
Glasampulle, Ready-made, Höhe 13,3 cm
© Staatliches Museum Schwerin, Sammlung Bundesrepublik Deutschland, Norddeutsche Landesbank für Mecklenburg-Vorpommern;
© VG Bild-Kunst, Bonn 2005

157 Christo and Jeanne-Claude, 5,600 Cubic Meter Package. 1968
On the occasion of documenta 4, 1968, in Kassel/Germany. Filled with a total of 6,000 kg of air, the package consisted of 2,000 m² of Trevira fabric, coated with PVC and tied with ropes.
Height 85 m, diameter 10 m
// Christo und Jeanne-Claude, 5.600 Cubic Meter Package. 1968
Zur documenta 4, 1968, in Kassel. Luft-Paket mit 6.000 kg Luft, Hülle aus 2.000 m² Trevira, mit PVC beschichtet und mit Seilen verschnürt. Höhe 85 m, Durchmesser 10 m
© laif, Photo by Wolfgang Volz

158 René Lalique (1860–1945), Victory (figure for car bonnet). Ca. 1930
Length 25 cm
// René Lalique (1860–1945), Sieg (Kühlerfigur). Ca. 1930
Länge 25 cm
© Courtesy, Private Collection Rau; © VG Bild-Kunst, Bonn 2005

159 Auto Union, 16-cylinder racing car. 1937
Streamliner, Bernd Rosemeyer drove this car on the Frankfurt to Darmstadt autobahn accelerating it to a speed of over 400 km/h
// Auto Union, 16-Zylinder Rennwagen. 1937
Stromlinien-Fahrzeug, Bernd Rosemeyer fuhr mit diesem Rennwagen auf der Autobahn Frankfurt–Darmstadt mit einer Geschwindigkeit von über 400 km/h
© Courtesy, Unternehmensarchiv AUDI AG, Ingolstadt

160 O'Galop (Marius Rossillon, 1867–1946), Le Coup de la Semelle Michelin. 1913.
Colour lithograph. Advertising poster for Michelin tires
// O'Galop (Marius Rossillon, 1867–1946), Le Coup de la Semelle Michelin. 1913.
Farblithographie. Werbeplakat für Michelinreifen
© akg-images

161 Cadillac Eldorado convertible. 1959
Maker: General Motors, top speed 185 km/h (115 mph), length 5.71 m, width 2.04 m
// Cadillac Eldorado convertible. 1959.
Hersteller General Motors, Höchstgeschwindigkeit 185 km/h, Länge 5,71 m, Breite 2,04 m
© Courtesy, Cadillac Deutschland

162 16-Foot Transonic Wind Tunnel at NASA Research Center, Hampton, Virginia, USA. 1939
A technician prepares to unlatch the door of the 16-foot high-speed wind tunnel. Operating transonically, or across the speed of sound, the wind tunnel causes the air in the test section to travel from about 150 mph (241 km/h) to 1000 mph (1.609 km/h)
// 16-Foot Transonic Wind Tunnel des NASA Research Center, Hampton, Virginia, USA. 1939
Ein Techniker öffnet die Tür zum transsonischen Windkanal (wegen seines Durchmessers »16-Foot« genannt). Der Windkanal arbeitet transsonisch, oder

über Schallgeschwindigkeit. Die Luft im Testfeld erreicht Geschwindigkeiten von 241 bis 1.609 km/h
© CORBIS

163 Marilyn Monroe and Tom Ewell in the movie ›The Seven Year Itch‹. USA, 1955
Director: Billy Wilder
// Marilyn Monroe und Tom Ewell in dem Film »Das verflixte siebente Jahr«. USA, 1955
Regie Billy Wilder
© akg-images

164 Gernot and Johanne Nalbach, Pneumatic Furnishing Carpet. 1967
Photomontage, 12 x 18 cm
// Gernot and Johanne Nalbach, Pneumatic Furnishing Carpet. 1967
Photomontage, 12 x 18 cm
© Courtesy, Gernot and Johanne Nalbach

165 Coop Himmelb(l)au, Cloud. 1968–1972
Wolf D. Prix, Helmut Swiczinsky. Conceived as a project for the study ›Forms of Future Living‹ to be shown at documenta 5, Kassel 1972. Not realised
// Coop Himmelb(l)au, Cloud. 1968–1972
Wolf D. Prix, Helmut Swiczinsky. Als Projekt für die Studie »Wohnformen der Zukunft« entworfen und für die documenta 5, Kassel 1972, geplant.
Nicht realisiert
© Courtesy, Coop Himmelb(l)au, Vienna

166 Archigram Architects, Cuishicle. 1966
// Archigram Architects, Cuishicle. 1966
© Ron Herron, Archigram

167 Dorothee Golz, Double hollow world. 1999
Resin, steel, crystal PVC, blower,
approx 2 x 2 x 3.80 m
// Dorothee Golz, Doppelhohlwelt. 1999
Harz, Stahl, klares PVC, Gebläse, ca. 2 x 2 x 3,80 m
© Courtesy, Dorothee Golz; © VG Bild-Kunst, Bonn 2005

168 Haus-Rucker-Co, exhibition Cover – Survival in a Polluted Environment, Museum Haus Lange, Krefeld/Germany, 1971
The architects spanned the house built for the Lange family in 1928–1930 by Ludwig Mies van der Rohe and part of the garden with an enormous air-supported structure
// Haus-Rucker-Co, Ausstellung Cover – Überleben in verschmutzter Umwelt, Museum Haus Lange, Krefeld 1971
Die Architekten überspannten für die Einzelausstellung das 1928–1930 von Ludwig Mies van der Rohe für die Familie Lange gebaute Wohnhaus und einen Teil der Gartenfläche mit einer gewaltigen Traglufthalle
© Courtesy, Günter Zamp Kelp

169 Haus-Rucker-Co, Oase Nr. 7. 1972
Created for documenta 5, Kassel/Germany, 1972. Conceived as an emergency exit leading from inside the building to a different situation. A sphere buoyed up by air, with two artificial palm trees with a hammock slung between them, floats in front of the façade of the Fridericianum
// Haus-Rucker-Co, Oase Nr. 7. 1972
Für die documenta 5, Kassel 1972, entstanden. Als Notausgang konzipiert, der aus dem Gebäude-Inneren in eine andere Situation führt. Eine luftgetragene Kugel mit zwei künstlichen Palmen und einer dazwischen aufgespannten Hängematte schwebt vor der Fassade des Fridericianums
© Courtesy, Günter Zamp Kelp

170 Haus-Rucker-Co, Big Piano. 1972
A project for documenta 5, Kassel/Germany, 1972, that was never realised. A music instrument for 300 players. The frame of steel tubing is approx 20 m high. The tread of each step is covered with a contact mat to produce, when stepped on, a particular note via a system of amplifiers, transistors and loudspeakers. Scales and melodies are produced by players moving up and down the steps
// Haus-Rucker-Co, Big Piano. 1972
Nicht realisiertes Projekt für die documenta 5, Kassel 1972. Musikinstrument für 300 Personen. Ein Gerüst aus Stahlrohren erreicht eine Höhe von ca. 20 m. Die Trittfläche jeder Stufe ist mit einer Kontaktmatte belegt, bei Belastung wird über ein System von Verstärkern, Transistoren und Lautsprechern pro Stufe ein bestimmter Ton produziert. Auf- und Abwärtsbewegungen der Spieler erzeugen Tonfolgen
© Courtesy, Günter Zamp Kelp

171 | 172 Haus-Rucker-Co, Grüne Lunge (Green Lung). 1973
The ›Green Lung‹ was installed in the domed hall of the Hamburg Kunsthalle. A tower of steel tubing topped by a glass cube with plants stood in a basin. Two semicircular air cushions made of transparent sheeting – the lobes of the lung–subdivided into chambers were attached to two sides of the cube, breathing air in and out by means of an alternating air pump controlled to inhale and exhale. Like the lobes of the human lung, they rose and fell, exhaling the air, which had been filtered and scented with artificial esters, into a system of rubber tubing which ran through the building to a place where it was discharged to be tapped in the square in front of the Kunsthalle
// Haus-Rucker-Co, Grüne Lunge. 1973
Im Kuppelsaal der Kunsthalle Hamburg wurde die »Grüne Lunge« installiert. In einem Becken stand ein Stahlrohrturm, darauf ein Glas-Kubus mit Pflanzen. An den Stirnseiten des Kubus waren zwei halbkreisförmige, in Kammern unterteilte Luftkissen aus durchsichtiger Folie – die Lungenflügel – angebracht, die über wechselweise gesteuerte Gebläse Luft aus dem Grün-Kubus ein- und ausatmeten. Wie die Flügel einer menschlichen Lunge, hoben sie sich und senkten sie sich dabei und stießen die Luft gefiltert und aromatisiert mit künstlichen Zusätzen in ein Schlauchsystem, das quer durch das Gebäude zu einer Abnehmerstelle auf dem Platz vor der Kunsthalle führte
© Courtesy, Günter Zamp Kelp

173 Haus-Rucker-Co, Gelbes Herz (Yellow Heart). 1967/68
// Haus-Rucker-Co, Gelbes Herz. 1967/68
© Courtesy, Günter Zamp Kelp

174 – 179 Martín Ruiz de Azúa, Basic House. 1999
Cubic balloon made of translucent polyester, 200 g, coated on two sides with metal: gold-coloured to protect from cold and silver to insulate from heat, 2 x 2 x 2 m. The slightest difference in interior and exterior air temperature enables ›Basic House‹ to retain its shape
// Martín Ruiz de Azúa, Basic House. 1999
Würfelförmiger Ballon aus durchscheinendem, auf beiden Seiten mit Metall beschichtetem Polyester, 200 g. Die goldfarbene Seite schützt vor Kälte, die silberfarbene vor Hitze, 2 x 2 x 2 m. Die kleinste Differenz von innerer und äußerer Lufttemperatur genügt, damit das »Basic House« seine Form behält
© Courtesy, Martín Ruiz de Azúa. Photo by Daniel Riera

180 Simone Decker, Air Bag. 1998
Video loop
// Simone Decker, Air Bag. 1998
Video-Schleife
© Courtesy, Simone Decker; © VG Bild-Kunst, Bonn 2005

181-184 Theo Botschuijver/ Jeffrey Shaw, Three Pavilions – Auditorium. 1971
Air structure installation: three inflatable pavilions, each with a specific function. Besides the ›Information Pavilion‹, an air-supported hemisphere covered with synthetic grass and ›Video Studio‹, a tensile structure stretched over three large arches inflated with air, there was a two storied air-supported ›Auditorium‹. The ground-floor lobby had a circular transparent wall and its ceiling, which constituted the floor for the second level, was ballasted by many sandbags. A spiral staircase took visitors upstairs to the second level, where they could sit on the soft air-supported floor around a small stage. The yellow domed roof could also be removed to create an ›open-air‹ theatre.
// Theo Botschuijver/ Jeffrey Shaw. Three Pavilions – Auditorium. 1971
Luftstruktur-Installation: drei aufblasbare Pavillons, jeder mit einer spezifischen Funktion. Neben dem »Informationspavillon«, einer luft-getragenen Halbkugel beschichtet mit künstlichem Gras, und dem »Video-Studio«, einer Zeltstruktur, deren Plane über drei große mit Luft gefüllten Bogen, gespannt war, wurde ein zweistöckiges »Auditorium« errichtet. Dessen untere runde Ebene hatte durchsichtige Wände, die Decke wurde mit Sandsäcken beschwert und bildete gleichzeitig den Boden für die obere Ebene. Eine Wendeltreppe führte die Besucher hinauf zur zweiten Ebene, wo sie auf dem weichen, mit Luft gefüllten Boden um eine kleine Bühne herum sitzen konnten. Das gelbe Kuppeldach konnte auch abgenommen werden, um eine »Freiluftbühne« zu schaffen.
© Courtesy, Jeffrey Shaw

185 | 186 Cocoon. 1998
Design: Gregor Schilling/ Axel Thallemer.
Inflatable small tent, membrane material PU, weight approx 1.3 kg, size 230 x 80 x 90 cm (folded 20 x 12 x 12 cm). Can be set up very easily and quickly by one person. The outer envelope is made of a laminated signalling foil, which reflects body warmth inside while deflecting cold from the outside. The body is insulated from low ground temperatures because the tent floor is an air mattress
// Cocoon. 1998
Design: Gregor Schilling/ Axel Thallemer.
Aufblasbares Minizelt, Membran-Material PU, Gewicht ca. 1,3 kg, Maße 230 x 80 x 90 cm (zusammengelegt 20 x 12 x 12 cm). Sehr einfach von einer Person in kürzester Zeit aufzubauen. Die Außenhülle besteht aus einer mehrschichtigen Signalfolie, die die Körperwärme nach innen reflektiert und gleichzeitig die Umgebungskälte abweist. Niedrige Bodentemperaturen werden durch die als Luftmatraze ausgebildete Liegefläche isoliert
© Courtesy, Festo Corporate Design

187 De Pas/D'Urbino/ Lomazzi/Scolari, Globulo Poufs. 1999
PVC foil, inflatable
// De Pas/D'Urbino/Lomazzi/Scolari, Sitzkissen Globulo. 1999
PVC-Folie, aufblasbar
© Courtesy, Zanotta Spa. Photo by Marino Ramazzotti

188 Gaetano Pesce, Donna. 1969
Moulded polyurethane foam, fabric, 92 x 117 x 137 cm, seat height 40 cm.
›Donna‹ consists of a moulded monoblock of foam without any supporting structure since the foam rubber is dense and free-standing. A finished piece of furniture covered with elastic nylon jersey is reduced in a vacuum chamber to about ten percent of its normal volume and is then wrapped in airtight foil. After removal of the wrapper, the chair slowly recovers its original shape without outside help as air seeps back into the capillaries of the polyurethane foam.
// Gaetano Pesce, Donna. 1969
Polyurethanschaum, Stoff, 92 x 117 x 137 cm, Höhe der Sitzfläche 40 cm.
»Donna« besteht aus einem geformten Polyurethanschaum-Block ohne tragende Substruktur, da der Schaumstoff so dicht ist, dass er seine Form behält. Ein fertiges, mit dehnbarem Nylon-Jersey-Stoff bezogenes Möbelstück wird in luftleerem Raum auf etwa zehn Prozent seines Volumens reduziert und dann luftdicht in Folie verpackt. Wenn die Verpackung entfernt wird, kehrt der Stuhl allmählich zu seiner ursprünglichen Form zurück, da sich die Kapillare des Schaumstoffes wieder mit Luft füllen.
© Courtesy, B&B Italia

189 Quasar (Nguyen Manh Khanh), Suspension Aerospace Lamp. 1967
White and clear PVC, inflatable, height 26 cm, diameter 76 cm
// Quasar (Nguyen Manh Khanh), Suspension Aérospace Lamp. 1967
Weiße und klare PVC-Folie, aufblasbar, Höhe 26 cm, Durchmesser 76 cm
© Courtesy, EcoMusée, St. Quentin-en-Yvelines

190 De Pas/D'Urbino/Lomazzi/Scolari, armchair Blow. 1967
PVC foil, first mass produced inflatable armchair
// De Pas/D'Urbino/Lomazzi/Scolari, Sessel Blow. 1967
PVC-Folie, erster in Massenproduktion hergestellter aufblasbarer Sessel
© Courtesy, Zanotta Spa. Photo by Marino Ramazzotti

191 Yukata Murata, Fuji Group Pavilion, 1970 Osaka Expo
The biggest inflatable construction up to then. Sixteen arched air tubes made of PVA fabric, with a diameter of 4 m and a length of 78 m each, over a circular ground-plan, 50 m in diameter
// Yutaka Murata , Fuji Group Pavilion. Expo Osaka 1970
Größte bis dahin gebaute aufblasbare Konstruktion. 16 bogenförmige Luftschläuche aus PVA-Gewebe mit Durchmesser 4 m, Länge 78 m, über kreisförmigem Grundriss, Durchmesser 50 m.
© Courtesy, ILEK Institut für Leichtbau, Entwerfen und Konstruieren, Stuttgart

192 – 194 Judit Kimpian. Pneumatrix. 2001
Pneumatic theatre with tiers for seating that are also pneumatic and inflatable. Submitted to the Royal College of Art, London, as a doctoral dissertation project with the support of Branson/Coates Architects and Axel Thallemer, Festo Corporate Design
// Judit Kimpian. Pneumatrix. 2001
Pneumatisches Theater mit ebenfalls pneumatisch entfaltbaren Sitzrängen. Als Doktorarbeit am Royal College of Art, London, mit Unterstützung von Branson/Coates Architects und Axel Thallemer, Festo Corporate Design
© Courtesy, Festo Corporate Design

195 | 196 Airquarium. 2000
Lead Design: Axel Thallemer, Festo Corporate Design. Membrane material: Vitroflex, membrane engineering: David Wakefield, Tensys Limited, membrane made by Hans-Jürgen Koch, Koch Membranen.
The idea for the ›Airquarium‹ occurred while raindrops were being observed as they fell on to the surface of water, forming a hemispherical dome.
The structure differs from the classical air-supported structure in having a foundation filled with 150 tonnes of water as ballast. A cupola 32 metres in diameter and 8 metres high is stretched across it and is supported by atmospheric pressure
// Airquarium. 2000
Design Axel Thallemer, Festo Corporate Design. Membran-Material Vitroflex, Membran-Konstruktion David Wakefield, Tensys Limited, Membran-Anfertigung Hans-Jürgen Koch, Koch Membranen.
Beim Betrachten von Regentropfen, die in der Natur beim Auftreffen auf einer Wasseroberfläche eine sphärische Kuppel erzeugen, entstand die Idee zu »Airquarium«. Die Struktur unterscheidet sich von der klassischen Traglufthalle durch das mit 150 Tonnen Ballastwasser gefüllte Fundament. Darüber spannt sich eine Kalotte mit 32 Meter Durchmesser und 8 Meter Höhe, die durch Luftdruck getragen wird
© Courtesy, Festo Corporate Design

197 Air bubble on the surface of water
// Luftblase auf einer Wasseroberfläche
© Courtesy, Festo Corporate Design. Photo by Walter Fogel

198 | 202 | 203 Inflate, Office in a bucket. 2004
Design Nick Crosbie, portable, inflatable structure, lightweight PU nylon, housed in a bucket. Size (inflated) 3 x 4 m, height 2.2 m
// Inflate, Office in a bucket. 2004
Entwurf Nick Crosbie, transportierbare, aufblasbare Struktur, leichtes PU Nylon, in einem Eimer verpackt. Maße (aufgeblasen) 3 x 4 m, Höhe 2,2 m
© Courtesy, Inflate

199 – 201 Alan Parkinson (Architects of Air), Luminaria Sculptures (Eggopolis 1990, Meggopolis 1994)
Air sculptures that can be entered, inflated walls of tinted, translucent PVC sheeting
// Alan Parkinson (Architects of Air), Luminaria Sculptures (Eggopolis 1990, Meggopolis 1994)
Begehbare Luftskulpturen, mit Druckluft befüllte Wände aus farbig getönter, durchscheinender PVC-Folie
© Courtesy, Alan Parkinson

204 Inflate, Inflatable wall. 2003
Design by Nick Crosbie, PVC, size various
// Inflate, Inflatable wall. 2003
Design Nick Crosbie, PVC, verschiedene Größen
© Courtesy, Inflate

205 – 207 Martin Creed, Half The Air in a Given Space (Work No. 360). 2004
Balloons, air, helium
// Martin Creed, Half The Air in a Given Space (Work No. 360). 2004
Ballons, Luft, Helium
© Courtesy, Johnen Galerie, Berlin

208 | 210 Philippe Parreno, Speech Bubbles. 1997
Mylar balloons, air, helium. Installation view Robert Prime, London 1997
// Philippe Parreno, Speech Bubbles. 1997
Mylar Ballons, Luft, Helium. Installationsansicht Robert Prime, London 1997
© Courtesy, Galerie Esther Schipper, Berlin

209 Lee Boroson, Pleasure Grounds. 1999
Nylon fabric, blower, electrical hardware, rope, dimensions variable
// Lee Boroson, Pleasure Grounds. 1999
Nylonstoff, Gebläse, elektrische Ausrüstung, Seil, Maße variabel
© The Tang Teaching Museum and Art Gallery, Skidmore College, Saratoga Springs, New York. Photo by Arthur Evans

211 Cloud type: Stratus
// Wolkentyp: Stratus
© Photo by Björn Beyer

212 Cloud type: Stratocumulus
// Wolkentyp: Stratokumulus
© Photo by Björn Beyer

213 Cloud type: Nimbostratus
// Wolkentyp: Nimbostratus
© Photo by Björn Beyer

214 Cloud type: Cumulus
// Wolkentyp: Kumulus
© Photo by Björn Beyer

215 Cloud type: Cumulonimbus
// Wolkentyp: Kumulonimbus
© Photo by Björn Beyer

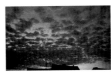

216 Cloud type: Altocumulus
// Wolkentyp: Altokumulus
© Photo by Björn Beyer

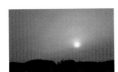

217 Cloud type: Altostratus
// Wolkentyp: Altostratus
© Photo by Björn Beyer

218 Cloud type: Cirrocumulus
// Wolkentyp: Zirrokumulus
© Photo by Björn Beyer

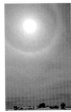

219 Cloud type: Cirrostratus
// Wolkentyp: Zirrostratus
© Photo by Björn Beyer

220 Cloud type: Cirrus
// Wolkentyp: Zirrus
© Photo by Björn Beyer

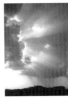

221 The Sun's rays shining through gaps in the clouds, with precipitation
// Sonnenstrahlen scheinen durch Wolkenlücken, mit Niederschlag
© Courtesy, Marc Vornhusen

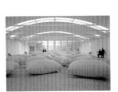

222 Lang/Baumann, Comfort #2. 2001
PVC sheeting, tubing, air pump, each approx 2 x 3.5 x 1.5 m
// Lang/Baumann, Comfort #2. 2001
PVC-Plane, Schläuche, Gebläse, je ca. 2 x 3,5 x 1,5 m
© Courtesy, Sabina Lang/ Daniel Baumann

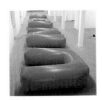

223 Lang/Baumann, Breathing Pillows. 1995
PE mats, vacuum cleaner, electronics, approx 10 x 15 x 1 m
// Lang/Baumann, Breathing Pillows. 1995
PE-Matten, Staubsauger, Elektronik, ca. 10 x 15 x 1 m
© Courtesy, Sabina Lang/ Daniel Baumann. Photo by Peter Cox

224 Lang/Baumann, undo. 1997
PVC sheeting, tubing, air pump, approx 2.8 x 10 x 1 m
// Lang/Baumann, undo. 1997
PVC-Plane, Schläuche, Gebläse, ca. 2,8 x 10 x 1 m
© Courtesy, Sabina Lang/ Daniel Baumann. Photo by David Aebi

225 Gregor Schilling/Axel Thallemer, Sleep – Air cushion. 2002
Non-toxic PVC, transparent. Even though this cushion for sleeping on at the office looks harmless and of course comical, it does draw attention to recently discovered medical knowledge that should be taken seriously. It has been scientifically shown that several brief catnaps (so-called ›power naps‹) taken during the work day considerably increase productivity and the ability to concentrate on something new each day
// Gregor Schilling/Axel Thallemer, Sleep – Luftkissen. 2002
Schadstoffarmes PVC, transparent.
Auch wenn das Büroschlafkissen auf den ersten Blick harmlos aussieht und es zwangsläufig lustig wirkt, macht es doch auf ernstzunehmende medizinische Sachverhalte aufmerksam, die erst kürzlich entdeckt wurden. Insbesondere wurde wissenschaftlich nachgewiesen, dass mehrere kurze Nickerchen (sogenannte »power-naps«) während des Arbeitstages unsere Leistungsfähigkeit und unsere Fähigkeit uns täglich auf's Neue zu konzentrieren, erheblich verbessern
© Courtesy, Festo Corporate Design

226 Takashi Murakami, Mr. DOB. 1994
Vinyl balloon, chloride and helium gas, 235 x 305 x 180 cm
// Takashi Murakami, Mr. DOB. 1994
Vinyl Ballon, Chlorid- und Heliumgas, 235 x 305 x 180 cm
© Takashi Murakami/Kaikai Kiki Co., Ltd.

227 Momoyo Torimitsu, Somehow I Don't Feel Comfortable. 2000
Two vinyl balloons, ventilator, plastic tubing, height each 480 cm
// Momoyo Torimitsu, Somehow I Don't Feel Comfortable. 2000
Zwei Vinyl-Ballons, Ventilator, Plastikröhre, Höhe je 480 cm
© Momoyo Torimitsu, courtesy of Galerie Xippas, Paris; © VG Bild-Kunst, Bonn 2005

228 Simone Decker, Chewing in Venice – Chewing gum Largo. 1999
Ilfochrome Classic on Dibond, 67 x 98 cm
// Simone Decker, Chewing in Venice – Chewing gum Largo. 1999
Ilfochrome Classic auf Dibond, 67 x 98 cm
© Courtesy, Simone Decker; © VG Bild-Kunst, Bonn 2005

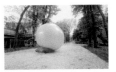

229 Simone Decker, Chewing in Venice – Chewing gum Misericordia. 1999
Ilfochrome Classic on Dibond, 67 x 98 cm
// Simone Decker, Chewing in Venice – Chewing gum Misericordia. 1999
Ilfochrome Classic auf Dibond, 67 x 98 cm
© Courtesy, Simone Decker; © VG Bild-Kunst, Bonn 2005

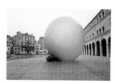

230 Simone Decker, Chewing in Venice – Chewing gum Rialto. 1999
Ilfochrome Classic on Dibond, 67 x 98 cm
// Simone Decker, Chewing in Venice – Chewing gum Rialto. 1999
Ilfochrome Classic auf Dibond, 67 x 98 cm
© Courtesy, Simone Decker; © VG Bild-Kunst, Bonn 2005

231 Simone Decker, Bubble (Ring). 1995
Latex on Column
// Simone Decker, Bubble (Ring). 1995
Latex auf Säule
© Courtesy, Simone Decker; © VG Bild-Kunst, Bonn 2005

232 Hans Hemmert, Samstag-Nachmittag, zuhause in Neukölln. 1995
Latex balloon, air, artist, room. Slide and light box, 43 x 62 cm
// Hans Hemmert, Samstag Nachmittag, zuhause in Neukölln. 1995
Latex-Ballon, Luft, Künstler, Wohnraum. Dia, Dialeuchtkasten, 43 x 62 cm
© Courtesy, carlier | gebauer Berlin; © VG Bild-Kunst, Bonn 2005. Photo by Hans Hemmert

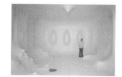

233 Hans Hemmert, Im Atelier. 1997
Latex balloon, air, artist, studio. Slide and light box, 128 x 160 cm
// Hans Hemmert, Im Atelier. 1997
Latex-Ballon, Luft, Künstler, Atelier. Dia, Dialeuchtkasten, 128 x 160 cm
© Courtesy, carlier | gebauer Berlin; © VG Bild-Kunst, Bonn 2005. Photo by Raimund Koch

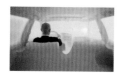

234 Hans Hemmert, Unterwegs. 1996
Latex balloon, air, artist, car. Slide and light box, 100 x 160 cm
// Hans Hemmert, Unterwegs. 1996
Latex-Ballon, Luft, Künstler, Auto. Dia, Dialeuchtkasten, 100 x 160 cm
© Courtesy, carlier | gebauer Berlin; © VG Bild-Kunst, Bonn 2005. Photo by Raimund Koch

235 Hans Hemmert, Ohne Titel. 1998
Latex balloon, air, 900 x 550 x 650 cm. Installation Centro Galeago de Arte Contemporanea, Santiago de Compostela
// Hans Hemmert, Ohne Titel. 1998
Latex-Ballon, Luft, 900 x 550 x 650 cm. Installation Centro Galeago de Arte Contemporanea, Santiago de Compostela
© Courtesy, carlier | gebauer Berlin; © VG Bild-Kunst, Bonn 2005. Photo by Xenaro Martinez Castro

236 – 241 Hans Hemmert, Ohne Titel (Gelbe Skulptur). 1998
Mixed Media, Cibachrome, 100 x 75 cm
// Hans Hemmert, Ohne Titel (Gelbe Skulptur). 1998
Verschiedene Materialien, Cibachrom, 100 x 75 cm
© Courtesy, carlier | gebauer Berlin; © VG Bild-Kunst, Bonn 2005. Photos by Raimund Koch

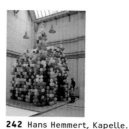

242 Hans Hemmert, Kapelle. 2004
Latex balloons, air, approx 600 x 380 x 400 cm
// Hans Hemmert, Kapelle. 2004
Latex-Ballons, Luft, ca. 600 x 380 x 400 cm
© Courtesy, carlier | gebauer Berlin; © VG Bild-Kunst, Bonn 2005. Photo by Hans Hemmert

243 Yoshiki Hishinuma, from the Clothes with Wind collection. 1991
// Yoshiki Hishinuma, aus der Kollektion Clothes with Wind. 1991
© Courtesy, Yoshiki Hishinuma

244 | 245
Hussein Chalayan, from the Kinship Journeys collection. Autumn/Winter 2003/2004
// Hussein Chalayan, aus der Kollektion Kinship Journeys. Herbst/Winter 2003/2004
© Hussein Chalayan. Photo by Chris Moore

246 – 249 Issey Miyake (Naoki Takizawa), Autumn/Winter 2000/2001 collection
// Issey Miyake (Naoki Takizawa), Kollektion Herbst/Winter 2000/2001
© Issey Miyake. Photo by Antoine de Parseval

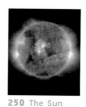

250 The Sun
Photo taken by the Extreme Ultraviolet Imaging Telescope on the Solar and Heliospheric Observatory (SOHO) satellite
// Die Sonne
Aufgenommen vom Extreme Ultraviolet Imaging Telescope an Bord des Solar and Heliospheric Observatory (SOHO) Satelliten
© Courtesy, Solar and Heliospheric Observatory (SOHO)

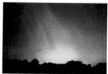

251 | 255 | 257 Polar lights are predominately green and red lines of atomic oxygen, blue-violet lines are composed of molecular nitrogen. Due to corpuscular radiation they flicker visibly in polar regions, altitude approx 70–1,000 km. Maximum intensity at an altitude of 100 km.
// Polarlicht ist dominiert durch grüne und rote Linien atomaren Sauerstoffs, blau-violette Linien entstehen durch molekularen Stickstoff. Durch Korpuskularstrahlung flackert es sichtbar in Polargebieten, zwischen ca. 70–1.000 km Höhe. Hellste Lichtstrahlung des Polarlichtes bei 100 km Höhe
© Courtesy, Heino Bardenhagen

252 – 254, title, and pp. 314|315
Mother-of-pearl clouds in the stratosphere at altitudes of 25–30 km
// Perlmutterwolken in der Stratosphäre, in einer Höhe von 25–30 km
© Courtesy, Håkon Hansson

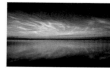

256 Noctilucent clouds, Flensburg fjord
// Leuchtende Nachtwolken, Flensburger Förde
© Courtesy, Bernt Hoffmann

258 | 259 Yves Klein/Werner Ruhnau, Air Roof Experiment. 1959
Air roof experiment conduct-

ed by the firm of Küppers-busch in Gelsenkirchen. The drops of water falling on the ceiling of pressed air are dashed away
// Yves Klein/Werner Ruhnau, Luftdachexperiment. 1959
Luftdachexperiment bei der Firma Küppersbusch in Gelsenkirchen. Die auf die Pressluftdecke fallenden Wassertropfen werden fortgeschleudert
© Courtesy, Werner Ruhnau; © Yves Klein: VG Bild-Kunst, Bonn 2005

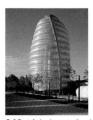

260 Nicholas Grimshaw, Leicester National Space Center. 2001
Semi-transparent tower, clad with inflated ETFE foil cushions
// Nicholas Grimshaw, Leicester National Space Center. 2001
Halbtransparenter Turm, Verkleidung aus mit Luft gefüllten Kissen aus ETFE-Folie
© View Pictures

261 Nicholas Grimshaw, Eden Project. 2001
Two vast greenhouses (Biomes) for the public.
The construction is based on Buckminster Fuller's geodetic domes, clad with lightweight, transparent ETFE foil cushions.
// Nicholas Grimshaw, Eden Project. 2001
Zwei riesige, öffentlich zugängliche Gewächshäuser (Biome). Die Konstruktion beruht auf Buckminster Fullers geodätischen Kuppeln, gedeckt mit leichten, transparenten ETFE-Kissen
© View Pictures

262 Shigeru Ban, Curtain Wall House, Tokyo. 1995
// Shigeru Ban, Curtain Wall House, Tokyo. 1995
© Courtesy, Shigeru Ban Architects

263|264 Funnbrella, 2001
Lead Design: Axel Thallemer, Festo Corporate Design. Membrane material: Précontraint ® 1502, membrane engineering: Rochus Teschner, Ingenieurbüro Teschner, membrane made by Hans-Jürgen Koch, Koch Membranen.
The neologism coined from the English terms ›funnel‹ and ›umbrella‹ stands for what is currently probably the largest funnel in the world, which rests on only a central support. A (slightly domed) square, whose sides measure 31.6 m roofs over a surface area of 998 m². The drip edge is at 11.50 m, the lowest point is 4.50 m. When opened, the spokes with the ribs weigh only 59 t; enough to open the membrane, which weighs 1270 kg mechanically. The support is designed statically so that the full weight of snow on it can rest asymmetrically on half of the umbrella surface and withstand gusts of wind of up to 200 km/h. The hollow central shaft conducts precipitation on to a bed of gravel above the sewer pipe
// Funnbrella. 2001
Design Axel Thallemer, Festo Corporate Design. Membran-Material Précontraint ® 1502, Membran-Konstruktion Rochus Teschner, Ingenieurbüro Teschner, Membran-Anfertigung Hans-Jürgen Koch, Koch Membranen.
Das aus dem englischen Begriff für Trichter (funnel) und Schirm (umbrella) geprägte Kunstwort steht für den gegenwärtig wohl weltgrößten Trichterschirm, der auf nur einer Mittelstütze ruht. Ein (leicht bobiertes) Quadrat mit 31,6 m Kantenlänge über-

dacht eine Fläche von 998 m². Die Traufkante liegt bei 11,50 m, der Tiefpunkt bei 4,50 m. Die aufgelöste Bündelstütze wiegt mit den Schirmauslegern lediglich knapp 59 t, um die Membrane mit einem Eigengewicht von 1.270 kg mechanisch vorzuspannen. Das Tragwerk ist statisch so ausgelegt, dass asymmetrisch die volle Schneelast auf der halben Schirmfläche liegen und gleichzeitig Orkanböen von bis zu 200 km/h angreifen können. Das zentrale Fallrohr leitet die Niederschläge auf ein Schotterbett oberhalb des Kanalisationsanschlusses ab
© Courtesy, Festo Corporate Design

265 Atrium roofing Festo TechnologyCenter. 2001
Pneumatically controlled sunshades for the foil roof over the atriums of the firm building Festo, Berkheim/Germany. Membrane made by: Foiltec GmbH, Bremen
// Atrienüberdachung Festo TechnologieCenter. 2001
Pneumatisch gesteuerter Sonnenschutz der Foliendächer über den Atrien des Festo Firmengebäudes, Berkheim. Membran-Anfertigung Foiltec GmbH, Bremen
© Courtesy, Festo Corporate Design

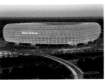

266 – 269 Herzog & de Meuron, Allianz Arena, Munich. 2005
Football stadium, surface area 258 x 227 x 50 m, façade (26,000 m²) and roof (38,000 m²) are clad with 2,874 air cushions of ETFE foil. The façade can be illuminated in different colours (red, blue, white)
// Herzog & de Meuron, Allianz Arena München. 2005
Fußball-Stadion, Grundfläche 258 x 227 x 50 m, Fassade (26.000 m²) und Dach (38.000 m²) sind mit 2.874 Luftkissen aus ETFE-Folie verkleidet. Die Fassade ist

in unterschiedlichen Farben (Rot, Blau, Weiß) beleuchtbar
© Courtesy, Allianz Arena, München Stadion GmbH.
© 269: Photographer unknown

270 Branson/Coates Architects, Powerhouse::UK. 1998
Four buildings, each with a diameter of 16 m; the steel-framed structure was clad in silver-coloured, inflated fabric
// Branson/Coates Architects, Powerhouse::UK. 1998
Vier Gebäude mit jeweils 16 m Durchmesser, das Stahlgerüst wurde mit silberfarbenem, mit Luft gefülltem Stoff verkleidet
© Courtesy, Branson/Coates Architects. Photo by Philip Vile

271|272 Airtecture. 1996
Lead Design: Axel Thallemer, structural engineering: Rosemarie Wagner, construction detailing: Udo Rutsche, all Festo Corporate Design
Polyamide fabric coated with Hypalon. Interior dimensions of the hall:
floor area 375 m², height 6 m, volume 2.250 m³. External dimensions: floor area 800 m², height 7.2 m. weight 7.5 kg/m².
A neologism coined from the English terms ›air‹ and ›architecture‹. An exhibition space with a support structure consisting of air chambers; all surfaces are air-filled membranes. They are inflated by atmospheric pressure instead of being mechanically pumped up. Unlike air-supported structures, this hall has the same atmospheric pressure inside and out. The design of the Y supports was derived from the support structure of dragonfly wings. The V-shaped supports form a spatial truss with the wall elements. In addition, the

pneumatic muscles react to counter wind-caused horizontal stress by tautening
// Airtecture. 1996
Design Axel Thallemer, Konstruktion Rosemarie Wagner, Ausarbeitung Udo Rutsche, alle Festo Corporate Design
Polyamidgewebe, Hypalonbeschichtet. Innenabmessungen der Halle: Grundfläche 375 m², Höhe 6 m, Volumen 2.250 m³. Außenmaße: Grundfläche 800 m², Höhe 7,2 m. Gewicht 7,5 kg/m².
Kunstwort aus dem englischen Begriff für Luft (air) und Architektur (architecture). Ausstellungshalle mit einer Tragstruktur aus Luftkammern, alle Hüllflächen sind luftgefüllte Membranen. Sie werden nicht mechanisch, sondern mit Luftdruck vorgespannt, im Innenraum ist im Gegensatz zu den Traglufthallen der gleiche atmosphärische Druck wie der Außenraum aufweist. Die Gestalt der Ypsilon-Stützen wurde aus der Tragstruktur von Libellen-Flügeln abgeleitet. Die V-förmig angeordneten Stützen bilden mit den Wandelementen ein räumliches Tragwerk. Zur Aufnahme der horizontalen Windlasten tragen zusätzlich die pneumatischen Muskeln bei: sie reagieren mit Anspannung
© Courtesy, Festo Corporate Design

273|274 PTW architects/ CSCEC-design/ARUP, Watercube – Olympic swimming center Beijing 2008
Lightweight construction, developed by PTW and CSCEC with ARUP, derived from the structure of the foam. Inner and outer skin of inflated ETFE cushions.
// PTW architects, Wasserwürfel – Olympisches Schwimmzentrum Peking 2008
Leichtbaukonstruktion, entwickelt von PTW und CSCEC mit ARUP, abgeleitet von der Struktur von Schaum. Innere und äußere Hülle mit Luft gefüllte ETFE-Kissen
© Courtesy, PTW architects

275|276 Peter Haimerl, Castle of Air. 2003/2004 High-gloss stainless steel, 7.5 x 7.5 m, height 6.5 m **//** Peter Haimerl, Castle of Air. 2003/2004 Hochpolierter Edelstahl, 7,5 x 7,5 m, Höhe 6,5 m © Peter Haimerl

277 – 280, endpapers, and pp. 312|313 Diller & Scofidio, Blur Building. 2002 An artificially generated cloud for Expo 2002 in Switzerland above the lake at Neuchâtel near Yverdon-les-Bains **//** Diller & Scofidio, Blur Building. 2002 Künstlich erzeugte Wolke für die Schweizer Expo 02 über dem Neuchâteler See bei Yverdon-les-Bains © Courtesy, Diller & Scofidio

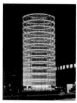

281 – 284 Toyo Ito, Tower of the winds, Yokohama. 1986 Height 21 m, tower covered with mirrored plates and encased in an oval aluminium cylinder. When the tower is lit during the night, floodlights positioned between these two layers make it look like a giant kaleidoscope. **//** Toyo Ito, Turm der Winde, Yokohama. 1986 Höhe 21 m, mit verspiegelten Platten verkleideter Turm, zusätzlich umhüllt von einem ovalen Aluminium-Zylinder. Flutlicht-Scheinwerfer, die zwischen diesen beiden Schichten angebracht sind, lassen den Turm nachts wie ein riesiges Kaleidoskop erscheinen. © Courtesy, The Japan Architect Co., Ltd.

285 Wilhelm Koch, Airparc – Pneu-Haufen (heap of tyre tubes). 2004 16 intussuscepted rubber tubes on a metal stand form a billowing organic primal form. Dimensions 120 x 120 x 180 cm **//** Wilhelm Koch, Airparc – Pneu-Haufen. 2004 16 ineinander verknüpfte Gummischläuche auf einem Metallpodest bilden eine prall organische Urform. Maße 120 x 120 x 180 cm © Courtesy of Festo Corporate Design; © VG Bild-Kunst, Bonn 2005. Photo by Heike Schiller, raumzeit3 Stuttgart

286 Wilhelm Koch, Airparc – Pneu-Thron (tyre-tube throne). 2004 Rubber-covered inflatable seat and back of a ›throne‹ on a stepped metal substructure measuring 200 x 80 x 220 cm **//** Wilhelm Koch, Airparc – Pneu-Thron. 2004 Gummibespannte und aufgeblasene Sitz- und Rückenfläche eines »Throns«, auf treppenförmiger Metall-Unterkonstruktion, Maße 200 x 80 x 220 cm © Courtesy of Festo Corporate Design; © VG Bild-Kunst, Bonn 2005. Photo by Heike Schiller, raumzeit3 Stuttgart

287 Klaus Illi, Pneumatic Mirror. 2004 The ›pneumatic mirror‹ consists of three separate chambers which are filled with air and deflated again so that the thin mirror membranes are convex in the front or concave at the back to create various spatial and temporal effects of miniaturisation and magnification. The ›mirror breathing‹ process can make viewers appear in duplicate or disappear altogether; they are transported through space. **//** Klaus Illi, Pneumatischer Spiegel. 2004 Der »pneumatische Spiegel« besteht aus drei separaten Kammern, die mit Luft gefüllt und wieder entleert werden, so dass sich die dünnen Spiegelmembranen konvex vorwölben oder nach hinten konkav einsaugen und verschiedene raumzeitliche Verkleinerungs- und Vergrößerungseffekte erzeugen. Die prozesshafte »Spiegelatmung« kann den Betrachter verdoppeln oder verschwinden lassen, er wird durch den Raum bewegt. © Courtesy of Festo Corporate Design; © VG Bild-Kunst, Bonn 2005. Photo by Heike Schiller, raumzeit3 Stuttgart

288 Jeff Koons, Balloon Flower. 1999/2001 Potsdamer Platz in Berlin/Germany. Stainless steel, 274 x 335 x 289 cm. DaimlerChrysler Collection **//** Jeff Koons, Balloon Flower. 1999/2001 Am Potsdamer Platz in Berlin. Edelstahl, 274 x 335 x 289 cm. DaimlerChrysler Collection © Photo by Wolfgang Seitz

289 Yves Klein, Le vent du voyage. 1960 Cosmogony, ›painting‹ made on a canvas (fixed on the roof) by wind and weather during a car trip from Paris to Nice, 93 x 73 cm **//** Yves Klein, Le vent du voyage. 1960 Kosmogonie, durch Wind und Wettereinflüsse entstandene »Malerei« auf einer Leinwand (auf dem Autodach befestigt) während einer Autofahrt von Paris nach Nizza, 93 x 73 cm © Courtesy, Yves Klein Archive, Paris; © VG Bild-Kunst, Bonn 2005

290 Eduardo Chillida (1924–2002), Peine del viento (wind combs). 1977 At the western end of La Concha Bay, San Sebastian, Spain. Iron sculptures **//** Eduardo Chillida (1924–2002), Peine del viento (Windkämme). 1977 Am Westende der Bucht La Concha, San Sebastián/Spanien. Eisenskulpturen © VG Bild-Kunst, Bonn 2005. Photo by Jesús Uriarte

291 Sea panorama **//** See-Panorama © Photo by MM-Vision, Matthias Michel

The numerals refer to the page numbers of the English text. Semibold numerals indicate pages with illustrations
// Die Ziffern verweisen auf die Seitenzahlen des englischen Texts. Halbfette Ziffern bedeuten Abbildungsseiten

OLIVER HERWIG, born 1967 in Regensburg/Germany.
Studied German literature, American literature and modern history at Regensburg University as well as comparative literature and art history at Williams College, Williamstown, Massachusetts/USA and the University of Illinois at Urbana-Champaign/USA before taking his doctorate at Christian Albrecht University, Kiel/Germany; dissertation: ›Word Design. Eugen Gomringer and the Visual Arts‹.

Today lives as a freelance journalist and writer in Munich/Germany, where he works for Bayerischer Rundfunk, Süddeutsche Zeitung and Frankfurter Rundschau.

In 1999 holder of a grant for the International Journalist Programme Great Britain and guest editor at wallpaper*; 2000 Karl Theodor Vogel Prize for Outstanding Technology Journalism (3rd prize); 2002 VCCA (Virginia Center for the Creative Arts) grant; 2005 instructor for the theory of design at Basle and Karlsruhe Universities.

OLIVER HERWIG, geboren 1967 in Regensburg.
Studierte Germanistik, Amerikanistik und Neuere Geschichte in Regensburg sowie Komparatistik und Kunstgeschichte am Williams College, Massachusetts/USA, und der University of Illinois at Urbana-Champaign/USA bevor er an der Christian-Albrecht-Universität zu Kiel mit der Arbeit »Wortdesign. Eugen Gomringer und die bildende Kunst« promovierte.

Heute lebt er als freier Journalist und Autor in München und arbeitet u. a. für den Bayerischen Rundfunk, die Süddeutsche Zeitung und die Frankfurter Rundschau.

1999 Stipendiat des Internationalen Journalistenprogramms Großbritannien und Gastredakteur bei wallpaper*, 2000 Karl-Theodor-Vogel-Preis für herausragende Technik-Publizistik (3. Preis), 2002 Stipendiat des VCCA (Virginia Center for the Creative Arts), 2005 Lehrbeauftragter für Designtheorie an den Hochschulen Basel und Karlsruhe.

AXEL THALLEMER, born 1959 in Munich/Germany.
Studied Theory of Science, Logic and Theoretical Linguistics at the Ludwig Maximilian University at Munich, achieved the degree »Diplom-Ingenieur« in Civil Engineering at the Academy of Fine Arts, Munich. Received a DAAD postgraduate scholarship in Business, Public Relations and Psychology at NYSID, New York City/Manhattan, USA. Since 1999 professorship for Computer Aided Design and Marketing, as well as Corporate Design at the Munich University of Applied Sciences. 2003 professorship for Technical Design at Academy of Fine Arts, Hamburg. From 2004 on, Head of Industrial Design department at Universitaet fuer Industrielle und Kuenstlerische Gestaltung at Linz, Austria as well as dean of the faculties for architecture, urban development and space planning, interior design. Guest professor at University of Houston, Texas, USA as well as at Academies of Fine Arts & Design Guangzhou and Tsinghua University, Beijing, PRC.

First appointment in a brand identity agency at Hamburg, working then for five years as Design Engineer in the styling studio at the Research and Development Center of Porsche AG, Stuttgart, initiating the introduction of the Computer Aided Styling process. 1994 founder and Head of Festo Corporate Design for long-lasting capital goods and components of industrial automation; – since 2004 self-employed under the motto »... innovation input by team Airena®!«

Participation in numerous group exhibitions and his designs are included in permanent collections of museums around the world, national and international awards and prizes. Since 2002 appointed Fellow of The Royal Society of Arts, Manufactures and Commerce, London, founded in 1754.

AXEL THALLEMER, geboren 1959 in München.
Studierte Wissenschaftstheorie, Logik und theoretische Linguistik an der Ludwig-Maximilians-Universität in München, erlangte an der Akademie der Bildenden Künste München den Grad »Diplom-Ingenieur«. DAAD Postgraduiertenstipendium in Business, Public Relations und Psychologie für den unternehmerischen Designer an der NYSID, New York City/Manhattan, USA. Ab 1999 Professur für Computer Aided Industrial Design an der Fachhochschule München. 2003 Professur für Technisches Design an der Hochschule für bildende Künste, Hamburg. Ab 2004 Leiter der Studienrichtung Industrial Design an der Universität für industrielle und künstlerische Gestaltung in Linz, Österreich sowie Institutsvorstand der Studienrichtungen Architektur, Städtebau und Raumplanung, Raumgestaltung sowie Werkerziehung. Gastprofessuren an der Universität von Houston, Texas/USA sowie an den Akademien für Bildende Künste und Design in Guangzhou, Canton und der Tsinghua Universität Peking, China.

Erstes Engagement in einer Hamburger Marken- und Identity-Agentur, anschließend fünf Jahre als Design-Ingenieur im Styling Studio der Porsche AG am Forschungs- und Entwicklungszentrum Weissach. Dort initiierte er u.a. die Einführung des Computer Aided Styling Prozesses. 1994 Gründung und Leitung von Festo Corporate Design für langlebige Investitionsgüter und Komponenten der Industrieautomatisierung. Ab 2004 selbständig mit »... innovation input by team Airena®!«

Globale Teilnahme an zahlreichen Gruppenausstellungen, seine Designarbeiten sind weltweit in Museen vertreten, nationale und internationale Auszeichnungen und Preise. 2002 Ruf in die 1754 gegründete Royal Society of Arts, Manufactures and Commerce, London.

I should like to express my appreciation
to everyone who has collaborated on making
this book possible, first and foremost
Festo AG & Co. KG

The Publisher

Ich danke allen, die am Zustandekommen
dieses Buches mitgewirkt haben, insbesondere
der Festo AG & Co. KG

Der Verleger

ARNOLDSCHE Art Publishers, Liststraße 9,
D–70180 Stuttgart
www.arnoldsche.com

Authors / Autoren
Oliver Herwig
Axel Thallemer

Editorial Work / Redaktion
Elke Thode, ARNOLDSCHE

Layout / Grafische Gestaltung
nalbach typografik, Silke Nalbach, Volker Kühn,
Stuttgart/Germany

Offset Reproductions / Offset Reproduktionen
Repromayer, Reutlingen/Germany

Printing / Druck
Druckhaus Beltz, Hemsbach/Germany

Bookbinding / Buchbinder
Buchbinderei Schaumann, Darmstadt/Germany

Cover / Umschlag
Lenticular foil / Lentikular-Folie
Vogt Foliendruck, Hessisch Lichtenau/Germany

This book has been printed on:
Dieses Buch wurde gedruckt auf:
Arctic the Volume, 150 g/m²
Opakal Dünndruck, 60 g/m²
Zanders Spectral hochweiß, 100 g/m²
Chromolux 700, 120 g/m²

This book has been printed on paper that is
100% free of chlorine bleach in conformity with
TCF standards.

Dieses Buch wurde gedruckt auf 100% chlorfrei
gebleichtem Papier und entspricht damit dem
TCF-Standard.

Book Air-bag / Buch-Airbag
Inflate, London/UK

Bibliographic information published by Die
Deutsche Bibliothek
Die Deutsche Bibliothek lists this publication
in the Deutsche Nationalbibliografie; detailed
bibliographic data is available in the Internet
at http://dnb.ddb.de.

Bibliographische Information Der Deutschen
Bibliothek
Die Deutsche Bibliothek verzeichnet
diese Publikation in der Deutschen
Nationalbibliografie; detaillierte
bibliografische Daten sind im Internet über
http://dnb.ddb.de abrufbar.

ISBN 3-89790-214-1

Made in Germany, 2005

9 783897 902145

Please visit our homepage
Besuchen Sie uns im Internet
www.arnoldsche.com